Giambologna 1529–1608
SCULPTOR TO THE MEDICI

Catalogue edited by Charles Avery and Anthony Radcliffe

An exhibition organised by the Arts Council of Great Britain and the
Kunsthistorisches Museum, Vienna, in association with the
Edinburgh Festival Society, the Royal Scottish Museum and the
Victoria & Albert Museum

Royal Scottish Museum, Edinburgh 19 August – 10 September 1978
Victoria & Albert Museum, London 5 October – 16 November 1978
Kunsthistorisches Museum, Vienna 2 December 1978 – 28 January 1979

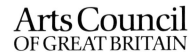

Arts Council
OF GREAT BRITAIN

Executive committee

Dr Charles Avery

Mr Malcolm Baker

Miss Janet Holt

Monsieur Bertrand Jestaz

Dr Manfred Leithe-Jasper

Mr Anthony Radcliffe

Dr Katharine Watson

Advisory committee

Professor Luciano Berti

Dr Elisabeth Dhanens

Professor James Holderbaum

Professor Dr. Herbert Keutner

Dottoressa Emma Micheletti

Professor Dr. Ulrich Middeldorf

Professor Sir John Pope-Hennessy

Dr. Hans Weihrauch

© The authors and the Arts Council of Great Britain 1978
ISBN 0 7287 0180 4 soft cover
ISBN 0 7287 0181 2 hard cover

Exhibition officer: Janet Holt
Editorial assistant: Irena Hoare
Research assistant: Anthea Brook
Catalogue design: Roger Huggett/Sinc
Printed in England by the Westerham Press

Exhibition design: Ivor Heal
Installation in Edinburgh and London: Beck and Pollitzer

Photographs have been supplied by lenders
and the following photographers

Annan, Glasgow
Archives photographiques, Paris
Balarini C., Milan
Ferdinandon Baisotti, Florence
Bertoni, Florence
Maurice Chuzeville, Paris
Stanley, J. Coleman (London) Ltd
Courtauld Institute of Art
Prudence Cuming Associates, London
U. Edelmann, F.F.M.
Frequin Photos, Holland
Hickey & Robertson, Houston, Texas
Etienne Hubert, Paris
Marchacroix, Nice
Photo Meyer KG, Vienna
Documentation photographique de la Réunion des Musées Nationaux
Tom Scott, Edinburgh
Studio Fotofast, Bologna
Taylor & Dull Inc., New York
Dick Wolters, Orezande, Netherlands

Acknowledgement

The Arts Council welcomed the invitation from the Victoria & Albert Museum to undertake with the museum the organisation of an exhibition of small bronze sculpture by Giambologna and his workshop and to publish the catalogue. The Edinburgh Festival Society readily agreed to hold the first showing of the exhibition in the Royal Scottish Museum and we are happy to continue our long association with the Edinburgh International Festival. At an early stage in the planning of the exhibition the Kunsthistorisches Museum expressed interest in mounting it in Vienna; thus through the close collaboration of the Directors and staff of the participating museums it has been possible to arrange three showings of the first major exhibition wholly devoted to the work of Giambologna.

The exhibition is the brain child of Dr Charles Avery and Mr Anthony Radcliffe and they and we have received valuable advice and practical assistance from the members of the Advisory Committee listed on page 2, to whom we would like to record our thanks.

The selection has been made by Dr Avery and Mr Radcliffe with Dr Manfred Leithe-Jasper (who has also been responsible for the organisation of the exhibition in Vienna), and Dr Katharine Watson. Their personal approaches to museums and collectors and the unique importance of the occasion are undoubtedly responsible for the extraordinarily generous response to loan requests. We would like to thank all lenders, some of whom wish to remain anonymous, whose names are listed on pages 5 and 6.

We are grateful to the authors and editors of this catalogue who are listed on page 8.

We would also like to thank, in Vienna Dr Hertha Firnberg, Der Österreichische Bundesminister für Wissenschaft und Forschung; Sektionschef Magister Leopold Obermann, Bundesministerium für Wissenschaft und Forschung; Ministerialrat Dr Carl Blaha, Bundesministerium für Wissenschaft und Forschung; W. Hofrat Dr Friderike Klauner, Erster Direktor des Kunsthistorischen Museum; Professor Dr Herbert Gaisbauer, Direktor des Österreichischen Kulturzentrums; in Edinburgh, Mr Norman Tebble, Director, Mr Revel Oddy, Keeper of Art and Archaeology, Mr Malcolm Baker and Mr Hector Fernandez of the Royal Scottish Museum, and in London, Dr Roy Strong, Director, and Mr John Beckwith, Keeper of Architecture and Sculpture, Victoria & Albert Museum. We are grateful for the support and co-operation of the Italian Institute in London, especially Professor Mario Montuori and Signora Barzetti. The Scottish Arts Council has also been of great assistance.

Joanna Drew *Director of Art*

Contents

Lenders

UNITED KINGDOM
Her Majesty the Queen 152, 153

ASHFORD John Hewett 22, 248
BATH Holburne of Menstrie Museum, University of Bath 20
CAMBRIDGE National Trust, Fairhaven Collection, Anglesey Abbey 2
EDINBURGH National Gallery of Scotland 212
Royal Scottish Museum 47
The University of Edinburgh 169
HORRINGER National Trust, Ickworth 68
LONDON Sir Leon Bagrit 18
British Museum 210, 211, 228, 229
Lord Clark 24, 25
Brinsley Ford 239, 247
S. Franses 138
Cyril Humphris 66, 198, 201
Victoria & Albert Museum 7, 52, 151, 162, 183, 208, 209, 222, 223, 225, 226, 227, 230, 231, 232, 233, 235, 243, 244
OXFORD The Visitors of The Ashmolean Museum 11, 205, 242
RAVENGLASS Sir William Pennington Ramsden, Bart 23

Private Collection 65, 71, 73, 141, 184, 197, 202, 214, 216, 224, 237

EIRE
DUBLIN National Gallery of Ireland 49, 75, 76, 83

AUSTRIA
VIENNA Kunsthistorisches Museum 1, 12, 26, 34, 53, 57, 59, 62, 79, 81, 82, 87, 118, 119, 156, 174, 175

CANADA
TORONTO Royal Ontario Museum 111

FRANCE
DIJON Musée des Beaux Arts 8, 144, 160
DOUAI Musée de la Chartreuse 64, 104, 108, 236
MAREUIL-SUR-ARNON Antony Embden 188
PARIS Musée du Louvre, Cabinet des Dessins 207
Dept. des Objets d'Art 13, 41, 44, 51, 60, 67, 70, 80, 84, 131, 171, 186, 190, 191
Dept. des Peintures 215
Dept. des Sculptures 146, 159, 238, 240

Monsieur et Madame Alain Moatti 4

WEST GERMANY
BERLIN Staatliche Museen Preussischer Kulturbesitz 38, 40, 45, 54, 55, 95, 139, 182, 241
Kunstbibliothek, Staatliche Museen Preussischer Kulturbesitz 203
BRUNSWICK Herzog Anton Ulrich-Museum 5, 39, 115, 116
FRANKFURT Städtische Galerie Liebieghaus 109
HAMBURG Museum für Kunst und Gewerbe 246
KASSEL Verwaltung der staatlichen Schlösser und Garten Hessen 161, 163
MUNICH Bayerisches Nationalmuseum 9, 58, 122–7

Private Collection 43, 168

Editors' acknowledgement

The editors wish to record their profound debt to the work of Elisabeth Dhanens, for whose monograph on Giambologna their respect continued to grow as work on the catalogue proceeded. Without it this catalogue would scarcely have been possible.

They also wish to express their personal thanks to James Holderbaum, who generously made available some of the hard-won fruits of his researches, to Irena Hoare, who skilfully handled a great load of sub-editorial work, to Janet Holt, to Lucy Cullen for rapid and accurate typing cheerfully done, to too many good friends and colleagues in the museum profession to list here, to Andrew Ciechanowiecki and to Merribell Parsons.

Charles Avery would like to record his gratitude to Professor Montuori of the Italian Institute, London, for arranging an Italian Government Grant for two months' research in Florence in 1976, during which basic information for the exhibition and catalogue was gathered.

Catalogue note

The catalogue is the work of seven different authors, and no attempt has been made by the editors to reconcile differing points of view. The origins of many sculptures by Giambologna are still obscure, and more than one interpretation of the documentary material is possible. In one case it has been thought worth while to print two entries which happened to be contributed on the same piece reflecting differing interpretations (cat. 35).

All entries are signed with initials, which indicate the following authors:

C.A. Dr Charles Avery, Deputy Keeper, Department of Architecture and Sculpture, Victoria & Albert Museum, London.

A.B. Anthea Brook.

H.K. Professor Dr Herbert Keutner, Director, Kunsthistorisches Institut, Florence.

M.L.-J. Dr Manfred Leithe-Jasper, Leiter, Sammlung für Plastik und Kunstgewerbe, Kunsthistorisches Museum, Vienna.

L.O.L. Dr Lars Olof Larsson, Department of Art History, University of Stockholm.

A.R. Anthony Radcliffe, Assistant Keeper, Department of Architecture and Sculpture, Victoria & Albert Museum, London.

K.J.W. Dr Katharine J. Watson, Director, Bowdoin College Museum of Art, Brunswick, Maine. Collaborative entries are signed with the initials of both authors, the former indicating the writer of the text.

Cat. followed by a number indicates an entry in this catalogue.

† indicates an exhibit not available for the exhibition.

A number, or combination of numbers and letters, immediately following the citation of a collection indicates the inventory number in that collection.

Measurements (except where otherwise indicated) are given in terms of centimetres to the nearest millimetre (some of these are not personally checked by the authors and are given as reported). *h.* indicates height; *l.* indicates length; *w.* indicates width; *d.* indicates depth. Except where otherwise indicated, the height given is exclusive of socle.

The terms *left* and *right* in the case of a statue or statuette indicate the left and right of the figure: in the case of a relief they indicate the viewer's left and right.

The term *base* is used to indicate an element on which a figure or group stands, of the same material as the figure or group (whether integral or not), which constitutes an essential part of the sculpture. The term *socle* is used to indicate a support (whether of the same material of another) which is not an essential part of the sculpture.

Bibliographical references given in the form of author, year and page number will be found set out in full in the bibliography in alphabetical order of the author's name. Catalogues of exhibitions which have no named author are cited under place and year.

Introduction
by Anthony Radcliffe

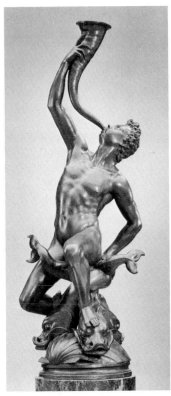

Triton, bronze
The Metropolitan Museum of Art, New York (Bequest of Benjamin Altman)

This exhibition was conceived with two main purposes in mind: the first was to demonstrate that Giambologna was one of the most inventive geniuses in the whole history of European sculpture, and the second was to provide the first opportunity ever for determining, amongst the vast accumulation of sculptures to which his name has been attached, what precisely is his own work and what is that of his assistants, pupils, followers and copyists.

No exhibition of sculpture can ever be complete: it is in the nature of the art that some of the greatest masterpieces can never be moved from their original sites. Inevitably this exhibition shows the art of Giambologna through portable works, and is dominated by bronze statuettes. But in the case of Giambologna small bronzes play an especially important part.

Although he spent virtually all his working life in Florence in the service of the Medici, Giambologna was in a sense sculptor to Europe at large, a truly international artist, whose revolutionary new style came to be embraced by sculptors throughout Europe. The dissemination occurred in two ways. Himself a Fleming, born at Douai (the Italian name 'Giambologna' is a corruption of his real name Jean Boulogne), and trained in the South Netherlands under the sculptor Jacques Dubroeucq, Giambologna welcomed into his busy workshop in Florence young sculptors from all over Northern Europe, who eventually recrossed the Alps to bring their own interpretations of his style to the courts of the North: Hans Mont from Ghent, who was to work in Vienna, Prague and Innsbruck, Adriaen de Vries from the Hague, who was to work at the Imperial court in Prague, Hubert Gerhard from s'Hertogenbosch, who was to work for the Fuggers in Augsburg and for the Duke of Bavaria in Munich, Pierre Francheville ('Francavilla') from Cambrai, who was eventually to become court sculptor to the King of France in Paris, Hans Reichle from Schongau ('Anzirevelle Tedesco'), who was to work in Brixen, Augsburg and Munich, and Hubert Le Sueur from Paris, who was to work for King Henri IV and, later, for King Charles I in London.

The second way in which Giambologna's style was disseminated was by his bronze statuettes. Many of these were given by the Grand Dukes as diplomatic presents to other European rulers: to Emperor Maximilian II in Vienna, and later to Rudolph II in Prague, to Elector Christian I of Saxony in Dresden and to Henry, Prince of Wales, in London, to name but a few. Others were ordered from his shop or bought in Florence by travellers and art dealers. The influence of these bronzes can be seen quite clearly in the sculpture of the countries to which they travelled. In Germany two well-known statuettes, the *Mars* and the *Astronomy*, inspired the splendid figures which flank the Doorway of the Gods in the Golden Hall at Schloss Bückeburg (1605). In France the Giambologna bronzes in the collections of Cardinal de Richelieu, many of which later belonged to the court sculptor François Girardon, as well as those of King Louis XIV, underlie the great marble groups of the gardens of Versailles. In England bronzes formerly in the Royal Collections are reflected in stone garden figures by Caius Gabriel Cibber (Victoria & Albert Museum and Mapledurham House) and the beautiful garden sculptures in lead by Andrew Carpenter.

Most of the bronzes with secure provenances from early princely collections have been borrowed for the exhibition: apart from bronzes which belonged to the Medici, there are pieces from the collections of the Dukes of Parma, the Elector Christian I of Saxony, the Dukes of Brunswick-Wolfenbüttel, the

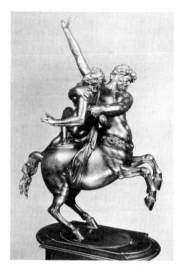

Nessus and Deianeira, bronze, signed
The Henry E. Huntington Library and
Art Gallery, San Marino, California
(detail opposite).

Emperors Maximilian II and Rudolph II and King Louis XIV of France. Regrettably, the collection of Prince Henry, which later belonged to King Charles I, was totally dispersed under the Commonwealth, and none of his Giambologna bronzes can now be identified with any certainty. The exhibition also includes every known signed bronze by Giambologna except one, which could not be lent because of the terms of foundation of the Henry E. Huntington Library and Art Gallery, San Marino, California. These will serve as criteria for the assessment of other pieces, the history of which is not known.

Bronze is by its very nature a reproductive medium. No bronze statuettes have been more reproduced than those of Giambologna. Apart from those cast in his own workshop by his assistant Antonio Susini, and those made later by Gianfrancesco Susini and by Giambologna's successor as Granducal sculptor, Pietro Tacca (examples of all of whose work are shown here), further versions were cast in the middle and second half of the 17th century by Ferdinando Tacca and Damiano Cappelli and in the early 18th century by Massimiliano Soldani. Models for bronzes by Giambologna inherited by Ferdinando Tacca were in the late 17th century sold by his heirs to the medallist Lorenzo Maria Weber, who presumably reproduced them, while the Roman bronze founder Francesco Righetti in his price list of 1795 (preserved in the Victoria & Albert Museum) offered casts of several of the best-known Giambologna models. Examples of these must exist, but none has so far been identified. In the mid-19th century the founders Crozatier in Paris and Hatfield in London made and sold casts of Giambologna bronzes, and as late as the early years of the present century the foundry of Chiurazzi and De Angelis in Naples was offering for sale excellent casts of the Giambolognas in the museum at Capodimonte. It is expected that in the present exhibition some cuckoos will be found lurking in the nest. Technical examination in the Victoria & Albert Museum has already eliminated some pieces which might otherwise have been candidates for the exhibition. In some instances several, often widely differing, versions of the same model are exhibited for comparison.

The list of *desiderata* was compiled and the catalogue has been written in an exploratory spirit. In the catalogue ascriptions are included in the titles only when they are beyond question, although frequently they are suggested in the texts of the entries.

The exhibition will differ slightly at each venue. In Edinburgh it will consist chiefly of bronzes, but in London it will also include the monumental marble *Samson and a Philistine* and two statues by Francavilla. It will be further augmented by sketch-models from the Victoria & Albert Museum and the Ashmolean Museum, from the Louvre, Berlin and from English private collections, all of which are in too critical a state to be risked for more than one showing. In Vienna it will include bronzes from the Liechtenstein Collection and pieces by Northern followers of Giambologna.

A section of the exhibition is devoted to the supposed portraits of Giambologna and Francavilla. In the absence of any systematic body of work on drawings possibly by, or connected with Giambologna, it was only possible to make a modest selection.

For those not familiar with the complicated techniques of bronze casting, an explanatory exhibit has been prepared by the Sculpture Department of the Royal College of Art under Professor Bernard Meadows especially for the exhibition.

The organizers hope that the exhibition will be instructive to connoisseurs and a pleasure to lovers of the art of sculpture, and that the genius of Giambologna will be self-evident to all who view it.

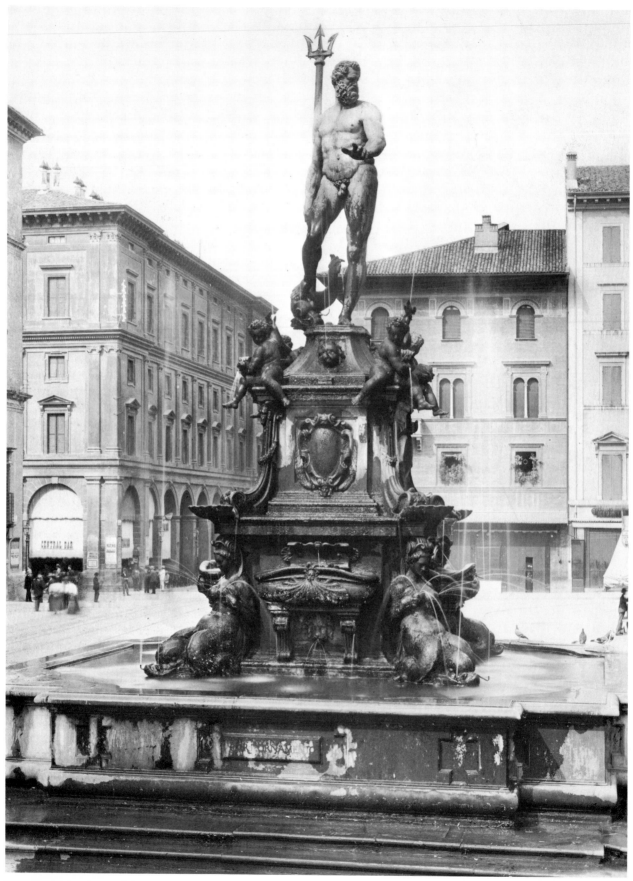

Fountain of Neptune, bronze, Bologna

Giambologna's career
by Charles Avery

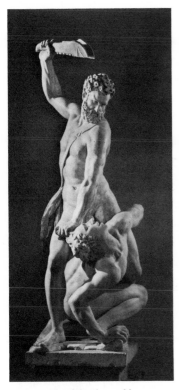

Samson and a Philistine, marble
Victoria & Albert Museum, London

Giovanni Bologna (or Giambologna) is the Italianized form of the sculptor's real name, Jean Boulogne. Born in Douai in 1529, he trained in his native Flanders under a major sculptor, Jacques Dubroeucq, who was carving a rood-loft for Ste. Waudru in Mons in about 1544. Giambologna thus mastered the techniques of modelling and carving, and learned the Italianate, classicizing style which Dubroeucq had evolved after a visit to Rome. Giambologna journeyed to Rome himself in about 1550 and made models of Graeco-Roman and Renaissance sculpture. He was deeply impressed by the technical and anatomical virtuosity of Hellenistic sculpture, with its ambitious groups of figures in action, for example, the 'Farnese Bull' (see Cat. 180, 181), excavated in about 1546 (Naples, National Museum). We are told that Giambologna met the elderly Michelangelo, who criticized a model he was shown for having too high a finish before the basic pose had been properly established – a fault characteristic of northern Renaissance sculpture as a whole. This lesson was never forgotten: Giambologna became an assiduous maker of sketch-models in wax or clay while preparing his compositions, and several have survived.

On his way homewards, Giambologna visited Florence, to study the sculpture of the early Renaissance and of Michelangelo. A rich patron of the arts, Bernardo Vecchietti, offered him accommodation and financial support and soon introduced him to Francesco de' Medici (later Grand-Duke). This encouraged the artist to settle in Florence and by 1561 he was being paid a monthly salary by the Medici. He produced ephemeral sculpture for public spectacles, bronzes and marbles for public or private display, and revived the medium of the small bronze statuette, destined for collectors' cabinets.

From the work of Michelangelo and his Florentine followers, Tribolo and Pierino da Vinci, the young Fleming evolved a style of composing figures with a *contrapposto* exaggerated far beyond the classical norm, with a serpentine axis and flame-like contour. This instilled new life into Florentine sculpture, which had become academic and stilted in the middle of the century, in the hands of Bandinelli and Cellini.

Giambologna made his name with a full-scale model of *Neptune* (lost, but see Cat. 222) for a competition to determine who should carve the monumental centrepiece for a fountain in the Piazza della Signoria in Florence. While he was not destined to win this commission, the success of his entry encouraged Francesco de' Medici to employ him to carve the first of his great series of group-sculptures in marble, the *Samson and a Philistine* (*circa* 1560–62), now in the Victoria & Albert Museum. Its subject and treatment recall a project of Michelangelo's from the 1520s, which is known only from bronze casts recording a lost original wax model.

Giambologna's developing powers were catalyzed in 1563 by a commission for bronze sculptures to decorate a *Fountain of Neptune* in Bologna. Free from the constraints of the Florentine milieu, he produced a masterly complex of sculpture in bronze and marble. The fountain is pyramidal in design, with a host of lively and sensuous subsidiary figures below, leading the eye up to the mighty *Neptune*, who has an energetic, spiral pose, momentarily arrested by the gesture of the arm and sharp turn of the head. Hellenistic and Michelangelesque motifs are amalgamated into a brilliant, original composition that is by no means eclectic in appearance. Possibly during his stay in Bologna he produced the earliest of several versions of a 'flying' figure of *Mercury*, which was to become

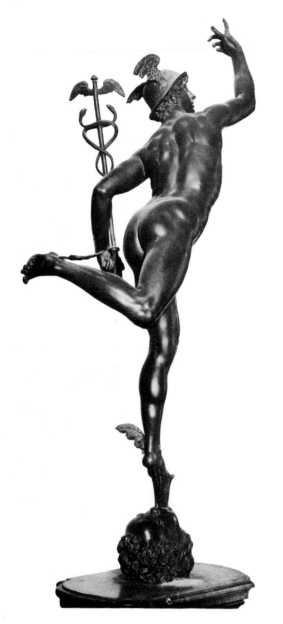

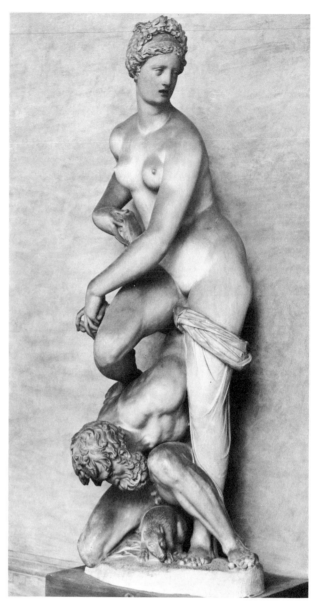

Above
Mercury, bronze
Museo Nazionale (Bargello), Florence.
Right
Florence triumphant over Pisa, marble
Museo Nazionale (Bargello), Florence.

his most celebrated composition (Cat. 33): a statuette initialled 'I B' was sent as a diplomatic gift from the Medici to the Holy Roman Emperor in 1565 (Cat. 34); a larger bronze version in the Bargello was cast later. The vigorous but beautifully balanced pose owes much to earlier bronzes, such as Verrocchio's *Boy with a dolphin* and Rustici's *Mercury*, both of which were in the Medici collections, while the subject may have been inspired by the *Mercury* statuette on the base of Cellini's *Perseus and Medusa* of 1554.

A political allegory of *Florence triumphant over Pisa* in the Bargello, Florence, was commissioned by Francesco de' Medici as a pendant to Michelangelo's group of *Victory*, released from the studio after the master's death in 1564. The young sculptor was forced to reconsider the problem of uniting two figures into an action-group, first posed by Michelangelo in his designs for the tomb of Pope Julius II, and attempted by most of the sculptors in Florence in the middle of the century – Bandinelli, Ammanati, Cellini, Pierino da Vinci. He resolved the problem with the help of preliminary models in wax (Cat. 223), terracotta (Cat. 224) and plaster, and the final composition is a triumphant amalgamation of spiralling curves and zig-zag lines, working within a conical volume.

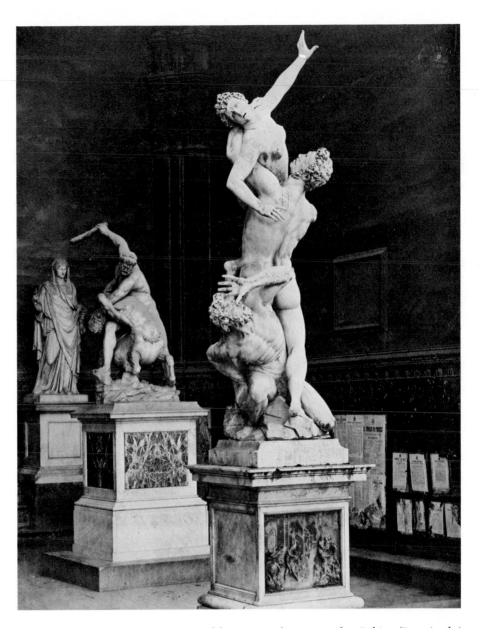

Rape of a Sabine and *Hercules and a centaur*, marble
Loggia dei Lanzi, Florence.

Giambologna's third great marble group, the *Rape of a Sabine* (Loggia dei Lanzi, Florence) was carved in the 1580s (see Cat. 58, 59). It represented the climax of his career as a figure sculptor, combining three figures into a cohesive group, an idea that had obsessed Michelangelo, without his ever having been permitted to realize it in marble. Giambologna's first thoughts are embodied in a bronze group with a standing man and a woman raised in his arms, which he produced in 1579 for Ottavio Farnese: 'The subject,' he wrote to this patron, 'was chosen to give scope to the knowledge and study of art' – *i.e.* it was a conceptual rather than a narrative composition. The sculptor's contemporaries subsequently compelled him to identify the particular episode shown in the full-scale marble version by adding a bronze relief below, showing the Romans and Sabines fighting over the women. The development from a group of two to one with three figures is plotted in preliminary wax models (Cat. 225, 226). The three figures are linked psychologically, by the directions of their glances, as well as formally, by the arrangement of their limbs and bodies. The spiral composition means that the group cannot be fully comprehended from any single viewpoint. In technical terms, the sculpture is a masterpiece of

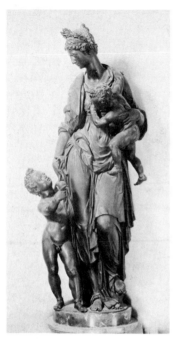

Charity, bronze,
Aula Magna, University of Genoa.

virtuosity, pushing to the furthest limits the technique of undercutting which Giambologna had observed in Hellenistic carving, and the use of which distinguishes his work so sharply from Michelangelo's.

In monumental sculpture, Giambologna's other major achievement was the equestrian statue in bronze of Cosimo I (Piazza della Signoria, Florence) (see Cat. 419), which set a precedent soon to be copied by virtually every monarch in Europe, employing his assistants, Tacca and Francavilla.

There are few points of reference in the enormous production of bronze statuettes by Giambologna and his principal assistant, Antonio Susini: most were original, small compositions rather than reductions from full-scale statues. Apart from the *Mercury* of 1565 mentioned above, the gilt-bronze female allegory of *Astronomy*, also signed, is probably an early masterpiece (Cat. 12). The closed composition and spiral axis given to the figure is characteristic, appearing for example in the larger statuette of *Apollo* (Cat. 36) contributed to the Studiolo of Francesco de' Medici. Apart from the human figure, Giambologna's repertory included animals, particularly horses (Cat. 151–8), bulls (Cat. 177–9) and groups showing them attacked by lions (Cat. 170–4), as well as life-size bronzes of birds, used to decorate garden grottoes (*e.g. Turkey* and *Owl*, in the Bargello, Florence). For the latter he invented an 'impressionistic' rendering in the original wax of birds' plumage, which was faithfully translated by skilful casting into the final bronze versions: his animals pointed the way for the French school of 'animaliers' in the 19th century.

Particularly for religious scenes, necessitated by the Counter-Reformation demand for clear exposition of narrative, Giambologna developed a logical relief style which owed more to Donatello in its rendering of perspective than to his immediate predecessors, Bandinelli and Cellini, whose fascination with Mannerist surface patterns militated against clarity (Cat. 118–29).

Giambologna exerted great influence during his lifetime and for some years afterwards, both in Italy and in the North. His statuettes made handsome gifts and were rapidly distributed through the courts and studios of Europe, disseminating a knowledge of, and enthusiasm for, his elegant style far beyond Florence. Later, his many pupils, often Flemings or Germans, were in demand to serve these very courts, thus reinforcing his influence, though with personal variations on his basic style (*e.g.* Adriaen de Vries; Hubert Gerhard; Hans Reichle). Giambologna occupies a crucial position in the history of sculpture between the better-known figures of Michelangelo and Bernini, for his style was only superseded with the advent of the Baroque in Rome.

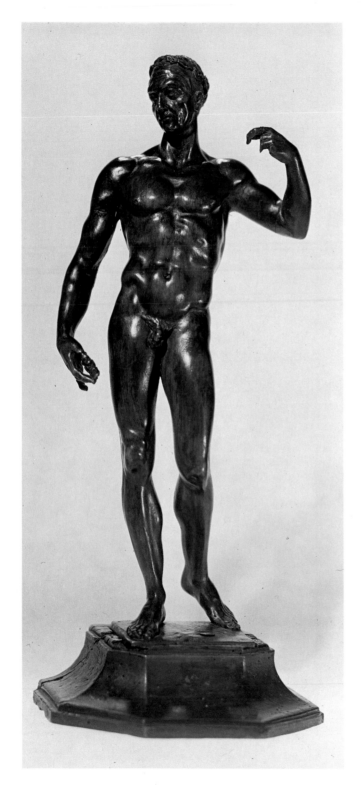

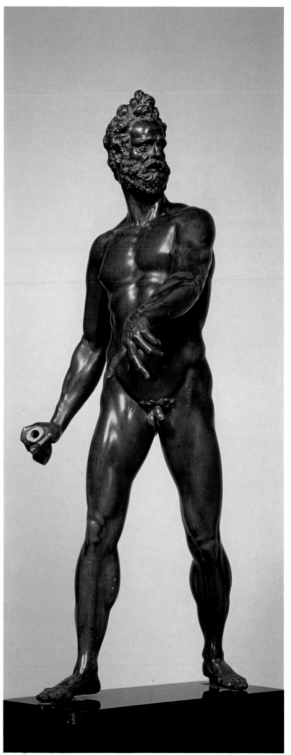

Julius Caesar, lime-wood, Cat. 221

Mars, bronze, Cat. 44

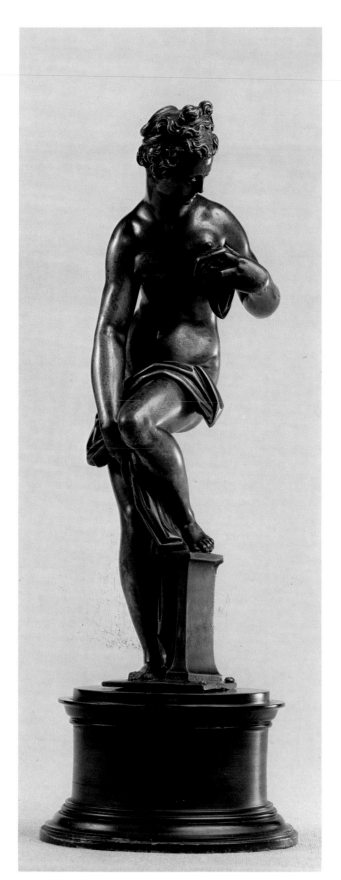

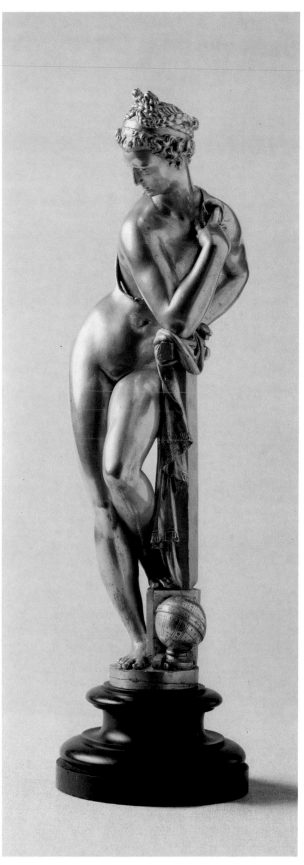

Woman bathing, bronze, Cat. 1

Astronomy, bronze, Cat. 12

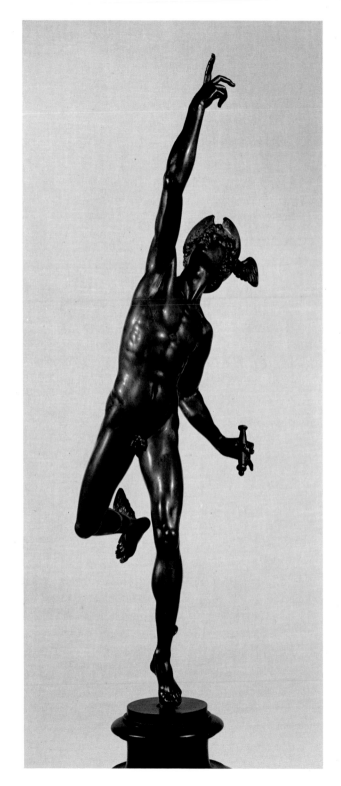

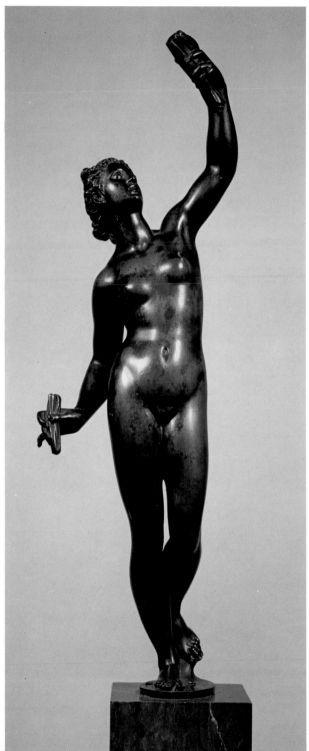

Mercury, bronze, Cat. 34

Fortune, bronze, Cat. 13

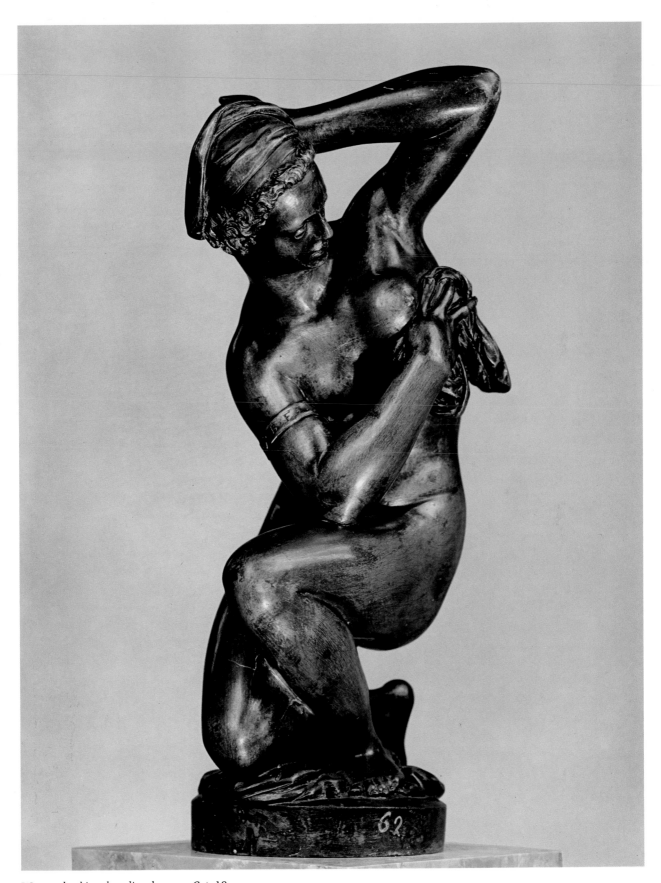

Woman bathing, kneeling, bronze, Cat. 19

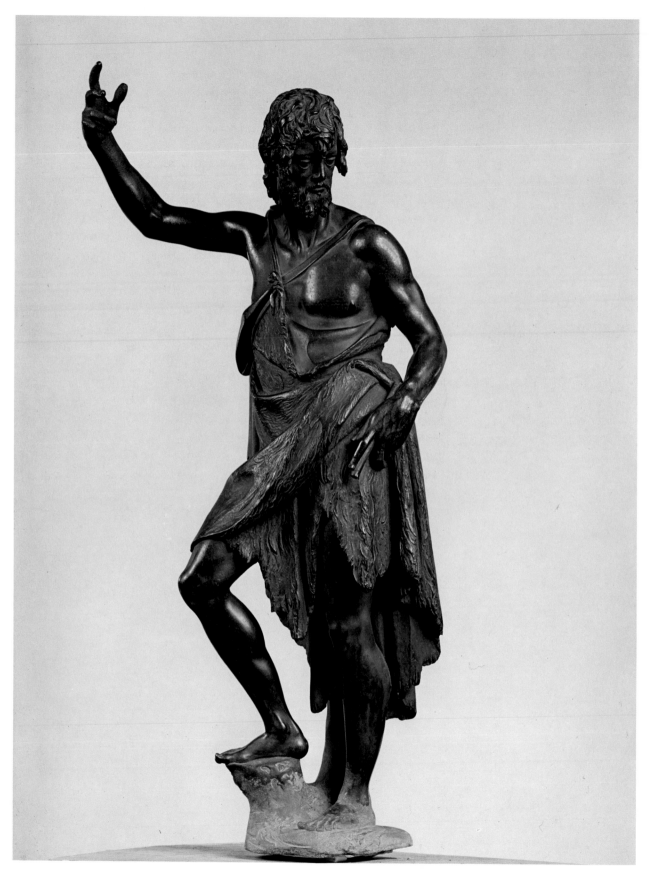

St John the Baptist, bronze, Cat. 91

Rape of a Sabine, bronze (detail), Cat. 57

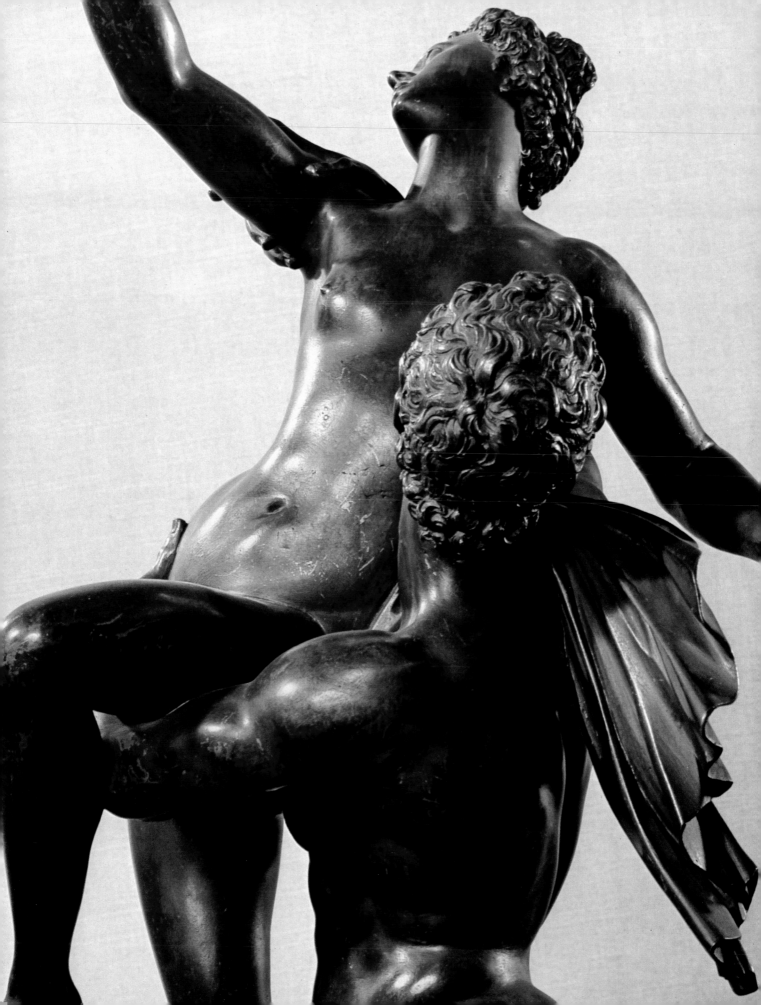

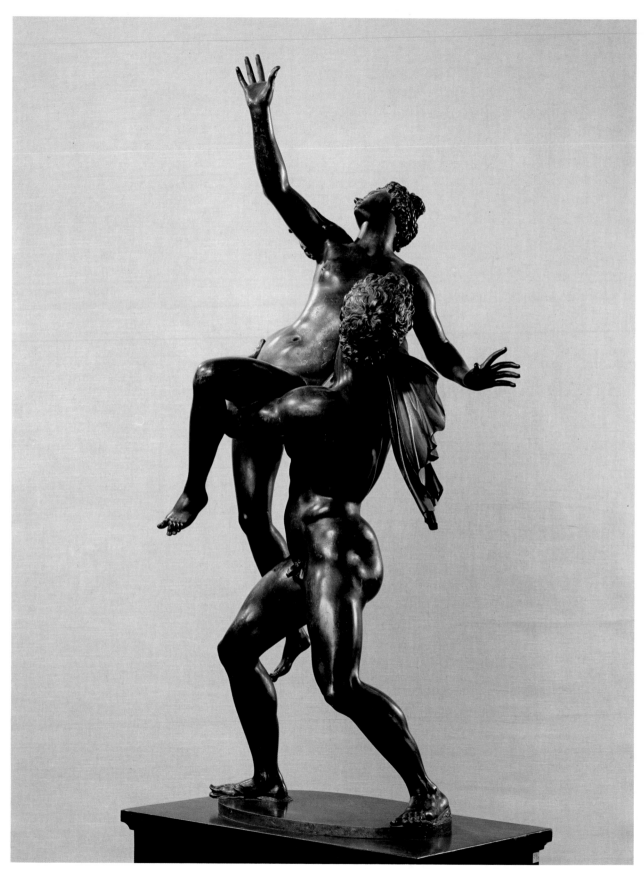

Rape of a Sabine, bronze, Cat. 57

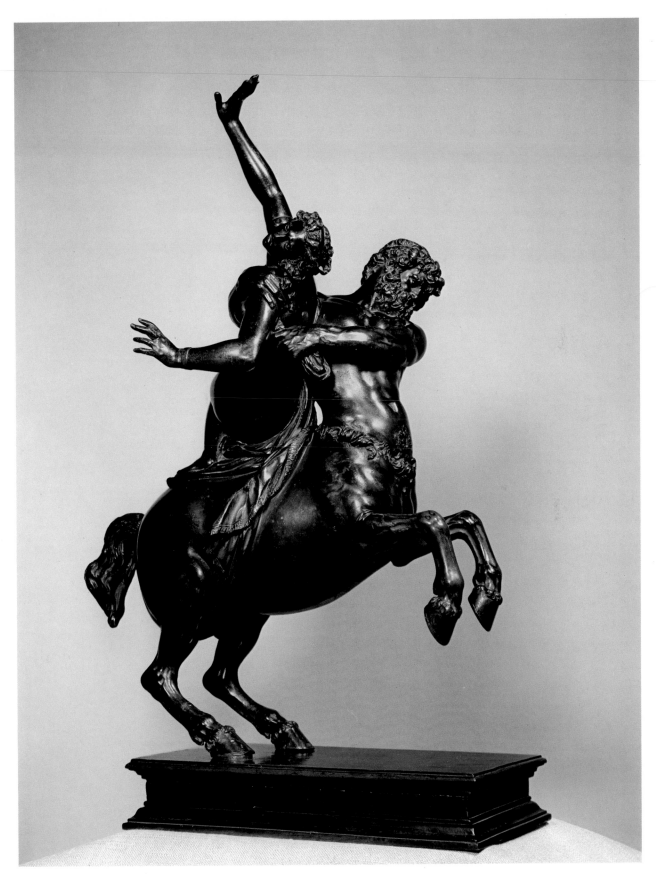

Nessus and Deianira, bronze, Cat. 60

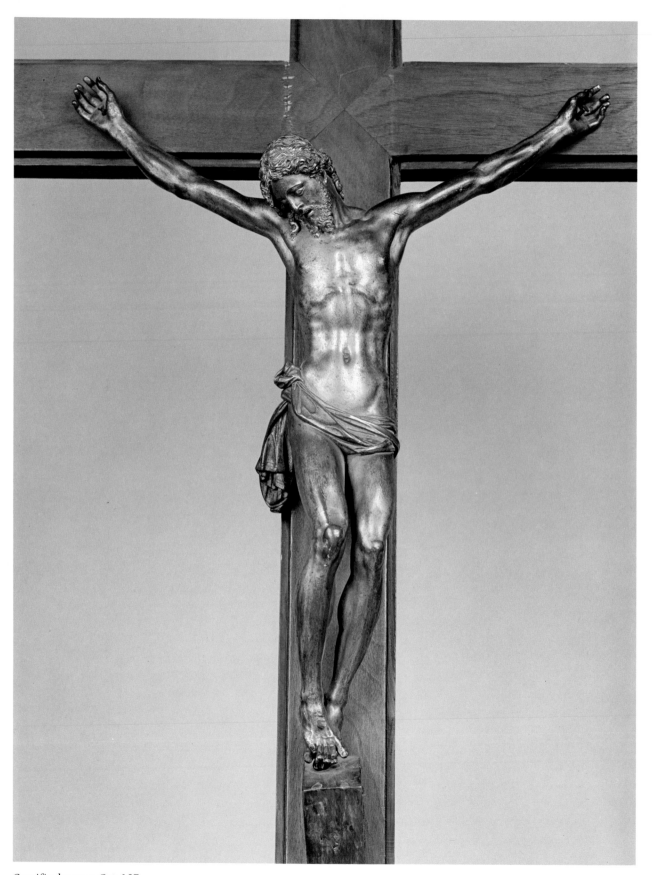

Crucifix, bronze, Cat. 107

The Salviati Chapel, San Marco, Florence

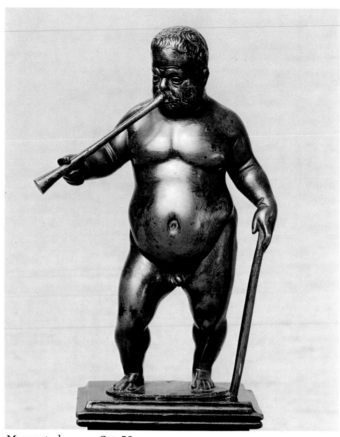

Morgante, bronze, Cat. 52

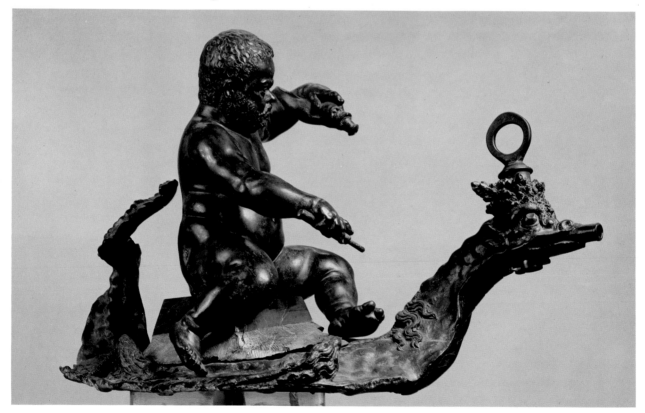

Morgante on a dragon, bronze, Cat. 50

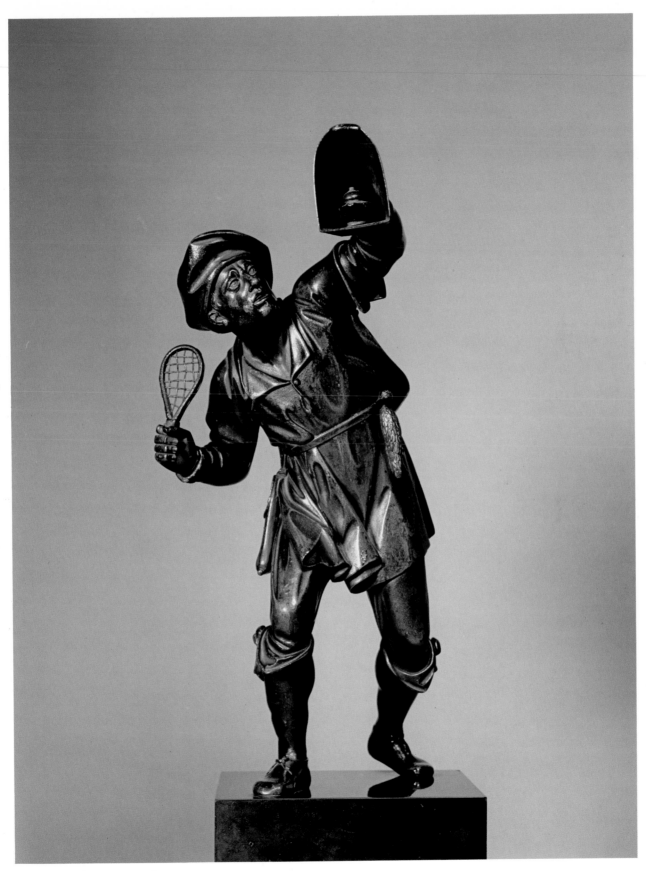

Bird-catcher, bronze, Cat. 131

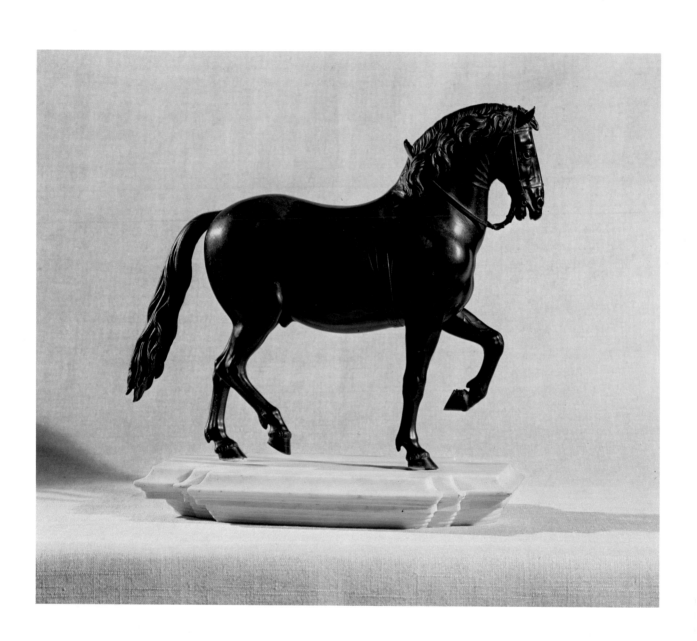

Horse, bronze, by Antonio Susini, Cat. 162

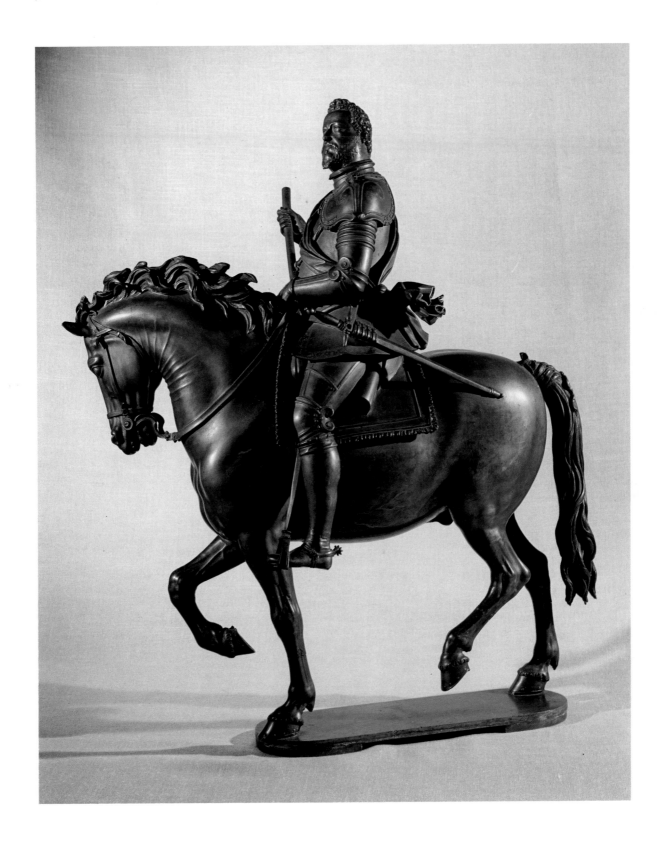

Ferdinando I on horseback, bronze, Cat. 150

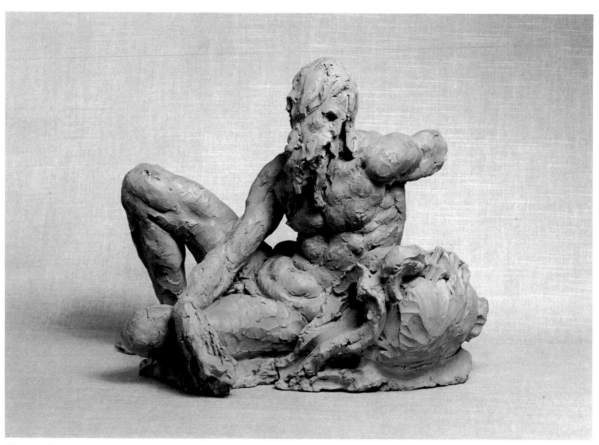

River god, terracotta, Cat. 235

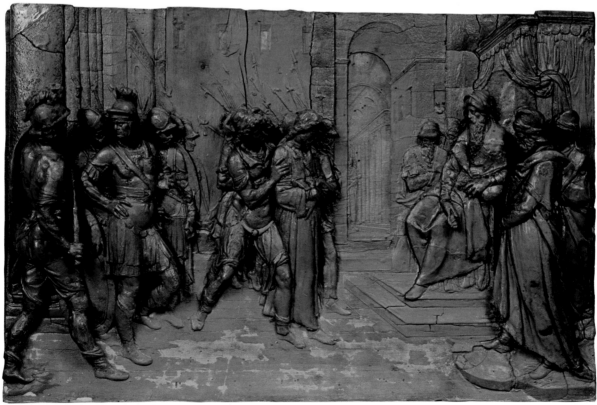

Christ before Caiaphas, wax, Cat. 230

Giambologna and his workshop: the later years
by Katharine Watson

This essay is one of a series of projects made possible by a grant, in part funded by the National Endowment for the Humanities, from the American Council of Learned Societies. I am also grateful to the Villa I Tatti, which has hosted my research year in Florence, and to Bowdoin College, which granted me leave of absence from the Museum of Art. The criticisms and suggestions of Malcolm Campbell have been most helpful. Some years ago Professor Ulrich Middeldorf lent me his collection of notes on Giambologna bronzes; his generosity in sharing that information is much appreciated. Initial research on Giambologna was part of my dissertation on the early career of Pietro Tacca, which will be published this autumn in thesis format by Garland Press.

In a letter of July, 1609, to the Earl of Shrewsbury, William Burghley commented briefly on architecture, painting, and sculpture in Italy. He wrote that 'John Bollognia' was 'the rarest man yt I sawe of any profession for his profession' and described the sculptor, whom he may have met, as a 'little ould man' (Cat. 143–7) and his reputation as 'not inferiour mutch to Michell Angelo'.[1] Lord Burghley's letter refers to Giambologna nearly a year after his death as if he were still alive, no doubt because he had received no recent news from Italy. In one sense indeed, Giambologna really did live on after 1608 through the works attributed to him which were executed long after his death. This phenomenon is due in part to a reorganization of granduçal artists by Ferdinando I occurring in Florence late in Giambologna's life. One result of the change was the Grand Duke's construction of an independent studio with a foundry for the sculptor – to facilitate production of his works in answer to international demand. This workshop became a school for the training of assistants, who grew so skilled in carving and casting from Giambologna's models at a time when he rarely handled marble and bronze himself, that his death did not interrupt production, particularly of his bronze statuettes.

The major themes of the later years of Giambologna's life are the founding and growth of this workshop; the rôle played by his students, several of whom carried his style to courts all over Europe; and the nature of his posthumous influence on Florentine sculpture, especially in his own studio, where his major assistant, Pietro Tacca, continued to work from his models and moulds.

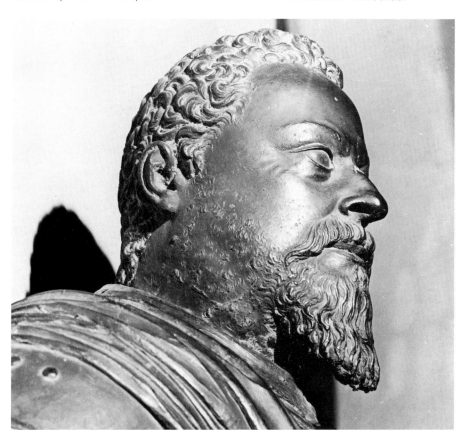

Ferdinando I de' Medici, bronze bust
Museo Nazionale (Bargello), Florence
(detail).

33

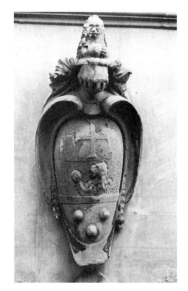

Coat of arms of Giambologna, stone
26 Borgo Pinti, Florence.

The final phase of Giambologna's career is defined chronologically by the reign of Ferdinando I, third Grand Duke of Tuscany, who succeeded his brother Francesco in October, 1587, and who died a few months after the sculptor in February, 1609. His accession almost immediately produced repercussions in the arts in Florence. By September, 1588, Ferdinando had placed nearly all of the granducal artists and artisans under the supervision of one administrator, who reported to him.[2] This decision coincided with the relocation, begun by Francesco I, of workshops from various points in the city, such as the Casino of San Marco, to the *Galleria dei lavori*, a series of rooms on the first floor of the west wing of the Uffizi. Centralization of the arts under the power of the Grand Duke, with an emphasis on increased efficiency and greater production, had already begun during the reigns of Cosimo I and Francesco, but the rigidity of the bureaucratic structure devised by Ferdinando, and the extent of his authority, were new.

The fact that the Grand Duke allowed Giambologna to be one of the few court artists to work outside this centralized system is indicative of the sculptor's high standing and influence. In about 1590, Ferdinando financed the construction of a workshop for Giambologna, next to the sculptor's house in Borgo Pinti.[3] The shop had many functions, one of which was as a storehouse of materials, models and moulds, as well as statues in varying stages of completion. A foundry with a large furnace was also installed there by the Grand Duke. During the casting of a major bronze, such as the horse for the equestrian monument to Cosimo I of 1591, the building served as a dormitory for labourers, technicians, and assistants.[4] The house and workshop in Borgo Pinti were points of interest for members of the local populace, as well as visitors to the city: both were showplaces for the sculptor's models and current projects. The Grand Duke Ferdinando frequently visited Giambologna to inspect and discuss the sculptures in progress.

Once Giambologna had in hand a commission, its execution was determined by the wishes of the Grand Duke, the availability of materials, and the time of year. Ferdinando's requests were given first priority: he naturally preferred monuments glorifying the Medici and works of art which could be used as diplomatic gifts. Indeed, the Grand Duke's needs embraced most sculptural activity in the city, and his priorities at times burdened, rather than helped, Giambologna's operation. For instance, in the early 17th century, the bronze ciborium of the *Cappella dei Principi* in San Lorenzo, not a Giambologna commission, had great significance for Ferdinando, and his decision to concentrate men and material on it postponed the completion of his own equestrian monument in the Borgo Pinti studio.[5]

The problem of acquiring the materials most commonly used, bronze and marble, was a serious factor for Giambologna in determining the scheduling of shop activities. Of the two, bronze was the more precious. Because of its rarity and importance to the military, the metal, such as that from cannons captured in battle by the granducal forces, was gathered and guarded in special locations in Florence, particularly at the Fortezza da Basso. Sculptors had to compete with cannon-founders for available supplies. Marble, though certainly more plentiful than bronze, also posed difficulties of acquisition and transport. Giambologna went to the quarries himself, sent an assistant, or relied on the services of another sculptor, to select the large blocks required for an important

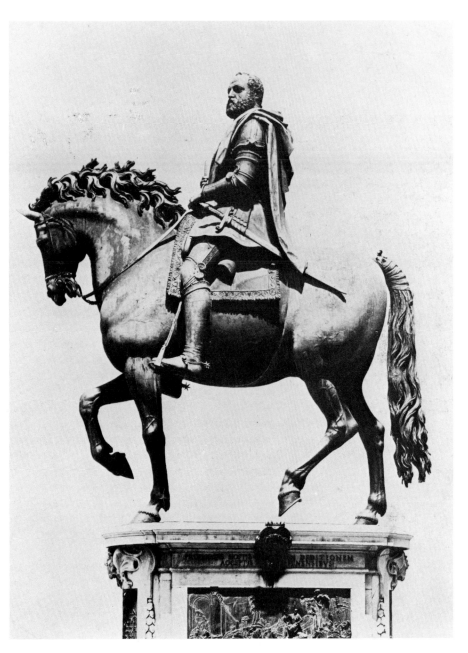

Cosimo I de' Medici, bronze
Piazza della Signoria, Florence.

commission. The marble chosen was often roughly hewn at the quarry in
conformity with a model of the sculpture brought from Florence. After the
difficult and dangerous process of moving the piece down to the sea, it was
transferred on to a barge and taken along the coast to the Arno, and then inland
by river to Ponte a Signa and finally overland by ox-cart to Florence.

Seasonal changes affected the workshop in several ways: marble could be
transported up the Arno, or a completed work, such as an equestrian statue
intended for export, moved down river only when the water was high enough.
During late summer and early autumn, there was sometimes not enough water
to float the barges which carried a major bronze or marble sculpture. But these
warm months were the best for drying clay, plaster, or core material, so that
certain preparatory stages in the casting process were most efficiently done
then. The melting and pouring of bronze could be accomplished at any time, but
the hottest months of the summer were certainly avoided for the sake of human
comfort.

St Luke, bronze
Or San Michele, Florence.

With a few exceptions, granducal commissions for sculpture were the primary concern of Giambologna during the last twenty years of his life. Even the statuettes in bronze and silver produced during this period were generally at the request of Ferdinando I. Every commission involved the collaboration of assistants; the casting of the horse for the monument of Cosimo I alone required nineteen men – sculptors, founders, a mason, etc. The small bronzes, too, were executed by a member of the shop other than Giambologna, although under his direction.

Among the most important projects were the equestrian monuments. The statue of Cosimo I with its elaborate base was completed in 1599 (Cat. 241) and the equestrian monuments to Ferdinando I (Cat. 150) Henri IV (Cat. 159–60), and Philip III (Cat. 161) were being worked on simultaneously in the early 17th century. Another series of major commissions was for standing portrait statues in marble: *Cosimo I* for Pisa; and *Ferdinando I* for Pisa and Arezzo (Cat. 239, 240). Of roughly the same date is the marble *Hercules and a centaur* for Florence – one of the last sculptures on which Giambologna himself worked directly. Commissions of a religious nature included a large bronze crucifix for the Duke of Bavaria, a ciborium for the monastery of the Certosa at Galluzzo (Cat. 112–16) – both of the mid-90s, – a marble *Saint Matthew* for the Cathedral of Orvieto, executed between 1597 and 1600, and the closely-related bronze *Saint Luke*, of the same years, for the church of Or San Michele in Florence. Two bronze angels and a crucifix for the Cathedral of Pisa were finished by 1601; the reliefs, decorative friezes, and niche figures for the three pairs of bronze doors for the west façade of the same Cathedral were a project which occupied many members of Giambologna's workshop at the turn of the century, but with which he does not seem to have been personally involved beyond an advisory rôle. The reliefs and crucifix for his own burial chapel were also of this period.

A striking characteristic of the sculptor's late years was his repetition of the same composition in different materials and sizes, and for a variety of projects and patrons. In this way he could conserve his failing energies, in the face of increasing requests for sculptures, and make the best use of his studio assistants. For instance, the monumental marble of *Hercules and a centaur* was an enlargement of a much earlier composition realized in silver and then in bronze (see Cat. 81–2). The statuettes of this period often turn out to have been from earlier models. Most patrons appear to have preferred casts of versions of familiar sculptures by Giambologna, rather than new compositions.

The bronzes for the ciborium of the Certosa at Galluzzo (Cat. 112–16), which was completed in 1596, constitute one good example of Giambologna's practice.[6] Bronze casts after the *Evangelists* (of which there is in any case more than one set) are incorporated in the south door on the west façade of Pisa Cathedral. One of them (Cat. 115) resembles in miniature the statues of *Saint Luke* for Or San Michele and *Saint Matthew* for Orvieto Cathedral, and perhaps was cast after a model – or served as a model – for those two projects. The design for one of the two *Angels* was probably taken from small studies for the large bronze angel in the Salviati Chapel in San Marco (colour plate p. 27) executed ten years earlier, while the *Risen Christ* (Cat. 112) may reflect a model for the marble *Christ* of 1577–79, which was carved for the central niche of the Altar of Liberty in San Martino, Lucca.

During these years it is difficult to determine Giambologna's exact rôle in the making of sculpture; his participation in the handling of bronze and marble was already limited in the 1590s. As early as 1584, when he was fifty-five, he had complained of old age.[7] But whether that complaint was part of an attempt to wheedle overdue payment from the Grand Duke, or an actual description of his state of health and mind, is open to question. In fact, that ambiguity, between feigned infirmity and true old age is found in the documents until about 1600. After then, however, there can be no doubt that Giambologna had retired from an active physical rôle in the making of sculpture, and could not accept major commissions, such as the west doors for Pisa Cathedral. In his stead, assistants, trained and supervised by him, were in control of the workshop's production. Giambologna nevertheless continued to receive full credit for these sculptures when he had created the original model.

Giambologna's assistants came from many countries, as well as Italy, and returned to their homelands having learned his artistic language. His design and technical innovations were transported by them to Munich, Augsburg, Prague, Paris and elsewhere. Among the more important assistants who were integral to the workshop's functioning in the twenty years before Giambologna's death were Pietro Francavilla, Antonio Susini, and Pietro Tacca.[8]

Pietro Francavilla (1548–1615), who was Flemish by birth, arrived in Florence in the early 1570s and collaborated for years with Giambologna, primarily as a carver of marble.[9] Although he had his own studio, and received independent commissions, he assisted the older sculptor until his final departure for Paris in 1606. Among Francavilla's works executed during the late period from Giambologna's models, are the statues of *Ferdinando I* in Arezzo (Cat. 239), *Ferdinando I* in Pisa (Cat. 240), and the *Saint Matthew* for Orvieto Cathedral. Even after he settled in Paris as sculptor to Henri IV and Marie de Medicis, he maintained contact with Florence. He was responsible for much of the work on the base of the equestrian statue of *Henri IV*, which was executed in the Giambologna workshop, and destined for the Pont Neuf.

Antonio Susini (active 1580; d. 1624), a Florentine, was a specialist in bronze statuettes, who achieved fame with the beautifully finished casts he made from Giambologna's models, as well as miniature versions of antique statues, though he was also capable of creating his own compositions.[10] His date of birth is unknown, but he was probably working with Giambologna by the early 1580s. Until about 1600 he remained in the Borgo Pinti studio and then moved to his own shop round the corner in the Via de' Pilastri. Giambologna regarded the bronzes which Susini made from his models as his own. Antonio Susini's nephew, Giovanni Francesco Susini, continued as a bronze-caster in the Via de' Pilastri using his uncle's and Giambologna's models, casting after the antique, and devising new compositions.[11]

The most important of Giambologna's students for the history of Florentine sculpture was Pietro Tacca, who entered the workshop only in 1592, but who succeeded his teacher as granducal sculptor.[12] Born in Carrara in 1577, he came to Florence probably with an introduction to Giambologna from Jacopo Piccardi, who was a stonecutter in the Borgo Pinti shop. As members of his family were well-known marble merchants, he liaised between the workshop and the Carrara quarries. He carved marble, but disliked doing so, and

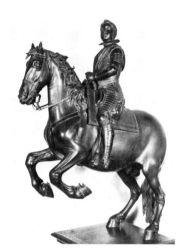

Louis XIII of France, bronze, by Pietro Tacca
Museo Nazionale (Bargello), Florence.

specialized in bronze. Tacca was involved in finishing the bronze reliefs on the base of the equestrian *Cosimo I*, his earliest documented activity; his first known independent work is a relief, also in bronze, of 1599 for the west doors of Pisa Cathedral.

Among Tacca's projects of these years was the series of sugar figures modelled after Giambologna compositions for table decorations at the wedding banquet of Marie de Médicis in 1600. Shortly after that, he started work on the marble figure of Marie for a column from Giambologna's model. With the supervision of Giambologna, Tacca began to assume more and more responsibility in the Borgo Pinti shop, because of his master's physical failing and perhaps because Francavilla had already announced his intention of moving to Paris. (As a sculptor of both marble and bronze, and with additional prestige as a member of a prominent Carrara family, Tacca was a more likely choice than Antonio Susini as a successor to Giambologna.) Before 1608, he brought nearly to completion the equestrian monument to Ferdinando I, and executed the early stages of the monuments to Henri IV and Philip III. He also cast the *Turtles* for the bases of the obelisks in Piazza Santa Maria Novella. A number of granducal busts on palace façades surely date from Tacca's early years; in 1602/3, he supervised the placing of such busts in the loggia of the Hospital of the Innocents. Another of his tasks was the manufacture and export of small bronzes, the majority cast from Giambologna's models.

Personal concerns played a major part in Giambologna's activities during his last years and were bound to have affected his professional life.[13] Several themes are repeated in his correspondence: a sharpened awareness of old age and approaching death; the resulting intensification of his drive for honour and glory already evident early in his career; the legal arrangements for his estate; and the choice of an heir to preserve for posterity his own name and Flemish identity.

These preoccupations have a direct bearing on Giambologna's last years. He was much involved with the remodelling of his burial chapel in Santissima Annunziata, which he designated as a sepulchre for Flemish artists in Florence. He was concerned, too, with enriching his property through work on his house, the building-up of an art collection, and the managing of land given to him years before by the Grand Duke Francesco. Insistent attempts to gain a knighthood beyond his Imperial order of nobility were evidence of his quest for contemporary recognition; while the selection of his young nephew 'Giovanni di Dionisio di Senua' as his heir (on condition that the little boy adopt the name and coat of arms of Giambologna and be a sculptor in the Borgo Pinti) is proof of his wish for fame after death.

In his testament of 1605, Giambologna chose Pietro Tacca as guardian of his seven-year-old heir.[14] Tacca was given permission to live in the Borgo Pinti house and use the studio, but only until the child's legal coming-of-age in 1616. This clause was intended to enable him to finish projects left incomplete at Giambologna's death which occurred on August 13, 1608.

At this time, Tacca's presence in the workshop should have guaranteed a relatively easy transition, even though the young Giovanni was called back to Flanders by his mother.[15] However, he was burdened with work and unsure of his own future, partly because of the conditions of Giambologna's will. Furthermore, he was busy with preparations for the wedding of Prince Cosimo, scheduled for October. This interrupted progress on the equestrian statues of Henri IV and Philip III, which he was continually under pressure to finish. Because of the terms of Giambologna's contract with the authorities of Santissima Annunziata, he was most probably forced to complete almost immediately the Cappella del Soccorso decorations. Ferdinando I died in February, 1609, a further complication in Tacca's life. As a result of this post-mortem confusion, some works recently begun by Tacca, such as a bronze *Nessus and Deianira* and a marble *Samson*, had to be put aside.

After 1608, Giambologna's wax models belonged to his nephew, a factor which certainly restricted the reproduction of the original designs, which were in constant demand. This problem was not solved until 1612, when the heir decided to renounce his Italian legacy, a decision which would become legal only in 1616. It was at this point that Pietro Tacca definitely became the successor to Giambologna. In 1612 the Grand Duke Cosimo II purchased the house, and Tacca the furnishings. Five years later Cosimo, on the advice of the sculptor, who acted as procurator, acquired the models.

Thus, by 1617 Giambologna's workshop and house had become the Grand Duke's property, his heir had returned permanently to Flanders, and Pietro Tacca had assumed the position of court sculptor. These events had great implications for the history of Florentine sculpture. Giambologna's private ownership of house and wax-models had given him a measure of freedom in his

dealings with the Grand Duke. His possessions were symbols of his capacities and accomplishments. In contrast to his master, Pietro Tacca lived and worked more completely within the machinery of the official establishment. Many of the wax-models, probably the piece-moulds from which he cast, his house and his studio all belonged to the Grand Duke. The most important sculptures finished in the shop were official projects such as the *Monument of the four Moors* (1615–24) for Leghorn and the rearing equestrian statue of Philip IV (1634–40) for Madrid. Few notices of private commissions exist. Furthermore, Tacca, like Giambologna before him, was bound to Florence. The Grand Dukes had the right to forbid his accepting commissions from foreign patrons. As a result of his working conditions, the sculptor was plagued by financial problems all his life, but never cut his ties with Florence or the Grand Duke. Pietro Tacca was forced by the demands of patrons, by the conditions of Giambologna's will, and by the organization of the studio, to work almost exclusively with the deceased sculptor's compositions. It is difficult not only to isolate Tacca's style from that of his assistants, but also to distinguish casts of Giambologna models made by him or members of his shop from those made by Giambologna himself or his assistants, some of whom worked after 1608 with Tacca.

Pietro Tacca's experience reflects the decisive change that took place in Florentine sculpture during the year after Giambologna's death: a transition from a workshop directed by a strong individual, but where the work of his assistants is distinguishable, to one where their personalities are totally submerged in a collaborative effort. This closer integration of the activities of artists, technicians and labourers in the Borgo Pinti studio reflected the priorities of the *Galleria* organization. The concept of a court sculptor was also firmly fixed during and after the last years of Giambologna's life: one address, in Borgo Pinti, was set for the sculptor's home and studio, both of which actually belonged to the Grand Duke by 1617. Cosimo II purchased Giambologna's models to guarantee granducal control of the replication of the famous figure compositions. In this atmosphere, the artist became entrepreneur; he was more of a business manager and technical director, whose presence guaranteed efficient production. In addition, he had to devote time and effort to the rôle of courtier, accompanying the Grand Duke and greeting distinguished guests.

These developments contributed to a gradual decline in Florentine sculpture. The popularity of the bronzes, with their unchanging vocabulary of style, was bound to fade over the years as taste changed. Perhaps because of the workshop organization, geared to assembly-line production, and the dominance of Giambologna's style, the initiative of the sculptor and the originality of his work diminished. With few exceptions, Florence could no longer attract and train young sculptors, who instead were drawn to the Rome of Bernini and Algardi. A real lack of talent manifests itself in Florentine sculpture during this period. Pietro Tacca's son, Ferdinando, was more engineer and architect than sculptor, although he inherited his father's position and the use of the Borgo Pinti workshop.[16] Relatively few works can be attributed to him, and the art of bronze casting on either a grand or a small scale was nearly lost during his life-time. By 1687, when Giovanni Battista Foggini moved into the house and studio a year after Ferdinando Tacca's death, the art of sculpture had been at such low ebb in Florence that the Grand Duke Cosimo III had been forced to send students, including Foggini, to Rome for training.[17] But the models of Giambologna, as well as works begun during his life-time but never completed, remained and his compositions continued to exert influence into the early 18th century: Foggini's contemporary, Massimiliano Soldani Benzi, Master of the Florentine Mint, actually made casts of Giambologna bronzes (Cat. 49).

Notes

1. J. Irene Whalley, 'Italian Art and English Taste: An Early Seventeenth-Century Letter', *Apollo*, Sept. 1971, pp. 184–91. The letter, transcribed p. 184 and reproduced p. 185 indicates that Burghley, later second Earl of Exeter, had visited Florence; he mentioned that he had seen two of Giambologna's works, but which ones, or where, is not clear.

2. The original document describing the *Galleria* organization is a *lettera patente* from Ferdinando I to Emilio de' Cavaliere who was chosen to become the first *soprintendente* or chief administrator: Archivio di Stato, Florence (hereafter A.S.F.), *Mediceo*, f. 62, c.222, 3 September, 1588. The letter was published by Gaye, III, 1840, pp. 484–5. There are many references to the document, the most recent of which is Fock, 1974, p. 122 ff.

3. The date of 1590 is approximate. Prior to the construction of the workshop in Borgo Pinti, Giambologna's casting needs were primarily met by members of the Portigiani family in the foundry of San Marco; even after 1590, the sculptor continued to use the San Marco foundry. Vasari, 1568, p. 876, suggested that Giambologna at that time worked in rooms set aside for him by Prince Francesco in the Palazzo Vecchio. According to F. Fantozzi, *Pianta geometrica dell' città di Firenze*, I, 1842, p. 238, Giambologna lived in the Borgo San Jacopo in 1576; the date of his move to Borgo Pinti is not known.

4. Giambologna's workshop at the time of the casting of the horse is described in a document of 1591: A.S.F., *Fabbriche Medicee*, f. 121, cc. 22v–23v, 27 September; first published in Del Badia, 1868, p. 17 ff.

5. Baldinucci/Ranalli, III, p. 674, refers to the ciborium problem. There are many unpublished notices in the A.S.F., particularly *Guardaroba*, f. 254.

6. Keutner, 1955, pp. 139–44.

7. Dhanens, 1956, p. 354: Giambologna to the Grand Duchess Bianca Cappello, 9 March, 1584.

8. Other assistants of this period, particularly Hans Reichle, a Bavarian, and Adriaen de Vries, a Dutchman, were of importance, but are not considered here, nor included in the exhibition as they remained in the Giambologna workshop for a relatively short time, and their greatest fame was achieved after they left Florence.

9. Selected Francavilla bibliography: Baldinucci/Ranalli, III, pp. 56–71; Pope-Hennessy, 1970(I), pp. 391–3 (with earlier literature); Pope-Hennessy, 1970(II), pp. 304–7; Ronen, 1970, pp. 415–42; Mastrorocco, 1975, pp. 98–120.

10. Selected Antonio Susini bibliography: Baldinucci/Ranalli, IV, pp. 109–18; Supino, 1899, pp. 387–8; Thieme and Becker, XXXII, p. 305, 1938; Keutner, 1955, pp. 139–44; Dhanens, 1956, pp. 70–1; Watson and Avery, 1973, p. 502, p. 504; Heikamp, 1963, *et passim*; Fock, 1974, p. 94, n. 41, p. 133, p. 153. Dr Gino Corti will soon publish the will of Antonio Susini which he recently discovered in the Florentine State Archives.

11. Selected Gianfrancesco Susini bibliography: Baldinucci/Ranalli, IV, p. 118; Supino, 1898, p. 394; Thieme and Becker, XXXII, 1938, pp. 305–6; E. Borea, *La Quadreria di Don Lorenzo de' Medici*, Direzione Generale per i Beni Artistici e Storici del Ministero dei Beni Culturali, Florence, 1977, p. 72.

12. Pietro Tacca bibliography: Torriti, 1975, pp. 115–8.

13. Dhanens, 1956, pp. 373–4 for transcription of Giambologna's will.

14. Documentation of the transition period after the death of Giambologna beyond Baldinucci is the sculptor's will (see note 13), the posthumous inventory of his possessions, Corti, 1976, pp. 629–34; and a contract for the acquisition of goods by Pietro Tacca, partially published by Lo Vullo Bianchi, 1931, pp. 189–91; unpublished accounts of the workshop and status of Pietro Tacca in December, 1608, and February, 1609, are A.S.F. *Fabbriche Medicee* f. 123, cc. 100r–101r; a concise description of this period in Tacca's life in Watson and Avery, 1973, p. 498, n. 26.

15. Baldinucci/Ranalli, IV, p. 121, briefly referred to Francesco Pezutelli who was a fine caster, particularly of crucifixes, but who died in poverty because *'essendo venuto tempo, che o per essere omai state fatte in Firenze tante a tante opere di metallo in piccola proporzione, o per esservi in sorta di simile manifattura gran copia di professori, non trovavasene più in Firenze l'antica chiesta . . .'* However, this 'decline' seems to have little influenced foreign patrons who continued to request Giambologna bronzes.

16. Selected Ferdinando Tacca bibliography: Baldinucci/Ranalli, IV, p. 97, p. 102, p. 105; Thieme and Becker, XXXII, 1938, p. 389; Zangheri, 1974, pp. 50–60; Torriti, 1975, *et passim*, Radcliffe, 1976, pp. 14–23. Anthea Brook's research on Florentine sculpture from *circa* 1640 to 1670 includes work on the career of Ferdinando Tacca. The generosity with which she has shared her discoveries is much appreciated.

17. Lankheit, 1962, p. 29 ff. for discussion of granducal Academy in Rome; p. 269 for transcription of inventory of Borgo Pinti shop on 25 November, 1687, when it was consigned to Foggini.

Giambologna's bronze statuettes
by Charles Avery

Reprinted, with minor alterations, from *The Burlington Magazine*, CXV (1973), by kind permission of the Editor.

The study of bronze statuettes has always been hampered by a scarcity of documentary evidence. Little information is to be found in the correspondence or accounts of patrons or artists: on the rare occasions when bronzes feature in inventories, the descriptions are usually so summary as to give little chance of identifying a particular piece or its author. The explanation is not far to seek: statuettes were generally regarded as domestic ornaments and were of comparatively little financial consequence, except in rare instances. Furthermore, they are easily portable and make welcome gifts, so their movements are often hard to trace, unlike those of more monumental works of art. The result is that the anonymous mass of such bronzes has perforce been divided by connoisseurs on the basis of style and facture among a few known artists and centres of production.

One of the most problematic classes of bronze statuette is that reflecting the style of Giambologna. This may seem a paradox, for generically such statuettes are readily distinguishable and comprise some of the best-known examples of his work. Nevertheless, behind the indiscriminate use of his name in connection with bronzes betraying his style of figure composition lie a number of complex issues. The sheer quantity of statuettes still extant, the number of variants of individual models and the wide differences in detail and surface treatment obviously preclude Giambologna's personal involvement in most cases. He was continuously occupied with prestigious commissions for monumental sculpture in Florence, serving as court sculptor to successive Medici Grand Dukes, Cosimo I, Francesco I and Ferdinando I. In any case, we know from contemporary sources that he employed a number of assistants – some apprentice-sculptors, some simply skilled craftsmen – in the multifarious activities that he undertook. Documents, and occasionally signatures on bronzes, prove that several of his best assistants were employed in bronze casting: among these Antonio Susini and Pietro Tacca held pride of place. To understand the rôle they played one must be conversant with the technique of lost-wax *(cire perdu)* casting, which involved a number of skilled craftsmen in the production of a single statuette.

The sculptor himself would make an original model in wax (with a fireclay core); this was handed over to a foundry (sometimes the sculptor's own, but more often an independent commercial enterprise mostly engaged in casting utilitarian items such as bells, mortars and cannons). There the time-consuming, critical and occasionally dangerous operations of making the moulds and pouring molten metal would be carried out. Then the rough cast was returned to the sculptor for finishing with the chisel, hammer and file. This after-working has a crucial effect on the final appearance of the work of art and the sculptor might choose to do it himself (in which case the bronze is designated 'autograph'); alternatively, to economise his own time and effort, he might prefer to delegate it to assistants who would imitate his style to the best of their ability. The degree of personal participation or supervision exercised by the master is normally reflected in the quality of the finished product.

The use of piece-moulds for the reproduction of the wax casting model permits the production of a number of examples from an original model. Equally, an existing bronze statuette may also be faithfully reproduced by taking new piece-moulds in plaster from it and then casting further bronzes. A given composition may therefore exist in a number of examples of varying

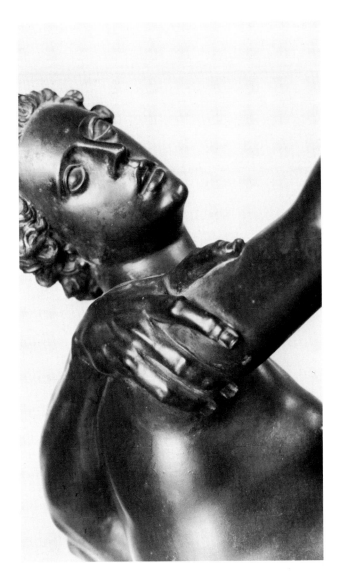

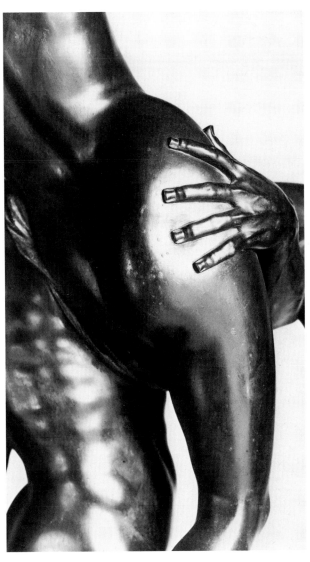

Rape of a Sabine, bronze
Museo e Gallerie Nazionali di
Capodimonte, Naples (details).

appearance, quality and detail. This is the case with bronzes in the manner of Giambologna. Careful comparison of the various examples of each model sometimes reveals consistent differences in treatment and detail which suggest the intervention of the same assistant in their manufacture. Thus one may be able to group a number of pieces round a subsidiary sculptural assistant, whose identity may ultimately be discovered.

From what we know about Giambologna's career it is reasonable to assume that after he had initially mastered the techniques of modelling for bronze sculpture and refined the finishing processes, he found it more economical to delegate most of the work to a corps of assistants whom he had trained for this purpose. One or two statuettes of superlative quality bear convincing signatures, which suggests that Giambologna finished them personally. These are probably the only 'autograph' bronzes and the rest, however excellent, must have been worked up by assistants from his original wax models.

Fascinating insights into Giambologna's attitude towards bronze statuettes may be gained from a perusal of surviving correspondence. He made it quite plain to the many would-be patrons who were continually pestering him for statuary that if they were prepared to accept work in bronze rather than marble, he could afford enough time from his major preoccupations to produce wax models for casting by his assistants, to which he might, if he could spare a moment, add the finishing touches. It is scarcely an exaggeration to regard his workshop as a production line, with every assistant performing the tasks at which he was best and quickest to ensure maximum output. Giambologna's great achievement was to train assistants of sufficient calibre, and presumably to exercise strict enough supervision, to ensure that even 'workshop' bronzes were of great perfection.

Two lists purporting to contain all his personal compositions in the way of bronze statuettes have come down to us, one transcribed in 1611 by Markus Zeh for the information of Hainhofer in Augsburg, the other included by Baldinucci in his biography of the sculptor (Dhanens, 1956, pp. 73–4). Both lists are posthumous and do not correspond precisely, while they omit several models which are undeniably his, as is proven by independent contemporary sources. They cannot therefore be regarded as definitive, even though they provide a secure nucleus. On the other hand they leave room for speculation whether some of the many different models in the style of Giambologna that are omitted were in fact designed by the assistants themselves, so expert had they become at reproducing his figure style and idiosyncratic treatment of details such as facial features, hair and drapery.

List of Baldinucci (1688)	*List of Markus Zeh (1611)*
1. Il Gruppo delle Sabine alto circa un braccio Fiorentino	Un gruppo del rapto d'una Sabina con 3 figure
2. L'Ercole che ammazza il Centauro	Un gruppo d'un Hercule ch'(amazzo) il Centauro
3. Il Centauro, che rapisce Deianira	—
4. Il Cavallo ucciso dal Leone	Un gruppo d'un lione ch'ammazo un cavallo
5. Il toro ucciso dal Tigre	Un gruppo d'un lione ch'uccide un toro
6. La femmina che dorme, e 'l Satiro, che la guarda	Un gruppo d'una nimpha che dorme con un satiro appresso
—	Un gladiatore
—	Una donna a sedere che rappresenta l'architettura
7. Il Mercurio volante	—
8. Il Cavallino, che sta in su due piedi	—
9. L'altro Cavallo camminante	—
10. Il Villano col Frugnolo	Un contadino che va à fragnuolo
—	Una femina diritta, per l'astrologie intesa
11. La femmina, che si lava	Un altra femina pur diritta, poco minore, et in altre attitudine
12 Quattro forze d'Ercole	—
13. Il Leone camminante	—
14. Fra le figure semplici sono più bellissimi Crocifissi	—

The crucifixes of Giambologna

by Katharine Watson

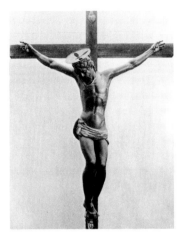

Crucifix, bronze
Santissima Annunziata, Florence.

Small crucifixes are not usually taken into account in discussions about Giambologna's sculpture in bronze, yet they were evidently produced in his workshop in some quantity and from a number of designs. Models dating as early as the 1570s seem to have served as studies for the life-size crucifixes executed only in the 1590s. A section of the present exhibition is devoted to the small figures of Christ on the cross, in the hope that close comparison of one example with another may permit a re-assessment of this neglected aspect of Giambologna's *oeuvre*.

The crucifixes, together with the reliefs of the Passion (Cat. 122–7), intrude upon Giambologna's normal, secular subject matter, presumably in response to requests from patrons, particularly Cardinal Ferdinando de' Medici and Luca Grimaldi of Genoa. Pressure may also have been exerted by Church officials, following the precepts of the Council of Trent. However, an element of genuine, personal conversion may be remarked in Giambologna's last years, which culminates in his acquiring in 1594 the Cappella del Soccorso in Ss. Annunziata as his own burial chapel. There are two basic types: a more traditional one showing Christ dead ('*morto*') with His head hanging down and His eyes closed, and another where He is still just alive ('*vivo*' or '*semi-vivo*') and glances upwards as He utters the last words from the cross: 'My God, my God, why hast thou forsaken me?' (Matthew, xxvii, 46; Mark, xv, 34); or 'Father, into thy hands I commend my spirit' (Luke, xxiii, 46); or 'It is finished' (John, xviii, 30). The crosses are sometimes set into richly worked bases representing the rocky terrain of Golgotha, 'the place of the skull', where Christ was crucified (repr. p. 47). Giambologna's *Christs*, whether they are meant to be alive or dead, are highly idealized, as indeed was normal in Italian, as opposed to northern European, sculpture. Their faces are tranquil, the features little marred by suffering, and there are no gaping wounds or distorted musculature. A spiral composition within the confines set by the fixed points of the nails at hands and feet characterizes the figures. The formal problem is of course unique in Giambologna's work and he solves it by denying any realistic equation between the weight of the body and the strain on the shoulders, arms and hands. His *Christs* almost seem to hover in front of their crosses.

With each type of crucifix, there are only slight variations in the figure composition, apart from the fairly securely documented Loreto crucifix (Cat. 106), which offers a surprising contrast to later examples from San Marco (Cat. 107) and from Santa Maria degli Angiolini (Cat. 105). After about 1590, the images were mass-produced in varying sizes and materials in Giambologna's workshop by his assistants and continued to be cast after his death. The second type, with Christ still living, seems to have appeared only in this late period (with the possible exception of Cat. 98 which has been dated to 1578, Casalini, 1964). Even before 1590, Giambologna finished very few crucifixes himself, and the degree of contrast in surface handling and patina between versions of the same composition, in the same material, even in the same size, indicates the variety of hands at work.

In 1581, '*Adriano orefice fiammingo*', possibly the young Adriaen de Vries functioning as a 'goldsmith', is documented as having executed two casts in silver of a crucifix at the order and with the models of Giambologna (Larsson, 1967, p. 11, p.14, p. 114). Antonio Susini was famed for his crucifixes, especially those in silver, cast in moulds taken from his master's models.

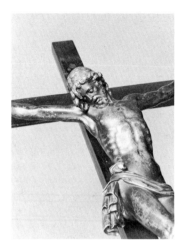

Crucifix, bronze
Liebieghaus, Frankfurt am Main
(detail).

Unpublished documents in the Florentine State Archives record that Gaspare Mola executed gold crucifixes from the models of Giambologna (H. Keutner, personal communication). A granducal jeweller and goldsmith, Jacques Bylivelt, bequeathed to Ferdinando I a crucifix in silver done from a model by Giambologna but finished by Susini, a gesture indicative of the great value placed by another artist on the Giambologna/Susini figures of Christ (Fock, 1974, p. 153). Bylivelt, who was one of the major forces in the organization of the *Galleria dei lavori* in the Uffizi, would have been familiar with the type of crucifix that he gave to the Grand Duke, for Giambologna crucifixes, particularly those in silver, were cast and sometimes finished in the *Galleria*; or else cast there, but returned to the Borgo Pinti workshop to be chased and chiselled by an assistant, such as Antonio Susini (Fock, 94, n. 41).

The small crucified *Christs* attributed to Giambologna are an especially difficult category in his *oeuvre*; a substantial number of models with slight variations exists and many probably remain in religious houses or private hands as objects of personal devotion, and are therefore difficult to trace. A number are documented in the Florentine State Archives, but it is not easy to link these unpublished citations to particular pieces. Crucifixes are mentioned throughout the later, published correspondence relating to Giambologna. The earliest reference – and one of the most important – is a letter of April, 1583, to the Duke of Urbino from Simone Fortuna, who was attempting to secure various sculptures, among them a large marble crucifix, from Giambologna for the Duke (Dhanens, 1956, pp. 351, 352). Fortuna mentions that the sculptor had executed four crucifixes in 'silver, bronze, or copper' and that he had seen the models for these which were a little less than two '*palmi*' in size (*circa* 44 cm). These were intended for the King of Spain, Pope Pius V (1566–72), the Grand Duke, and Grand Duchess ('which went to Loreto'). Of the early biographers, only Baldinucci mentions the crucifixes, the last entry on his list of models in bronze reading: '*Fra le figure semplici sono piu bellissimi Crocifissi*' (Baldinucci/Ranalli, II, 1846, p. 583). Crucifixes, especially small ones, seem to have been ignored by otherwise thorough authors of guide books, almost as though they were not to be viewed as works of art.

Not all of Giambologna's patrons wanted crucifixes; there are few notices for example, of any for the Grand Duke Francesco I. However, when still a Cardinal in Rome, Ferdinando de' Medici was already requesting crucifixes from Giambologna, while during his reign as Grand Duke, the images were mass-produced. Ferdinando may even have been the source for the novel iconography of the '*semi-vivo*' type. Crucifixes, large or small, were sent by Ferdinando as diplomatic gifts – symbols of a shared faith – to Roman Catholic rulers all over Europe, including the Duke of Bavaria, the King of Spain or members of his court, and the Holy Roman Emperor. There must have been some hidden irony in the curious exchange of gifts between Cosimo II and the Duke of Mantua which took place in 1609: a silver crucifix '*semi-vivo*' by Giambologna was sent in gratitude for certain fish, including a carp and large trout. Cosimo II asked that no one be allowed to copy the crucifix, for the particular model was highly prized both by his father and by himself – it may possibly have been a cast of the cross given by Bylivelt to Ferdinando I; see above (Luzio, 1913, p. 267; Mattioli, 1976, pp. 64–70).

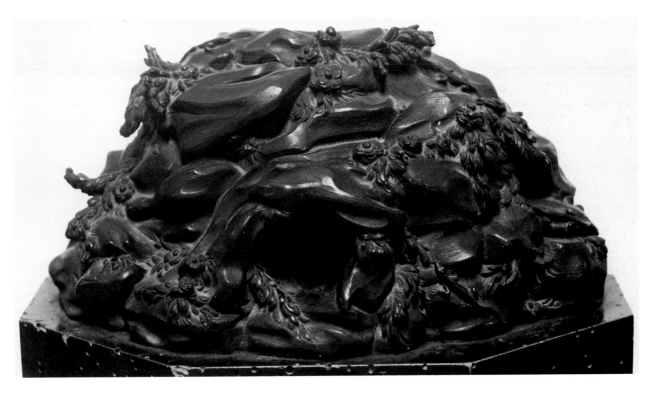

Golgotha, bronze, by Antonio Susini
Smith College Museum of Art,
Northampton, Mass. (given by Mrs
Maurice van Dyck Emetaz in memory
of Mary Waring Fitch '93).

The emphasis on the individuality of a design must have faded with the years – as the production of such bronzes grew. Pietro Tacca, his son Ferdinando, and Felice Palma all designed crucifixes which were cast over and over again in different sizes. Antonio Susini continued to produce crucifixes, most of them based on Giambologna's models: in 1622, he presented ten – five with Christ living and five with Him dead – to the Duke of Mantua, who was to choose which ones he wished (Luzio, 1913, p. 270). His nephew, Giovanni Francesco Susini, also cast crucifixes. Damiano Cappelli produced crucifixes from models by Giambologna, Pietro Tacca, both Susinis, and even Algardi (Baldinucci/ Ranalli, IV, pp. 106, 107). One of Antonio Susini's students described by Baldinucci, Francesco Pezutelli, specialized in bronze crucifixes, but died in poverty because the demand of an earlier time had fallen off (Baldinucci/ Ranalli, IV, p. 121).

Basic bibliography for the crucifixes:

Dhanens, 1956, pp. 204–9 (with previous published references)
Parronchi, 1961, pp. 15–17
Casalini, 1964, pp. 266–76.
Legner, 1967, pp. 60–1.
Staedel Jahrbuch, 1967, pp. 254–6, 269.
Utz, 1971, pp. 66–80, illus. 53–63.
Casalini, 1973, pp. 207–9.
Avery and Keeble, 1975, pp. 12–14.

The sketch-models of Giambologna
by Charles Avery

More sketch-models ('*bozzetti*') for sculpture by Giambologna have survived than by any other Renaissance artist. Like many sculptors – though unlike Michelangelo – he seems to have preferred to invent his compositions in three-dimensional form from the outset, instead of resorting to the standard, two-dimensional approach of a graphic artist. Few, if any, preliminary sketches survive, and of the drawings which are associated with Giambologna several are impressions of whole, finished projects, for example fountains, which have the character of an architect's presentation drawings (Cat. 199, 205).

Giambologna had learned the rudiments of his craft from Jacques Dubroeucq in Flanders. He may also have learned the art of bronze-casting, which was practised with great skill in the Meuse Valley, especially at Dinant and Liège (see Cellini, *Treatises*). Baldinucci relates that Giambologna spent two years in Rome making models of everything he saw ('*modellò quanto di bello gli potè mai venir sotto l'occhio*'): these were probably made not only for practice, but as a repertory of forms to take home, for use in his future career. He used to tell a story against himself in his old age: how he once took a wax model for inspection to the elderly Michelangelo, and the latter squashed it in his hands and re-modelled it, admonishing the student not to attempt a high finish before he had learned how to model properly: '*or va prima ad imparare a bozzare, e poi a finire*'. This was a lesson Giambologna never forgot: ever afterwards he was an assiduous modeller in wax, clay and stucco.

Having reached Florence, Giambologna was encouraged to stay there and work for the Medici by a patrician banker, Bernardo Vecchietti (1514–90), who was a friend of the heir-apparent, Francesco. Bernardo seems to have been an eager collector of his protégé's models, judging from the description of his country villa 'Il Riposo', in the book of the same name published by Raffaello Borghini in 1584, and it is probably to him that we owe the survival of so large a number. Thanks to the interest of English 'milords', connoisseurs and artists in the 18th century, a high proportion of Giambologna's and his followers' models was eventually brought to England. Their taste was influenced by Sir Joshua Reynolds and the aims of the nascent Royal Academy. For example, at the posthumous sale of William Lock of Norbury Park at Christie's ('Fitzhugh', 16 April, 1785), a number of Florentine models, probably from Vecchietti's collection, were sold: 'Four basso rilievos in wax' (*i.e.* the scenes from *Christ's Passion*, now in the Victoria & Albert Museum and Brisbane) were bought by the sculptor Nollekens (Cat. 230–2). The miniature-painter Richard Cosway bought lot 19, twenty-two unspecified models, perhaps for re-sale to his clients, for like so many artists of the day he supplemented his income by dealing. Soon afterwards, successive Presidents of the Royal Academy, Sir Benjamin West and Sir Thomas Lawrence, possessed similar models: the latter once owned wax models for Giambologna's *Rape of a Sabine*, *Ferdinando I de' Medici* and *Architecture*, all now to be seen in South Kensington (Cat. 226, 239, 237).

Apart from Vecchietti's collection, there were others in Florence, primarily that of the sculptor himself, as we know from the posthumous inventory of his studio effects (1608). Giambologna also gave numerous models to his assistant, Antonio Susini, to transform into bronze statuettes. According to Vasari, the Granducal mason, Maestro Bernardo, also possessed a number of models, probably relating to projects in which he had personally been involved. His models may have subsequently come into the possession of the Gherardini

family, whose collection – including four definite Giambolognas – was purchased in 1854 for the Museum of Ornamental Art (now the Victoria & Albert Museum). One is a terracotta grimacing mask, prepared as an architectural ornament for the town palace of Vecchietti (Cat. 233); the others are tiny wax sketches for three of Giambologna's most celebrated marble sculptures: *Florence triumphant over Pisa*; *the Rape of a Sabine*; and *Hercules and a centaur* (Cat. 223, 225, 227).

By examining the available evidence, it is now possible to reconstruct Giambologna's working procedure. For his *Florence triumphant over Pisa* all the stages survive. He began with tiny models of wax, which he built up round an armature of iron wire or a nail, demarcating the volumes and establishing the *'disegno'*: the anatomical forms are usually very attenuated and 'mannered' at this stage. Such models are about 10 to 20 cm high. Subsequently they were 'fleshed out', a process which began at the next stage, in clay: a model of 40 or 50 cm (about a Florentine *braccio*) was built up, with more naturalistic proportions, giving an accurate idea of the general appearance of the final statue (Cat. 224). If necessary, small, separate studies of details, such as heads, might be made to refine the expressions. A direct and rapid technique of modelling distinguishes some of Giambologna's terracottas; the finest example in the exhibition is the *River-god* (Cat. 235). From the terracotta, a full-scale model was then produced in plaster by a process of enlargement, probably using some mechanicals aids, such as a grid system in three dimensions, to permit accurate enlargement. Two such full-scale plasters (*not* plaster-casts!) survive in the Accademia in Florence, for *Florence triumphant over Pisa* and the *Rape of a Sabine*. The former was actually exhibited as a pair to Michelangelo's *Victory* in the festive decorations for the wedding of Francesco de' Medici in 1565 and the final marble version (Museo Nazionale, Florence) was not carved for some years. How far this logical sequence corresponded with previous studio practice is not clear, but it proves that Bernini and Canova were not the earliest sculptors to run highly-organized studios, where much of the drudgery could be delegated to more or less skilled assistants.

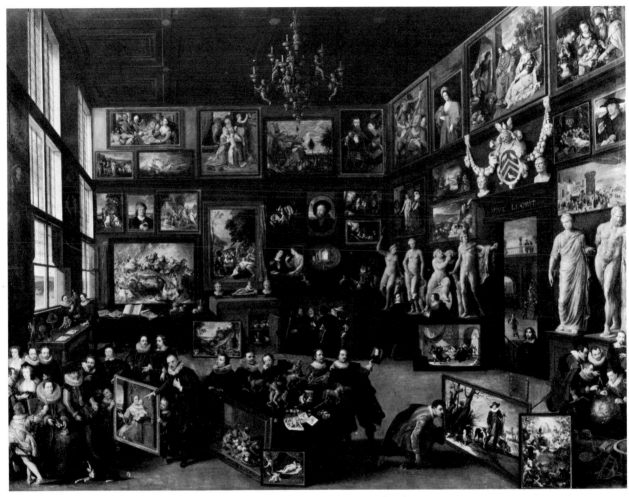

The Art Gallery of Cornelis van der Geest, oil on canvas, by Willem van Haecht the Younger, Rubenshuis, Antwerp

Bronze statuettes by Giambologna in the Imperial and other early collections
by Manfred Leithe-Jasper

Among the princes outside Italy who took an interest in Giambologna and his work, those of the House of Austria take first place both from the chronological point of view and as regards the number and quality of the artist's works in their possession.

The connection goes back to the Emperor Ferdinand I, for in 1560 members of his court were already considering ways of attracting the young sculptor, whose fame had been carried across the Alps by northern artists returning from Italy.[1] The Abel brothers, for instance, suggested that the Emperor should commission Giambologna to execute their design for the funeral monument to Maximilian I in the Hofkirche at Innsbruck.[2] This plan did not materialize, however, and instead the work was executed by Alexander Colin.

We do not know whether Ferdinand owned any works by Giambologna, or who was the recipient of the marble *Galathea*, two and a half *braccia* in height, which Bernardo Vecchietti is said to have sent to Germany in about 1560.[3]

A few years later we reach firmer ground with Ferdinand's eldest son and successor, the Emperor Maximilian II. Vasari, in the second edition of his *Lives* (1568), writes of Giambologna: '*E di bronzo ha fatto . . .; & vn Mercurio in atto di volare, molto ingegnoso, reggendosi tutto sopra vna gamba & in punta di pie, che è stata mandata all'Imperadore Massimiliano, come cosa, che certo è rarissima.*'[4] ('And in bronze he made . . . a Mercury about to take flight, very ingenious, balancing on one leg and on tiptoe, a most exquisite work, which was sent to the Emperor Maximilian.')

In 1584 Borghini wrote in his life of Giambologna: 'At that same time' (*i.e.* when working on the *Fountain of Neptune* at Bologna) 'he made a bronze Mercury as big as a lad of 15, which was sent to the Emperor together with a bronze history and a figurine, also of metal.'[5] This statement was repeated more than a century later, in somewhat abridged form, by Giambologna's third biographer, Baldinucci, who wrote: 'and at that time he cast a Mercury in bronze, which was presented to the Emperor with other casts of his.'[6]

Apparently these three works were sent as presents to the Emperor at the suggestion of the Bishop of Edelburg, nuncio to the court of Vienna, when Cosimo I de' Medici sought the hand of an Imperial princess for his eldest son Francesco.[7] The Emperor's sister, Archduchess Barbara, was first chosen, but she then married Alfonso II, Duke of Ferrara and Modena. It was thus her younger sister, Archduchess Johanna, who arrived in Florence on 16 December, 1565, and contracted what proved an extremely unhappy marriage with Francesco I de' Medici.[8]

The gifts in question were formerly identified with three works by Giambologna now in the Kunsthistorisches Museum, Vienna: a bronze statuette of Mercury in flight, signed *I.B.* (Cat. 34); a small bronze relief with an Allegory of Francesco de' Medici (Cat. 119) and a statuette of a *Woman bathing* (Cat. 1); but the general view today is that this probably only applies to the bronze relief.[9]

The statuette of a *Woman bathing* (Cat. 1) is recorded for the first time in 1788, in an inventory of the collection at Schloss Ambras near Innsbruck. It may have got there by way of gift or inheritance from the Imperial family, however. Archduke Ferdinand II, the governor of the Tyrol and founder of the Ambras Collection, was not himself in contact with Giambologna,[10] but he was a younger brother of the Emperor Maximilian II; while Archduke Maximilian III,

Ferdinand's successor as Governor, was the son of Maximilian II and the younger brother of the Emperor Rudolph II.

The inventory of the Ambras Collection,[11] drawn up in 1596 on the death of Archduke Ferdinand II, is in general very informative, but unfortunately describes the bronze statuettes so cursorily that none of them can be identified with certainty as Giambologna's work. It must be remembered, however, that the Tyrolean branch of the house of Habsburg, which began in 1619 with the Styrian Archduke Leopold V, contracted two marriages with the Medici. Leopold himself married Claudia de' Medici, the dowager duchess of Urbino, daughter of Ferdinand I and Christina of Lorraine; and the eldest son of Leopold and Claudia, Archduke Ferdinand Carl, married Anna de' Medici, daughter of Cosimo II and Archduchess Maria Magdalena of Austria. Works by Giambologna may have found their way to Ambras as a result of these alliances, especially as Leopold V is known to have possessed some. Moreover, it was certainly owing to direct knowledge of Giambologna's work and that of Pietro Tacca that Leopold's court sculptor, Caspar Gras, was able in 1625 to create the equestrian statue of his master at Innsbruck, the first life-size monument to represent a curvetting horse.

Returning to Cosimo's three gifts to Maximilian II, however, it is uncertain whether the *Mercury* now in the Kunsthistorisches Museum (colour plate p. 20) is actually the bronze in question – which the Emperor must have received before 1568, the date of the second edition of Vasari's *Lives*. Borghini's statement that the figure was 'as big as a lad of 15' was originally regarded as casting doubt on the identification, although neither Vasari nor Baldinucci after him give indications of size. It was supposed from the statement that the work must be a life-sized figure similar to the *Mercury* now in the Museo Nazionale del Bargello in Florence, made by Giambologna in 1580 for Cardinal Ferdinando de' Medici, who placed it in the garden of his Roman villa.[12] This figure actually returned to Florence only in 1780, under the Habsburg-Lorrainer Pietro Leopoldo, later Emperor Leopold II.

It is only Borghini, then, who gives an indication of the size of Emperor Maximilian's figure of *Mercury*; and, strictly speaking, his statement does not express actual dimensions but merely implies that the figure looked like an adolescent. With only one other exception, when speaking of the height of a work he quite properly uses the term *altezza* and the measurement in *braccia* (plural of *braccio*, 'yard' or 'ell').[13] The probability that it was a statuette and not life-size is increased by the fact that Francesco de' Medici is said to have delivered these gifts in person to the Emperor in Vienna in October, 1565. The Bargello *Mercury* is no doubt a later, more elaborate variant; otherwise the biographers would hardly have forgotten, when describing the original version sent to Maximilian, to mention the head of Zephyrus on a puff of whose breath Mercury appears to glide. We are more impressed by the conclusion of later research that the style of the Vienna statuette is closer to that of the 1570s than to Giambologna's early work. To elucidate this matter is one of the main purposes of the present exhibition, in which it is possible for the first time to compare the statuettes from Vienna and Naples with that from Bologna – which is regarded as a *bozzetto* – and to place them in the wider context of a general cross-section of the artist's work.

Even though Maximilian II's *Mercury* may actually be lost, the signed bronze

now in Vienna certainly belonged to his son Rudolph II and can be identified without question in the inventory of his collection.[14] It then came into the possession of his brother and successor Matthias, who attached large parts of Rudolph's Prague collection to the *Kunstkammer* or the *Schatzkammer* at Vienna.[15] The bronze remained in that collection until 1800, when it was transferred to the Imperial Cabinet of Coins and Antiquities. In 1880 it was re-transferred to the Ambras Collection, which had been brought to Vienna in 1603, when Rudolph II bought it from the heirs of Ferdinand II. Then, a few years later, the Ambras Collection including the bronze was incorporated in the newly-founded Kunsthistorisches Museum.[16]

Since it is clear from the inventory of Rudolph II's *Kunstkammer* that the bronze relief with an *Allegory of Francesco I de' Medici* was definitely in his possession,[17] one can now state that at least the third of the gifts to Maximilian II has been preserved in Vienna.

Archduchess Barbara, who was originally to have been Francesco's bride, may have received the work in the first place and added it to the collections of the house of Este when she married Alfonso II. We reach a firmer basis of tradition in 1604, when Rudolph II, aided by the indefatigable Hans von Aachen, finally succeeded in obtaining it as a gift, in return for political support, from Cesare d'Este, Duke of Modena. 'At last it is mine,' the Emperor exclaimed as he bore the relief off to his private apartments, where he placed it on a small cupboard. [18] There could be no better illustration of Rudolph's attachment to Giambologna, from whom, or from whose studio, he already possessed numerous *objets d'art*. The Emperor undoubtedly owned the finest collection of the artist's work outside Italy, and probably the finest anywhere except for that of the Medici. In 1588 he raised Giambologna to the nobility, although the latter had refused several times to leave Florence and enter the service of the house of Austria.[19]

Only twenty-seven items in Rudolph's *Kunstkammer* can be identified with any certainty as the work of Giambologna or his studio. [20] Some of them are still in the Kunsthistorisches Museum in Vienna, the heir to the Imperial collections. Perusing the inventory drawn up in 1607–11, we find the following items:

1686: '*Ein zimblich gross silbern quader und histori abgegossen nach einem von metal, so der Johan Bolonia gemacht, darinn vornean ein alter man beim kolfewr sich wermet, uff der anderem Seitten ein Venere nackendt und Murcurius dabey.*' ('A fairly large silver narrative picture cast from a metal one by Johan Bolonia, depicting in front an old man warming himself by a coal fire, on the other side a naked Venus and Mercury.') This is inventory no. 1195, the silver copy of the bronze relief with the *Allegory of Francesco I* (Cat. 119).

1728: '*Ein kniendt von silber abgossen weiblein, so sich mit einer gwendlein abrucknet und über sich sicht.*' ('A small kneeling female figure cast in silver, drying herself with a cloth and looking over her shoulder.') Perhaps identical with a replica of Cat. 22.

1734: '*Der Centaurus mit dem weiblin.*' ('The centaur with the maiden.') Perhaps identical with inventory no. 5847 in the Kunsthistorisches Museum, which however might also be no. 1882 in Rudolph's inventory (see Cat. 61).

1777: '*Ein aussgestreckter Christus ohne* (a cross) *von messing, ist von der Joh: de Bolonia hand.*' ('A brass figure of Christ outstretched, without a cross, by the hand of Joh. de Bolonia.') Probably a *Crucifix* (Cat. 106–111).

1876: '*von bronzo gegossen ein nacket schlaffendt weiblin uff einem bett.*' ('A naked maiden sleeping on a bed, cast in bronze.') Perhaps a sleeping nymph, but without the satyr watching her (Cat. 69–72).

1878: *'von metal gegossen das pferd, welches ein lew uberfellt und uff ein seitten reisst.'* ('A metal cast of a horse which a lion is attacking and clawing on one side.') To be identified with inventory no. 6018 in the Kunsthistorisches Museum (Cat. 171).

1880: *'von bronzo ein Hercules, welcher den risen Caco under sich hatt.'* ('A bronze Hercules, holding the giant Cacus beneath him.') Probably one of the *Twelve Labours of Hercules* executed by Giambologna by 1581 (see general note before Cat. 75); probably a lost or still unidentified replica of the bronze of this subject in the Wallace Collection, London.

1882: *'Item ein Centaurus von bronzo, welcher ein nacket weiblin hinder sich fiert.'* ('Item, a bronze centaur leading a naked maiden behind him.') Possibly identical with inventory no. 5847 in the Kunsthistorisches Museum, unless this corresponds to no. 1734 or 1896 of the Rudolph inventory.

1885: *'folgendt ein Hercules, welcher ein risen endtvor hebt und zwischen den armen zerkwetscht, vonn bronzo.'* ('Next a bronze Hercules, holding up a giant and crushing him in his arms.') This statuette is based on one of Giambologna's models of the *Twelve Labours of Hercules*, dating from between 1576 and 1581, and is to be identified with inventory no. 5845 in the Kunsthistorisches Museum (Cat. 87).

1887: *'Ein mannsfigur, trägt ein Schwein über die achsel, ist auch von bronzo.'* ('A figure of a man, also in bronze, carrying a boar over his shoulder.') This statuette is also based on one of Giambologna's models for the *Twelve Labours of Hercules*, executed between 1576 and 1581. It is to be identified with inventory no. 5846 in the Kunsthistorisches Museum (Cat. 79).

1894: *'Ein springendt ledig rösslein von bronzo.'* ('A leaping riderless horse in bronze.') Possibly a horse as referred to by Baldinucci among Giambologna's models as *'Il Cavallino, che sta in su due piedi'* ('A small horse standing on its hind legs'), which was also re-cast subsequently (see Cat. 153; 164–5; 167–8).

1896: *'Ein Centaurus welcher ein weiblin rubiert und empfiert, von bronzo.'* ('A bronze centaur abducting a maiden.') Possibly to be identified with inventory no. 5847 in the Kunsthistorisches Museum, but this may be identical with no. 1734 or 1882 of the Rudolph inventory (Cat. 61).

1898: *'Ein Tarquinius und ein weiblein Lucretiae, so er umbringen will mit einem dolchen, von bronzo.'* ('A Tarquin, in bronze, with the maid Lucretia, whom he is trying to stab with a dagger.')

1900: *'Ein einzele figur von bronzo, ist ein gladiator.'* ('A single bronze figure of a gladiator.') Probably a *Mars* (Cat. 42–7).

1901: *'Ein stuckh mit 2 figurn, ist einer so ein nacket weib raubt.'* ('A piece consisting of two figures, a man abducting a naked woman.') This is certainly the large group of two figures, inventory no. 6029 in the Kunsthistorisches Museum (Cat. 57).

1902: *'Ein rösslin mit einer Satteldeckh, welches wie ein ordinari pass geht, von bronzo.'* ('A bronze pony with a saddle-cloth, pacing like a palfrey.') Perhaps identical with inventory no. 5839 in the Kunsthistorisches Museum, provided it is not actually intended to be a palfrey (Cat. 156).

1907: *'Ein gruppo nach dem Giovan Bolona so er zu Florentz von weissem marmo gemacht, sein 3 figurn von bronzo, ist ein rabimento Sabine.'* ('A group of three bronze figures representing the Rape of the Sabines, after the group in white marble by Giambologna in Florence.') It cannot as yet be stated with certainty whether the three-figure abduction group, inventory no. 5899 in the Kunsthistorisches Museum, is really identical with the group mentioned in the Rudolph inventory (Cat. 59).

1911: *'Ein klein Rösslein mit ein Satteldeckh, von bronzo.'* ('A bronze pony with a saddle-cloth.') Probably identical with inventory no. 5839 in the Kunsthistorisches Museum (Cat. 156), if this is not no. 1902 in the Rudolph inventory. It may, however, refer to a pony like that in the Bargello (Cat. 158).

1912: *'Ein nacket stehend weiblin, so sich wascht und abtrücknet, von bronzo.'* ('A standing bronze figure of a naked maiden, washing and drying herself.') Perhaps one of Giambologna's statuettes of a *Woman bathing* (Cat. 1–4).

1936: *'Ein bawrsmändl mit einer lagel, so sich auf seinem stab und mantel stewrt von metal.'* ('A peasant with a barrel, in metal, leaning on his staff and mantle.') An example of the *Peasant, resting on his staff* (Cat. 137–8).

1938: *'Ein weiblein kniendt mit dem rechten fuss und mit der rechten Hand sich mit einem tuch abwischendt, von metal und in pletlen goldt vergult.'* ('A maiden kneeling on her right knee and drying herself with a cloth held in her right hand, in metal and gilded with gold leaf.') A gilded replica of the *Woman bathing, kneeling* (Cat. 19, 20).

1939: *'Ein ander weiblein von metall, so sich abwischt und mit den lincken fuss uff einem stockh*

ruhendt.' ('Another metal figure of a maiden drying herself, her left foot resting on a stump.') Probably a replica of the *Woman bathing*, although it can scarcely be the signed statuette, inventory no. 5874 in the Kunsthistorisches Museum (Cat. 1), since in that case the artist's name would presumbably be given.

1941: *'Ein ander klein weiblin von metal, kniendt, sicht über sich und trucknet sich auch mit einem tuch ab.'* ('Another metal figure of a maiden kneeling, looking over her shoulder and drying herself with a cloth.') Doubtless a replica of Cat. 21.

1953: *'Zwen lewen von metal, darunter der eine in fewer vergult.'* ('Two lions cast in metal, one fire-gilt.') These are inventory nos. 5865 and 5876 in the Kunsthistorisches Museum (Cat. 175).

1970: *'Uff dem schreibtisch von ebenholtz mit N° 80 steht zu oberst ein Mercurius nach des Jo. Bolonia, von bronzo.'* ('On the ebony desk with no. 80, at the top, is a bronze Mercury after G.B.') The statuette signed *I.B.,* inventory no. 5898 in the Kunsthistorisches Museum (Cat. 34).

1979: *'Ein qudretto di bassorilievo von Joh: de Bolonia, da vornenan ein alter man beim kolfewer sich wermet, uff der anderm seitten ein Venere, nacket und Mercurius dabei, haben I.May.: von silber abgiessen lassen, such vornen fol: 276.b.'* ('A bas-relief picture by Giambologna, with in front an old man warming himself by a coal fire, on the other side a naked Venus and Mercury beside her; a silver cast made by His Majesty's order, see below fol. 276.b.') This is inventory no. 5814 in the Kunsthistorisches Museum, *i.e.* the relief that Emperor Rudolph reacquired from Cesare d'Este, Duke of Modena, in 1604 (Cat. 119).

This enumeration shows what a wide selection of Giambologna's work could be found in a princely collection north of the Alps as early as *circa* 1600. The principal models of secular subjects were represented. It must be emphasized that Giambologna's art was particularly to Rudolph II's taste, which no doubt also accounted for the success of Bartholomäus Spranger and Hans Mont, who hastened to the Emperor's court at Prague on Bologna's recommendation. We may suppose that Francesco de' Medici, who was probably Giambologna's chief customer and no doubt also inspired his work, resembled Rudolph in his cast of mind and aesthetic tastes. The fact that the Emperor possessed almost all Giambologna's statuettes of Venus is evidence of his fondness for female nudes. This was well known to the European courts and was observed in the choice of diplomatic gifts to the Emperor, who at times expressly mentioned it, as when he asked Cesare d'Este to let him have a certain antique nude and *'un'altra donna più nuda della medema grandezza di mano di Giovan Bologna'* ('another, more naked female figure of the same size by Giambologna.')[21] However, Rudolph also showed great interest in Giambologna's equestrian statue of Cosimo I, of which he wished to have a model.[24] This may be identical with the bronze now in Stockholm (Cat. 149), which in fact has the portrait head of Rudolph, and could have been brought there in 1648 with the rest of the Swedish army's booty from Prague.[25] Several of the bronzes listed above may have had the same fate and remained in Sweden, if they were not too under-clad for Queen Christina's taste.

The items, however, that were listed in the inventory of the Emperor Matthias's collection on his death in 1619[26] were transferred to Vienna and afterwards deposited in the *Kaiserlich Schatzkammer,* where they reappear in the inventory of 1750, the oldest extant inventory of the *Schatzkammer,* listed according to the different rooms.[27] When the Imperial collections were reorganized in the early 19th century some bronze statuettes were assigned to the Collection of Coins and Antiquities and others to the Ambras Collection, which had meanwhile been moved to the Untere Belvedere. Later the Ambras Collection was incorporated in the Collection of Applied Art in the Kunsthistorisches Museum, now known as the Sammlung für Plastik und Kunstgewerbe.

Not only the house of Austria, however, but other princes and wealthy bourgeois of the Empire showed a taste for Giambologna's work, so that in the 16th and early 17th century many collections and *Kunstkammern* in Germany contained works of his which were singled out in inventories and descriptions as of special importance. Some of the collectors had met the artist himself in Italy. In 1599–1600 Duke Friedrich of Württemberg travelled to Italy incognito for the main purpose of seeing with his own eyes the marvels of contemporary Italian art; among his suite was the architect Heinrich Schickhardt, whose diary shows that Giambologna's work excited the greatest interest.[28] A visit to the latter's studio seems in fact to have been a regular feature of princely 'grand tours.' Duke Augustus the Younger of Brunswick-Wolfenbüttel, who was in Florence in June 1599, wrote in his diary on the last day of his stay: 'On 15 June, visit to the abode of Johan Bologni; in the evening, Montelupo village.'[29]

The Elector Augustus I of Saxony (d. 1586) and his son Christian I (d. 1591), who were both collectors of note, possessed fine bronzes by Giambologna which are still in the Dresden collections.[30] The electoral court maintained close relations with the Grand Dukes of Tuscany in Florence. In 1577 Francesco de' Medici visited Augustus I in Dresden, and in 1586 he wrote to Christian I congratulating him in very friendly terms on his accession. There were thus plenty of occasions for the exchange of gifts between the two courts, and this no doubt accounts for the presence of works by Giambologna in the 1587 inventory of the Dresden *Kunstkammer*: these comprised a flying *Mercury*, a sleeping nymph watched by a faun (Cat. 69), and the magnificent signed group of *Nessus and Deianira* (Cat. 61). The Dresden inventories are so detailed that we even learn from them that a statuette of *Mars* (Cat. 43), also mentioned in 1587, was presented by Giambologna himself to the Elector, who in return sent the artist a golden chain (see Cat. 213).[31]

Giovanni Maria Nosseni and Carlo di Cesare, both court sculptors to the Elector, were in personal and professional touch with Giambologna and helped to popularize his style. Nosseni was himself an enthusiastic collector of Giambologna's work, several pieces of which passed to the *Kunstkammer* on his death in 1620.

The court at Munich, which was already a lively centre of collector's activity, also acquired works by Giambologna at an early stage. Borghini records that the Duke of Bavaria – this must be Albert V, who reigned from 1550 to 1579 – received a marble figure of a seated woman by Giambologna at the time when the artist was working on the group *Florence triumphant over Pisa, i.e.* about 1565–70.[32] This work is unfortunately lost, and we do not know what it looked like or what the subject was (see Cat. 248); it may have resembled the *Architecture* which seems to date from the same period (Cat. 17). An important commission was that of Duke William V of Bavaria for a life-size crucified Christ in bronze; this work by Giambologna was presented by Grand Duke Ferdinand to William, whose letter of thanks is dated 3 December, 1594.[33] The crucifix is now in St Michael's church in Munich; it is completed by a figure of Mary Magdalene at the foot of the cross, the work of Giambologna's pupil Hans Reichel. Giambologna's figure influenced to an outstanding degree the portrayal of the Crucified Christ in South Germany in the Counter-Reformation period.

A generation later, however, interest in Munich had shifted from Giam-

bologna and centred on Albrecht Dürer. This must be the explanation of the fact that in 1630 the Elector Maximilian I (reigned 1597–1651) refused to accept six bronze reliefs with scenes of the Passion by Giambologna, offered to him by the city of Nuremberg in the hope of escaping the heavy burden of providing billets for troops during the Thirty Years' War.[34] It is an historical irony that these reliefs, which were then in the possession of the Augsburg art dealer Barnhard Zäh and were sold to a buyer in Amsterdam, apparently found their way to Munich after all: they are in all probability identical with a set which the Palatine Elector Johann Wilhelm (reigned 1690–1717) acquired in the Netherlands for his gallery at Düsseldorf, the contents of which passed to Munich by way of inheritance in 1805 (Cat. 122–7).[35]

As we have seen, the Medici were connected with the Habsburgs by Francesco I's marriage to Archduchess Johanna, and through them they were linked to the Wittelsbachs of Bavaria, with whom further marriages took place. In addition the court of Florence had political reasons for desiring association with the Electors of Saxony, who were particularly close to the Imperial court at Prague. For all these reasons it is not surprising that many works by Giambologna found their way into the Munich and Dresden collections. It is more remarkable, however, that by the beginning of the 17th century many of his works were already to be found in German bourgeois collections, for example that of Paul von Praun at Nuremberg[36] and especially that of the Imperial and Württemberg councillor Markus Zech at Augsburg. Concerning the latter, Philipp Hainhofer wrote in 1610 to Duke Philip II of Pomerania that no prince of the Empire could boast of having so many and such fine works by Giambologna. This, of course, appears an exaggerated claim in view of Emperor Rudolph II's collection[37]; but Zech did possess an example both of the two-figure (Cat. 56–7) and the three-figure abduction group (Cat. 58–9), two groups representing animals fighting (Cat. 170–4), the sleeping nymph watched by a satyr (Cat. 69–72), a gladiator (Cat. 42–7), *Architecture* (Cat. 17), a *Bird-catcher* (Cat. 130–3), *Astrology* (Cat. 12), and a statuette of a standing female figure.[38] These ten works by Giambologna were offered for sale, their estimated value being 4,000 crowns.[39] Zech also possessed other works by the artist which he did not intend to sell. One of these, according to Hainhofer, was an equestrian statue of Francesco de' Medici: this, as has often been suggested, may be the one now in the collection of the Reigning Prince of Liechtenstein (Cat. 150). In addition there were 'bronze tablets which he caused to be made for his Epitaphium'. Zech's tomb was erected in 1617, during his lifetime, in the cloister of the Discalced Carmelites' church at Augsburg, and inserted in it was a bronze relief of the *Flagellation of Christ*: this was a slightly altered replica of one of the six reliefs of the Passion which Giambologna made between 1579 and 1585 for the funeral chapel of Luca Grimaldi in Genoa, and which he afterwards had cast, again in a slightly altered form, for his own mausoleum (see Cat. 125).[40] Thus it was possible in 1617 for a bourgeois collector in Augsburg to select for the adornment of his tomb a replica of the work which the artist had chosen for his own monument in the choir of the Santissima Annunziata in Florence.

Later in the 17th century another German collector of note took a similarly close interest in Giambologna's work. Everard Jabach of Cologne (1618–95) possessed a gilded bronze statuette (h.13) cast from a model by Giambologna and representing Venus drying herself after the bath. The underside of the round

plinth was engraved so that he could use it as a seal: what better way of enjoying the sensual charm of a work by Giambologna than by thus grasping it every day?[41] Jabach may have become acquainted with the artist's work through his close contacts with the court of Louis XIV of France, who, as the 'Inventaire de la Couronne' tells us, possessed many of Giambologna's bronzes.[42] André le Nôtre and Cardinal Richelieu[43] had previously collected works by Giambologna, but although two queens of France came from the house of Medici there is no evidence for any collection of his works in that country during his lifetime; his services were, however, used more than once for purposes of state. In 1567 Catherine de Médicis tried unsuccessfully to secure the artist's collaboration for an equestrian statue of her consort Henri II, which she wished to have cast in Rome.[44] In 1604, when Marie de Médicis commissioned an equestrian statue of Henri IV, Giambologna was 75 years old; the queen, fearing that he might have lost his skill, asked her cousin Ferdinand to let her have the horse already cast for his own monument, but he naturally refused.[45]

Whether Giambologna's work was collected in Spain cannot now be ascertained. It appears from letters that before 1581, and in 1585, small sculptures by him or from his studio were sent to Madrid,[46] and in 1585 the Spanish court tried unsuccessfully to engage his services.[47] Later Ferdinand, with diplomatic adroitness, used Giambologna's art for political ends. In 1597 he presented the archbishop of Seville, Rodrigo de Castro, count of Lemos, with a bronze statue for his tomb.[48] He also arranged for Pietro Tacca to execute an equestrian statue of Philip III of Spain,[49] and presented Philip's powerful minister, the Duke of Lerma, with the marble group of *Samson and a Philistine* which Giambologna had made for Francesco de' Medici in 1566–7.[50] This work did not remain long in Spain, however; in 1623, after Lerma's fall, it was acquired by George Villiers, Duke of Buckingham, and it is now in the Victoria & Albert Museum.[51] It reached England at a time when Giambologna's work was already popular there; interest in it may have awakened later than elsewhere in Europe but remained strong for a considerable time, as is shown by the many works of his which are still in British collections.

In 1612, three years after Giambologna's death, Cosimo II sent several bronze statuettes after models by him, probably cast by Antonio Susini and Pietro Tacca, to Henry, Prince of Wales, son of James I.[52] In the same way as half a century earlier, the purpose of the gift was to secure a matrimonial alliance which would enhance the prestige of the house of Medici. The latter hoped, despite the competition of Spain, France and even Savoy, to induce Henry to marry Cosimo's sister Catarina; however, Henry died and instead she married into the house of Mantua. There was no special pretence in this case of gratifying any artistic taste. Henry did not trouble to give instructions about the statuettes for six months, and he seems to have followed the suggestion of the Florentine special envoy, the Marchese Salviati, rather than expressing a desire of his own. However, when he did see the works he is said to have been delighted with them.

The statuettes are known to have been in Charles I's collection, but they disappeared after the Civil War. Quite possibly they exist, unidentified, among the numerous replicas of bronzes by Giambologna. They were not among the many works of art acquired from England by Archduke Leopold William of

Habsburg (1614–62) during his governorship of the Spanish Netherlands from 1647 to 1655. He was more interested in painting, and the sculpture in his large collection consisted mainly of contemporary or much older works.[53] However, much interest was taken in Giambologna's work in the Netherlands and his statuettes must have figured in many collections, as we see from their presence in numerous paintings of interiors. In the most famous work of this kind, *The Art Gallery of Cornelis van der Geest* by Willem van Haecht,[54] a whole collection of bronze statuettes after models by Giambologna can be seen on the hexagonal table in the foreground.

As Giambologna became famous throughout Europe it was natural that young sculptors flocked to his studio from every quarter. These pupils helped to increase the popularity of his style and the demand for works by his own hand. For generations to come Giambologna remained a 'classic of sculpture'; casts continued to be made from his models, and his work became known on a scale exceeding that of any other sculptor before or after him.

Notes

1. D. von Schönherr, ' Geschichte des Grabmals Kaiser Maximilians', *Jahrbuch der Kunsthistorischen Sammlungen des allerhöchsten Kaiserhauses in Wien*, XI, 1890, p. 210.

2. *I.*, 'Urkunden und Regesten aus dem K.K. Staathalterei-Archiv in Innsbruck', *Jahrbuch der kunsthistorischen Sammlungen des allerhöchsten Kaiserhauses in Wien*, XI, 1890, Regesten Nr. 7592.

3. Raffaello Borghini, *Il Riposo . . .*, Florence, 1584, p. 586.

4. Giorgio Vasari, Life of Giambologna, in *Le vite de' più eccelenti pittori, scultori e architetti . . .*, Florence, 1568, ed. Milanesi, 1878–85, Vii, 629.

5. Raffaello Borghini, *op. cit.*, p. 587.

6. Filippo Baldinucci, *Notizie dei professori del disegno, Giovanni Bologna, scultore, e architetto fiammingo*, 1688, p. 122.

7. *Cf.* E. Dhanens, *Jean Boulogne*, Brussels, 1956, pp. 56 and 127 ff. It is not quite clear, however, when and through whom these gifts reached Maximilian II. There was at no time a bishopric of 'Edelburg'. The nuncios may have played some part, but according to Galluzzi (*cf.* note 18) Francesco de' Medici himself delivered the gifts to the Emperor in October 1565.

8. R. Galluzzi, *Istoria del Granducato di Toscana sotto il governo della Casa Medici*, Florence, 1781, II, 48 ff.

9. For a recent summary of the facts, see E. Dhanens, *op. cit.*, cat. nos. XV, XVI and XVII.

10. E. Dhanens, *op. cit.*, p. 59.

11. Printed in *Jahrbuch der Kunsthistorischen Sammlungen des allerhöchsten Kaiserhauses in Wien*, VII, 1888, Regest Nr. 5556.

12. See E. Dhanens, *op. cit.*, cat. no. XV.

13. R. Borghini, *op. cit.*, pp. 585 ff. The other exception is an *'altra figura di marmo à sedere della grandezza d'una fanciulla di sedici anni, la quale statua fu mandata al Duca di Baviera'* (another seated marble figure of the size of a girl of sixteen, which was sent to the duke of Bavaria). He also describes the *fanciulli* surmounting the altar at Lucca as *'dimostranti l'età di dieci anni'* (like ten-year-old boys), and they cannot really be called *putti*.

14. Inventory of Emperor Rudolph II's *Kunstkammer*, 1607–11, ed. Rotraud Bauer and Herbert Haupt, in *Jahrbuch der Kunsthistorischen Sammlungen in Wien*, 72 (new series, Vol. XXXVI), 1976, no. 1970.

15. Wilhelm Köhler, 'Aktenstücke zur Geschichte der Wiener Kunstkammer in der Herzoglichen Bibliothek zu Wolfenbüttel', *Jahrbuch der Kunsthistorischen Sammlungen des allerhöchsten Kaiserhauses in Wien*, 27, 1906/07, p. XV: 'Allerlei schone stukh von messing', no. 5 or 6. Although the *Mercury* is not designated as by Giambologna in this and later inventories of the *Schatzkammer*, there is sufficient evidence for this identification.

16. For the general history of the collection, see A. Lhotski, *Festschrift des Kunsthistorischen Museums, Die Geschichte der Sammlungen*, Vienna, 1941–45.

17. R. Bauer and H. Haupt, *op. cit.*, no. 1979.

18. A. Venturi, 'Zur Geschichte der Kunstsammlungen Kaiser Rudolfs II.', *Repertorium für Kunstwissenschaft* 8, 1885, p. 18.

19. See the summary of information in E. Dhanens, *op. cit.*, pp. 56 ff. and 355 (Giambologna's letter of June 1585 to Antonio Serguidi).

20. R. Bauer and H. Haupt, *op. cit.*, esp. pp. 99 ff.

21. A. Venturi, *op. cit.*, pp. 2 ff.

24. E. Dhanens, *op. cit.*, p. 277.

25. Perhaps identical with *'Ein ross, darauf kaiser Rudolphus, von metal gegossen, auf einen schönen marmorsteinernen fuess'* (Emperor Rudolph on horseback, cast in metal, on a fine marble pedestal): see Heinrich Zimmermann, 'Das Inventar der Prager Schatz- und Kunstkammer vom 6. Dezember 1621', *Jahrbuch der Kunsthistorischen Sammlungen des allerhöchsten Kaiserhauses* 25, Vienna, 1905, p. XXXV, no. 709.
 This bronze group seems to have been part of the Swedish booty taken from Prague to Stockholm in 1648, and to be identical with inventory no. 749 in the sculpture collection of the National Museum in Stockholm. It is not certain however, whether the figure is really Rudolph II or Cosimo I. See Cat. 149.

26. Wilhelm Köhler, *op. cit.*, p. XV: *'allerlei schone stukh von messing.'*

27. Heinrich Zimmermann, 'Inventare, Acten und Regesten aus der Schatzkammer des allerhöchsten Kaiserhauses', *Jahrbuch der Kunsthistorischen Sammlungen des allerhöchsten Kaiserhauses* 10, 1889, pp. CCLI ff., Regest 6253, inventory of 1750.

28. C. Hulsen, 'Ein deutscher Architekt in Florenz (1600)', *Mitteilungen des Kunsthistorischen Instituts in Florenz*, Vol. II, 1912–17, pp. 152 ff.

29. Cod. Guelf. 42. 19 Aug. fol., Herzog August Library, Wolfenbüttel, fl.16.V. Information kindly furnished by Frau Dr Johanna Lessmann in Brunswick.

30. See especially W. Holzhausen, 'Die Bronzen der Kurfürstlichen Sächsischen Kunstkammer zu Dresden', *Jahrbuch der Preussischen Kunstsammlungen*, Vol. LIV, Berlin, 1933, *Beiheft*, pp. 45 ff.

31. *Ibid.*, p. 55.

32. R. Borghini, *op. cit.*, p. 587.

33. E. Dhanens, *op. cit.*, pp. 58 and 204 ff.; R. A. Peltzer, 'Ein Bronzerelief von Giovanni da Bologna zu Augsburg', *Zeitschrift für Bildende Kunst*, 59, 1925/26, p. 192.

34. A. Ernstberger, 'Kurfürst Maximilian von Bayern und Albrecht Dürer, zur Geschichte einer grossen Sammlerleidenschaft', *Anzeiger des Germanischen National-Museums 1940–1953*, p. 167.
 Rudolph II's interests as a collector were more varied: he too was a passionate admirer of Albrecht Dürer, but this did not prevent him from collecting with enthusiasm works by Pieter Brueghel, Correggio or Giambologna.

35. H. R. Weihrauch, *Bayerisches Nationalmuseum München, Kataloge, Bd. XIII, 5. Die Bildwerke in Bronze und in anderen Metallen*, Munich, 1956, pp .92 ff., nos. 115–20.

36. C. T. de Murr, *Description du cabinet de Monsieur Paul de Praun à Nuremberg*, Nuremberg, 1797, pp. VI and 230.

37. O. Doering, *Des Augsburger Patriciers Philipp Hainhofer Beziehungen zum Herzog Philipp II. von Pommern-Stettin*, Vienna, 1894, p. 196.

38. *Ibid.*, pp. 96 ff.; see catalogue, p. 44 for transcription of the list.

39. *Ibid.*, p. 237.

40. R. A. Peltzer, *op. cit.*, p. 190.

41. Brigitte Klesse and Hans Mayr, *Verborgene Schätze aus sieben Jahrhunderten – ausgewählte Werke aus den Kunstgewerbe-Museen der Stadt Köln*, Cologne, 1977, p. 60.

42. J. Guiffrey, *Inventaire Général du Mobilier de la Couronne sous Louis XIV*, II, Paris, 1886, pp. 32 ff.; 'Bustes et figures en bronze'. For individual works see also P. Verlet, 'Chapeaurouge et les collections royales françaises' in *Festschrift für Erich Mayer*, Hamburg, 1959, pp. 280 ff., and B. Jestaz, 'La statuette de Fortune de Jean Bologne' in *La revue du Louvre et des Musées de France*, 1978, no.1, pp. 48. ff.

43. H. Landais, 'Sur quelques statuettes léguées par Le Nôtre à Louis XIV', *Bulletin des Musées de France*, 1949, pp. 60 ff.; *id.*, *Les Bronzes de la Renaissance*, Paris, 1958.

44. E. Dhanens, *op. cit.*, pp. 55, 337 and 365; M. Campbell and Gino Corti, 'A Comment on Prince Francesco de' Medici's Refusal to Loan Giovanni Bologna to the Queen of France', *The Burlington Magazine*, CXV, 1913, pp. 507 ff.

45. E. Dhanens, *op. cit.*, p. 370.

46. *Ibid.*, pp. 62, 204, 352.

47. *Ibid.*, pp. 62, 356.

48. *Ibid.*, pp. 62, 286–87, 292; see Cat. 112.

49. *Ibid.*, pp. 297 ff.

50. *Ibid.*, p. 62, nn. 152 ff.

51. J. Pope-Hennessy, *Catalogue of Italian Sculpture in the Victoria & Albert Museum*, London, 1964, pp. 460 ff., no. 486.

52. K. Watson and Charles Avery, 'Medici and Stuart: a Grand Ducal Gift of ''Giovanni Bologna'' Bronzes for Henry, Prince of Wales (1612)', *The Burlington Magazine*, CXV, 1973, pp. 493 ff.

53. Adolf Berger, Inventar der Kunstsammlungen des Erzherzogs Leopold Wilhelm von Österreich, in *Jahrbuch der Kunsthistorischen Sammlungen des allerhöchsten Kaiserhauses*, I, 1883, pp. CLXV ff.: 'Verzaichnusz der stainenen, metallenen Statuen, anderen Antiquitäten vndt Figuren.'

54. Antwerp, Rubens House.

Catalogue

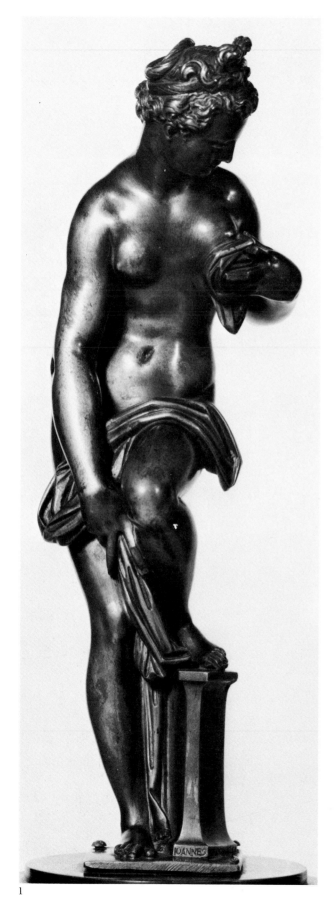

1

1

Woman bathing

h.24.9

Bronze. Golden transparent varnish; over it, especially on the breast and face, remains of a second transparent, reddish-brown varnishing; light brown natural patina.
Engraved at the base of the pedestal: *IOANNES / BOLOGNA . BELGA*
Kunsthistorisches Museum, Vienna, Sammlung für Plastik und Kunstgewerbe (5874)

The woman stands on a shallow square base with her left foot on a polygonal pedestal. With her right hand she grasps the towel which is slipping down between her legs, and in her left she holds a cloth with which she is drying her left breast, looking down leftwards at her body as she does so. This statuette is always regarded as an early work by Giambologna and as a compositional development of the *Fiorenza* at the Villa Petraia in Castello near Florence. However, whether students may have been over-influenced by the fact that the statuette was believed to be the *'figurina di metallo'*, which, according to Borghini and later writers, was presented to Emperor Maximilian II in about 1565 together with the *Mercury* and a relief. If that is the case it seems extraordinary that in about 1583, nearly twenty years later, Giambologna reverted to the theme and produced a nearly identical replica of the statuette at life-size in marble for G. G. Cesarino, a work which is now in the American Embassy in Rome (the former Villa Ludovisi). Many versions are known, but none of them approaches in quality the Vienna statuette, cast and chased with extreme care, which is also the only signed one. Other, somewhat larger replicas Cat. 2, 3, 4, about 33 cm high, are regarded as reductions of the Cesarino *Venus* (see Dhanens, with a fairly complete list of replicas).

BIBLIOGRAPHY: Planiscig 1924, p. 147, no. 249; Gramberg 1936 (1933), pp. 78–80; Kriegbaum 1952–53, p. 60; Dhanens 1956, pp. 138 ff.; Wixom 1975, no. 148 (for the version at Cleveland and list of replicas); Franzoni, 1970, pp. 128–9.
PROVENANCE: old Habsburg property, identified with certainty in the inventory of the Ambras collection, 1788.

M. L-J.

2

Woman bathing

*h.*33.8

Bronze, dark red-brown lacquer.

Engraved on pedestal below left foot: *No. 210*.

National Trust, Fairhaven Collection, Anglesey Abbey, Cambridge

A version of Cat. 1, the bronze is one of three known casts (see Cat. 3, 4) of this model bearing the engraved inventory number 210 of the French Crown Collection. No. 210 is first listed in the Crown inventory of 1707 (Archives Nationales, 0¹3348,p. 143), appearing again in that of 1729 (Archives Nationales, 0¹3334, f.270v., f.279v., note following No. 309), and lastly in that compiled for the Assemblée Nationale in 1791 (p.231). It remains to be explained how the same number came to be engraved on three bronzes. Another version of the same model identically described was in the Crown Collection by 1684 under No. 48 (Guiffrey, 1886, p. 35). No. 48 was ceded by the Republic to Jacques de Chapeaurouge of Hamburg in part payment for debts (Verlet, 1957, p. 289). A version of the model described as by Susini after Giambologna was in the collection of Cardinal de Richelieu at his death in 1642 (Inv. no. 71; Boislisle, 1881, p. 89; Champier and Sandoz, I, 1900, p. 68). This is identified by Landais (1961, p. 141) with a version in the collection of François Girardon (Charpentier, 1710), described as by Antonio Susini after Giambologna, but is not necessarily identifiable, as Landais supposed, with No. 210 of the Crown Collection. Cat. 2, 3 and 4 all have the appearance of Florentine bronzes.

ADDITIONAL BIBLIOGRAPHY: see Cat. 1.

PROVENANCE: Lord Fairhaven, Anglesey Abbey, Cambridgeshire.

A.R.

3

Woman bathing

*h.*33.8

Bronze, translucent yellowish lacquer. A crack between separately cast sections below the top of the pedestal under left foot. A pinned join in the left hand.

Engraved on pedestal: *No. 210*.

Menil Foundation Collection, Houston, Texas (70–54–DJ)

See Catalogue number 2.

PROVENANCE: Michael Hall Fine Arts Inc., New York.

A.R.

4

Woman bathing

*h.*33.9

Bronze, translucent golden lacquer, much rubbed.

Engraved on pedestal: *No. 210*.

M. et Mme. Alain Moatti, Paris

See Catalogue number 2.

A.R.

 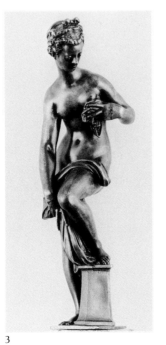 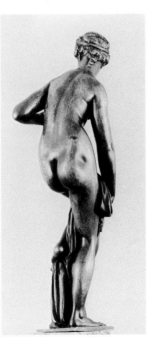 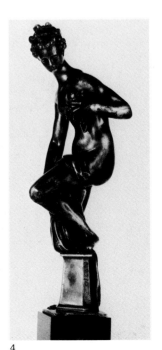

2 3 3 4

5
Woman bathing
*h.*14.3 (including integral bronze base)
Bronze, gilt.
Herzog Anton Ulrich-Museum, Brunswick (Bro. 90)

The bronze, which is an unusually thin cast, is exceptionally highly worked in all the details, the towel being textured all over in the wax and carefully chased out in the metal. In general the bronze has the character of goldsmith's work. The high, square, integrally-cast bronze base with a central fixing hole suggests that the figure may have been made to surmount a cabinet.

Wrongly classified by Gramberg as a replica of the *Woman bathing* in Vienna (Cat. 1), the statuette is regarded by Weihrauch (1967, p. 205) as an autograph work by Giambologna. It is indeed intimately related to the style of Giambologna: the relationship to Cat. 1 is obvious, but the figure also reflects in reverse the pose of the *Apollo* of the Studiolo (Cat. 36; 1572–73) and the motif of the arm carried across the front of the body to rest on the thigh reflects the marble group of *Florence triumphant over Pisa* (Cat. 223, 224; 1565–70). But, although the drapery forms are in general consistent with those of Giambologna, and the handling of some details, such as toe-nails, is very close to his, the facial type and the general goldsmith-like character of the piece would seem to preclude a direct attribution to him. It may be that the bronze is the work of a court goldsmith following a Giambologna prototype.

As noted by Wixom (1975, no. 149) a version of the model was in the collection of François Girardon in 1710, curiously described as antique (Souchal, 1973, p. 46). Versions of the model of a more conventional character exist in which the figure is accompanied by a figure of Cupid (see Cat. 9).

FURTHER VERSIONS: private collection, Ohio (Wixom, 1975, no. 149).
ADDITIONAL BIBLIOGRAPHY: Jacob, 1972, p. 19, no. 31.
PROVENANCE: old Ducal collections, Brunswick.

A.R.

6
Woman bathing, small
*h.*13.2
Bronze
Museo Nazionale, Bargello, Florence (71)

The traditional attribution of the statuette to Giambologna (Bode, 1912, p. 7; Dhanens, 1956, pp. 123–5; Watson and Avery, 1973, p. 504) is undoubtedly correct, provided that we are thinking in terms of the invention of the composition, that is of the wax model (lost) documented in a drawing by Hans Bock (*circa* 1550–1624) signed and dated '*H. Bock. nach Wachs Anno 90*' (illustrated without comment in: F. Thöne, *Schweiz. Inst. f. Kunstwissenschaft, Jahresbericht 1965*, fig. 77).

Heretofore the dating of the statuette has been commented upon only by Dhanens (1956, pp. 123–5), who suggested that Cat. 6 and 21 could be bronze casts of the lost '*termini*' that Giambologna executed in gold in 1564, for a cabinet designed by Bernardo Buontalenti (Vasari 1568, ed. Milanesi, VII, 1881, p. 615, and Borghini, 1584, pp. 610–11). Her contention, however, can no longer be maintained, because the '*termini accoppiati*' were, in fact, double herms personifying the three ages of man (Corti, 1976, p. 633). Thus the dating of the present statuette remains open.

I am inclined to consider our bronze and other similar small studies (Cat. 21 and 37) as belonging to the numerous '*opere di terra cruda e cotta, di cera e di altre misture*' mentioned by Vasari in 1568, which Giambologna designed as a stock of compositional ideas between 1555 and 1561, years when he had not yet received large commissions in Florence. During his life-time he filled in this collection of models with variations, executing some of them on a larger scale in bronze or marble.

Examples of the present composition have been finished with varying degrees of care. Nonetheless, all still unmistakably betray the characteristic features of the *bozzetto*: proportion, posture, and movement are definitively established, while all the details are left in a

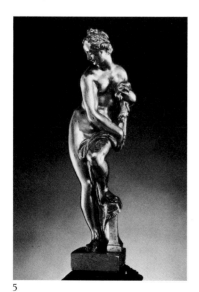

5

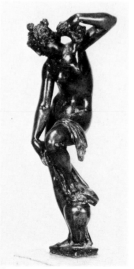

6

sketchy state. Thus it is evident that Giambologna did not make this statuette for a collector's cabinet, but created it for himself, as a compositional study for his own workshop. Although all known examples are, so to speak, only half-finished, some of them, such as the present bronze, that in the Kunstgewerbemuseum, Cologne, or in the Wallace Collection, London, can be considered autograph casts; other examples were produced by pupils, or by artists of a later generation, who desired them for their own collections of models.

FURTHER VERSIONS: Berlin, Staatliche Museen, Skulpturenabteilung, (5029; 1967, left arm with jug incorrectly completed); Catania, Museo Civico; Cologne, Kunstgewerbemuseum, gilded, (H 494, with the arms of the collector Everhard Jabach, 1618–95, engraved on a bronze disc attached to the base); Douai, Musée de Douai, (896); Florence, Museo Bardini; London, Victoria & Albert Museum, (1439–1855; 7933–1861); London, Wallace Collection (S 127).

ADDITIONAL BIBLIOGRAPHY: Bode, 1930, p. 33; Mann, 1931, p. 48; Leroy, 1937, p. 128; Weihrauch, 1967, p. 210; B. Klesse and H. Mayr, *Verborgene Schätze aus dem Kunstgewerbemuseum der Stadt Köln*, Cologne, 1977, pp. 60–1.

PROVENANCE: Galleria degli Uffizi, Florence, former Medici property.

H.K.

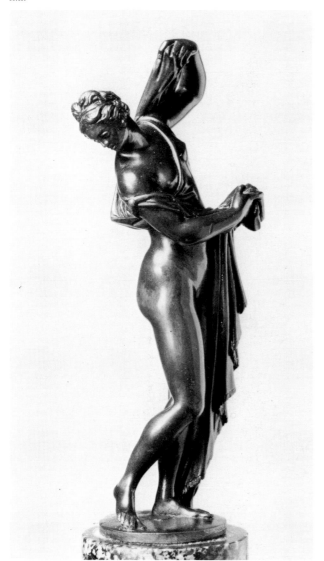

7

7
Venus Kallipygos
h.12.6 (including integral bronze base).
Bronze. Light golden lacquer, much rubbed and darkened; on integral circular base.
Victoria & Albert Museum, London (A. 141–1910)

The bronze is adapted from the celebrated antique statue known as the *Callipygian Venus*, now in the Museo Nazionale, Naples. This was excavated in the mid-16th century on the site of the Golden House of Nero in Rome, and came into Farnese possession, being recorded in the Palazzo Farnese in Rome in 1585 by Giambattista De Cavalleriis (*Antiquarum statuarum urbis Romae*, Rome 1585, II, pl. 66). It was heavily restored in Naples between 1780 and 1788 by Carlo Albacini to the form it now has, and it is noted by Maclagan (*ms.* catalogue of bronzes in the Victoria & Albert Museum) that the present bronze differs radically from the marble as it now is in the restored parts (head, left arm, etc.). Taking into account the character of the bronze, Maclagan proposed an origin for it in the early 17th century.

The bronze is in fact in every way entirely characteristic of the work of Antonio Susini. Not only the general facture and the patination, but the handling of details of the face and hair and the finger-nails and toe-nails are consistent with his signed bronzes. Decisive for his authorship is the handling of the drapery which is completely re-invented and assumes his characteristic sharp scooped forms resembling wood carving. There can be little doubt that the bronze is a work of Antonio Susini of the highest quality. Although bronze reproductions of the *Callipygian Venus* of all sizes and dates are legion, no other version of this model is known.

It is interesting that a pupil of Giambologna, Hans Mont of Ghent, visited the Golden House around 1570, and later produced his own free version of the statue in two larger bronze versions, one in the Ashmolean Museum, Oxford (see K. Parker, Ashmolean Museum, *Report of the Visitors*, 1960, pp. 63, 64), and the other in the Herzog Anton Ulrich-Museum, Brunswick (S. Jacob and B. Hedergott, *Europäische Kleinplastik*, Brunswick, 1976, no. 13).

ADDITIONAL BIBLIOGRAPHY: L. Franzoni, *La Galleria Bevilacqua*, Milan, 1970, pp.124–135
PROVENANCE: George Salting, London; bequeathed 1910.

A.R.

8
Woman bathing, with knee on stool
*h.*12.7
Bronze. Gilt; with integrally-cast circular base.
Musée des Beaux-Arts, Dijon (T.1357)

The bronze is an unusually fine version of a model which must have originated in Giambologna's workshop. The model is more commonly known in combination with a figure of Cupid, and a superb example of this group (Cat. 10) is clearly from the hand of Antonio Susini.

FURTHER VERSIONS: Staatliche Museen, Berlin-Dahlem (1900, Bode, 1930, no. 153).
BIBLIOGRAPHY: E. Gleize, *Catalogue descriptif des objets d'art formant le Musée Anthelme et Edma Trimolet*, Dijon, 1883, p. 204, no. 1357.
PROVENANCE: Trimolet collection, Lyons, bequeathed in 1878.

A.R.

9
Venus and Cupid
*h.*14.8
Bronze. Dark brown patina, with remains of black lacquer; on integrally-cast rectangular bronze base.
Bayerisches Nationalmuseum, Munich (49/39)

The figure of Venus is a version of the same model as Cat. 5, but the bronze is of a more conventional character. Weihrauch (1956, no. 114), who considers Cat. 5 to be by Giambologna, classifies the present bronze as possibly by Gianfrancesco Susini adapting a Giambologna model, and the figure of Cupid has indeed very much the same character as those in the two pairs of signed groups by Gianfrancesco Susini, in Vaduz and in the Louvre, of Venus and Cupid (see Cat. 190, 191).

As noted by Weihrauch (*loc. cit.*), a variant version was in the collection of Jacobus de Wilde in Amsterdam in 1700 (*Signa Antiqua e Museo Jacobi de Wilde per Mariam Filiam Aeri Inscripta*, Amsterdam, 1700).

PROVENANCE: Lucerne art market, 1949.

A.R.

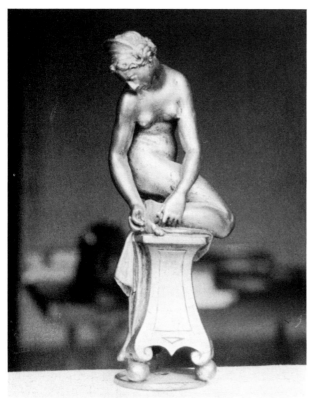

8

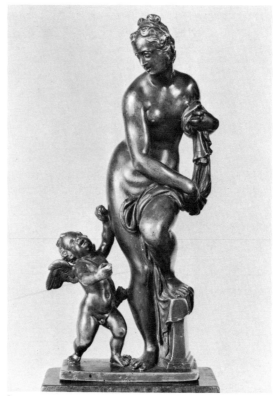

9

10
Venus and Cupid
h. 12.7
Bronze. Remains of red-gold lacquer; on integrally-cast oval bronze base.
Metropolitan Museum of Art, New York, Friedsam Collection, Bequest of Michael Friedsam, 1935 (32.100.183)

The model is nowhere recorded, but the bronze is a typical work by Antonio Susini of the very highest quality. Not only the general facture and patination, but the handling of the details and the chasing are entirely consistent with his signed bronzes. The integrally-cast shallow oval base appears in figurines from the Giambologna-Susini workshop of exceptional quality (*e.g.* Cat. 52, 53, 137, 138), and it seems that this feature might have been present in the silver figurines which were loaned to Antonio Susini to be copied in bronze (see Cat. 137). It is possible that this group is a copy of a lost silver. It does seem likely, however, that the original model was by Antonio Susini himself in view of striking similarities, particularly in the child figures, between this bronze and the statuette of the *Virgin and Child*, which is very probably from an original model by Susini (see Cat. 92).

FURTHER VERSIONS: Cat. 11; Victoria & Albert Museum, London (A.150–1910; poor, rough cast); Civico Museo Schifanoia, Ferrara (C.G.F. 8485, Varese, 1974, no. 132; poor, rough cast).
BIBLIOGRAPHY: W. Bode, *Collection of J. Pierpont Morgan: Bronzes of the Renaissance and Subsequent Periods*, Paris, 1910, II, no. 149.
PROVENANCE: J. Pierpont Morgan, London and New York; Michael Friedsam, bequeathed 1931.

A.R.

11
Venus and Cupid
h. 12.4
Bronze. Dull, light brown patina; on integrally-cast rectangular bronze base.
The Visitors of the Ashmolean Museum, Oxford (Fortnum 426)

The bronze is a good later version of Cat. 10. It was correctly classified by Charles Drury Fortnum himself as school of Giambologna (*A descriptive and illustrated catalogue of his collection of works of Antique, Renaissance and Modern art by C. Drury E. Fortnum*, II, *Bronzes*, 1897, no. 426 – *ms.* in Ashmolean Museum archive), but a marginal note in the manuscript catalogue records that Bode, on a visit to Oxford, later ascribed it to Giambologna.

FURTHER VERSIONS: see Cat. 10.
PROVENANCE: Charles Drury E. Fortnum (acquired 1867); bequeathed 1899.

A.R.

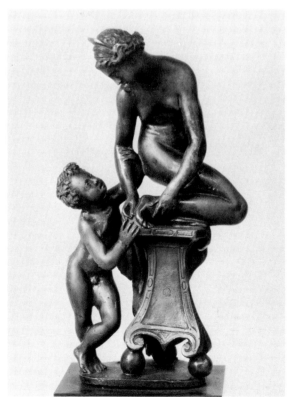

10

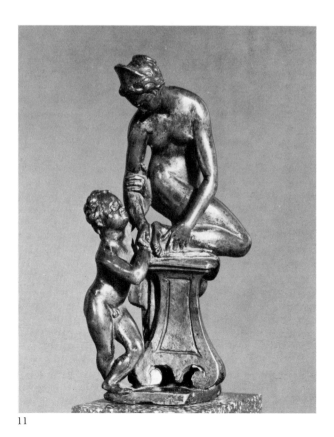

11

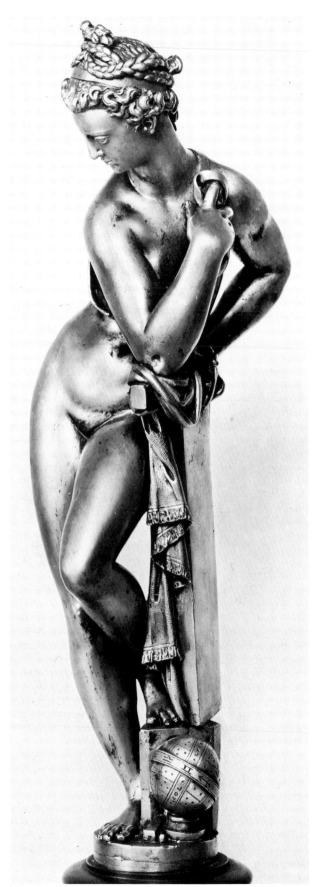

12

Astronomy or **Venus Urania**

*h.*38.8

Bronze, very thick wall; fire-gilt. Under the gilding,
especially at the back, are many traces of old fillings to
repair casting flaws.

Engraved on the girdle, running across her back: *GIO
BOLONGE*.

Kunsthistorisches Museum, Vienna, Sammlung für Plastik
und Kunstgewerbe (5893)

The young female figure stands on a small round base. Her
left foot rests on a prism with an armillary sphere leaning
against it; on this are engraved *VENNUS, LUNNA* and
SOL, signs of the Zodiac, stars and meridians. (All the *N*'s
and *S*'s are back to front). Other instruments, difficult to
identify, lie beside it, together with a round plummet.
With her left hand, which holds a ruler and compasses, the
goddess leans on a straight-edge supported by the prism;
on this again is a set-square wrapped in a drapery, on
which she rests her right elbow. In her right hand, raised
almost to the left shoulder, she holds a girdle that encircles
the upper part of her body and bears the artist's signature
at the back. Her long hair is plaited over her head and
secured by a fillet. She looks downwards and to her right.

The figure's sharply contorted attitude offers an
excellent view from any angle. It is thus a compositional
counterpart to the *Apollo* of the Studiolo (Cat. 36), the
movement of which it reproduces in mirror-image. Its
stylistic resemblance to that figure, which dates from
about 1573, suggests that it was executed about the same
time. Among Giambologna's female figures the closest to it
is the *Venus* in the Grotticella of the Boboli Gardens, but
the latter does not show the same perfect balance. The old
title '*Venus Urania*' in the Vienna *Schatzkammer* inventory
of 1750 is highly appropriate to the figure's appearance.
The extreme elegance of the composition, the refined
chiselling, as if by the goldsmith's art, and the resulting
sensual charm appear unequalled in Giambologna's work.
This also seems to be the reason for the gilding, which at
the same time covers over casting flaws. None of the many
replicas or copies in other materials comes anywhere near
the quality of this statuette.

BIBLIOGRAPHY: Planiscig 1924, p. 148, no. 250 (where previous literature
is cited); Dhanens 1956, pp. 184 ff., citing numerous replicas.
PROVENANCE: old Imperial property, but first clearly identifiable in the
Schatzkammer inventory, 1750.

M. L-J.

12

13
Fortune
h. 46.8
Bronze.
Engraved on base: *No. 68*
Musée du Louvre, Paris, Département des Objets d'Art
(OA 10598)

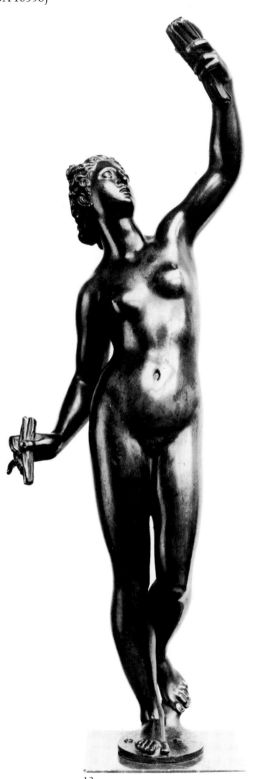

13

Giambologna's authorship of a model for a bronze statuette showing Fortune in the traditional guise of a nude woman holding up a sail – and Antonio Susini's and Pietro Tacca's involvement with casting examples of the composition – was demonstrated on the basis of documents by Watson and Avery (1973, pp. 502, 503). Their suggestion that the *Fortune* might have been conceived as a pair to Giambologna's *Mercury* (Cat. 33–5) has since been corroborated by the publication of an inventory of the collection of Benedetto Gondi in 1609, where the two models are in successive entries, and qualified as originals by Giambologna (Corti, 1976, p. 633). It is not at present clear whether Giambologna himself invented the composition from scratch, or refined a pre-existing one, for there are many confused strands of evidence which must be taken into account. A number of variants are known, some representing *Venus Marina* and not *Fortune*, for they have no sail, but hold a shell instead and walk directly on the waves; *e.g.* one in the National Museum of Wales, Cardiff (*h.* 46), formerly in the Camillo Castiglioni (Planiscig, 1923, no. 46) and Nettlefold collections (Forrer, 1934, pl. 17), on a fine, old octagonal base inlaid with tortoiseshell; and a terracotta (?) cast formerly in the Albin von Prybam collection, Munich and recently in the Von Hirsch collection (sale, Sotheby, 22 June, 1978, no. 385) *h.* 43. Other variants are in the Museo Nazionale, Bargello, Florence, and in the Kunsthistorisches Museum, Vienna (see Planiscig, 1921, pp. 411–15; 1924, no. 162; Weihrauch, 1967, pp. 142–5). Planiscig invented an attribution to Danese Cattaneo covering all bronzes of this general composition, but this is no longer tenable in most cases.

A drawing by Bandinelli of about 1529 for the base of a monument to Andrea Doria (Musée du Louvre, Cabinet des Dessins, no. 86) shows a sea-battle flanked by large figures of Fortune holding up a sail and standing on a wheel (D. Heikamp, 'In margine alla "Vita di Baccio Bandinelli" del Vasari', *Paragone*, 191, p. 55, fig. 38), which suggests that the composition was thought of in sculptural terms at least a generation before Giambologna. The reverse of Jacques Jongheling's medal of Anthonis van Stralen, struck in 1565, shows Fortune in a similar pose, balanced on a globe set on a shell, floating on the sea and propelled by a sail (J. Simonis, *L'art du médailleur en Belgique*, Brussels, 1900–04, II, p. 126, pl. X, 4). This shows that the design was current in the Netherlands early in Giambologna's career.

The present version, formerly in the French Crown Collections, was recently acquired by the Louvre and Jestaz (1978) persuasively suggests that it was cast and chased by Antonio Susini, probably during Giambologna's lifetime.

FURTHER VERSIONS: Cat. 14; formerly Salviati collection, Florence, 1609 (Watson and Avery, 1973, pp. 501–3); (on a ball) Girardon Collection (Charpentier, 1710); University Museum, Stanford, California (62.235).
PROVENANCE: King Louis XIV of France, by 1684 (Guiffrey, 1886, p. 36, no. 68: *'Une figure de femme debout, toutte nüe, qui tient de sa main gauche une maniere de linge qu'elle regarde, haulte de 17 pouces'*); French Crown Collections; Jacques de Chapeaurouge, Hamburg, 1796 (Verlet, 1957, p. 289); given by Paul Salmon, 1976.

C.A.

14
Fortune
h. 48
Bronze.
Metropolitan Museum of Art, New York, Gift of Ogden Mills, 1924 (24.212.5)

See Cat. 13, to which the present example is closely similar.

FURTHER VERSIONS: see Cat. 13.
PROVENANCE: Ogden Mills collection, 1924.

C.A.

15
Fortune
h. 54
Bronze.
Metropolitan Museum of Art, New York. Purchase, 1970, Edith Perry Chapman Fund (1970.57).

The composition is closely related to the Giambologna type, though it does not appear to have the facture normal in his workshop. In that Fortune here stands on a globe (either terrestrial or celestial?) the iconography of the statuette is a variant, but one that is perfectly legitimate, indeed, if anything, more correct: the changes of Fortune blown hither and thither with every gust of wind are made more acute and uncontrollable when so balanced. If in addition the globe is characterized as heaven or earth, as in the present case, Fortune's rule is shown as omnipotent. Alciati's *Emblemata*, Lyons, 1550, p. 107 (repro. Watson and Avery, 1973, fig. 15) shows the goddess stepping on to such a globe, beside the seashore. The globe also features in at least two other variant models of Fortune from quite different workshops (though both are currently still attributed unconvincingly to Danese Cattaneo): one in the Museo Nazionale, Bargello, Florence; and the other in the Kunsthistorisches Museum, Vienna (Planiscig, 1921, pp. 411–15; 1924, no. 162; Weihrauch, 1967, pp. 142–5, figs. 161–2).

C.A.

16
Fortune
h. 53.8
Bronze. Black lacquer.
Lent anonymously

Statuettes with the sail or veil of Fortune complete and billowing out above the head in the wind, as is iconographically normal, are less usual than those with it torn away and only the two ends still remaining in her hands. From a technical point of view it would be normal, as in the present instance, to cast the outlying component separately and join it near the hands to the main figure. However, none of the known examples without the sail shows any sign of ever having had one: the upper edge of the fragment of cloth in each hand is carefully worked, *e.g.* in Cat. 13, 14. Even so, it might be argued that this amount of detail could have been added by after-working of the two extremities where the sail should have been joined on. The probable existence of the present, complete, model during the lifetime of Giambologna may be inferred from the appearance of a closely similar motif in a painting by Spranger (1546–1611), of *circa* 1590, now in the Art Institute of Dayton, Ohio, (42.13: see *Fifty Treasures of The Dayton Art Institute, Ohio*, 1969, p. 76, no. 24) where, however, Fortune stands on a cartwheel, set horizontally. A bronze statuette recently on the London art market reflects the painting closely.

FURTHER VERSIONS: Uzielli collection, London, 1860 (J. C. Robinson, *Catalogue of the various works of art forming the collection of Matthew Uzielli*, London, 1860, no. 613: 'Venus. A standing statuette the left arm upraised, holding one end of a scarf or mantle, the other end of which is held in the right hand, and is supposed to be floating in the wind, forming an arch above the head of the figure. A highly-finished *cinque-cento* bronze. From the Collection of the Marquis della Gherardesca, Florence, 1859. Entire height about 18in.'
ADDITIONAL BIBLIOGRAPHY: University of Notre Dame Art Museum, *The Age of Vasari*, Notre Dame, Indiana, 1970, no. 510.
PROVENANCE: art market.

C.A.

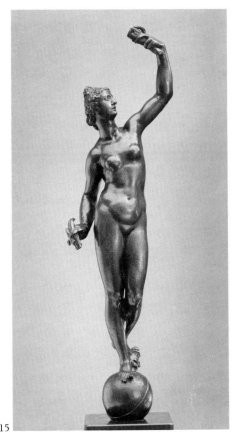

15

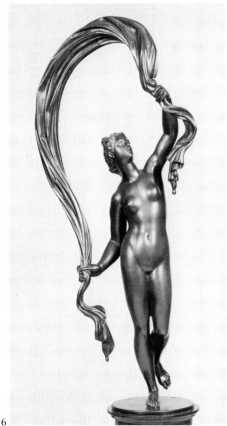

16

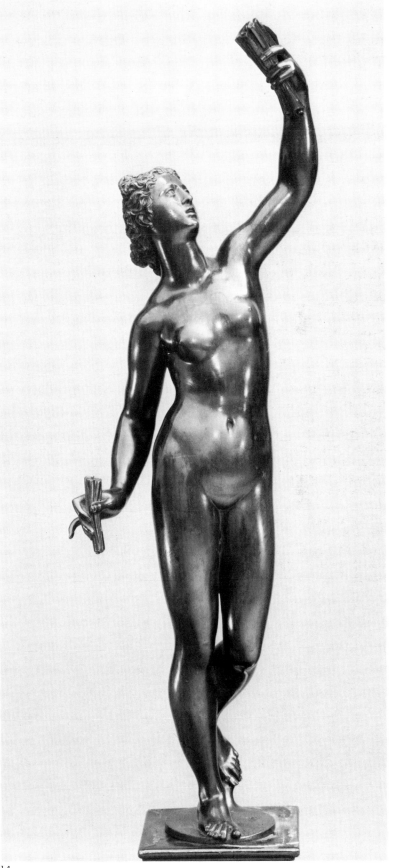

14

17

Architecture

h. 35.5

Bronze. Reddish, translucent lacquer, darkened in places and abraded on high points revealing bare metal.
Engraved on lower edge of drawing board:
GIO BOLONGE
Museum of Fine Arts, Boston, Massachusetts (40.23)

This is the best, and only signed, example of a widely divulgated model by Giambologna. The form of the signature is exactly the same as that on the *Astronomy* in Vienna (Cat. 12). The subject of *Architecture* (or *Geometry*, as it is sometimes called) is indicated by the set-square, protractor, and pair of dividers held in the right hand, as well as by the drawing-board supported on the ground behind by the fingers of the left hand: this corresponds with an item in the list of Markus Zeh in Augsburg (1611): '*Una donna a sedere che rappresenta l'architettura*' (Döring, 1894, p. 97; Dhanens, 1956, p. 74; this Catalogue Introduction, p. 44). There are no other documentary indications of the origins of the subject, though it may be noted that Giambologna was a practising architect and prided himself on the fact: he is recorded as such in the frame of Van Veen's engraved portrait of 1589 (Cat. 214), and he is shown holding the tools of the architect's as well as the sculptor's profession in two other portraits, Cat. 216 and Zuccaro's fresco on the cupola of Florence Cathedral (see Cat. 212 – the preparatory drawing, where he held only a sketch-model, which was ultimately changed into a set-square and mallet). Among his buildings, the town-palace and country villa, 'Il Riposo', for his patron Bernardo Vecchietti, his own house and studio in Borgo Pinti and his project for a façade for Florence Cathedral hold pride of place.

The seated pose and pensive expression, together with the sideways and downward glance, to some extent recall the *Architecture* carved by Giovanni Bandini for the tomb of Michelangelo in Santa Croce (paid for in 1568: Pope-Hennessy, 1968, pp. 132–5), and one wonders whether Giambologna was interested in or inspired by that commission (see Dhanens, 1956, p. 164). An unfinished, weathered and partially resurfaced marble statue close in composition to the signed bronze, first recorded in the Boboli Gardens in the 18th century without an attribution, is now in the Bargello (Dhanens, 1956, pp. 163–4). It has sometimes been linked with a reference in Borghini (1584, p. 587) to a marble statue showing a seated girl of about sixteen years of age, which was sent to the Duke of Bavaria, but which can no longer be located in Munich: there was never any overwhelming reason to identify this with the *Architecture* in the Bargello and a possible alternative candidate has recently come to light in a Swedish private collection, see Cat. 248. That the composition of the marble probably originates from Giambologna himself is demonstrated by the recent discovery of a wax sketch-model evidently by him, which seems to relate to it rather than to the type of bronze statuette under discussion (see Cat. 237). The present bronze and an example in the Louvre (see below), alone of all the known casts, share with

the marble statue an important detail which sets them apart as prototypes: the turned pendant which hangs from the rope-like necklace (perhaps to be thought of as an architect's plumb line) around the neck and which by its weight causes the lowest loop to form a 'V' shape, and not a smooth, catenary curve. It therefore appears that all the other casts in which the necklace forms a 'V' shape, but has no pendant to cause this, were produced from a slightly defective model or master-mould. The cross-piece of the set-square is also usually missing. It seems unlikely that this could have occurred under the master's direct supervision.

Apart from the version recorded in 1611 in the possession of Markus Zeh (see above) there are no other explicit references in the early Florentine inventories that have so far been published. However, a version is clearly recognizable in the hands of a man standing at the window in the painting showing the *Gallery of Cornelis van der Geest* by Willem van Haecht the Younger, dating from before 1620. A number of versions are recorded in France during the 17th century: one is in the inventory after decease of Cardinal de Richelieu in 1643 (Boislisle, 1881, p. 88, no. 66: '*Une figure d'une Géometrie de bronze, d'un pied ½ de haut, sur son pied de bois noirci, de même que dessus [i.e. 'fait par Messer Jean Boulogne et reparé du Soucine']*). This is almost certainly identical with one later recorded in the Girardon Collection (Charpentier, 1710, pl. VI, no. 3): '*Vénus et la Géometrie figures de bronze de Jean de Boulogne reparées par A. Soucine*' (Souchal, 1973, pp. 37, 38). Charpentier's plate shows the figure complete with pendant and top of set-square. This may be identical with an example now in the Louvre (Legs Gatteaux, 1881, *h.* 35, Migeon, 1904, no. 148), which has these assets too.

Furthermore, there were no fewer than three examples in the collection of Louis XIV, as noted by Landais, 1961, p. 141: Guiffrey, p. 32, 1886, no. 8 (with description but without specific title); Guiffrey, 1886, p. 36, no. 65 (called *Architecture*); Guiffrey, 1886, p. 36, no. 66. Of these, nos. 8 and 66, which are not of outstanding quality, are in the Trianon at Versailles, while no. 65 has disappeared. There is a further, defective cast in the Louvre, from the Crown Collection, inventory of 1707, p. 883 (Migeon, 1904, no. 149, *h.* 35).

The importance of the references in the Richelieu and Girardon inventories is that they describe the status of the bronze in question precisely as 'made by Mr Giambologna and repaired (*i.e.* piece-moulded and cast) by Antonio Susini'.

FURTHER VERSIONS: too frequent to enumerate, but see Dhanens, 1956, p. 165, n. 2 and Wixom, 1975, no. 150.
ADDITIONAL BIBLIOGRAPHY: E. J. Hipkiss, '*Architecture* by Gian Bologna', *Bulletin of the Museum of Fine Arts*, Boston, Mass., XXXVIII, 1940, pp. 38, 39; Weihrauch, 'Giovanni Bologna: die "Architektur"'; *Die Kunst und das schöne Heim*, 8, 1958, pp. 292–5; Weihrauch/Volk, 1974, no. 15.
PROVENANCE: Knoedler (?); Seligman, Rey & Co., Inc. (1938); Clendening J. Ryan sale, New York, 1940.

C.A./A.R.

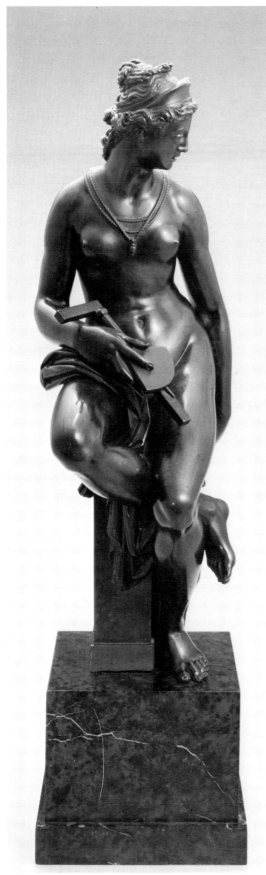

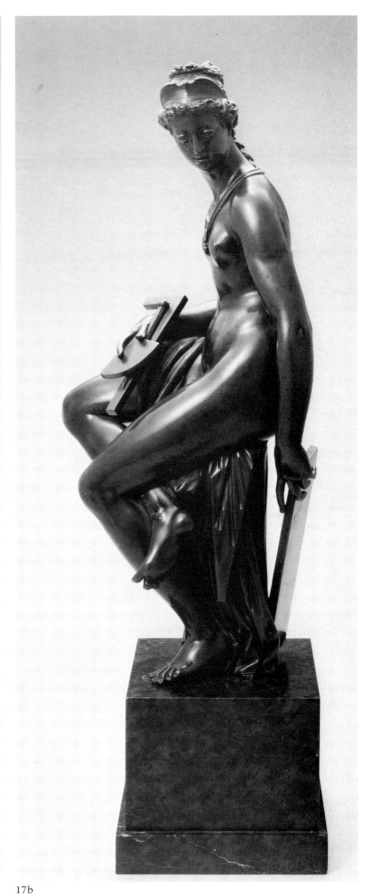

17a 17b

18
Flora (Spring)
*h.*31.8
Bronze. Red-brown lacquer.
Sir Leon Bagrit, London

The only other known version of the model, in the Grünes
Gewölbe, Dresden, (IX.99), was ascribed by Kriegbaum
(1931, pp. 237–8) to Hans Reichle ('Anzirevelle Tedesco'),
who worked with Giambologna from 1588 to 1594 and
again in 1601. The ascription is followed by Raumschüssel
(1963, p. 213, no. B37), who remarks that the model reflects
the *Architecture* of Giambologna (Cat. 17), and by Weihr-
auch (1967, p. 334). The present version is classified as
school of Giambologna by Forrer (1934, p. 47, pl. 11) and as
attributed to Giambologna by Hackenbroch (1959, p. 215),
who relates it to Giambologna's allegorical female nudes.
Kriegbaum and Forrer identify the subject as *Ceres*,
Hackenbroch, Raumschüssel and Weihrauch as *Spring*.
The latter view is undoubtedly correct, since the quadrant
on the base bears in relief the zodiacal signs of spring,
Aries, Taurus and Gemini, while at the back of the pedestal
is the head of the infant Zephyr, and the figure holds a
spray of flowers. The bronze is typically Florentine in
facture, closely related in handling to Antonio Susini and
in style to Giambologna.

PROVENANCE: General Buller (1884); James Gurney (sale Christie, London,
8–12 March, 1898, no. 558); Sir John Ramsden, Bart. (sale Christie,
London, 23 May, 1932, no. 17); F. J. Nettlefold.

A.R.

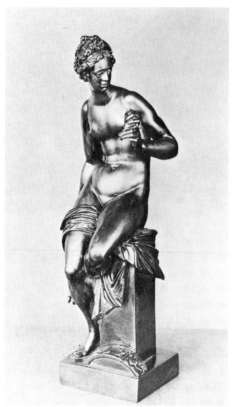

18

19
Woman bathing, kneeling
h. 25.3
Bronze
Engraved on the bracelet: *I.B.F.*
Museo Nazionale, Bargello, Florence (62)

The statuette was first described in a 1584 inventory of the
Villa Medici, the Roman residence of Cardinal Ferdinando
de' Medici, later the third Grand Duke of Tuscany
(1587–1609), as '*una femina che sta con un ginocchio in terra,
una mano alla testa e l'altra alla poppa manca, con panno
sotto piè . . .*' (Dhanens, 1956, p. 142). In 1589 such a
'*figurina di bronzo chinata . . . di mano di Gian Bologna*' was
exhibited in the *Tribuna* of the Uffizi along with the
choicest works of art owned by the ruling house (Arch
Sopr. Gallerie, Florence, Ms. 70, fol. 20). It is possible that
in both instances it is our signed example which is
recorded, for Ferdinando could have brought it with him
when he returned to Florence in 1587, but it is equally
possible that two separate statuettes have been listed. In
the latter case, the example in the Huntington Collection,
San Marino (R. R. Wark, *Sculpture in the Huntington
Collection*, Los Angeles, 1959, p. 63), which unlike any
other replica corresponds with our example in all details,
could be the second, unsigned but nonetheless autograph
bronze.

 The early dating of the work to the mid 1560s (Gram-
berg, 1936, pp. 59–60, 139, '*circa* 1564'; and Dhanens,
1956, pp. 142–3, '*circa* 1565') is based on the consideration
that here Giambologna has come to terms with the antique
theme of the crouching *Venus* for the third and last time.
Unlike the earlier versions – the alabaster (Cat. 23) and the
small bronze (Cat. 21) – he proceeded according to com-
positional principles that he first observed in the first half
of the 1560s, principles that were aimed at representing
figures in complex movements, concentrating solely upon
themselves, and absorbed in their own activities. In the
context of these compositions so highly characteristic of
Giambologna's art – namely, the Cortesi *Bacchus* (*circa*
1559–60), the *Fishing boys* (*circa* 1560–62), the *Samson and
Philistine* group (*circa* 1562–63), the flying *Mercury* (*circa*
1564–65, see Cat. 33–5), or the standing *Woman bathing*
(*circa* 1564–65, see Cat. 1) – the present statuette can be
placed *circa* 1565–66, as clearly the last of the series, since
she, owing to the enlarged volumes of her body and the
summary modelling of the individual forms, is already to
be associated with the works of the subsequent period.

FURTHER VERSIONS: Cat. 20; Vaduz, the Prince of Liechtenstein collection (since 1658); Berlin, Staatliche Museen, Skulpturenabteilung (M.V.72); Brussels, Kon. Museum voor Kunst en Geschiedenis; Florence, Museo Horne, terracotta, damaged, (101); Florence, Corsini Collection; Florence, Dr R. Ergas collection, terracotta (sale Helbing, Munich, 1931, no. 94); Frankfurt, Liebieghaus, St.P. 130; Frankfurt, Wilhelm Henrich, 1955; Paris, Musée du Louvre, (396); Providence, R.I., Rhode Island School of Design, Museum (69.210); San Marino, California, Huntington Art Collection.

ADDITIONAL BIBLIOGRAPHY: Bode, 1930, p. 34; Squilbeck, 1944, p. 4; F. Rossi, *Il Museo Horne a Firenze*, Milan, 1966, p. 154; A. Legner, *Kleinplastik der Gotik und Renaissance aus dem Liebieghaus*, Frankfurt, 1967, no. 43; Pope-Hennessy, II, 1964, pp. 476–7; Landais, 1958, pp. 69–70; Bregenz, 1967, pp. 27–8; Weihrauch, 1967, pp. 208–10; Watson and Avery, 1973, p. 504, Appendix I, no. 1082.

PROVENANCE: Galleria degli Uffizi, Florence, former Medici property.

H.K.

20
Woman bathing, kneeling
*h.*24.9
Bronze, light brown lacquer.
Engraved on back under left shoulder: *No. 35.*
Holburne of Menstrie Museum, University of Bath, Bath (C.904)

A version of Cat.19. The engraved number is that of the French Crown Collection, and the bronze is listed under No. 35 in the inventory of the *Mobilier de la Couronne* of 1684 (Guiffrey, 1886, p. 34). A version of this model described as being by Susini from a model by Giambologna was in the collection of Cardinal de Richelieu at his death in 1642, and this is possibly identical with a version described as being by Antonio Susini after Giambologna in the collection of François Girardon in 1710 (Charpentier, 1710). Cat.20 has the appearance of a bronze by Antonio Susini.

FURTHER VERSIONS: see Cat. 19.
ADDITIONAL BIBLIOGRAPHY: W. Chaffers, *Catalogue of the Holburne of Menstrie Museum*, Bath, 1887, no. 545. See Cat. 19.
PROVENANCE: King Louis XIV of France (by 1684); Kings Louis XV, XVI of France; Sir Thomas William Holburne of Menstrie, Bart. (d. 1874); bequeathed by Mary Holburne to the city of Bath, 1882.

A.R.

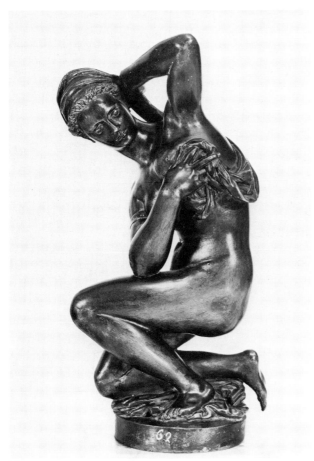

19

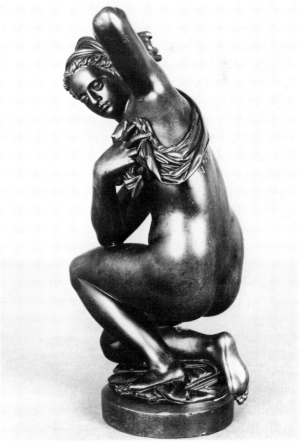

20

21

Woman bathing, kneeling and looking up
h. 9.5
Bronze.
Museo Nazionale, Bargello, Florence (69)

Like the small *Woman bathing* or the small *Apollo* (Cat. 6 and 37–9), this statuette, undocumented as to date or commission, may be considered a bronze cast of a *bozzetto* that Giambologna added to his collection of models as early as the 1550s.

The early date of the work is suggested by the composition in which Giambologna comes to terms with the *Venus Anadyomene* of Doidalses. He derived the motif of the crouching female figure from this ancient statue, which he had encountered in Rome before 1555–56 in two fragmentary examples, one in the Palazzo Madama and the other in the collection of Cardinal Cesi. Departing from this ancient model, he restored the work as an animated and moving figure: through her turned-back head, her up-turned glance, and her protectively raised left arm, her action is clearly directed towards a non-existent companion piece.

Previously the statuette has been identified either as Susanna or as Venus (or rather a nymph), owing to the assumption that the counterpart of the young woman was either the old judges (Daniel, 13) or a satyr. We may infer from Adrian de Vries's bronze group of a *Nymph and faun* (Dresden, Skulpturensammlung) that instead of Susanna (we know no free-standing group of 'Susanna and the Elders'!) a nymph surprised at her bath is intended. Here de Vries has modified his teacher's composition only slightly (Larsson, 1967, p. 13, fig. 7). Rubens, too, in his painting, *Nymphs and satyrs* (Madrid, Prado) has in a similar fashion given a new interpretation to the *Venus of Doidalses* in one of his satyr-surprised nymphs (M. Winner, *Zeichner sehen die Antike*, Berlin, 1967, pp. 106–8).

A dating of the individual bronze casts known at present is hardly possible, although we may suppose that Giambologna made, or supervised the making of, this version, as well as the examples in the Galleria Colonna in Rome (attached to a cabinet around 1680, in any event presumably once in the possession of the Salviati family), and in the Skulpturensammlung in Dresden (from the possession of Giovanni Maria Nosseni, who most likely had received the bronze in Florence directly from Giambologna in 1589).

For Dhanens's conjecture (1956, pp. 124–5) that the statuette might have been designed in the 1560s to decorate a cabinet see Cat. 6.

FURTHER VERSIONS: Cat. 22; Berlin, Staatliche Museen, Skulpturen-abteilung (K.F.M.V. 46); Berlin, formerly E. Simon collection (sale, Cassirer and Helbing, October 10–11, 1929, no. 58); Braunschweig, Herzog Anton Ulrich-Museum (Bro. 92); Douai, Musée de Douai (883); Dresden, Skulpturensammlung; Copenhagen, Statens Museum for Kunst (Dep. 24; formerly Berlin, R. Ph. Goldschmidt collection); London, Peel and Humphris Ltd., cat. 1963; Rome, Galleria Corsini, cat. 1937 (cabinet).
ADDITIONAL BIBLIOGRAPHY: Bode, 1930, p. 34; Holzhausen, 1933, pp. 62, 77–81, 87; Weihrauch, 1967, p. 210.
PROVENANCE: Galleria degli Uffizi, Florence, former Medici property.

H.K.

22

Woman bathing, kneeling and looking up
h. 9.3
Bronze. Black patina, rubbed in places; the bronze much flawed and left in the rough; mounted on a modern green marble socle inscribed *Modello di Giovan Bologna*.
John Hewett

As the inscription on the modern socle implies, the bronze was traditionally supposed to be an original bronze model by Giambologna for his small kneeling bathing woman (Cat. 21). This was no doubt suggested by its flawed and unfinished condition. It is in fact a failed cast of the model, too flawed to be worth finishing, and as such is a rare sur-vival, providing valuable evidence of casting practice in the workshop. One iron core pin is still clearly visible at the front of the right shoulder, others, less distinct, survive in each thigh, while others have fallen out leaving clearly-defined holes. The stump of a runner or a riser is visible below the left breast, another has been partially filed off from the back of the head, and the runner connecting the fingers of the left hand is still in position. In this state the bronze gives an indication of the after-work necessary to achieve the finish of Cat. 21.

FURTHER VERSIONS: another unfinished version, with core pins analogously placed, somewhat less flawed, on which finishing work has been begun and abandoned, Lord Methuen collection, Corsham Court, Wiltshire.

A.R.

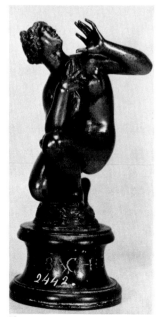

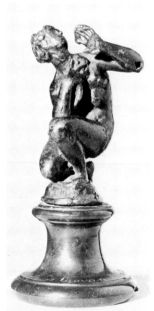

21 22

23
Woman kneeling and wringing out her hair
*h.*74 (approx.)
Alabaster. The tress of hair and left knee repaired in a more translucent alabaster. Flaws and cracks elsewhere. Hair weathered by water. Possible re-cutting in places.
Sir William Pennington-Ramsden, Bart.

The statue was regarded by Dhanens (1956, p. 105) as an early work by Giambologna, related to the bronze statuettes of *Women kneeling and bathing* (Cat. 19, 21). Not having seen the original, which had been lost to scholarship from 1913 until 1977 when it was noticed by Avery at Muncaster Castle, she was following Gramberg (1936, pp. 56–60) who identified it with the early marble *Venus* carved for Vecchietti (Borghini, 1584, p. 586). Its presumed provenance from the collection of M. Foresi in Florence was adduced as corroboratory evidence of its possible origin from Vecchietti's collection.

W. R. Valentiner (1913) seems to have been the first to associate the statue with Giambologna, in his catalogue of the Lydig Collection. While the statue manifests the style of Giambologna, the date of its production remains in doubt. The identification with Vecchietti's *Venus*, the whole point of which was to demonstrate that the young sculptor could carve marble as well as he could make models, may be ruled out on the grounds of medium, for alabaster, being far softer than marble and easier to carve, would not have proved the point. The condition of the sculpture, which is weathered, severely broken, and possibly re-cut, makes assessment difficult.

ADDITIONAL BIBLIOGRAPHY: M. Foresi, 'Ville Medicee: Castello, Petraia e Pratolino', *La Rassegna Nazionale*, CLXIV (1908), pp. 386–96; W. R. Valentiner, *The Rita Lydig Collection*, New York, 1913, p. 22, no. 16; J. A. Brooks, *Muncaster Castle* (guide book), Norwich (1976), repro.
PROVENANCE: (?) Bernardo Vecchietti, Florence; (?) M. Foresi, Florence; Charles Loeser, Florence; Rita Lydig, New York (sold American Art Association, New York, 4 April, 1913, no. 32).

C.A.

24
Woman reclining and holding a ring
*h.*18 *l.*33 *d.*10
Bronze.
Lord Clark

This bronze and its pair (Cat. 25), which are unique casts, were published by Dhanens (1956) pp. 188–9, without a reproduction, as being related to the models of a *Woman reclining and writing* (Cat. 26–8; 241) and the *Sleeping nymph with satyr* (Cat. 69–72).

They appear to have reclined on the sloping surfaces of a pediment, probably above a cabinet. The combination of the devices which they hold, a diamond ring and a caltrop, point the way to an identification of their original patron or owner. Whether the diamond ring is to be associated with the Medici is uncertain. The Italian word for caltrop is *'tribolo'*, but no such device is recorded in the standard Italian literature on *'imprese'*.

One figure, that holding a ring, seems to reflect a model by a superior hand, possibly Giambologna.

The other, holding a caltrop, is distinctly weaker, and was perhaps modelled by an assistant such as Antonio Susini to make a pair.

C.A.

25
Woman reclining and holding a caltrop
*h.*19 *l.*34 *d.*13
Bronze.
Lord Clark

See Catalogue number 24.

C.A.

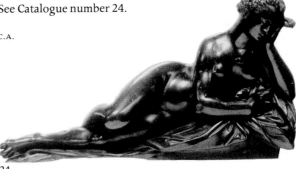
24

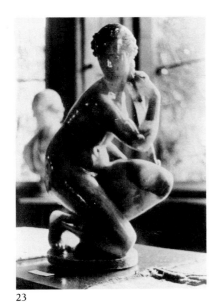
23

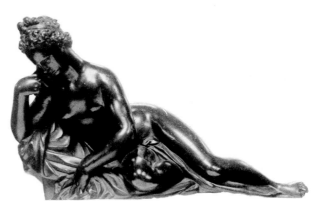
25

26

Woman reclining and writing ('Geometry and astrology')

*h.*8.5

Alabaster, traces of cement on the hands.
Inscribed on rim of base in front: *GEOMETRIA. ET. ASTROLOGIA*; at the back: *M.D.L.XIX.*
Kunsthistorisches Museum, Sammlung für Plastik und Kunstgewerbe, Vienna (4430)

A naked female figure reclines on an oval base covered by a cloth. The upper part of her body rests on a celestial globe. Beside the globe is a book, and on it are two more books; she writes in the upper book with a pen, holding an ink-well in her left hand. At her feet are an extinguished torch and a female mask with a snake crawling through its eye-sockets.

This small alabaster statuette is related, with minor differences, such as the position of the head, to the bronze figures of a reclining woman sometimes entitled, probably wrongly, *'Historia'* (Cat. 27–8), which are based on a model by Giambologna or his shop (Cat. 243). The inscribed title is more suitable, in view of the attributes. The statuette may be a contemporary version of the Giambologna model by a 'Little Master', probably of Flemish or northern French origin, such as Willem van den Broeck (alias 'Guglielmus Paludanus'), in which case its dating would provide an important *terminus ante quem* for the model. Tietze-Conrat connects it with a red chalk drawing by Pontormo in the Biblioteca Marucelliana in Florence, and believes that Giambologna may have taken as his model a terracotta *bozzetto*, also by Pontormo, which formed the basis for the drawing.

ADDITIONAL BIBLIOGRAPHY: Schlosser, 1910, p. 20 (wrongly numbered as 3), pl. LII, no. 4 (as a German work from the entourage of Rudolph II); Tietze-Conrat 1929/30, pp. 165 ff.
PROVENANCE: probably from the collection of Archduke Ferdinand II, but first identifiable with certainty in the Ambras inventory of 1621: brought to Museum 1821.

M. L-J.

27

Woman reclining and writing

*h.*20.5 *l.*35.5

Bronze. A heavy, rough cast with many flaws and pittings on the surface. Some areas well-chiselled, *e.g.* the face and hair; the mask with a snake; the geometrical instruments.
Boymans van Beuningen Museum, Rotterdam (1151)

This statuette and a similar one in Baltimore (Cat. 28) are casts which seem to derive from the terracotta model in the Victoria & Albert Museum (Cat. 243), Dhanens (1956, p. 188) denies Giambologna's authorship on the grounds that the composition is exaggerated, and does not discuss further candidates. Neither bronze has the facture characteristic of Giambologna or Susini and in technical terms both are what is traditionally termed 'northern casts'. The subject, dating and source of the model are discussed in Cat. 26, 243. When in the Hainauer collection the present bronze was described as 'near Michelangelo' (W. v. Bode, *Die Sammlung Oskar Hainauer*, Berlin, 1897, p. 75, no. 94, repro. p. 21). Subsequently Bode (1912, p. 4, pl. CXCV) gave it to Giambologna: 'More attractive and of great vitality is the recumbent female figure – the "Allegory of History" – evidently an original...'. This was accepted by E. Tietze-Conrat (1918, pp. 62–6, fig. 57). Variations of the motif recur in miniature on the lid of an inkstand in the Victoria & Albert Museum (M.682–1910); and in a statuette in Berlin (Goldschmidt, 1914, p. 34, no. 157, pl. 45: as 'style of Giambologna').

FURTHER VERSION: Cat. 28.

ADDITIONAL BIBLIOGRAPHY: Museum Boymans van Beuningen, *Kunst-schatten*, Rotterdam, 1955, no. 235.
PROVENANCE: F. Spitzer, sold before the auction sale of 1893 to O. Hainauer; Pierpont Morgan; F. Schuster; Frederiks (sold to Museum 1959).

C.A.

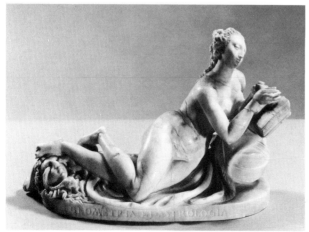

26

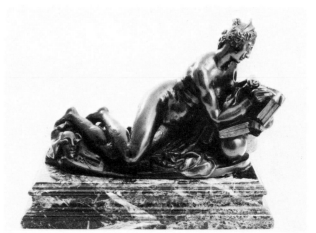

27

28
Woman reclining and writing
h.19.1 *l*.31.4
Bronze. Copper-coloured, black lacquer.
Walters Art Gallery, Baltimore, Maryland (54.214)

The statuette is related to the example now in Rotterdam, which has been extensively discussed and published (see Cat. 27). A full bibliography was given in: Smith College Museum of Art, *Renaissance Bronzes in American Collections*, 1964, no. 27, where the present bronze was described as 'Roman, mid-16th century' and entitled *Music and Melancholy* (P. Verdier, on the basis of: Günther Bandmann, *Melancholie und Musik*, Cologne and Opladen, 1960).

FURTHER VERSION: Cat. 27.
ADDITIONAL BIBLIOGRAPHY: Columbus Gallery of Fine Arts, *The Renaissance Image of Man and the World*, 1961, no. 52.
PROVENANCE: Daguerre, Paris, 1930.

C.A.

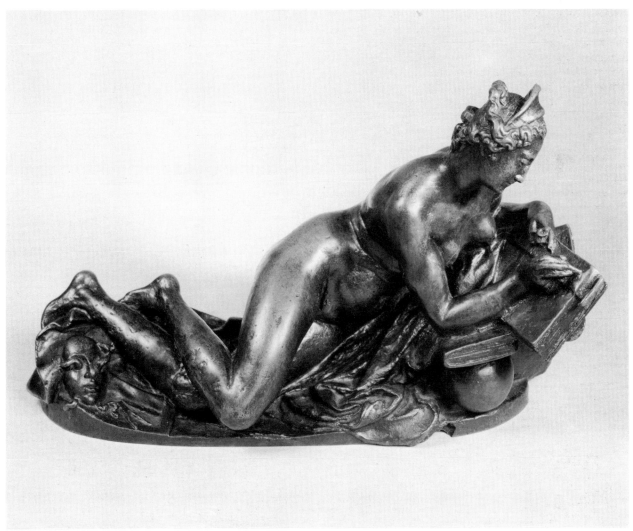

28

† 29
Florence (La Fiorenza)
*h.*125
Bronze
Villa Petraia, Florence. Soprintendenza ai Monumenti per le Provincie di Firenze

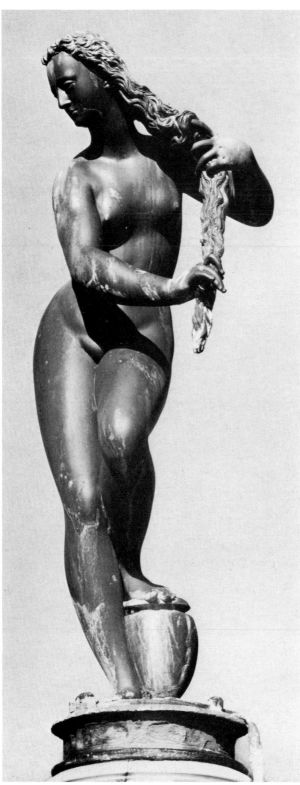

29

The *Fiorenza*, a young woman who wrings water from her hair, crowns the candelabrum fountain designed by Niccolò Tribolo (1500–50), transferred around 1785 from its original location in the garden of the Villa Castello to that of the neighbouring Villa Petraia (F. Chiostri, *La Petraia, Villa e Giardino*, Florence 1972, pp. 50–1). Although the fountain was only half-finished when Tribolo died, Vasari reports that he had projected a statue of *Fiorenza* from whose hair water flowed in order to express that Florence, situated at the confluence of the Arno and the Mugnone and favoured by an abundant water supply, was an ever flourishing community (Vasari, 1568, ed. Milanesi, VI, 1881, p. 79).

We do not know to what extent Giambologna was guided by Niccolò's model in the composition of the *Fiorenza*. Nonetheless, stylistically it represents without doubt his own personal, authentic work, even in the absence of any contemporary documentation. The statue was first reported by Baldinucci (Ranalli, II, p. 568) in a brief and inexact account: *'(Giovanni) gettò di poi a Firenze una femina in atto di pettinarsi le chiome'* (sic). Wiles (1933, p. 27), Gramberg (1936, p. 55–6), Dhanens (1956, pp. 105–6), and Pope-Hennessy (IV, 1970, p. 380) all place the statue in the years around 1560–62, but sound reasons speak against so early a date.

The finishing of the decoration of the rear area of the Castello garden, in particular the grotto and our fountain, did not take place until after 1567. Giambologna is demonstrably active at the garden from this year, when for the grotto he made models for large bronze birds (Cat. 185). But he must have made the *Fiorenza* only around 1570–71, because Hans von Aachen portrayed him at that time in his workshop with the casting model for the *Fiorenza* and with the model of the *Oceanus*, certainly finished in 1571 – undoubtedly his two most recently finished designs (Cat. 216).

Finally, the personification *Fiorenza* fits easily with Giambologna's works created between 1565–66 and 1571–73, that is, with a group of other allegorical figures whose compositions were established without exception according to the same basic scheme – the *Florence triumphant over Pisa* group (1565–72, Cat. 224), the *Architecture* (1570–72, Cat. 17), or the *Astronomy* (1571–73, Cat. 12). He rendered visible the abstract character of all these personifications of ideas through an accentuated generalization of the forms and a blandness in the expression.

(The composition is indebted to an engraving dated 1506 by Marcantonio Raimondi [Bartsch, XIV, 312] and the motif of wringing out the hair recalls Pliny's description of a painting by Apelles [*Hist. Nat.*, XXXV, 79] c.a.)

FURTHER VERSIONS: Douai, Musée de Douai (852, plaster cast); Los Angeles, Los Angeles County Museum (A 5141.51–19, bronze copy of the 19th century?).
ADDITIONAL BIBLIOGRAPHY: Venturi, X, 3, 1937, pp. 704–9; Leroy, 1937, p. 126; W. R. Valentiner, *Gothic and Renaissance Sculptures in the Collection of the Los Angeles County Museum* (Los Angeles), 1951, p. 164.
PROVENANCE: Villa Castello, Florence.

H.K.

30
Minerva
h.16
Bronze. Raw, brassy metal.
Museo Nazionale, Bargello, Florence (420)

This figurine appears to be a unique cast, and though on display in the Bargello has not hitherto attracted attention. However, the facial type and handling of drapery are characteristic of Giambologna's circle.

It may be associable with documentary references of 1577–78 cited by Dhanens (1956, p.186), which refer to casting certain female figures in silver. These have not survived, but the description of one might be applied to the present bronze: 1577 August 12: '*Giovanni Bologna riceve come sopra (una quantita di argento) per gettare due figurine, rappresentanti due donne, una nuda col bastone in mano, e l'altra vestita*' (Desjardins, 1883, p. 140). 1578 July 3: '*. . . un altra figurina staccata dispersa con uno squdo in mano et uno bastone*' (Florence, Archivio di Stato, Guardaroba Reg. 98, fol. 146–7; *c.f.* Churchill [1913–14], p. 349).

Dhanens remarks of the first reference that a *clothed* female figure is a rarity in Giambologna's oeuvre. It is interesting to note that her nude counterpart held a staff (*bastone*), as did the figurine in the second document. While the latter is not specified as clothed, she held the same attributes as does the present figurine, a staff and shield.

C.A.

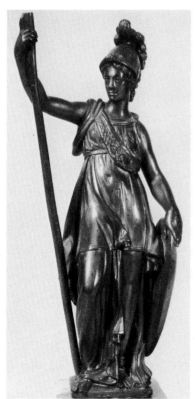

30

31
Neptune
h.78.6
Bronze. Warm gold brown patina; filed on torso and front part of arms and legs; not worked up on backs of legs or in detailed sections; many iron core pins still visible; upper part of trident, originally cast separately, now missing.
Museo Civico, Bologna (1503)

Giambologna's model for the twice life-size *Neptune* of the fountain in the Piazza Maggiore in Bologna (1563–67) has survived in the form of this bronze. The sculptor began preparing the clay model for the statue 28 September, 1563 (Gramberg, 1936, p. 96, Reg. XVII), and the bronze version was presented to Pope Pius IV, sovereign of Bologna, for approval in Rome during May, 1564 (Dhanens, 1956, pp. 121–2) and must have been made in the winter of 1563–64.

With his *Neptune* the young master evidently wanted to measure himself against Michelangelo, as well as Bandinelli and Ammannati, and at the same time to outdo them. *Neptune's* head, with its waving beard and its expression of commanding might, directly recalls that of Michelangelo's *Moses*, while the powerfully formed musculature of the torso, arms, and legs – an example, as it were, of the perfect anatomical development of an athletic body – is reminiscent of Bandinelli's *Hercules and Cacus* or Ammannati's *Neptune*, both on the Piazza della Signoria in Florence.

Unlike the work of the older masters, Giambologna's *Neptune* stands in freer movement and with a more natural, living animation. By placing the right foot drawn back high up on the dolphin, the sculptor gave his *Neptune* such an extreme *contrapposto* that the statue maintains itself upright only through a correspondingly energetic counter-movement, by the extreme turning of the upper part of the body, by his right hand that reaches backwards and grasps the staff of the trident, and by the far outstretched left hand. In this balancing stance, with his forward gaze and his beard blown backward, Neptune is represented as the king of the seas, shown as if he were sailing across the waters.

The statuette of *Neptune* (*h*.115) in the Nationalmuseum in Stockholm (Cat. 32) should be considered a variant of this model, made after 1600. The imitator constructed his figure by reversing the *contrapposto*. He also changed the position of the left arm, and, above all, transformed the base into a rippling water surface from which a wind-god materializes. Contrary to Gramberg's assumption (1936, pp. 33–6), this bronze has no place in the history of the Bologna fountain (nor in that of the Florence fountain competition of 1560).

FURTHER VERSIONS: Puerto Rico, Museo de Arte de Ponce (*h*.79, later cast after our model); sale Christie, London, 10 June, 1931 (*h*.17.8, bronze reduction of the executed colossal statue); Consul Joseph Smith collection, Venice (1682–1770), (Gori, II, 1767, engraved p. 22).
ADDITIONAL BIBLIOGRAPHY: P. Ducati, *Guida del Museo Civico*, Bologna, 1923, pp. 202–3; Nationalmusei Skulptursamling, Cat. Stockholm, 1929, p. 12; Wiles, 1933, pp. 54–7; Pope-Hennessy, 1964, II, pp. 465–7; Weihrauch, 1967, p. 199.

H.K.

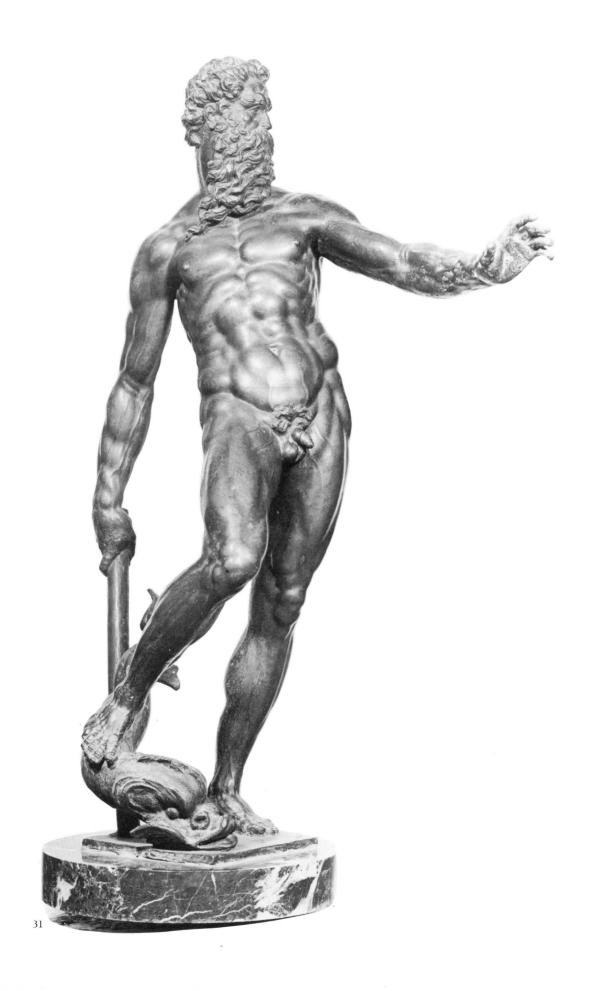

31

32

Neptune with putto's head

*h.*115

Bronze. Black lacquer. Two fingers of left hand broken.
Nationalmuseum, Stockholm (SK.351)

This bronze statue, ignored by Dhanens (1956, pp. 95f.,
111f.), is clearly connected with one of the projects for a
Fountain of Neptune with which Giambologna was in-
volved early in his career (Florence, 1560; Bologna, 1563–
66). Pope-Hennessy (1964, p. 466) noted the relationship in
pose with the clay model of *Neptune* in the Victoria &
Albert Museum (Cat. 222). The muscular type of body, the
head with a flowing beard, and the movements of the arms
also correspond broadly with the smaller bronze version in
Bologna (Cat. 31). The position of the legs is different,
however, and a *putto's* head is substituted for the standard
dolphin. Cat. 32 has evolved from a simple *contrapposto*
figure into a fully developed *figura serpentinata*. The large
and small bronze versions of *Neptune* in Bologna have more
'open' compositions. Cat. 32 may reflect a contemporary,
alternative solution to the problems of design presented by
a free-standing, central figure to crown a fountain. Its
actual casting and finishing are in no sense 'autograph',
and one of Giambologna's assistants, possibly working
from a small sketch-model by him, was probably respon-
sible. An attribution to De Vries in the old Swedish inven-
tories (Granberg, 1930, pp. 99, 102, 243) may be ruled out,
but the name of Francavilla, introduced by Gramberg
(1936, p.35, n. 17) and supported by Weihrauch (1967, p.
506, n. 246) may be retained, pending comparisons to be
made in the present exhibition.

ADDITIONAL BIBLIOGRAPHY: Nationalmuseum, *Peintures et sculptures des
écoles étrangères*, Stockholm, 1958, p. 250, no. 351.

PROVENANCE:Swedish Royal Collection, at Drottningholm about 1715–19;
Carl Gustaf Tessin, 1770; Swedish Royal Collection, 1861, no. 175.

L.O.I/C.A.

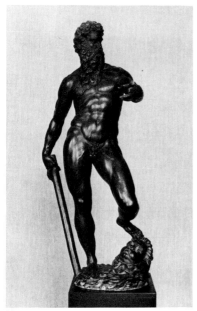

32

33

Mercury

*h.*55.5 (vertical)

*h.*56.2 (from lowest point to tip of raised finger)

Bronze. Black lacquer, rubbed to reveal dark naturally
patinated metal; unchased, barely cleaned cast; many iron
core-pins still remaining in place; many unfilled holes
where other core-pins have fallen out; the handle of the
caduceus is not drilled and it appears that the shaft of the
caduceus was never added; the index finger appears to
have always been crooked as now, and not bent later; the
original, integrally-cast fixing pin, now broken off, was on
the ball of the foot; the present iron fixing pin set in the
instep is out of true, and throws the figure too far back.
Museo Civico, Bologna

This statuette records in bronze Giambologna's first design
for a *Mercury*. He received the commission for the work in
the second half of 1564, during the time when Cosimo I and
Maximilian II were negotiating the marriage of Francesco I,
heir to the Tuscan throne, to Joanna of Austria, the
Emperor's sister. Prior to the conclusion of the marriage
contract in January 1565, Cosimo sent the Emperor, among
other gifts, three works by Giambologna, a relief, a
statuette, and a flying *Mercury*, the last being as large as a
fifteen-year-old youth (Borghini, 1584, p. 587). This gift
represented a quite intentional choice, for it contained a
personal reference to Maximilian. Indeed, the Emperor
apparently considered the messenger of the gods to be his
antique prototype, venerating him as his mythical
protector. On the reverse of a medal that Leone Leoni
struck for him around 1551, Maximilian caused to be
shown, as his *impresa*, a Mercury who flies over the
clouds, along with the motto, *'Quo me fata vocant'* (G.
Habich, *Die Medaillen der italienischen Renaissance*,
Stuttgart-Berlin, 1922, p. 132, pl. XCI, 3).

Doubtless Giambologna knew this medal reverse at the
time he composed our model, or it must have been
expressly shown to him, for it is remarkable just how
faithfully he has translated the relief image into three
dimensions. From it he derived the general conception of a
figure moving in extreme *contrapposto*, specifically a figure
on tiptoe who supports himself on his left leg alone, his
right leg flung far back, his right arm lifted, with its bent,
upward pointing finger, and his left arm drawn back
holding the caduceus. And, moreover, he also modelled his
Mercury as a similarly athletic figure with wide shoulders,
a muscular torso, and sinewy arms and legs.

Although Giambologna took Leoni's medal reverse as
the basis for his own work, or, as seems more likely, was
required to take it as his basis, his personal, artistic
accomplishment was to transform the two-dimensional
model into such a marvellously novel, freely-posed figure
that the sight of it dispels any recollection of its small
counterpart. He solved, through an ingeniously calculated
disposition of weights, the difficult static problem of
balancing the Mercury upon his small base, as it were,
upon a single point (the statue thereby becoming virtually
self-sustaining, shown as if Mercury was about to be lifted
off the ground), and at the same time imparted to his figure

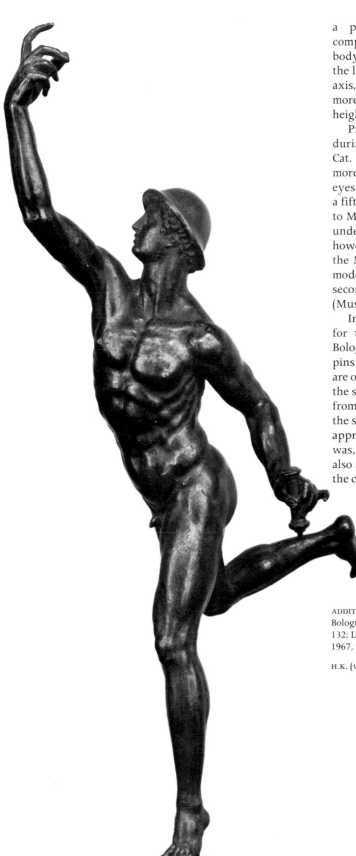

a pleasing, aesthetically flawless form, no longer comparable with the relief image: he has positioned the body altogether more steeply, drawn all the movements of the limbs more decisively into relationship with a vertical axis, and likewise turned the head and glance of the youth more clearly upward toward the finger pointing to the heights above.

Proceeding from this first model, designed and cast during the work on the Neptune fountain in Bologna (see Cat. 31), the sculptor created in the same year, 1564, the more slenderly proportioned and more supple, and to our eyes more weightless, flying *Mercury* which was the size of a fifteen-year-old youth. It was this statue which was sent to Maximilian II in Vienna, but it has been missing for an undetermined length of time: we know the model, however, in a second version, the 180 cm high bronze in the Museo Nazionale, Bargello, in Florence. Giambologna modelled further variant versions of the *Mercury*, in the second half of the 1570s (see Cat. 35) and in the 1590s (Musée du Louvre, Paris, MR 3279).

In facture the bronze exactly matches the bronze model for the statue of Neptune, also in the Museo Civico, Bologna (Cat. 31). The surviving square-sectioned core-pins and the unfilled holes where core-pins have fallen out are of the same shape and size in both bronzes, which share the same experimental quality and lack of finish. It is clear from these technical observations that both were cast in the same foundry (presumably that of Zanobi Portigiani) at approximately the same time, and that the present bronze was, as has been proposed, like the *Neptune*, a model: this also appears to be borne out by the fact that the handle of the caduceus was never drilled to take the shaft.

ADDITIONAL BIBLIOGRAPHY: P. Ducati, *Guida del Museo Civico di Bologna*, Bologna, 1923, p. 203; Amsterdam, 1955, no. 297; Dhanens, 1956, pp. 131, 132; Landais, 1958, pp. 68, 69; Amsterdam, 1961–62, no. 119; Weihrauch, 1967, pp. 199–203; Herklotz, 1977.

H.K. (with additions by A.R.)

33

34
Mercury in flight
h.62.7

Bronze. Remains of transparent golden lacquer; light brown natural patina. Only the handle of the caduceus has survived; break on the left shin since 1973; an old bronze plug between knee and knee-hollow of the right leg. Engraved on the underside of the petasus, above the forehead, the signature *.I..B.*
Kunsthistorisches Museem, Vienna, Sammlung für Plastik und Kunstgewerbe (5898)

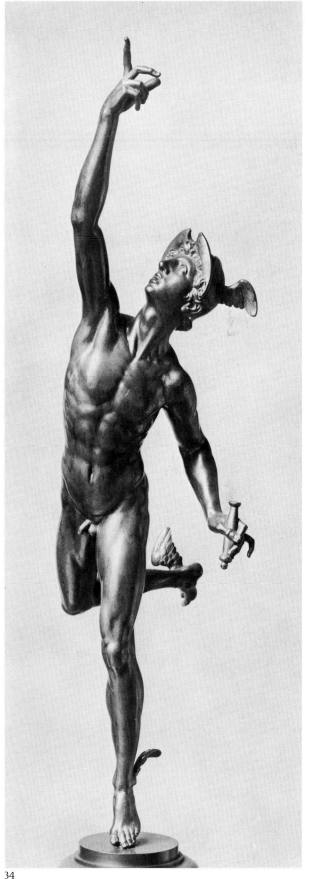

Mercury is shown in flight, completely naked. The toes of his left foot barely touch the ground. His right arm is raised vertically and the index finger points directly upward; in his lowered left hand he holds the handle of the caduceus. Each ankle is winged on the outside, and on his head is the winged petasus.

Mercury is shown here as the divine messenger carrying out Jupiter's behests; the impressive upward gesture with his right hand alludes to the higher power by whom he is sent. As literary sources may be cited *Odyssey*, V, 45–6 (Gramberg) and a passage in the fourth book of the *Aeneid*, while as regards iconography one may recall *Annunciations* by Leonardo da Vinci and Benvenuto Tisi, known as Garofalo (Herklotz). Mercury's role as a conveyor of divine commands lends plausibility to the idea that this work may have been inspired by the reverse of a medal of Maximilian II by Leone Leoni, which displays a flying Mercury with the inscription *QVO.ME.FATA.VOCANT.* (Vermeule and, independently, Keutner in a lecture of 1967). The first mention of a flying Mercury by Giambologna (Vasari, 1568, followed by all later sources) expressly states that it was sent to Maximilian II, and it is thus quite likely that the artist, commissioned by the Grand Duke Cosimo I, conceived the figure specially for this purpose and did not simply copy his own earlier work. It is disputed, however, whether the present statuette, signed *I.B.*, is actually the bronze presented to the Emperor in 1565. While Vasari spoke of '. . . *un Mercurio in atto di uolare, molto ingegnoso, reggendosi tutto sopra vna gamba & in punta di pie, che è stata mandata all'Imperatore Massimiliano, come cosa che certo è rarissima*' ('a flying Mercury, very ingenious, balancing on one leg and on tiptoe, a most exquisite work which was sent to the Emperor Maximilian'), Borghini wrote sixteen years later: '*In questo medesimo tempo fece vn Mercurio di bronzo grande come vn fanciullo di 15 anni, il quale insieme con vna historia di bronzo, & vna figurina pur di metallo fu mandato all'Imperadore*' ('At the same time' [*i.e.* when working on the *Fountain of Neptune* at Bologna] 'he made a bronze Mercury as big as a lad of 15, which was sent to the Emperor together with a bronze *historia* [narrative relief] and a figurine, also of metal'). However, Borghini elsewhere (with only one other exception) uses the correct word, *alto,* to indicate height, and gives the measurement in *braccia*. By *grande* ('big') he probably only means to indicate roughly the age of the boy, and not the actual size of the statue. The Vienna *Mercury* and its replicas and variants do give the impression of a stripling. More per-

34

suasive, perhaps, is the conclusion of recent research that the style of the Vienna statuette is closer to that of Giambologna's work in the 1570s than to his early work.

The Vienna *Mercury* differs from the variant in Naples which was sent to Ottavio Farnese in about 1579 not only by its size (about 4.5 cm higher) and different patina but above all by its still more elongated proportions and the taut, elastic body culminating in the index finger, the gesture being enhanced by the god's upward gaze. Whereas the statuette of Mercury in the Museo Civico in Bologna is generally regarded as a preliminary model, the nearly life-size variant in the Bargello seems to date from as late as *circa* 1580. This version is embellished by the head of Zephyrus, on whose breath Mercury glides; but the composition lacks the verticality of the Vienna figure, and the proportions of the body are heavier and more virile.

A statuette traceable in Dresden from 1587 is probably closest to the Vienna *Mercury*, while most of the numerous other replicas seem to be based on the Naples variant.

By choosing the motif of a figure in flight, which had previously been reserved to two-dimensional media, Giambologna broke away from the static laws that had governed sculpture and opened up entirely new prospects. Since, in addition, his *Flying Mercury* was effective from every angle of vision, it ranked as a mannerist figure *par excellence* and influenced the development of sculpture into the Baroque period and beyond.

BIBLIOGRAPHY: Planiscig 1924, p. 148, no. 251 (with citation of previous literature); Gramberg 1936 (1928), pp. 72 ff.; Vermeule 1952; Kriegbaum 1952–53, p. 45; Dhanens 1956, pp. 125 ff.; Bauer and Haupt 1976, p. 103, no. 1970; Herklotz 1977, pp. 270 ff.
PROVENANCE: old Imperial possession, most probably identical with a statuette in the inventory of the *Kunstkammer* of Emperor Rudolph II in Prague. From there it probably came to the Imperial *Schatzkammer* in Vienna and, at the end of the 18th century, to the Imperial Collection of Coins and Antiquities, whence it was taken over in 1880.

M. L-J.

35

Mercury
h. 57

Bronze. Red-gold lacquer, much darkened, considerable oxidization; very little cleaned or chased: unremoved pieces of investment still adhering to the metal between the legs and inside the hand; the caduceus broken off at the handle; the right index finger totally broken off; a break or flaw in the upper right arm repaired with lead; a crack in the left ankle; painted on the left thigh the old Farnese inventory number 19.
Museo e Gallerie Nazionali di Capodimonte, Naples (10784)

The bronze is mentioned in a letter of 13 June, 1579, from Giambologna to Ottavio Farnese, Duke of Parma, concerning the delivery of the bronze *Rape of a Sabine* (Cat. 56, *q.v.* for transcription of the relevant passage). The letter implies that the *Mercury*, together with another bronze described as a *Femina* (Woman; untraced) had already been delivered to Parma some time before, and that on the occasion of that delivery Giambologna had accepted the commission for the *Rape of the Sabine*. The date of completion of the *Mercury* is thus dependent upon the possible date of commencement of the *Rape of a Sabine*. The latter was one of the most complex and ambitious compositions which Giambologna had ever attempted at that date, but even so it seems unlikely that the completion date of the *Mercury* would have been much more than a year before 13 June, 1579, although Dhanens (1956, pp. 125, 130) places it tentatively in 1575.

Assuming, as seems likely, that the *Mercury* of Bologna (Cat. 33) is the earliest of Giambologna's *Mercuries* and that the signed version of Vienna (Cat. 34) is the one presented to Emperor Maximilian II in 1565, the present bronze is the third *Mercury* by Giambologna of which we have knowledge. While it shares the general character of Cat. 34, it is not cast from the same model, but is considerably varied (see account Cat. 34). It is smaller than the Vienna version, but not so much smaller as the dimensions here quoted would seem to indicate, since the index finger of the raised hand, which was originally vertical, is now completely missing. Both the Vienna bronze and the present bronze have an experimental character, and it is clear that at this stage the final form in which Giambologna's small *Mercury* was to be reproduced in the workshop had not yet been set.

The bronze thus immediately preceded Giambologna's first large-scale *Mercury* (now in the Bargello, *h.* 180) which was completed in May, 1580, and delivered to Cardinal Ferdinando de' Medici in Rome in June, 1580 (documentary information kindly supplied by Professor James Holderbaum). But for that Giambologna reverted to the less elongated type of the Bologna bronze possibly because of the difference in scale. The Naples bronze seems to have established the form in which the *Mercury* was later reproduced on a small scale in the workshop, but it was on this type that the late large-scale *Mercury* of the Louvre (*circa* 1597–98; Vitry, 1922, no. 379) was also to be based.

The bronze shares with the Naples *Rape of a Sabine* a

very noticeable lack of finish, even to the extent that pieces of the investment are still adhering to the surface in unexposed parts, and it is clear that, like the Naples *Rape*, it was never handed over by Giambologna to the chaser (see Cat. 56).

It seems possible in view of the evidence of an early pairing of the *Mercury* with Giambologna's figure of *Fortuna* in the inventory of the collection of Bartolommeo Gondi of 1609 (Corti, 1976, p. 633) that the now lost *Femina* with which the present bronze was sent to Ottavio Farnese was an early version of the *Fortuna* (see Cat. 13).

A.R.

H.K. writes:

In addition to the signed *Mercury* statuette in Vienna (Cat. 34) we know three further examples of this version attested to as the work of Giambologna by three documents from the years 1579 to 1589: our example (document of 1579, see Filangieri di Candida, 1897, pp. 20–4), the one in Dresden (document of 1587, see Holzhausen, 1933, pp. 55–9) and that in Florence (document of 1589, see the unpublished manuscript inventory of the Uffizi Tribuna).

For the dating of this particular version of the *Mercury*, the last two documents, both only short inventory entries, provide the only testimony to the execution of the bronzes in Dresden and Florence, before 1587 and 1589 respectively. Moreover, the earliest mention of our example furnishes no more than a *terminus ante quem*: in a letter of 13 June, 1579, Giambologna informs Duke Ottavio Farnese that he has by now finished and chased a two figure group of an abduction that he promised the Duke on the occasion of the consignment of the *Mercury* statuette. Thus our example in Naples was cast before 1579. Dhanens (1956, p. 130) has suggested the year 1575 as a *terminus post quem* since Ottavio Farnese visited Florence and Pratolino in May of that year, and then, or soon afterwards upon his return to Parma, he could have commissioned Giambologna with the execution of the work. Thus she specified the years between 1575 and 1578, a period during which, in my opinion, not the Naples bronze only but this *Mercury* design also must have come into being.

In the context of the four versions of the *Flying Mercury* which Giambologna did during his lifetime, our work finds its place after the first two versions, the 55.5 cm high bronze model in Bologna dating from 1564 (Cat. 33) and the 180 cm high *Mercury*, who stands on a gust of wind, dating from 1564–65, which was sent to Maximilian II in Vienna (a version still surviving in the Bargello, Florence), and before the fourth version, which dates from the 1590s, into which elements of the second as well as our third version went. In 1598 an example of this last version, a 170 cm high *Mercury* statue, was sent to France (now in the Louvre, Vitry, 1922, no. 379).

Concerning this chronological ordering of the four versions, particularly with regard to the dating of the second and third, there are still differing opinions which cannot be discussed here. A generally conclusive answer to the questions remaining open can come only through the discovery of new documents.

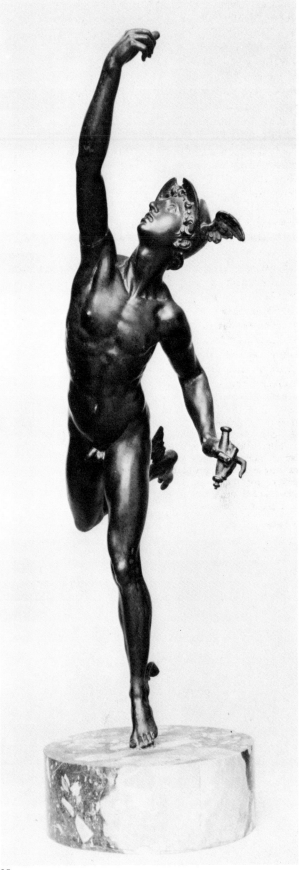

35

Among the four examples of the present version documented to Giambologna (see above), the signed Vienna statuette was doubtless reworked and chased by Giambologna himself. For the finishing of the other examples he may well have called upon Antonio Susini whom he took into his workshop in the second half of the 1570s, from an apprenticeship with the goldsmith Felice Traballesi, as a highly talented performer of this task.

FURTHER VERSIONS: Cat. 34; Grünes Gewölbe, Dresden (IX. 98, inventoried in the *Kunstkammer* of Christian I of Saxony in 1587; Holzhausen, 1933, p. 55); Museo Nazionale, Bargello, Florence (documented in 1589); Staatliche Museen, Berlin-Dahlem (2244, Bode, 1930, no. 164); private collection, Bremen (formerly Dresden, Skulpturensammlung); Kunsthistorisches Museum, Vienna (5812, Planiscig, 1924, no. 252); Stift Klosterneuburg, Planiscig, 1942, no. 33); Allen Memorial Art Museum, Oberlin, Ohio (45.26, Wixom, 1975, no. 147).
ADDITIONAL BIBLIOGRAPHY: Filangieri di Candida, 1897, p. 20; De Rinaldis, 1911, no. 709; Gramberg, 1936, pp. 72–8; Landais, 1958, pp. 68, 69; Amsterdam, 1961–62, no. 120; Holderbaum, 1966, p. 6; Weihrauch, 1967, pp. 203, 204; Watson, *Allen Memorial Art Museum Bulletin*, 1976, pp.59–71.
PROVENANCE: Ottavio Farnese, Duke of Parma, Parma, before 1579; Farnese collection, Palazzo Farnese, Rome; Charles III Bourbon, King of the Two Sicilies (inherited in 1731 from Antonio Farnese and transferred to Naples in 1737–38); Museo Borbonico, Naples (1738–59).

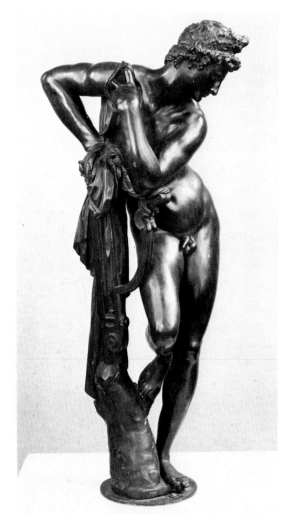

36

Apollo

*h.*88.5

Bronze. Red lacquer.

City of Florence, Ripartizione Belle Arti e Antichità

This statuette is today in the place for which it was originally intended, the Studiolo in the Palazzo Vecchio, the study and *Kunstkammer* furnished from 1569 for Francesco I (colour, page 31). The decoration of the room, undertaken by more than thirty painters, sculptors, and wood-carvers, was devoted to the glorification of the four elements. Each element was assigned one of the four walls of the room, which were, in turn, ornamented with paintings illustrating the blessings and uses of the elements for mankind. In the upper half of each wall two niches contained bronze statuettes of the gods who, from ancient times, stood for the element the wall represented. On the north wall, dedicated to fire, there stand in two niches a figure of *Vulcan* by Vincenzo de' Rossi and *Apollo* by Giambologna.

Its casting was finished in 1573, its chasing in 1575, and it was installed in 1576. The *Apollo*, alone among the eight statuettes of the Studiolo, was set in its niche so that it could be turned by a mechanism (Keutner, 1958, p. 428), and thus admired from various sides. Indeed, the *Apollo*, who stands peacefully supporting himself and calmly looking down from his high vantage point, is so animated in his repose that this artful combination of rest and movement cannot be captured in a single principal view.

As early as 1586 the Studiolo was dismantled and the majority of its paintings and bronzes were utilized in the first installation of the Uffizi Gallery. Before this statuette was re-exhibited in the *Tribuna* of the Uffizi, Antonio Susini polished it with pumice and applied a reddish varnish (Heikamp, 1963, p. 245, docs. 5, 6). Subsequently, in the early 1870s, the statuette was moved from the Uffizi to the newly-founded Museo Nazionale, and in 1910, when Giovanni Poggi restored the Studiolo to its original state, the *Apollo* was returned to the niche where he first stood.

ADDITIONAL BIBLIOGRAPHY: Supino, 1898, p. 398; G. Poggi, 'Lo Studiolo di Francesco I al Palazzo Vecchio', *Marzocco*, 11 December, 1910; Dhanens, 1956, pp. 182–3; L. Berti, *Il Principe dello Studiolo*, Firenze, 1967, pp. 61–84; Weihrauch, 1967, pp. 190–2; Larsson, 1974, pp. 66, 77.
PROVENANCE: Palazzo Vecchio; Uffizi Gallery; Museo Nazionale; Palazzo Vecchio Studiolo.

H.K.

36

37
Apollo, small
*h.*13.7
Bronze
Museo Nazionale, Bargello, Florence (71)

The so-called *Apollino* (his indistinguishable attributes do not permit a secure designation) has, since Bode (1912, p. 7) been held to be a first design for the *Apollo* of the Studiolo (Cat. 36). The correspondences in composition between the two figures are unmistakable; their distinctive traits suggest that the *'Apollino'* is a first solution, and the *Apollo* a second, revised, solution for the motif of a figure standing in repose. This does not mean, however, that the two works were created in close succession in the early 1570s, that is, on the occasion of the commission for the large *Apollo* statuette. A common dating for both works would appear questionable if only in the light of their differing anatomical forms, which stem from two distinct conceptions of proportion and beauty.

Apart from the fact that Giambologna appears to have already used the composition of the *Apollino* in 1565 in the female figure of *Florence triumphant over Pisa* there are reasons to suppose that the work had been designed as early as the late 1550s. In my opinion the *Apollino* was modelled at the same time as the small *Woman bathing* (Cat. 6) and designed as her male counterpart. The two statuettes are the same size, they correspond with one another in their stances which are in mirror image, in the proportions of their bodies, and in the working of their surfaces; moreover, in the form of their heads and their facial features they are like brother and sister.

Just as in the case of the small *Woman bathing*, Giambologna must have modelled the *Apollino* as a compositional study for himself, not for a specific commission, and indeed perhaps without any definitive theme in mind. And as with the small *Woman bathing*, too, he later drew upon this *bozzetto* in the process of designing other, larger commissions.

FURTHER VERSIONS: Cat. 38; Cat. 39; Douai, Musée de Douai (another coarsely worked rough cast, not listed in Leroy, 1937).
ADDITIONAL LITERATURE: Bode, 1930, p. 37, no. 175; Dhanens, 1956, p. 183; Weihrauch, 1967, p. 205; Jacob, 1972, pp. 8–9.
PROVENANCE: Galleria degli Uffizi.

H.K.

38
Apollo, small
*h.*13.5
Bronze. Solid-cast, with reddish-brown patina and remains of lacquer. Traces of the seams of a piece-mould visible, *e.g.* down left arm; left leg, front and back; down left buttock; front of right thigh. Remains of pours of metal chiselled off: outside left elbow; inside right calf.
Staatliche Museen, Berlin-Dahlem (1952)

For the dating and stylistic situation of this statuette, see Cat. 37. It is included in the exhibition because the absence of after-working permits one readily to visualize the original wax sketch-model from which the figurine was cast, as in the case of the *Woman bathing* (Cat. 22). It is not clear how statuettes such as these escaped the normal workshop processes of finishing, but it may be inferred that they were regarded as insufficiently perfect castings. Alternatively, the intention may have been simply to preserve a wax model by the master, after it had begun to show signs of deterioration.

FURTHER VERSIONS: Cat. 37, 39
ADDITIONAL BIBLIOGRAPHY: Bode, 1930, no. 175, as 'style of Giambologna'.
PROVENANCE: purchased from the Falke collection London, 1892.

C.A.

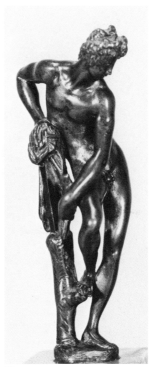

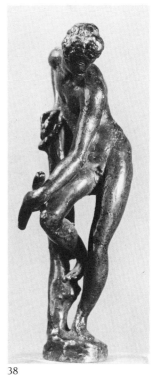

37 38

39
Bacchus
*h.*14.1 (including integrally-cast bronze base).
Bronze. Dark patina.
Herzog Anton Ulrich-Museum, Brunswick (Bro. 114)

The figurine is a variant of Cat. 37, 38, in which the tree-
stump has apparently become a vine-stock, and the figure
holds a horn in his left hand. It shares with these other two
bronzes the character of a cast from a wax sketch-model,
being very freely modelled, particularly in the hair, and
not worked-up in the metal. In this excellent cast the
handling of such details as the face and eyes and the toe-
and finger-nails are characteristic of the practice of
Giambologna and his workshop.

FURTHER VERSIONS: Museum für Kunst und Gewerbe, Hamburg (1950.76).
BIBLIOGRAPHY: Jacob, 1972, pp. 8, 9, no. 10.
PROVENANCE: ancestral collections of the Duke of Braunschweig-
Wolfenbüttel.

A.R.

40
Meleager
*h.*15.4
Bronze. Hollow-cast, with flaws in the crutch and between
Meleager's foot and the boar's head. Thin, brown lacquer.
Staatliche Museen, Berlin-Dahlem (2594)

The figurine is introduced for the sake of comparison with
Giambologna's small versions of Apollo. The *contrapposto*
is clearly derived from this source, and Cat. 40 may be the
work of one of his pupils of northern origin. It is a very
competent, thin-walled hollow casting and the surfaces are
carefully tooled: the naked flesh is matt-punched all over,
while the drapery is smoothly chiselled, and the details,
particularly the head of the boar, are incisively picked out.

ADDITIONAL BIBLIOGRAPHY: Bode, 1930, no. 142 (inaccurately citing as
another version of Cat. 40 a quite different *Meleager* in the Bayerisches
Nationalmuseum, Munich (11/12, see Weihrauch, 1956, no. 109)
PROVENANCE: anonymous Russian dealer, sale Lepke, Berlin; given by
Herr Minister von Dirksen, 1901.

C.A.

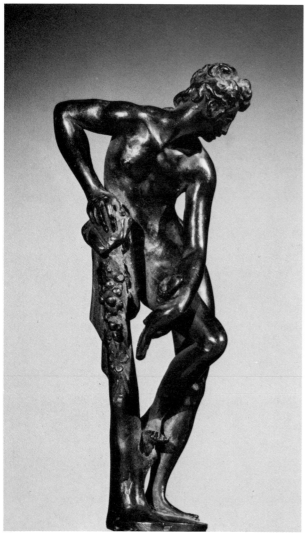

39

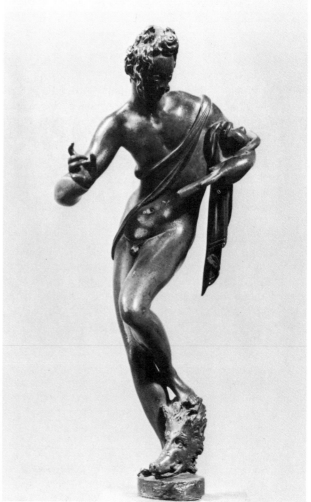

40

41
Triton
*h.*42.3
Bronze. Modern dark re-patination; piped for water; much
damaged, the lower part of the conch broken away, a hole
in the left breast.
Musée du Louvre, Département des Objets d'Art, Paris
(Th. 95)

None of the written primary sources mentions a bronze
triton by Giambologna. The first references to such a work
(and to a hitherto unpublished document) occur in
Desjardins (1883, p. 190) and Müntz (1895, p. 426). Later,
Wiles (1933, pp. 88, 89, 131) identified the over-life-sized
marble of a triton on three dolphins in the Museo
Nazionale, Palermo as a work of Battista Lorenzi executed
'before 1574' (Borghini, 1584, p.598). She compared this
with Cat. 41 and with two further small bronze versions of
the same subject (Frick Collection, New York and Kunst-
historisches Museum, Vienna), suggesting 'Giovanni
Bologna?' as the author of the three bronzes. Sub-
sequently, however, this attribution has been disregarded,
and Battista Lorenzi has been held to be responsible for the
three small bronzes and for a medium- sized bronze ver-
sion of the *Triton* in the Metropolitan Museum, New York
(repr. p. 9, formerly ascribed to Adriaen de Vries).

 The document which Desjardins and Müntz apparently
knew but failed to publish reads as follows: '*Addì 29 di
Luglio 1598. Copia d'un Inventario di robe che S.A. ha
mandato in Francia . . . Un tritone con dalfini che getta aqua,
di mano di gian bologna. libbre 110 – .*' This proves that in
1598 Giambologna had cast a fountain-figure of a triton
which Ferdinando I sent to France. Since the work
weighed 110 *libbre* (about 36 kg), it cannot have been the
bronze now in the Louvre. Nonetheless, I am convinced
that the three small bronzes in Paris, Vienna and New York
derive from a model by Giambologna, and that Cat. 41 re-
flects his hand more directly than do the other two.

 An early representation of triton by Giambologna
appears in the relief of the *Triumph of Neptune* on the
plinth of the *Fountain of Oceanus* (after 1567–76) in the
Boboli Gardens. Although this figure is represented only
from the back, it can be seen to correspond precisely with
the present bronze in composition: particularly in the
modelling of the back, in the backward-thrown head and
in the outstretched arm holding a slender horn. It seems
that both works must derive from one and the same model.

 The original model can have been created only around
the same time as the *Flying Mercury* in the Bargello in
Florence, that is between 1562 and 1565. Like the *Mercury*,
the *Triton* is in an unstable pose and strains upward with
great exertion in an energetic *contrapposto*, totally ab-
sorbed in his own action. It seems likely, therefore, that
Cat. 41, which appears to have been cast within Giam-
bologna's lifetime, faithfully records a composition
designed by him in the 1560s.

 The autograph *Triton* weighing about 36 kilograms,
mentioned in the document of 1598 as having been sent to
France, appears to survive in the medium-sized bronze
(*h.*91.5) in the Metropolitan Museum, New York. Both Olga

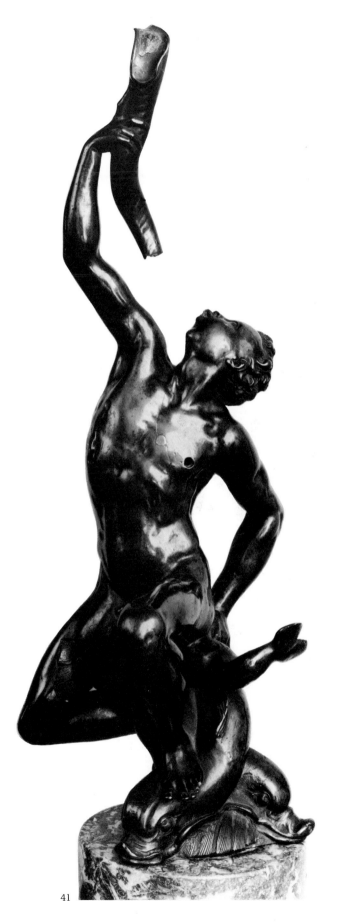

41

Raggio and Anthony Radcliffe in written communications consider this statue unreservedly to be by Giambologna. It is closely related in handling to works of the late 1590s, such as the *Flying Mercury* in the Louvre (*circa* 1597–98) and the candlestick-bearing angel in the Duomo at Pisa (1599–1601), works which are comparable in their relatively summary modelling and chasing and in which the collaboration of Pietro Francavilla and Pietro Tacca has to be allowed for.

It would appear that Battista Lorenzi in his marble *Triton* in Palermo adapted the early model by Giambologna and translated it to a monumental scale.

Evidence of an early traditional ascription of the model to Giambologna is provided by a plaster cast, of apparently the same dimensions as the Metropolitan bronze, formerly in the possession of the Royal Academy in London, and probably one of the plasters taken over by the Academy from the earlier St Martin's Lane academy. This is now destroyed, but is recorded in a drawing of 1779 by E. F. Burney (Byam Shaw, *Burlington Magazine*, CIV, 1962, pp. 212, 213), and was described by Baretti (1781, p. 24) as 'TRITON, a Sea God; a small statue by *Giambologna*, probably made to decorate some piece of water in some Garden'.

FURTHER VERSIONS: Metropolitan Museum, New York (14.40.689, Altman Collection; formerly Esterhazy Collection; *h*.91.5; autograph); Kunsthistorisches Museum, Vienna (9115; *h*.44.5; possibly a cast by Pietro Tacca); Frick Collection, New York (16.2.44; *h*.44.1; later cast).
ADDITIONAL BIBLIOGRAPHY: Blanc, 1884, p.30, no. 95; *Handbook of the Benjamin Altman Collection in the Metropolitan Museum*, New York, 1914, p. 132, no. 72; Strohmer, 1950, p. 120, no. 63; Amsterdam, 1955, no. 316; Weihrauch, 1967, p. 188; Larsson, 1967, p.127, no. 26; B. Jestaz, 'Travaux récents sur les bronzes, I,' *Revue de l'art*, 5, 1969, p. 81; Pope-Hennessy, 1970, III, pp. 203–6; Leithe-Jasper, 1976, pp. 88, 89, no. 88.
PROVENANCE: Humann Collection, Paris (sale, Paris, 8 February, 1858, no. 47); Louis Adolphe Thiers, Paris (1797–1877); acquired 1881.

H.K. (with additions by A.R.)

Mars

General note

The model is variously described in early sources as *Mars* or as a *Gladiator*: the former title is now conventional. The earliest documentary reference to the model dates from 1587, when a version, presented by Giambologna to the new Elector of Saxony, Christian I, was inventoried in the Dresden *Kunstkammer*. That version is Cat. 43 (*q.v.*). Christian I had succeeded his father Augustus I in February, 1586, and it therefore seems likely that the bronze was cast in 1586 and arrived in Dresden late in 1586 or early in 1587. It is clear, however, that the model was considerably older. Stylistically it appears to date from at least as early as the 1570s, and a copy by Pietro da Barga probably made for Cardinal Ferdinando de' Medici in the mid-1570s (Cat. 48, *q.v.*) would appear to indicate that the model was already in existence at that time.

Versions exist in which the figure holds a severed head in the left hand (see Cat. 49) and apparently represents an executioner with the head of St John the Baptist. Bode (1911, p. 636, 1912, pp. 4, 5) argued that the original model must have included this feature, which would help to explain the curious arrangement of the fingers of the left hand. However, all known versions of this variant appear to be late casts. It is persuasively suggested by Middeldorf (1968, pp. 174–6) that the *Mars* derived its inspiration from a lost statuette by Antonio del Pollajuolo recorded in early drawings in the Louvre and the British Museum and later drawn by Leonardo da Vinci on a sheet in Turin connected with the *Battle of Anghiari*. It is noteworthy that in all these drawings the attitude of the left hand is closely analogous to that in the bronzes, and in none of them is there a severed head.

The ascription by Winckelmann of the large bronze *Mars Gradivus* in the Uffizi to Giambologna (Desjardins, 1883, p. 74) has led to confusion in the minds of some writers on the *Mars* (Tietze-Conrat, 1917, pp. 41–5, Santangelo, 1954, pp. 53, 54). This bronze, as established by Kriegbaum (*Mitteilungen des Kunsthistorischen Institutes in Florenz*, III, 1929–32, pp. 71 ff.), was made by Bartolommeo Ammanati in 1559, and apparently has little to do with Giambologna's statuette.

The *Mars* was one of the most popular models of Giambologna, and (although not mentioned in Baldinucci's list) was much reproduced at least from the early 17th century. A version is recognizable in the inventory of the *Kunstkammer* of Emperor Rudolph II at Prague compiled in 1607–11 (Bauer and Haupt, 1976, p. 100, no. 1900). This is perhaps identifiable with a superb version now in the Nationalmuseum, Stockholm, inventoried at the Royal Castle of Drottningholm in 1777 (Sk334, Nationalmuseum, *Äldre utländska målningar och skulpturer*, Stockholm, 1958, p. 250). A version was in the possession of Markus Zeh at Augsburg in 1611 (Dhanens, 1956, p. 74). Evidence for reproduction of the model by Antonio Susini is provided by the inventory after the death of Cardinal de Richelieu (see Cat. 44). A variant version was produced in the early 18th century by Massimiliano Soldani (see Cat. 49), and a '*Mars du même (Jean Bologna)*' appears disturbingly in the price list of 1795 of bronzes made by Francesco Righetti in Rome (copy in Department of Prints and Drawings, Victoria & Albert Museum).

It is to be noted that Cat. 42, which is signed, and Cat. 43, which is documented in 1587, have the left heel raised from the ground, as do some other exceptionally good versions (Cat. 44, 45, 46). This feature, which makes the gait more lively, must have been present in the original model. Even so, some versions with the left heel flat on the ground are of excellent quality and certainly early (*e.g.* Stockholm, Cleveland).

A.R.

42

Mars

*h.*39.4

Bronze, gilt. The blade of the sword is a restoration.
Chased on the sole of the right foot: *.I.B.*
Lent anonymously

The signature '*.I.B.*' under the right foot of the present bronze is in a form which occurs in only two other bronzes, the *Nessus and Deianira* of Dresden (Cat. 61; first inventoried in 1587) and the *Mercury* of Vienna (Cat. 34; probably sent to Emperor Maximilian II in 1565). In the former of these it is punched, and in the latter engraved, while here it is chased. The bronze is certainly one of the finest versions known, and must be early.

One other signed version is recorded, formerly in the collection of Dr Ernö Wittmann in Budapest. This was last noted in 1937, when it was exhibited in Budapest (*Esposizione di antichi maestri italiani*, Nemzeti Szalon, Budapest, 1937, no. 45), and it is said to have been exported from Hungary in 1938 to Bath in England (G. Entz, 'I bronzetti della collezione Marczibányi', *Acta Historiae Artium*, II, 1955, p. 232, n. 8, p. 230, no. 3). From that point there is no record of it. The signature on the Wittmann bronze is reported by Meller ('Dr Wittmann Ernö kisplasztikai gyüjteménye; *Magyar művészet*, X, 1934, p. 240) to have been in the same form (*.I.B.*) and to have been on the sole of the foot (which foot is not specified). Planiscig (1930, p. 48) states that it was on the sole of the left foot, but this seems unlikely, since the Wittmann bronze, as can be seen in the photograph published by Meller (p. 243), had, like the present bronze, a cast-on fixing rod on the ball of the left foot, and it is possible that Planiscig was writing in terms of the viewer's left. It is argued by Wixom (1975, no. 145) that the two bronzes cannot be identical, since the Wittmann bronze is not reported to have been gilt. However, judging from the photograph published by Meller, it was in all respects of pose, modelling and surface detail apparently identical to the present bronze: the fixing rods were in precisely the same positions, and, most significantly, there is clearly visible on the inside right leg of the Wittmann bronze, just above the knee, a crack in the metal in the identical position and of apparently the identical shape as in the present bronze. The Wittmann bronze had no blade to the sword, but it is clear that the blade of the present bronze is a restoration. The present bronze appeared without provenance on the London art market, as have other bronzes from the Wittmann collection. If it may be supposed that at some time since 1937 the Wittman bronze was gilded and a new blade added, there is nothing further to preclude its identification with the present bronze.

A suggestion by Entz (*op. cit.*, pp. 221, 222, 230) that the Wittmann bronze was earlier in the Marczibányi collection remains to be substantiated.

FURTHER VERSIONS: Cat. 43–9; Nationalmuseum, Stockholm (Sk334, *h.*39.5, *Nationalmusei skulpturensamling beskrivande katalog*, Stockholm, 1929, p. 12, no. 334, pl. 2 – see above); Herzog Anton Ulrich–Museum, Brunswick (Bro.106 – a good version ruined by brutal repatination); Museo di Palazzo Venezia, Rome (F.N.413, *h.*38.6, Santangelo, 1954, pp. 53,54, from the Corsini collection, inscribed *P.C*, on old socle inlaid with agate – an excellent version, 17th century, wrongly classified by Dhanens, 1956, p. 199, as 19th century); Liechtenstein Collection, Vaduz (*h.*40, Bregenz, 1967, p. 28, no. 17); Cleveland Museum of Art, Cleveland, Ohio (64.421, *h.*39, Wixom, 1975, no. 145); Grünes Gewölbe, Dresden (IX.64); Skulpturensammlung, Dresden (H.156/52, *h.*37.7, Raumschüssel, 1963, p. 212, no. B17); Staatliche Museen, Berlin-Dahlem (2733, *h.*38.6, Bode, 1930, no. 160); Civico Museo Schifanoia, Ferrara (C.G.F.8535, *h.* including bronze socle, 42.7, Varese, 1975, no. 128); Museo Nazionale, Bargello, Florence (Carrand Collection, De Nicola, 1916, p. 364); Landesmuseum Joanneum, Graz, (47); Statens Museum for Kunst, Copenhagen (5502, *h.*37.5, 5503, *h.*37.8, Olsen, 1961, p. 104); Victoria & Albert Museum, London (A. 99–1956, *h.*39.2 – late cast; A.51–1910 – fragmentary cast, see Cat. 48); Museo del Castello Sforzesco, Milan (Br.148); Yale University Art Gallery, New Haven, Conn. (1956.17.8. *h.*38.1); Musée Jacquemart-André, Paris (475, *h.*, including socle, 46.7, *Catalogue itinéraire*, 1933, p. 67 – on old socle with arms of (?) Strozzi); Fitzwilliam Museum, Cambridge (M.1.1856, *h.*38 – see Cat. 48); Museo Lazaro Galdiano, Madrid (Camón Aznar, 1967, p. 47 – see Cat. 48); Museo Nazionale, Bargello, Florence (Carrand Collection, Supino, 1898, p. 84, no. 230 – a small gilt variant with shield); private collection, Belgium *h.*39, Laarne, 1967, no. 73); formerly Hainauer collection, Berlin, (*h.*38.5, Bode, *Die Sammlung Oscar Hainauer*, Berlin, 1897, p. 77, no. 107, repro. Berlin, Kunstgeschichtliche Gesellschaft, *Ausstellung von Kunstwerken des Mittelalters und der Renaissance*, Berlin, 1899, pl. XXXIV, no. 5).

ADDITIONAL BIBLIOGRAPHY: Holzhausen, 1933, pp. 54, 55, 60; Dhanens, 1956, pp. 198, 199.

PROVENANCE: ([?] Werner, Vienna and Munich; Dr Ernö Wittmann, Budapest); London art market.

A.R.

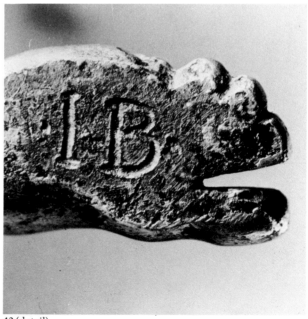

42 (detail)

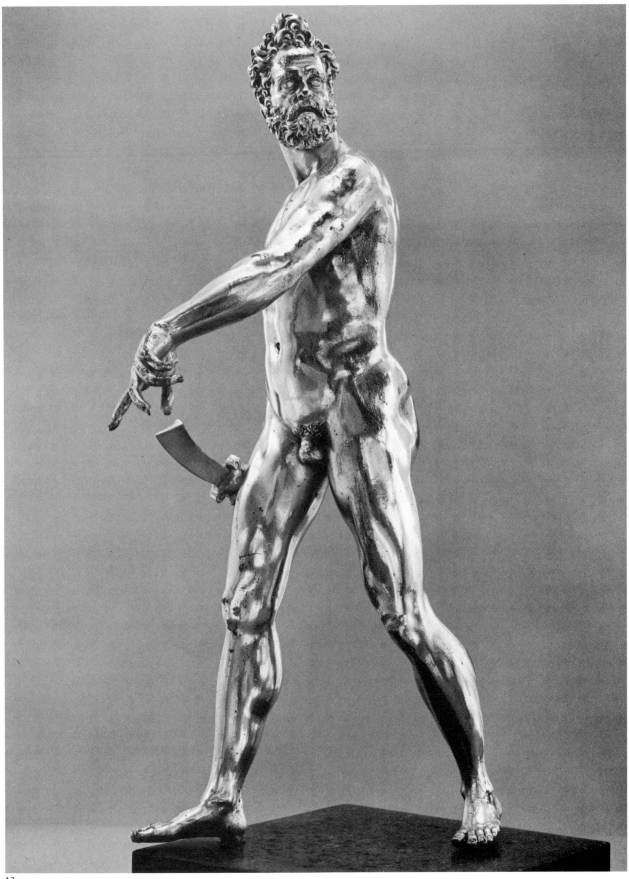

42

43
Mars
h.40
Bronze.
Lent anonymously

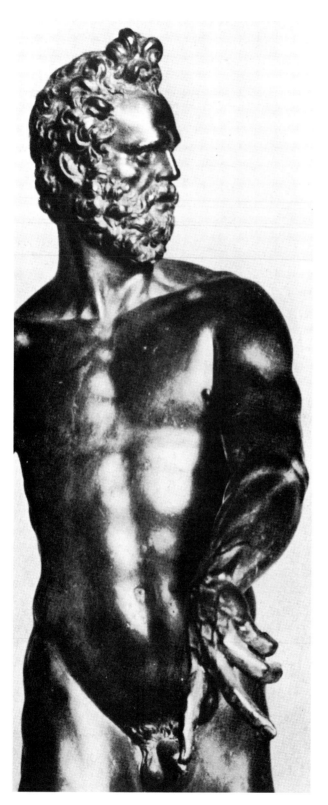

Giambologna received a supply of silver to make a '*figurina con uno sgudo in mano et uno bastone, innuda*' on 3 July, 1578 (A.S.F. Guard. fil. 98, fol. 147r.; Churchill, 1913–14, p. 349). Although not certain, it is highly probable that the small nude figure with a shield and a command baton described in the document corresponds with the present model, which was to be executed in silver. In the surviving bronze examples the grasping, spread fingers of the down-turned left hand suggest that it was to hold a shield, while in the right hand there is, instead of the command baton, a sword. Thus the document appears to support the general supposition that Giambologna designed the composition in the second half of the 1570s.

The present version of the *Mars* is the only one for which we know of a document dating from the master's own lifetime. In the first inventory of the Dresden *Kunstkammer*, made in 1587, it is recorded thus: '*Mössing gegossen Bildnus Martis, hatt Johan Pollonia S(einer) Churf(ürstlichen) gn(aden) zugeschickt.*' The statuette was then a personal gift of the sculptor to the Elector Christian I of Saxony, who the same year, 1587, had a gold chain sent to Giambologna in acknowledgement (Holzhausen, 1933, pp. 55–6, 60). Hendrik Goltzius portrayed the artist wearing this chain in his drawing of 1591 (Cat. 213).

Bronze examples of the *Mars Gradivus*, the Mars who rushes forward into battle, exist in great numbers. Among other traits, it is characteristic of the autograph statuettes that the war god strides with an elastic, springing step, his left heel raised off the ground.

In addition to a *Mars* statuette formerly in the Ernö Wittmann collection in Budapest, (signed *I.B.* and thus securely from the artist's hand), possibly identical with Cat. 42 (*q.v.*), Cat. 45 must also be considered autograph.

FURTHER VERSIONS: see Cat. 42
ADDITIONAL BIBLIOGRAPHY: see Cat. 42
PROVENANCE: Kurfürstliche *Kunstkammer*, Dresden; Collection of the former Royal House of Wettin, Dresden.

H.K.

43 (detail)

44
Mars
h.39.3
Bronze. The blade of the sword missing.
Engraved: *No 243*
Musée du Louvre, Paris, Département des Objets d'Art
(OA 5439)

The engraved number is the inventory number of the
French Crown Collections, and the bronze was first inven-
toried in the collection of King Louis XIV in 1713. It is
suggested by Landais (1961, p. 141, fig. 2) that either this
or another bronze in the Louvre (OA 5085, Crown inven-
tory No. 201) might be identical with a bronze in the
collection of Cardinal de Richelieu at his death in 1642,
described as a gladiator cast by Susini from a model by
Giambologna (Boislisle, 1881, p. 88, no. 67), and a bronze
later in the collection of François Girardon, described as
Mars by Antonio Susini after Giambologna (Charpentier,
1710). While the identification remains to be proved, the
present bronze is certainly of a quality consistent with the
work of Antonio Susini, and it should be noted that it has
the left heel raised from the ground as do the signed
version (Cat. 42) and the version documented in 1587 (Cat.
43). Whatever the earlier provenance, this is without
doubt one of the most authentic versions of the model.

Yet another version was in the collection of Louis XIV
by 1684 (Guiffrey, 1886, p. 34, no. 21).

FURTHER VERSIONS: see Cat. 42
ADDITIONAL BIBLIOGRAPHY: Migeon, 1904, p. 160, no. 158.
PROVENANCE: King Louis XIV of France; French Crown Collections
(*Inventaire des diamants de la Couronne*, 1791, p. 240).

A.R.

45
Mars
h.39.9
Bronze. Gold-brown lacquer.
Staatliche Museen, Berlin-Dahlem (4/65)

One of the finest known versions of the model, the bronze
has the left heel raised, in common with the signed version
(Cat. 42) and the version documented in 1587 (Cat. 43). Un-
like most other versions, it appears to have retained the
original sword-blade intact.

A suggestion (*Connoisseur*, CLIX, 1965, p. 175) followed
by some writers that it comes from the Grünes Gewölbe in
Dresden, and is the version presented to Elector Christian I
of Saxony by Giambologna in or before 1587, is un-
founded. The bronze was in the possession of Dr Eduard
Simon by 1912 (Bode, 1912, pp. 4, 5, pl. CXCIV), while the
Dresden bronze was in the possession of the Werein Haus
Wettin in 1925, and is to be identified with Cat. 43 (*q.v.*).

FURTHER VERSIONS: see Cat. 42
ADDITIONAL BIBLIOGRAPHY: Metz, 1966, p. 108, no. 621.
PROVENANCE: Dr Eduard Simon, Berlin, by 1912 (sale Cassirer and
Helbing, Berlin, 10, 11 October, 1929, no. 56).

A.R.

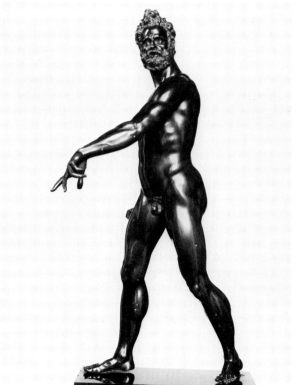

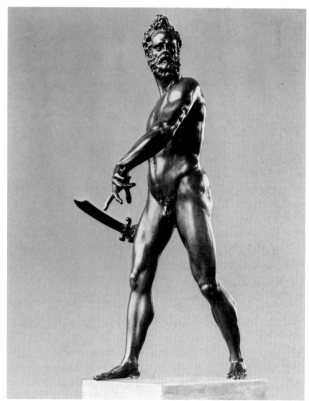

44

45

46
Mars
h.38.5
Bronze. Dark brown patina with traces of black lacquer; green oxidization on head and right hand; the blade of the sword missing.
From the Schloss Pommersfelden Collection

An exceptionally good version, the bronze has the left heel raised in common with the signed version (Cat. 42) and the version documented in 1587 (Cat. 43).

FURTHER VERSIONS: see Cat. 42.
BIBLIOGRAPHY: Weihrauch, 1967, p. 217.

A.R.

47
Mars
h.38.5
Bronze. Dark brown patination.
Royal Scottish Museum, Edinburgh (1960.910)

A later version of the same model as Cat. 42–6.

FURTHER VERSIONS: see Cat. 42
PROVENANCE: art market, 1960.

A.R.

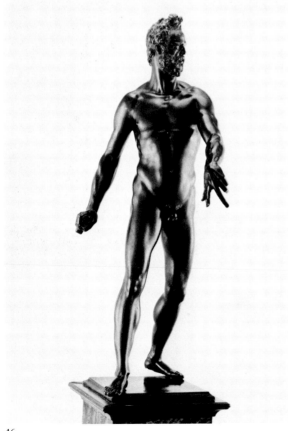

46

48
Mars
by **Pietro da Barga** (active 1574–7)
h.39
Bronze. Green varnish.
Museo Nazionale, Bargello, Florence (371)

Ascribed to Giambologna by Desjardins (1883, p. 135), the bronze, which is actually a modified copy of Giambologna's *Mars* (Cat. 42, 43), was recognized by De Nicola (1916, pp. 364, 369) as forming part of a series of bronzes in the Bargello of identical facture and patination, some of which are documented to Pietro da Barga in the inventory of the *Guardaroba* of Cardinal Ferdinando de' Medici (later Grand Duke Ferdinando I) in entries ranging from 1575 to 1577. These bronzes are all copies, deriving their models from a wide variety of sources, both classical and modern, and all are finished with a pseudo-antique green patination.

Pietro da Barga, who is otherwise quite unknown, is shown by entries in the inventory to have held the position of sculptor to Cardinal Ferdinando in Rome in the mid-1570s. The earliest entry referring to him dates from April, 1574, and the latest from February, 1577. While it is possible that he was in the Cardinal's service both earlier and later than these dates, the abrupt cessation of references to him suggests that he was not employed for very long after 1577.

The present bronze is not itself specifically mentioned in the inventory (it is too big to be identifiable with a *Gladiator* by da Barga cited in an entry of 27 July, 1575, the height of which is given as about one *palmo*, *i.e.* 22 cm). But it does seem likely that, along with the other bronzes by da Barga, it was made in the 1570s for Cardinal Ferdinando. As a copy of Giambologna's *Mars*, it would therefore provide evidence for an earlier existence than has so far been proposed for that model, which is first recorded as late as 1587 (see Cat. 42, 43).

The bronze is a fairly free copy after the original. As noted by De Nicola, the stride is considerably reduced, both heels are placed flat on the ground, the right arm is swung farther forward, and the musculature is generalized. A *Mars* in the Fitzwilliam Museum, Cambridge (M.1.1856, *h*.38), ascribed to Pietro da Barga, has a similar green patina, the same shortened stride and forward-swinging right arm, and the same generalized surface. Although the forelock is modelled differently, the ascription is almost certainly correct. A fragmentary version in the Victoria & Albert Museum (A.51–1910, clearly a hopelessly failed cast) shows many similarities to the present bronze, and is perhaps also by da Barga. A poor, unworked cast with a black patina in the Museo Lazaro Galdiano, Madrid, ascribed to da Barga (Camón Aznar, 1967, p. 47), appears to be of later origin.

ADDITIONAL BIBLIOGRAPHY: Müntz, 1896, pp. 144, 147, 148.
PROVENANCE: old Medici collections.

A.R.

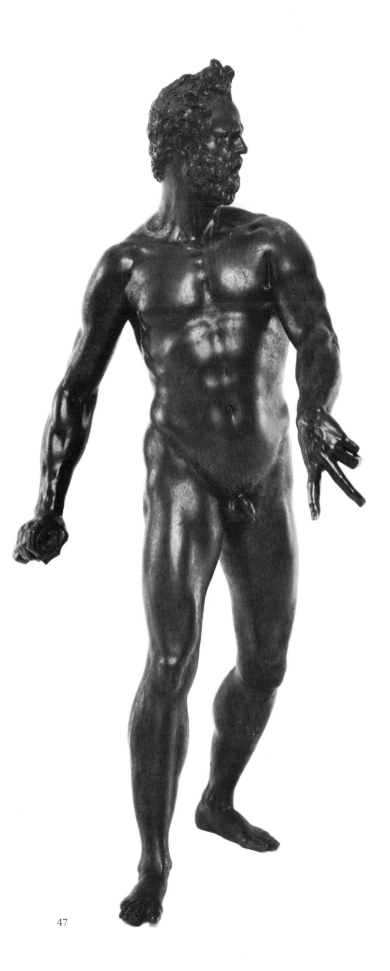

47

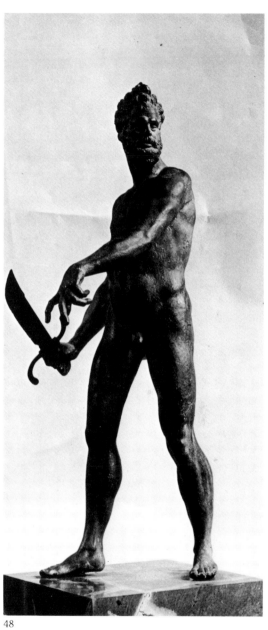

48

49

Executioner with the head of Saint John the Baptist
by **Massimiliano Soldani Benzi** (1656–1740)
*h.*including base 40.2, excluding base 38.1
Bronze. Rich brown lacquer, on separately-cast oval
bronze base.
National Gallery of Ireland, Dublin (8122)

A rare variant of Giambologna's *Mars* (Cat. 42–8), the
model is known in a small number of versions of widely
differing size and quality. It was argued by Bode (1911, p.
636; re-stated 1912, pp.4, 5, and 1930, no. 160) that
Giambologna's original model for the *Mars* must have held
the severed head of an enemy, but that this was not as a
rule cast with the figure in small bronze versions, as being
too grim in character for reproduction. This view is con-
tested by Dhanens (1956, p. 199), who considers the
severed head a variation introduced later by pupils, and by
Weihrauch (1967, pp. 217, 218), who, noting that the
addition of the severed head transforms the subject into an
executioner with the head of St John the Baptist, classifies
this model as a later unauthorized variant. However, as
Avery (1976, pp. 170, 171) has remarked, the head fits
admirably well into the unmodified fingers of the *Mars*
model in much the same way as does the head of Medusa
into the hands of Cellini's *Perseus*. Avery also noted the
significance of the subject in a Florentine context. The
origin of the *Mars* is obscure, and until more light can be
shed on this, the question of whether the *Executioner*
reflects a lost original by Giambologna should, as Avery
indicated, be left open.

No version of the *Executioner* has yet appeared which
seems to be contemporary with Giambologna. Cat. 49, as
recognized by Radcliffe (1972), is an early 18th-century
version by Soldani. The high surface finish, the fine matt-
punching in the tightly-modelled hair, the patina and the
type of the bronze base are characteristic of his work.
Decisive for his authorship are first the peculiar method of
fixing to the base by large bronze lugs cast onto the feet,
secured by tapering iron pins driven through slots in their
tips (a method which appears uniquely in some bronzes by
Soldani, *e.g.* a *Bacchus* after Michelangelo at Blenheim
Palace and a *Pomona* in Toronto; Avery, 1976, pp. 167–70),
and secondly the Baroque form of the sword-guard, which
relates closely to that on the sword in Soldani's tomb of
Manoel de Vilhena in S. Giovanni, La Valletta (1725–9: the
sword reproduces one given to Vilhena by the Pope; Lank-
heit, 1962, pp. 157–60, pl. 73). Of the other recorded
versions only one formerly in the Eissler Collection,
Vienna (*h.*38.4; Planiscig, 1930, pl. CCIX, no. 357) appears
to be of equivalent quality. Cat. 49 was almost certainly
acquired by Joseph Leeson, later 1st Earl of Milltown, in
Florence in 1744–45 or 1750–51 along with other bronzes
after Giambologna (Cat. 75, 76, 83; Wynne, 1974).

FURTHER VERSIONS: Michael Hall Fine Arts Inc., New York (*h.*39.7; Notre
Dame, 1970, p. 169, no. S13; this apparently identical with one formerly
Viktor collection, sale Dorotheum, Vienna, November, 1921, no. 204);
Museo Poldi-Pezzoli, Milan (FC 42/68); sale Sotheby, London, 18 March,
1976, no. 159 (*h.*37.5).
ADDITIONAL BIBLIOGRAPHY: Potterton, 1974, p.145; Wynne, 1975, p. 40.
PROVENANCE: Joseph Leeson, 1st Earl of Milltown (1701–83), Russ-
borough, Co. Wicklow; given by Geraldine, Countess of Milltown, 1902.

A.R.

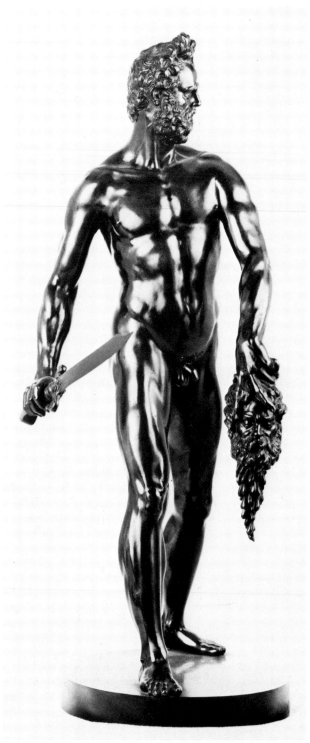

49

50

Morgante on a dragon

h.36.5

Bronze. Much oxidized, dark brown patina; Morgante and
the dragon separately cast, and both piped for water; the
dragon fitted with a tap (original) in its head; the central
support on which Morgante sits is a modern substitute.
Museo Nazionale, Bargello, Florence (9)

The figure portrays Morgante (*circa* 1535–after 1594),
court dwarf to Cosimo I and his two immediate successors,
who was ironically so named after the legendary giant
Morgante Maggiore of Luigi Pulci's epic poem first pub-
lished in Florence in 1481. Variously ascribed in early
literature to Giambologna and (most often) to Valerio Cioli,
the figure of Morgante was established by Keutner (1956)
and Holderbaum (1956), working independently, as the
work of Giambologna and the dragon as that of Lorenzo
(called 'Cencio') della Nera, a Granducal goldsmith who
also worked in association with Giambologna on other
occasions. Documents published by these two writers
indicate that the figure of Morgante had been cast by 5
December, 1582, by Giambologna's founder Fra Domenico
Portigiani, and was later delivered to Giambologna. Nearly
four months later, on 28 March, 1583, Portigiani recorded
that he had cast the dragon, the model of which he had had
from Cencio della Nera. The group was made to surmount a
fountain in a garden created for Grand Duke Francesco I on
the terrace on top of the Loggia de' Lanzi, where it was to
stand under a *loggetta*. The oval marble basin for the
fountain still stands on the terrace in a mutilated state.

Giambologna's part in this collaborative enterprise
seems to have been limited to the provision of the superb
figure of Morgante: this was a particularly busy juncture
in his career. However, Cencio della Nera continued to
work on the fountain until 1585, adding to the scheme a
flight of brass butterflies.

In its present mutilated state, with its makeshift central
support, the group is not easy to appreciate. But it must
always have been a somewhat curious work, with its con-
trast between the deeply cogitated figure by Giambologna
and the light-hearted fantasy of Cencio's dragon.

FURTHER VERSIONS: typical is one in the Walters Art Gallery, Baltimore, of
uncertain origin.
ADDITIONAL BIBLIOGRAPHY: Bode, 1911, p. 632; Planiscig, 1930, pl. CCXIX,
no. 373; Kriegbaum, 1952–53, p. 63; Dhanens, 1956, pp. 213, 214;
Amsterdam, 1961–62, no. 117.
PROVENANCE: old Medici collections.

A.R.

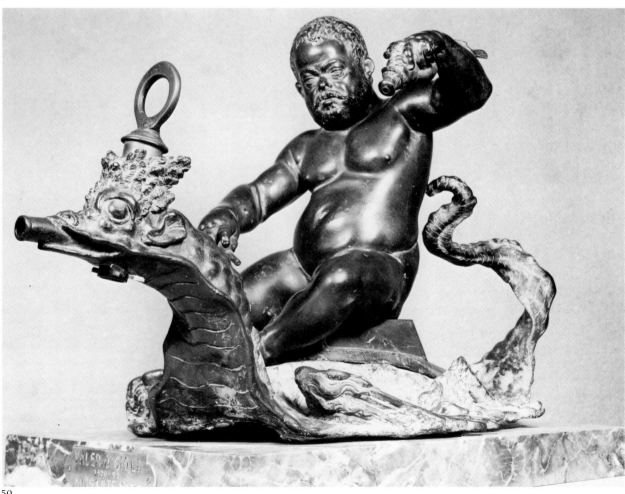

50

51
Morgante on a barrel
*h.*41

Bronze. Dark patina; cast in one piece and provided with four big integrally-cast lugs below for fixing; the bowl of the *tazza* in the left hand missing.
Musée du Louvre, Paris, Département des Objets d'Art, Paris (OA 8973)

Morgante is represented as Bacchus, seated on a barrel with a tap in his right hand and a *tazza* (now broken) in his left. The pose is basically the same as that of *Morgante on a dragon* (Cat. 50). Dhanens considers the bronze to be possibly the work of a pupil of Giambologna (1956, p. 214). However, it is of the very highest quality both in modelling and finish, and is unique in bronze.

A sugarpaste sculpture of Morgante on a barrel with a *tazza* in his hand formed part of the table decorations at the banquet given in the Salone del Cinquecento on 19 October, 1608, to celebrate the marriage of Prince Cosimo (later Grand Duke Cosimo II) to Maria Maddalena of Austria. This was probably made by, or under the supervision of, Pietro Tacca (see forthcoming article by K. Watson in *Connoisseur*, September, 1978). It seems likely that the sugarpaste sculpture followed the present bronze.

FURTHER VERSIONS: Museo Stibbert, Florence, terracotta (copy ?).
ADDITIONAL BIBLIOGRAPHY: Landais, 1958, p. 117, pl. XXVI.
PROVENANCE: sale Dorotheum, Vienna, 31 March–1 April, 1916, no. 518 (as by Valerio Cioli); acquired in 1936 from Hackenbroch, Frankfurt-am-Main.

A.R.

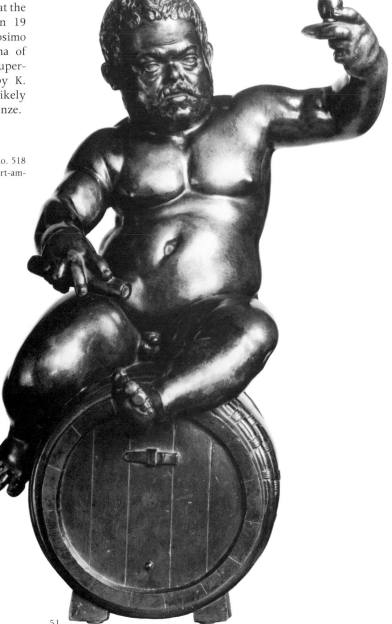

51

52

Morgante standing, blowing a cornetto
h.13
Bronze. Red-brown lacquer, much rubbed and darkened; integral oval base with central fixing pin; the (perhaps originally separately-cast) shaft of the cornetto broken above the hand and repaired.
Victoria & Albert Museum, London (65–1865)

The model, which portrays Morgante (*circa* 1535–after 1594), the ironically-named court dwarf of the Medici, is known in two basic variants: one (variant A) in which, as here, Morgante blows a cornetto which he holds in his right hand while supporting himself with a stick held in his left, and the other (variant B) in which he is personified as Bacchus with a wine cup in his right hand and a bunch of grapes in his left (*e.g.* Berlin and Bargello).

Cat. 52 is the only known complete example of variant A: in other versions the cornetto is either wholly missing (*e.g.* Cat. 53 and Royal Museum, Copenhagen) or lacking the bell (*e.g.* Beit Collection and Martin le Roy Collection). It is closely analogous in facture to the two best surviving versions of the *Peasant resting on a staff* (Cat. 137, 138; before 1601) and shares with them, as do all the best versions of variant A, the integrally-cast oval base with central fixing pin. Examples of variant B are generally of coarser quality and lack the integral base.

The model, in both variants, has variously been ascribed to Giambologna (*e.g.* Bode, 1911, pp. 636, 638 – the Martin le Roy version wrongly captioned as that in Berlin; Bode 1912, pl. CCVII – Cat. 52 wrongly captioned as that in the Bargello; Kriegbaum and Zahle, *Kunstmuseets Aarskrift*, XVI–XVIII, 1929–31, pp. 88, 94, 95) and to Valerio Cioli (*e.g.* Bode, 1930, no. 181; Planiscig, 1930, pl. CCXX, no. 374 – Cat. 52 wrongly captioned as that in the Bargello). The latter ascription was based on comparison with Cat. 50, which was long ascribed to Cioli by analogy with the documented marble by Cioli of *Morgante on a tortoise* (the '*Fontana di Bacco*') in the Boboli Gardens. Since the establishment of Cat. 50 as a work by Giambologna (Keutner, 1956; Holderbaum, 1956), most authorities have agreed that the present model must also by analogy be by him, although Keutner (1956, p. 248, n. 35) speculates on its possible dependence from a hypothetical lost further marble by Cioli of Morgante as Bacchus which might have formed a close pendant to Cioli's marble of Pietro Barbino; (for the Cioli marbles see Gurrieri and Chatfield, 1972, pp. 37, 38, pls. 15, 41). The model does to some extent relate in pose to the two-sided portrait of the young Morgante nude by Bronzino of about 1553 (Uffizi; Holderbaum, 1956, pp. 441, 442, figs 29, 30).

Comparison with Cat. 50 does indeed show that the present model must also be due to Giambologna, and, although Dhanens (1956, pp. 213, 214) dates it earlier, possibly in the 1570s, it seems to show Morgante at about the same age (*i.e.* at about fifty) and must therefore also date from the 1580s. The earliest recorded example of the model is the gilt version of variant A in Copenhagen, which was inventoried in the Danish Royal Cabinet of Curiosities in 1673–74 (Olsen, 1961, p. 103).

FURTHER VERSIONS: A (blowing cornetto): Cat. 53 (the cornetto missing); Royal Museem of Fine Arts, Copenhagen (5599, gilt, the cornetto missing, Olsen, 1961, p. 103, pl. CXXIIIa); Beit Collection (the cornetto broken, B.F.A.C., 1913, p. 59, no. 12, pl. XXX); formerly Martin le Roy Collection (rectangular base, the cornetto broken, Migeon, 1907, pp. 45, 46, no. 22, pl. XII). B (as Bacchus): Museo Nazionale, Bargello, Florence (Dhanens, 1956, fig. 140); Staatliche Museen, Berlin-Dahlem (Bode, 1930, no. 181); Musée du Louvre, Paris (Thiers Collection, Blanc, 1884, p. 18, no. 51); David Peel, London, 1970 (variant with vase on left arm); National-museum, Copenhagen (ABa 24, coarse variant with vase on left arm and vine wreath on head, Olsen, 1961, p. 108, pl. CXXIIIb).
ADDITIONAL BIBLIOGRAPHY: Fortnum, 1876, p. 18
PROVENANCE: Count of Pourtalès-Gorgier (sale, Paris, 7 March, 1865, no. 1593).

A.R.

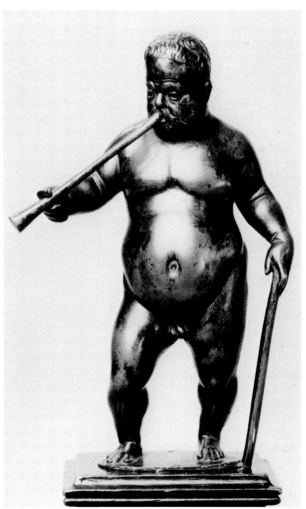

52

53

Morgante standing

h.13 (figure alone)

Bronze. Dark brown patina, traces of black-brown lacquer;
on separately-cast oval base and later rectangular socle; an
object missing from the right hand.

Kunsthistorisches Museum, Sammlung für Plastik und
Kunstgewerbe, Vienna (10.001)

A version of the same model as Cat. 52. It has been
proposed (Leithe-Jasper, 1976, p. 88, no. 86) that the object
now missing from the right hand was a cup, which would
have made the statuette into a personification of Bacchus.
It may, however, have been a cornetto (see Cat. 52).

FURTHER VERSIONS: see Cat. 52.
PROVENANCE: Robert Mayer, Vienna; acquired 1960.

A.R., M.L-J.

54

Dwarf seated ('Luxuria')

by **Valerio Cioli** (1529–99)

h.16.7

Bronze. Chestnut-coloured patina with traces of blackish-
brown lacquer.

Staatliche Museen, Berlin-Dahlem (2583)

Included without qualification under the works of Cioli
(1529–99) by Bode (1930, no. 182) with a suggestion that it
might reflect a model for a fountain. It seems likely that
Morgante is represented, seated amidst the fruits of the
earth, *e.g.* a pumpkin and a bunch of grapes in front, with a
fish in his left hand, resting on a net that is draped over his
knee and round the back, and with his right hand
supporting protectively a raffia-covered flask. The toe-
and finger-nails are incisively chiselled into square shapes.
The facture of the bronze does not recall Giambologna's
workshop. The statuette is included to complete the
iconography of Morgante.

PROVENANCE: gift of Frau Martin Liebermann, 1901.

C.A.

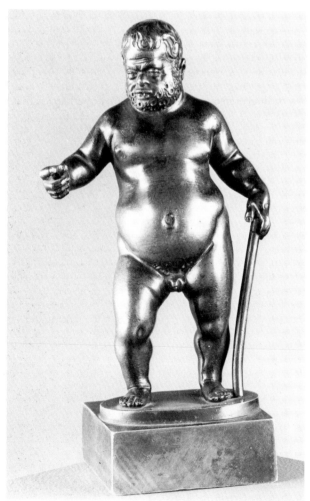

53

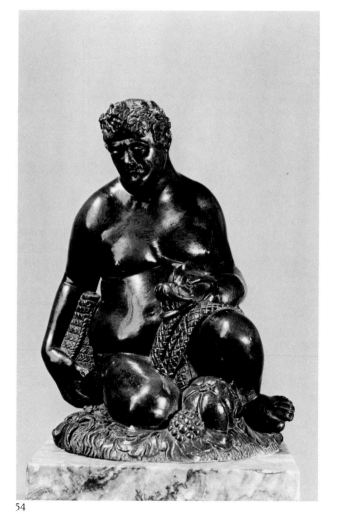

54

55

Morgante seated, small
after **Valerio Cioli** (1529–99)
*h.*7.5
Bronze. Gilded.
Staatliche Museen, Berlin-Dahlem (7107)

This bronze cast showing Morgante astride a missing object is derived from a terracotta model formerly in Berlin (V.360), where he is shown seated on a tortoise, which was probably a sketch for the marble statue of the same subject now at the entrance to the Boboli gardens (Bode, 1930, no. 180). According to Vasari (Milanesi, VII, p. 639) and Borghini (1584, p. 600) the marble was carved for the gardens by Cioli between 1561 and 1568. The statuette is included in the exhibition to complete the iconography of Morgante.

PROVENANCE: anonymous gift, 1911.

C.A.

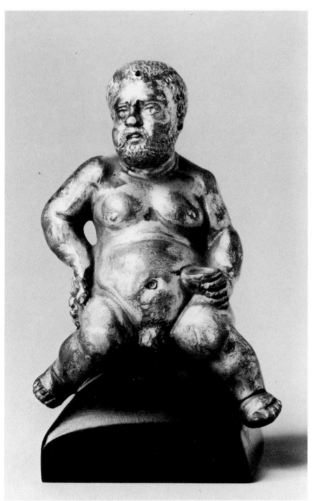

55

56

Rape of a Sabine (two figures)
*h.*99.5 (with bronze base) *h.*98 (figures alone).
Bronze. Modern black patination over remains of light brown or golden lacquer; on original oval bronze base; serious casting flaws between the legs of the Roman and on his left foot, and large bronze patches on the inside of his right thigh; large areas of the bronze left unchased; the first finger of the Sabine's right hand broken away at the first knuckle; left foot of Roman lifted on a pad, right foot sunk into a cavity in the base.
Museo e Gallerie Nazionali di Capodimonte, Naples (10524)

The date of completion of the bronze is documented in a famous letter of 13 June, 1579, from Giambologna to Ottavio Farnese, Duke of Parma, which opens as follows: '*Havevo apunto compito et rinettato il groppo delle due Figure di Bronzo che io promessi a V.Ecc. Ill.ma di volerli fare quin li mandaj il Mercurio e la Femina, et cosi fornitolo d'una basa di Ebano, adorna d'alcune pietre, in due casse l'havevo già consegnato al Condottore, che per la strada ordinaria a Parma liene conducesse ...*' (I have just completed and chased the bronze group of two figures which I promised your most Illustrious Excellency to make when I sent you the Mercury and the Woman. It has been furnished with an ebony base set with stones, and I have already handed it over in two cases to the courier who is to take it by the normal road to Parma ...') (Filangieri di Candida, 1897, pp.20, 21).

In a later passage, which affords a valuable insight into Giambologna's indifference to the nominal subjects of his sculptures, he writes: 'The two above-mentioned figures may be interpreted as the rape of Helen, or perhaps as that of Proserpine, or of one of the Sabine women: the subject was chosen to give an opportunity for the knowledge and study of art. Later he infers that he has attended to the finishing himself and not handed it over to the chaser, who would have disturbed the surface or removed the blemishes with a file: the implication is that the bronze has deliberately been left fairly raw with the flaws undisguised.

The letter strongly implies that this was at the time an entirely new sculpture, and not simply a version of a model which already existed. The character of the bronze bears this out. That it was cast from a modelled wax, and not, as with repetitions, from a moulded wax, is demonstrated most clearly by the surface of the drapery where the textile pattern of the cloth used to support the wax in the model is clearly visible, and there are several other indications of direct modelling.

The bronze is thus probably Giambologna's first essay in the subject of a male figure lifting a female, and the starting-point of a development which was to culminate in the great marble group of the *Rape of a Sabine* unveiled in the Loggia de' Lanzi on 14 January, 1583. However, although the marble group is known to have been already well in hand by October, 1581, the bronze is in no sense a study for it, and it is doubtful whether Giambologna even had a marble in mind when he modelled it. The construc-

tion of the group is conceived entirely in terms of metal sculpture, and, before the subject could be translated into terms of marble, the whole scheme had to be re-thought in a process which can be traced in part through two surviving wax sketch-models (Cat. 225, 226).

But the idea of a two-figure lifting group was in Giambologna's mind a good year before the despatch of this bronze to Ottavio Farnese in 1579, for on 3 July, 1578, Giorgio d'Antonio had been paid for the silver cast of Giambologna's *Hercules and Antaeus* destined for the Tribuna of the Uffizi (see Cat. 87; Churchill, 1913–14, p. 349). That Giambologna's own model for the *Hercules and Antaeus* played a part in his ideation of the *Rape of the Sabines*, is proved by the reproduction in reverse of the figure of Hercules, in the group to the left of centre, in the narrative bronze relief which he later made for the plinth of the marble group in the Loggia, in which the figure of the Roman from the present bronze is also reflected in the group on the right.

One ultimate source for this bronze group was thus the antique marble *Hercules and Antaeus* in the courtyard of the Palazzo Pitti, brought from Rome to Florence in 1560. Another, as demonstrated by Pope-Hennessy (IV, 1970, p. 52), was the Hellenistic marble group of the *Punishment of Dirce* (the 'Farnese Bull', now in Naples) which had, significantly, been a prized Farnese possession since its excavation in 1546 in the pontificate of Paul III (Alessandro Farnese), and was restored by Bianchi in 1579.

Of the other known versions only two appear to be contemporary with Giambologna. One of these (Cat. 57) was in the possession of Emperor Rudolph II. The other is in the Metropolitan Museum of Art, New York (63.197). In sharp distinction from the Naples bronze, both of these show the superbly professional execution and high quality of finish which suggests the intervention of Antonio Susini. Yet they are not merely second casts, but represent a revision of the model, for which Giambologna himself was probably responsible (for an account of this see Cat. 57). The most striking difference between them and the Naples version is in the drapery, which here falls over the left shoulder of the Roman and is freely modelled, while in the other two versions it falls over the right shoulder and assumes the hard schematized forms resembling woodcarving which are more usual in Giambologna's bronzes.

Typical of other versions is one with a bland surface and without the drapery or the oval base in the Victoria & Albert Museum (A.11–1957, *h.*94), which must date from the 19th century. The Naples bronze was exactly reproduced by the foundry of Chiurazzi and De Angelis in Naples in the early part of the present century (*Fonderie Artistiche Riunite, Catalogo*, Naples 1910, p. 175).

ADDITIONAL BIBLIOGRAPHY: Filangieri di Candida, 1898; De Rinaldis, 1911, no. 710; Dhanens, 1956, pp. 232–41; Pope-Hennessy, IV, 1970, pp. 52, 53, 383, 384; Weihrauch, 1967, p. 218.
PROVENANCE: Ottavio Farnese, Duke of Parma, 1579; Farnese collection, Palazzo Farnese, Rome; Charles III Bourbon, King of the Two Sicilies (inherited in 1731 from Antonio Farnese and transferred to Naples in 1737–38); Museo Borbonico, Naples (1738–59).

A.R.

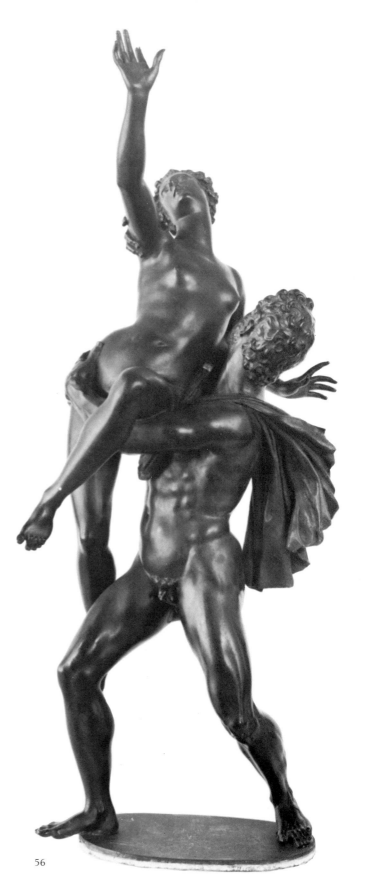

56

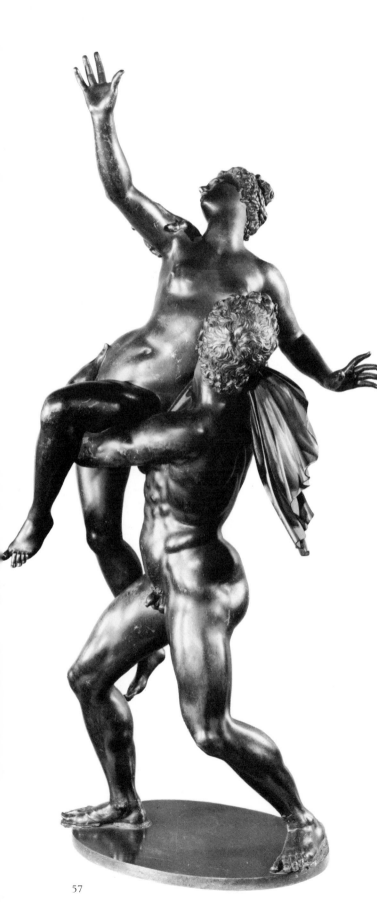

57

57

Rape of a Sabine (two figures)
*h.*98.2
Bronze. Dark reddish-brown varnish, light brown natural patina; large crack on the man's left ankle; the woman's right index finger is broken off.
Kunsthistorisches Museum, Vienna, Sammlung für Plastik und Kunstgewerbe (6029)

A naked, athletically built man with a piece of drapery over his right shoulder is carrying off a naked woman whom he holds aloft; she does not resist, but extends both arms in a plea for help. The oval base is a projection onto the horizontal plane of the spiral upward movement from the man's left foot to the woman's right hand; the man strides powerfully forward and, bending slightly at the knees, gives a ballet-type impetus to the raised figure. In this abduction scene Giambologna created a motif which influenced sculptors as late as the 18th century.

For the origin of the composition in 1579 see Cat. 56. This date of origin no doubt also applies more or less to the Vienna group; this, however, is by no means a mere re-cast of the same model but differs appreciably from the Naples bronze.

In the Vienna group the torsion of two bodies is stronger and the spiral movement more pronounced. This effect is enhanced by the fact that the man has both his feet within the circumference of the oval base, giving a rotatory effect, whereas in the Naples version the base is smaller and half his right foot projects over the edge, giving the impression of hastening forward. In that version the woman's body is slightly more upright and the drapery falls over the man's left shoulder, which is towards the spectator, so that the effect is rather that of sculpture to be seen from the front. The male figure in the Naples version is also closer to the model in the '*Farnese Bull*' group. We may thus suppose that the version executed for Ottavio Farnese was the original form of the composition and that Giambologna then improved it into the Vienna group, which is equally effective from every angle. There are also small variations of detail: *e.g.* in the Vienna version the woman's hair is embellished with plaits, but her diadem is simpler in style.

FURTHER VERSIONS: see Cat. 56.
BIBLIOGRAPHY: Planiscig, 1924, p. 155, no. 258; Leven, 1971, no. 4; and see Cat. 56.
PROVENANCE: the group was certainly in the possession of Emperor Rudolph II and is to be identified with no. 1901 of the Rudolph *Kunstkammer* inventory (Bauer and Haupt, 1976, p. 100). Through his brother and heir Matthias it then came to the Vienna *Kunstkammer* or the *Kaiserliche Schatzkammer*.

M.L.-J.

58
Rape of a Sabine (three figures)
h.59
Bronze. With golden-brown lacquer.
Bayerisches Nationalmuseum, Munich (52/118)

The statuette appears to be an excellent Florentine cast probably from the early 17th century. It is a reduction from Giambologna's celebrated marble group in the Loggia dei Lanzi, Florence (see this Catalogue introduction, fig. repr. p. 15; see also Cat. 59). It has been thoroughly catalogued by Weihrauch (1956, no. 110), who remarks that none of the known examples of the three-figure *Rape of a Sabine* is autograph work, and a good number of them are probably to be associated with Gianfrancesco Susini, whom Baldinucci records as having produced the model (Ranalli, IV, p. 118). The present reduction is extremely accurate in details and facial expressions, which are carefully chiselled. The old inventories of the House of Hessen have been destroyed and so it is not possible to determine which of the art-loving Landgraves acquired the bronze for Kassel.

FURTHER VERSIONS: Palazzo Corsini, Rome (662, *h*.64, engraved *P.C.*; from the old Corsini collections); Museo Nazionale, Bargello, Florence (Bode, III, 1913, pl. 186); Liechtenstein collection (Tietze-Conrat, 1917, p. 19); Albertinum, Dresden; Wallace Collection, London (Mann, 1931, S113); Henry Hirsch sale, Christie's 10–11 June, 1931, no. 143, signed (according to Holzhausen, 1933, p. 56,*I.B.*), but judging from the illustration the group (the location of which is not known) is not very distinguished.
ADDITIONAL BIBLIOGRAPHY: H. Keutner, 'Giovanni Bologna: Der Raub der Sabinerin', *Kunstwerke der Welt aus dem öffentlichen bayerischen Besitz*, Munich, 1966, pp. 239–40.
PROVENANCE: Landesbibliothek, Kassel; art market, The Hague; acquired 1952.

C.A.

59
Rape of a Sabine
h.59.5
Bronze. Brown varnish, brown natural patina. Cracks on the arms of the cowering figure.
Kunsthistorisches Museum, Vienna, Sammlung für Plastik und Kunstgewerbe (5899)

This statuette derives from Giambologna's monumental three-figure marble group of the *Rape of the Sabines* executed in the early 1580s and unveiled on 14 January, 1583. Like the many other replicas which have survived, it is certainly a reduction of that work and not a preliminary study for it, as are the two-figure bronze group (Cat. 56, 57) and the wax models (Cat. 224, 225). The colossal group in the Loggia dei Lanzi was so universally celebrated that a demand for copies arose on every hand. The Emperor Rudolph II possessed a bronze group of this kind: '*Ein gruppo nach dem Giovan Bolonia so er zu Florentz von weissem marmo gemacht, sein 3 figurn von bronzo, ist ein rabimento Sabine.*' ('A bronze group of three figures, a Rape of the Sabines, after the white marble one by G.B. in Florence'). Whether this bronze can be identified with the group still in Vienna cannot as yet be determined with certainty, and its date is also an open question, for the Vienna group differs from the other surviving replicas in several respects: the separately cast, naturalistic base with flowers and lizards, the careful, rather finicky chasing, the youth's stubbly beard, the woman's punched diadem and the softer treatment of the strands of hair.

BIBLIOGRAPHY: Planiscig 1924, p. 155, no. 157; Dhanens 1956, p. 239; Weihrauch 1956, p. 86; *id*. 1967, p. 219.
PROVENANCE: old Imperial possession, but not certainly from the collection of Emperor Rudolph II. However, in 1802 the group came from Schloss Belvedere in Vienna to the Imperial Collection of Coins and Antiquities, whence the Museum acquired it in 1880.

M. L–J.

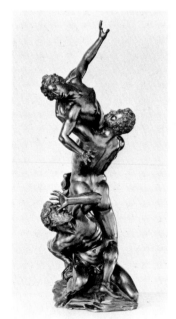

58

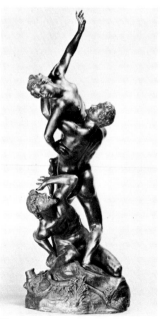

59

Nessus and Deianira

General note

Bronzes of this subject which can be related directly to the style of Giambologna fall into three basic types, here designated *Type A, Type B* and *Type C*. Each of these types represents a completely distinct model, and within each type there are variant versions. Versions of *Type A* are normally around 42 cm in height (*e.g.* Cat. 60–3, 65), although some (*e.g.* Cat. 64) are a little smaller, versions of *Type B* (*e.g.* Cat. 66) are on the same scale, while all versions of *Type C* are on roughly twice the scale, around 80 cm in height (*e.g.* Cat. 67).

The earliest published document for a representation of *Nessus and Deianira* by Giambologna is an entry in the Salviati family papers of 30 April, 1577, recording payment to Giambologna for a bronze centaur (G. Pampaloni, *Il Palazzo Portinari-Salviati*, Florence, 1960, pp. 48, 49, repro. pl. XIII). In a letter of 27 October, 1581, to the Duke of Urbino Simone Fortuna mentions statuettes of a centaur by Giambologna, half a *braccio* high, in the collections of cavaliere Gaddi and Jacopo Salviati (Dhanens, 1956, p. 346). In the inventory of 1609 of the inheritance of Jacopo Salviati's son Lorenzo the Salviati centaur mentioned by Fortuna appears described as '*Un centauro di bronzo con una femina addosso, di mano di Gio. Bologna . . .*' (A centaur of bronze with a woman on his back, by the hand of Giambologna . . .). Later in the same inventory there appears '*Un centauro di bronzo con una femina in braccio di mano del Susini . . . , e detto centauro e di altezza di braccia 0/2 incirca.*' (A centaur of bronze with a woman in his arms by the hand of Susini . . . , and the said centaur is about half a *braccio* in height) (Watson and Avery, 1973, p. 504, inventory nos. 954, 1078).

Baldinucci cites the *Nessus and Deianira* in his list of bronzes produced from models by Giambologna (Ranalli, II, p. 583) and in his list of those reproduced by Gianfrancesco Susini (Ranalli, IV, p. 118). He also makes three other significant mentions of the subject. In his life of Antonio Susini he relates that Susini made a bronze *Nessus and Deianira* from Giambologna's model, which Giambologna himself so admired that he sent Pietro Tacca to buy it from him for two hundred *scudi*, and that as a result of this Susini cast many more which he sold for the same price (Ranalli, IV, pp. 110, 111). This must have occurred after about 1600, when Susini left Giambologna's studio and set up his own shop. In his life of Giambologna Baldinucci states that Giambologna made several studies of centaurs, and singles out for special mention one, intended to be cast in bronze, of which the casting never took place, and the model for which was still standing in his studio at his death (Ranalli, II, p. 572). Finally, in his life of Pietro Tacca he relates that Tacca was commissioned by Cosimo II in 1609 to make a bronze *Nessus and Deianira* for the fountain of S. Croce, but that this project was later abandoned because of the pressing need for Tacca to finish the equestrian statue of Henri IV for Paris (Ranalli, IV, p. 85).

Turning from the documents to the known bronzes of the subject, an apparent problem arises: Fortuna states in his letter of 1581 that the versions in the Gaddi and Salviati collections were half a *braccio* high. If this were an accurate measurement, it would indicate a height of 29.2 cm, somewhat smaller than the known small bronzes. However, in the same letter he refers to the statuettes of the *Labours of Hercules* (Cat. 75–87) as being half a *braccio* high. These in fact average much the same height as the small bronzes of *Nessus and Deianira*, and it would seem that we have to do here merely with an approximate estimate of scale.

Three examples of *Type A* are signed (none of *Types B* and *C* is signed), Cat. 60, 61 and another in San Marino, California (see below), and it is clear that this type represents an authentic model by Giambologna. The earliest known date-able version of *Type A* is Cat. 61, which is recorded in the *Kunstkammer* of Christian I of Saxony in 1587. The three signed versions differ from each other in details, Cat. 61 being closest to the form in which the type was commonly reproduced. It seems possible that Cat. 60 and the version in San Marino are earlier versions. Landais (1958, p.67) tentatively suggests that they might be the Gaddi and Salviati bronzes. The idea is attractive, but cannot be substantiated. However, the Gaddi and Salviati bronzes must have been of *Type A*.

Type B (Cat. 66) is less commonly encountered. It represents a fundamental revision of the model in which Deianira does not sit on the back of Nessus as in *Type A*, but is clasped in his arms across his back and struggles violently to free herself. This appears to be the type described in the Salviati inventory of 1609 quoted above, under no. 1078, as 'a centaur who holds a woman in his arms by the hand of Susini': the description is clearly differentiated from that in the earlier mention of the bronze by Giambologna: 'a centaur with a woman on his back'. It seems likely that *Type B* derives from a late model made at the time when the ageing Giambologna was becoming increasingly dependant upon Susini for the execution of his models in bronze. Perhaps it was a version of this type which so pleased him that he sent Pietro Tacca to buy it for him from Susini.

In the much larger bronzes of *Type C* (Cat. 67) the composition of *Type A* is reversed. It may be that this type reflects the model which Baldinucci states was left uncast in Giambologna's studio at his death, since the special mention of this model seems to indicate a version on a larger scale than normal. However, the *Type C* bronzes relate very closely to the style of Pietro Tacca, and it is possible that the model originated in connection with Tacca's abortive project for the fountain of S. Croce, commissioned in 1609.

The question of a possible marble version of the subject is too complex and fraught with uncertainty to be dealt with here. It remains to be noted that in Pietro Tacca's workshop in the Borgo Pinti on 15 June, 1635, there was a '*Macchina del modello di nesso centauro . . .*' The word *macchina* would appear to indicate a metal armature prepared for a model. A painting by Sebastian Vrancx at Naples (Gallerie Nazionali di Capodimonte; De Rinaldis, 1911, no. 600; repro. C. Mignot, *Revue de l'Art*, 19, 1973, Fig. 18) of the gardens of the Villa Medici in Rome shows a colossal bronze version of *Type A* on a plinth in the central fore-ground. No such colossal version has survived, and there is no mention of any such group in documents relating to the Villa Medici. The painting is dated 1615. Vrancx (1573–1647) is known to have visited Italy in 1591, but was back in Antwerp by 1600, when he is recorded as matriculating in the guild of painters. He is not known to have revisited Italy, and the painting may have been a partial fantasy in which Vrancx used a small bronze of *Type A* as his model.

While it is frequently stated that the *Nessus and Deianira* of *Type A* was designed as a pendant to Giambologna's *Hercules and a centaur* (Cat. 81), there is no early evidence for such a pairing, although they must have originated at roughly the same time (the earliest notice of *Hercules and a centaur* is in 1576).

A.R., C.A.

110

60

Nessus and Deianira (Type A)

*h.*42.1

Bronze. Dark red-brown lacquer; on old bronze socle.
Engraved (on the fillet around the head of Nessus): *IOA BOLONGIE*: on the left buttock of Nessus: *No 176*.
Musée du Louvre, Département des Objets d'Art, Paris

The present bronze is one of three signed versions of *Type A*, in which Deianira sits along the back of Nessus with both arms flung out, while Nessus clasps her round the breast with his right arm and with his hand secures her to his back with a piece of drapery passed around her body. A version from Dresden (Cat. 61) is signed under the base '*I.B.*', while the third signed version, in the Huntington Collection, San Marino, California (Wark, 1959, pp. 63, 64) is signed on the fillet around the head of Nessus 'IOANES BOLOGNA'. The Dresden bronze is recorded in the inventory of the *Kunstkammer* of Christian I of Saxony of 1587 (see Cat. 61), but the present bronze is first documented only in 1693, when it was given to King Louis XIV of France by André Le Nostre (Guiffrey, 1911, p. 224; Landais, 1949, p. 63). The three signed versions differ from each other considerably in detail. The drapery forms are different in each case. The Dresden and San Marino bronzes stand on oval bronze bases which are certainly original, since the signature on the Dresden bronze appears under the base, while the present bronze stands on a large moulded bronze socle of a unique type which may also be original. A notable feature of the present bronze is the form of the tail. In the other two signed versions the tail is in the regular form in which the model was reproduced, while in the present bronze it is in a less developed form which is apparently unique. This might perhaps be taken to indicate an earlier origin for the present bronze than for the other two.

FURTHER VERSIONS: Cat. 61, 62, 63; Kunsthistorisches Museum, Vienna (5849; Planiscig, 1924, no. 263); Schloss Pommersfelden (silver cast; communication from Dr Hans Weihrauch); Victoria & Albert Museum, London (A.146–1910, Radcliffe, 1966, pl. VI; late cast); Bayerisches Nationalmuseum, Munich (11/1, Weihrauch, 1956, no. 125); Georges Salmann, Paris (variant with drapery falling to the ground); Galleria Colonna, Rome (on a cabinet of 1680 by the brothers Stainhart, repr. Weihrauch, 1967, p. 469, fig. 557).

ADDITIONAL BIBLIOGRAPHY: Migeon, 1904, no. 151; Landais, 1958, p. 116, pl. XXV; Dhanens, 1956, pp. 200–3; Weihrauch, 1967, pp. 220, 221.

PROVENANCE: André Le Nostre; given to King Louis XIV of France in 1693; French Crown collections.

A.R., C.A.

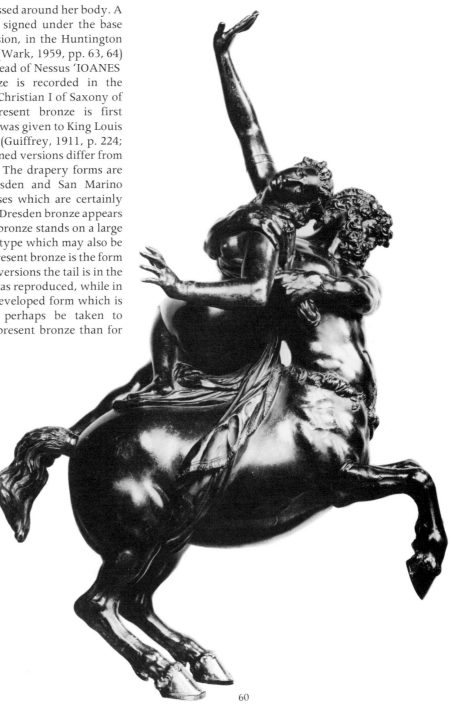

60

Nessus and Deianira (Type A)
*h.*42.8
Bronze. On oval bronze base.
Chased under the base: *I.B.*
Staatliche Kunstsammlungen, Skulpturensammlung,
Dresden (H.23/95)

The autograph nature of this bronze is secured by the signature under the base, and furthermore it is attested to by an entry in the first inventory of the Dresden *Kunstkammer* of 1587, which states that the Elector Christian I of Saxony had received the work as a gift from the Duke of Florence (Holzhausen, 1933, pp. 54–7). Further signed examples are found in the Louvre (Cat. 60) and in the Huntington Art Gallery in San Marino, California (Signed: *IOANES BOLOGNA.*, *h.*41.5, Wark, 1959, pp. 63–4).

We learn from a letter that the art agent Simone Fortuna wrote to Duke Francesco Maria II of Urbino on 27th October, 1581, that statuettes *'d'un Centauro'* were then to be found in the possession of the Gaddi and Salviati families. That in this instance *'Centauro'* refers not to a *Hercules and a centaur* (Cat. 81, 82) group, but to the *Nessus and Deianira* emerges from a hitherto unknown document preserved in the archives of the Salviati family, according to which the casting and finishing *di un Centauro che rapisce una Donzella di Bronzo di Giambologna'* had been under way since December, 1575. Thus the model must have been made in the autumn of 1575, around the same time as the master's first designs for his series of the *Labours of Hercules* (Cat. 75–87).

Using both arms the centaur tightly holds the frightened, struggling Deianira on his back and, with raised front legs, rides off at full speed. In the invention of the galloping Nessus, Giambologna might have relied upon previous works that are no longer extant, perhaps even on his first model of a horse, about 120 cm high, which he designed in 1562–3 (Siena, Bibl. Com., Misc. Milanesi, vol. XV, fol. 157). In any event, he surely drew upon his designs for four over life-size rearing horses which he had made in stucco for the quadriga on a triumphal arch in 1565 (P. Ginori Conti, *L'apparato per le nozze di Francesco de' Medici e di Giovanna d'Austria*, Florence, 1936, pp. 46–51).

A small marble equestrian group carved either by Giambologna himself or under his direct supervision is documented for the year 1591, and this work, which corresponds to his autograph bronzes, is now in a Canadian private collection, where it unfortunately survives only in a fragmentary state without the legs of the centaur and the arms of Deianira (*h.*24.1).

FURTHER VERSION: see Cat. 60.
ADDITIONAL BIBLIOGRAPHY: Raumschüssel, 1963, no. B15; and see Cat. 60.
PROVENANCE: old Electoral collection, Dresden.

H.K.

Nessus and Deianira (Type A)
*h.*40.8
Bronze. Reddish-brown, partly transparent lacquer, light brown patina. The third and fourth fingers of Deianira's right hand are broken off.
Kunsthistorisches Museum, Vienna, Sammlung für Plastik und Kunstgewerbe (5847)

One of the best in quality of the many versions of this model, signed examples of which are in Paris (Cat. 60), Dresden (Cat. 61) and San Marino, California. The present version differs from these, however, not only by its sharper modelling but in details such as the drapery, the torsion of the figures and the sharper angle at which Nessus is rearing.

BIBLIOGRAPHY: Planiscig, 1924, p. 162, no. 264; Leithe-Jasper, 1976, p. 87, no. 84; Bauer and Haupt, 1976, p. 100, no. 1882.
PROVENANCE: the group was probably in the possession of Emperor Rudolph II and is possibly to be identified with nos. 1882, 1896 or 1734 of the inventory of his *Kunstkammer*. Through his brother and successor Matthias it found its way to the Vienna *Kunstkammer* or *Schatzkammer*.

M.L.-J.

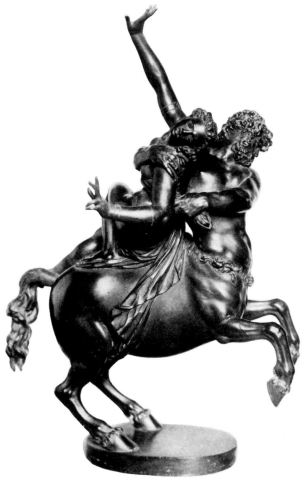

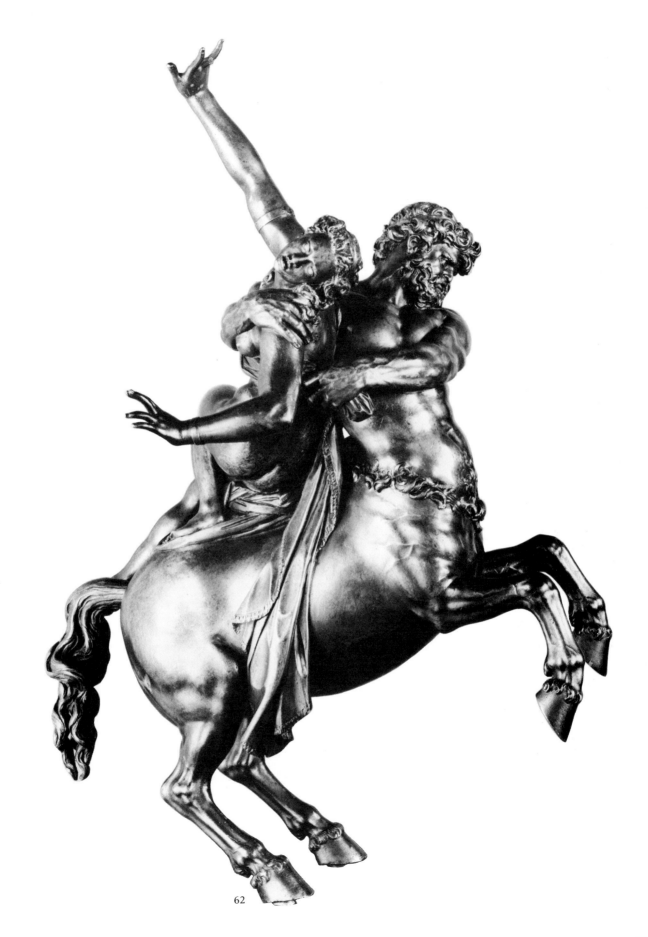

62

63

Nessus and Deianira (Type A)

*h.*38

Bronze. Rough cast and flawed, without afterworking. Black patination. Thumb of Deianira's right hand and two fingers of her left hand broken. Cleaned in 1968.
Nationalmuseum, Stockholm (340)

The inventory of the collection of Queen Christina (1652) contains four bronzes, with slight variations, described as *'un centaur ayant entre les bras une femme'*, which probably came from Prague.

The Stockholm bronze comes very close to the signed groups in Vienna (Cat. 62) and Dresden (Cat. 61). The modelling is very fine, indicating that the group was at least modelled in the work-shop of Giambologna during his life-time. The cast shows some faults which may be the reason why the group was not chased. The unchased state raises the question of its provenance. It seems improbable that an unfinished work was sold or left the work-shop as a gift to any important patron. Perhaps it was kept by one of the assistants, who brought it to Germany or Prague.

ADDITIONAL BIBLIOGRAPHY: Nationalmuseum, Stockholm, *Peintures et sculptures des écoles étrangères*, Stockholm, 1958, no. 340.
PROVENANCE: Probably in the collection of Queen Christina in 1652; The Royal collection at Drottningholm in 1777; 1865 to the Nationalmuseum.

L.O.L./C.A.

64

Nessus and Deianira (Type A)

*h.*37.8 *w.*28.3 *d.*14.7

Bronze. Golden, translucent patination.
Musée Municipale de la Chartreuse, Douai

See Catalogue number 60. Possibly a cast by Antonio Susini (Leroy, 1937, no. 858). Cited by Desjardins (1883, p. 132, n. 1) as having been in the Bartolomei collection until 1846 (see below).

PROVENANCE: Palace of the Marchesi Bartolomei, Florence until 1846; Foucques de Vagnonville collection; bequeathed to the museum in 1877.

C.A.

65

Nessus and Deianira (Type A)

*h.*43.1

Bronze. Light gold-brown lacquer, now much darkened.
Lent anonymously

The bronze is a variant version of the *Type A* model. Here the tail is completely re-modelled in a more lively form, and the falling drapery is re-constructed so as to swing upwards and backwards, giving a more dramatic effect. The same variations occur in the version from Douai (Cat. 64). The tendency visible here towards a more spirited rendering of movement recalls the style of Gianfrancesco Susini, whom Baldinucci records as having reproduced this subject (Ranalli, IV, p. 118), and the high quality of execution and chasing is consistent with that found in his mature signed bronzes (*e.g.* Cat. 190, 191).

PROVENANCE: Baron Mayer Amschel de Rothschild, Mentmore Towers, Buckinghamshire; Hannah de Rothschild: Earls of Rosebery; sale, Sotheby, Mentmore Towers, 18 May, 1977, no. 325.

A.R., C.A.

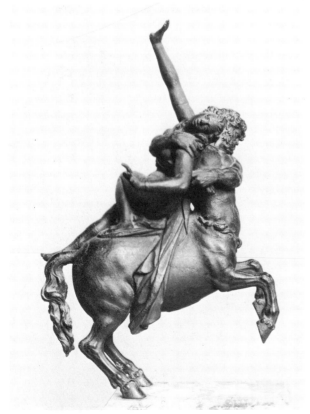

63

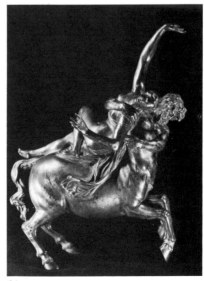

64

66

Nessus and Deianira (Type B)
*h.*43.5
Bronze. Red-brown lacquer, rubbed and darkened, brown
natural patina.
Cyril Humphris, London

The bronze represents the second basic type of small-scale
Nessus and Deianira, here designated *Type B*. The model,
which is much rarer than *Type A* (Cat. 60–5), is not merely a
variant, but is the result of a fundamental revision of the
composition in which the dramatic content of the subject is
much more strongly stressed. Here Deianira does not sit on
the back of Nessus with her outstretched leg lying straight
along his back, but is placed across his back in a much less
stable pose, supporting herself only on her left foot, while
her right leg swings out down his flank. Instead of merely
appealing for help, as in *Type A*, she seems here to be
struggling to escape. Nessus, instead of looking straight
ahead, turns to look at her. He grasps her firmly round the
waist with his right arm and grips her right shoulder with
his left hand. His tail swings upwards and splays out, and
the drapery, instead of hanging rather slackly down both
his flanks, swings down his left flank and up under his
belly. Not only is the composition more dramatic, but it is
more tight-knit and circular.

There is no evidence for the date at which this revised
composition originated, but it must have been consider-
ably later than *Type A*. The most important document for it
is the volume of engravings made of the collection of
François Girardon in 1710, where a version of this type is
clearly represented from both sides (Charpentier 1710, pl.
II, no. 3; Souchal, 1973, p. 71) and the caption reads
'*Groupe de Bronze du Ravissement de Déjanire par le*

*Centaure Nessus fait par J. de Boulogne réparé par A.
Soucine*', indicating that the bronze was moulded and cast
by Antonio Susini from a model by Giambologna.
Girardon's bronze was almost certainly identical with one
listed in the inventory after death of Cardinal de Richelieu,
1643 (Boislisle, 1881, p. 88, no. 60), which is described in
similar terms, and with the same ascription. There seems to
be no good reason to doubt the accuracy of this perfectly
specific ascription of the model to Giambologna, since this
brilliant composition appears to be absolutely in line with
his thinking in the later years of the 16th century, when he
was becoming increasingly dependent upon Antonio
Susini for the execution of his models in bronze.

A version of the model appears on the central table in
the painting by Willem van Haecht the Younger of the
Gallery of Cornelis van der Geest in Antwerp (before 1620;
Rubenshuis, Antwerp). A version in the Louvre, formerly
in the collection of King Louis XIV (OA 9520, Crown
inventory No. 175) is tentatively identified by Landais
(1961, p. 139, fig. 1) with that formerly in the Richelieu and
Girardon collections.

The present bronze is of a facture and quality consistent
with its having been cast and chased by Antonio Susini, as
is the version in the Louvre.

FURTHER VERSIONS: formerly collection of Princess Wsevolojska, St
Petersburg (acquired from the Niccolini family in Florence in 1845;
Desjardins, 1883, pp. 129–32); Wallace Collection, London (S117, Mann,
1931, pp. 44, 46; later variant with drapery falling to the ground);
collection of Graf Waldburg, Schloss Assumstadt (Weihrauch, 1967, fig.
261; similar to Wallace version); Bayerisches Nationalmuseum, Munich
(R3235, Weihrauch, 1956, no. 124; French early-18th-century cast).
ADDITIONAL BIBLIOGRAPHY: Weihrauch, 1967, p. 221.
PROVENANCE: Robert Strauss collection (sale, Christie, London, 3 May,
1977, no. 98).

A.R., C.A.

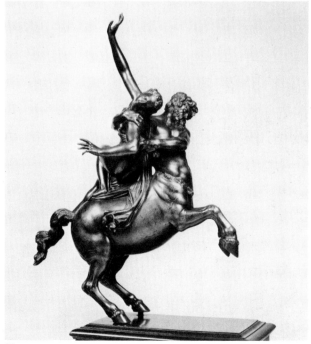

65

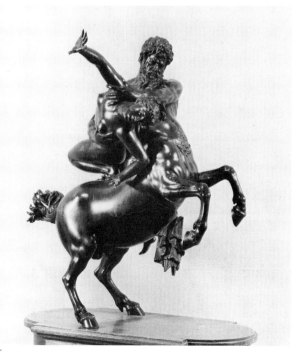

66

67

Nessus and Deianira (Type C)
*h.*86.5
Bronze.
Engraved: *No 305.*
Musée du Louvre, Paris, Département des Objets d'Art
(OA 9480)

The bronze represents in this exhibition a distinct class of representations of *Nessus and Deianira*, here designated *Type C*. All the many known versions and variants of *Type C* are about 80 cm or more in height, that is, about twice the size of the normal versions of *Type A* (Cat. 60–3). The composition is related to that of *Type A*, but in reverse: here Nessus holds Deianira to the left of his body instead of, as in *Type A*, to the right, and there are further, less basic, variations: Deianira uses her lower arm to support herself with one hand on Nessus's back, and the drapery, instead of flowing down Nessus's flanks, is less voluminous and is more compactly held under Deianira's body.

Of none of the versions of *Type C* is there an explicit notice earlier than the 18th century. The present bronze was first inventoried in the collection of King Louis XIV of France in 1713. A somewhat smaller version in the Skulpturensammlung, Dresden (*h.*76.5), with less elaborated draperies and a more developed tail, stands on a plinth of breccia marble which bears the inscription '*IOANNIS BOLONIAE MAGNI HETRUR. DUCIS SCULPTORIS*'. As noted by Holzhausen (1933, pp. 63–5) this inscription, while it brings the bronze into relationship with Giambologna, does not amount to a signature. The Dresden version was engraved in the early 18th century by Felippo Vasconi when it was in the possession of the Venetian dealer Valentino Nicoletti (the engraving, in the Kupferstichkabinett, Dresden, shows the same inscription on the plinth), and Holzhausen concludes that the bronze was purchased by Le Plat in Venice in 1722–23 for Augustus the Strong.

Most of the versions of *Type C* approximate fairly closely to the model of the present bronze with minor variations in the form of the tail and the drapery. However, two versions stand out from the rest as representing a quite distinct variant of the model. One of these is in the Frick Collection, New York (15.2.49, *h.*88.3) and the other in the State Hermitage, Leningrad (*h.*86, Androsov, 1977, no. 28). That in the Frick Collection was related by Levi d'Ancona (*The Frick Collection Catalogue*, VI, New York, 1954, pp. 23, 24) to Adriaen de Vries, and the suggestion was tentatively accepted by Pope-Hennessy and Radcliffe (Pope-Hennessy and Hodgkinson, 1970, pp. 40–5). However, the analogies drawn with de Vries's group of *Hercules, Nessus and Deianira*, dated 1622, now at Drottningholm (Larsson, 1967, p. 120, no. 17, fig. 179) are not convincing. The precise, clean modelling of the Frick bronze is quite distinct from the soft and generalized handling of de Vries, and the spirited treatment of the tail is in sharp contrast to the compacted and limply hanging tail of de Vries's centaur. The modelling and the facture of the Frick bronze in fact testify to a Florentine origin, as do those of the

Leningrad bronze. Close parallels for the treatment of the tails, with their differentiated and dispersed strands, and for the swirled ends of the drapery at the backs of these two bronzes, are to be found in the equestrian portraits on rearing horses by Pietro Tacca, for example that of Carlo Emanuele of Savoy (Cat. 163: note the swirled end of the sash), and it seems clear that the Frick and Leningrad variants of *Type C* must be by Pietro Tacca.

The equestrian portrait of Carlo Emanuele is datable to 1619–21, but there is evidence to show that Pietro Tacca had so far emancipated himself from the style of Giambologna as to have evolved the type by 1615 (see Cat. 135).

The problem of the origin of the other versions of *Type C*, represented by the present bronze, remains. The type has been connected with the mention by Baldinucci (Ranalli, II, p. 572) of a model for a bronze of Nessus and Deianira which was never cast, and was still in Giambologna's studio at his death, and that this does not refer to either of the small variants, *Type A* or *B*, seems clear. What does appear to have relevance in the present instance is Baldinucci's statement (Ranalli, IV, p. 85) that in 1609

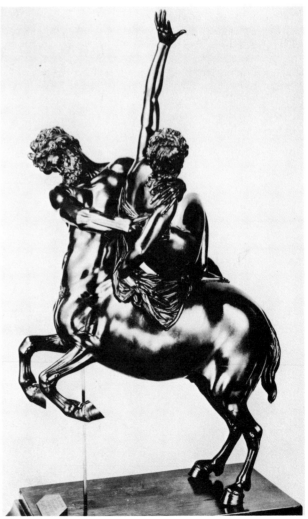

67

Pietro Tacca was commissioned by Cosimo II to make a model of *Nessus and Deianira* to be cast in bronze for the fountain of S. Croce. This project was later abandoned because of the pressing need for Tacca to finish the equestrian monument to Henri IV for Paris. Baldinucci confusingly says that this was in the lifetime of Giambologna, who had actually died in 1608. However, what emerges is that, either shortly before or just after the death of Giambologna, Pietro Tacca embarked on a project for a bronze fountain group of *Nessus and Deianira*.

It is correctly noted by Holzhausen that the hair-style of Deianira in the bronzes of *Type C* is not characteristic of Giambologna himself, and indicates a later hand. It should also be noted that the angle at which Nessus rears, steeper than in *Type A*, and the arrangement of his forelegs are closely paralleled in Pietro Tacca's equestrian portraits of rearing horses. It would appear to be likely, therefore, that *Type C* originated with Pietro Tacca, possibly in the first instance in connection with the S. Croce fountain project.

It would seem that the present bronze represents the original model, while the Frick and Leningrad bronzes represent a more developed and emancipated later variant model.

Amongst other known examples Holzhausen singles out one in the Wallace Collection (S114, *h*.89.1, Mann, 1931, pp. 43, 44) on an original oval bronze base closely resembling that of Cat. 61 as being probably an early version. This is possibly correct.

FURTHER VERSIONS: Staatliche Museen zu Berlin (K.-F.-M.-V.38, *h*.81, Bode, 1930, no. 165); private collection, Denmark (on loan to Statens Museum for Kunst, Copenhagen, *h*.83, Olsen, 1961, p. 104, pl. CXXVIb).
ADDITIONAL BIBLIOGRAPHY: Dhanens, 1956, p. 202.
PROVENANCE: King Louis XIV of France (inventory of 1713, no. 305); French Crown collections; given by L. Guiraud, 1949.

A.R., C.A.

68
Europa and the bull
h.32.5 *l*.30.5
Bronze. Black lacquer
National Trust, Ickworth, Suffolk

The model was clearly designed as a pendant to Giambologna's group of *Nessus and Deianira* (Cat. 60–7), for the pose of the woman on the back of the quadruped is analogous. Indeed, such a pair with identical facture and patination exists in the Museo di Palazzo Venezia (Santangelo, 1954, pp. 54, 56: PV9285, PV9286). It is not clear however whether it originated in Giambologna's or Susini's workshop, for none of the four examples at present known has their characteristic facture, or indeed their artistic quality, though the type of the bull is related to the standard pacing version (Cat. 177, 178). The casting of the present example is thin and light, while the fixing of Europa and her drapery to the bull's back is not satisfactory. Dhanens (1956, p. 203) includes the model as by Giambologna, despite the complete lack of documentation. There is a waxy quality to the modelling which conveys the impression that the bronzes may have been cast from an original wax model, but the flaccid folds of the drapery are uncharacteristic of the Florentine workshop.

FURTHER VERSIONS: Museo Nazionale, Bargello (no. 433, *h*.32.6, see Dhanens, 1956, fig. 127); Museo di Palazzo Venezia, Rome (PV9285, *h*.26.5, Santangelo, 1954, p. 54, formerly Barsanti collection); private collection, Chicago (*h*. approx. 30; exhibited at the Art Institute of Chicago, *Small Bronzes from Chicago Collections*, 1972).
PROVENANCE: Frederick Augustus Hervey, 3rd Earl of Bristol and Bishop of Derry (d. 1803).

C.A.

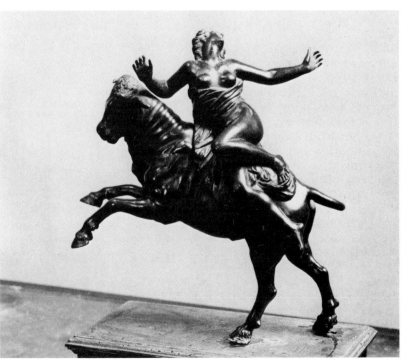

68

† 69

Sleeping nymph with satyr
*h.*21 *l.*31
Bronze.
Staatliche Kunstsammlungen, Dresden, Grünes Gewölbe
(IX, 34)

Although it is not a nymph's custom to sleep upon a *chaise longue*, the name of this group has nonetheless come down in this way for centuries. In 1611, in the possession of the Augsburg alderman Markus Zeh, it was described for the first time as *'Un gruppo d'una nimpha che dorme con un satiro appresso'* (Döring, 1894, p. 97). Both patron and sculptor, however, may have perhaps had in mind a representation of 'Venus and a Satyr', or even 'Jupiter' (in the guise of a satyr) 'and Antiope'. For this composition Giambologna could have drawn upon an extensive tradition of artistic representations of the theme reaching back to the Quattrocento, mainly in paintings and engravings. The figure of the half-lying, half-sitting nymph, her arm laid over her head, is usually thought to result from the sculptor's intense interest in the so-called Cleopatra (*i.e.*, Ariadne) in the Vatican (Weihrauch, 1967, pp. 210–12).

Among the examples known at present this is the only one documented in Giambologna's lifetime, for it is listed in the first inventory of the Dresden *Kunstkammer*, made in 1587 (Holzhausen, 1933, p. 55). We have a *terminus ante* for the invention of the composition in a further document of 1584, according to which Francesco I sent his brother,

Cardinal Ferdinando, then residing in the Villa Medici in Rome, *'(une femina) nuda in atto di dormire'* (A. S. F. Guard., f. 79, fol. 37v.; Dhanens, 1956, p. 187). Even though no satyr is mentioned in this notice, we can, and, indeed, should connect it with an example (possibly incomplete) of our bronze, for in Giambologna's *oeuvre* there is no instance of an isolated sleeping female small bronze.

Exactly when before 1584 the composition of the group originated is unknown. The Dresden example could, at the earliest, have entered the *Kunstkammer* in 1577, when Francesco I visited the Elector of Saxony. Both the theme and the style of the group permit one to suppose that it originated in the mid-1570s, at a time when Giambologna was engaged in the decoration of the grottoes in the garden of Pratolino, as well as in designing the groups of *Nessus and Deianira* and the deeds of Hercules. The differentiated patination of the two figures – the nymph is light-skinned and the satyr dark, according to an antique tradition definitely current in the Cinquecento – also lends support to a dating in the mid-1570s, for, at this time, in other works the sculptor also incorporates similar colour contrasts into his artistic calculations, through the use of different kinds of materials.

FURTHER VERSIONS: see Cat. 72.
ADDITIONAL BIBLIOGRAPHY: Bode, 1912, p. 4; Raumschüssel, 1963, p. 212, B 16.
PROVENANCE: old Electoral collections, Dresden, by 1587.

H.K.

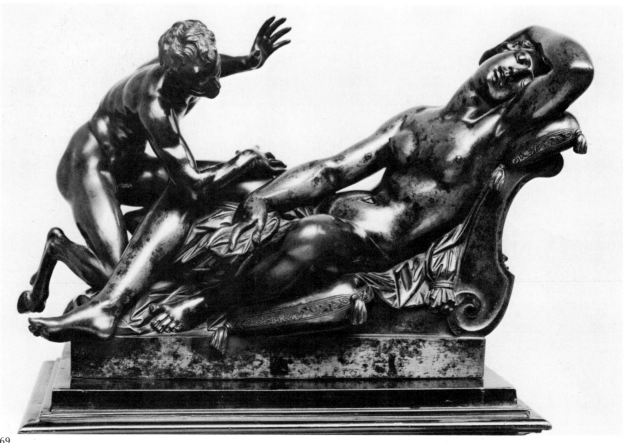

69

70
Sleeping nymph with satyr (missing)
*h.*20.5 *l.*32
Bronze. Hole for attachment of satyr visible at left.
Engraved: *N° 37.*
Musée du Louvre, Paris, Département des Objets d'Art
(MR 3319)

This bronze is listed as No. 37 in the inventory of the *Mobilier de la Couronne* of King Louis XIV of France dated 20 March, 1684 (Guiffrey, 1886, p. 34: *'Un autre group de deux figures, qui représentent une femme toutte nüe, couchée sur un drap, regardée par un Satyre'*). By the time Migeon was writing (1904, no. 147) the satyr was missing. Richelieu owned an example, complete with satyr, qualified in his inventory after decease as by Giambologna and 're-paired' by Susini (Boislisle, 1881, no. 61). This is probably identical with that in Girardon's collection (Souchal, 1973, no. 154 bis).

The mask on the back of the couch is particularly well modelled.

FURTHER VERSION: see Cat. 72.
ADDITIONAL BIBLIOGRAPHY: Landais, 1958, p. 68.
PROVENANCE: King Louis XIV of France (by 1684).

C.A.

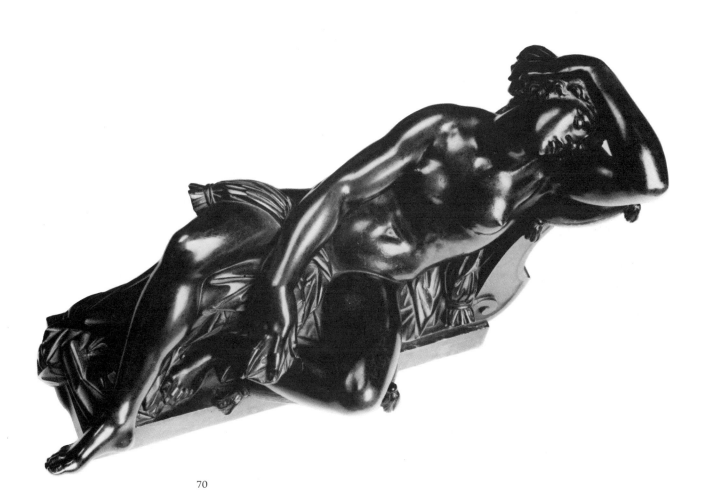

70

71
Sleeping nymph with satyr
*h.*20.6 *l.*31.7
Bronze, red-brown lacquer.
Engraved on front of base: *No.82.*
Lent anonymously

A version of Giambologna's *Sleeping nymph with satyr* (Cat. 69), the bronze is listed as No. 82 in the inventory of the *Mobilier de la Couronne* of King Louis XIV of France dated 20 March 1684 (Guiffrey, 1886, p. 37). It was one of two similar versions in the Crown Collection at that date, the other (Cat. 70), now in the Louvre, being listed under No. 37. It subsequently appears in Crown inventories of 1729 and 1775 and in the inventory compiled by order of the Assemblée Nationale in 1791 (for full references see Heim, 1973, no. 23). On 28 September 1796 it was ceded to Jacques de Chapeaurouge of Hamburg in part payment for debts (Verlet, 1957, p. 289). It has not been established at what date this bronze and Cat. 70 entered the Crown Collection. Landais (1961, p. 139) notes that a version said to be by Susini after Giambologna was in the collection of Cardinal de Richelieu at his death in 1642 (Inv. no. 61; Boislisle, 1881, p. 88; Champier and Sandoz, 1900, I, p. 68), and identifies this with a version said to be by Antonio Susini after Giambologna engraved in 1710 in the collection of Girardon (Charpentier, 1710). There is some doubt as to whether this is also identifiable, as Landais supposed, with No. 280 of the Crown Collection, which may in fact have been the bronze *Diane et un Satire* bequeathed to the King by André Le Nôtre in 1699 (Guiffrey, 1911, p. 224; Radcliffe, 1976, p. 20). The present bronze and Cat. 70 have the appearance of bronzes by Antonio Susini.

FURTHER VERSIONS: see Cat. 69, 72.
ADDITIONAL BIBLIOGRAPHY: see Cat. 69, 72.
PROVENANCE: King Louis XIV of France (by 1684); Kings Louis XV, XVI of France; Jacques de Chapeaurouge, Hamburg (1796); Heilbronner, Berlin.

A.R.

72
Sleeping nymph with satyr
*h.*19.3
Bronze. Reddish-gold patination under black lacquer.
Boymans van Beuningen Museum, Rotterdam (1123)

This is another excellent example of the complete group, for which see Cat. 69. The composition and its origin are also discussed by Dhanens, 1956, pp. 187–9. An example without a satyr was sent by Francesco I from Florence to his brother Cardinal Ferdinando in Rome (see Cat. 69): it was received into the collection along with two other bronzes on 7 April, 1584 (Müntz, 1896, pp. 150–1: '*Tre figurine di bronzo sopra base di legno tinte di nero fatte da M. Gio. Bologna, che due femine, una nuda in atto di dormire, . . .*'). Listed by Desjardins as lost (1883, p. 154, no. 17, citing Baldinucci, *Arch. med.* Miscellanea, I, filza 69). The model may have been among six small bronzes of recumbent figures recorded in the villa La Magia in 1587, as well as among the effects at decease in 1621 of Don Antonio de' Medici (Müntz, 1895, p. 426, n. 1). The model also features in Baldinucci's list of authentic Giambologna bronzes (1688: see this Catalogue Introduction, p. 44): '*La femmina che dorme, e'l Satiro, che la guarda*', and among those cast subsequently by Gianfrancesco Susini (Ranalli, IV, p. 118: '*la femmina che morde il satiro che la sta guardando*').

OTHER VERSIONS: (complete with satyr) Cat. 69, 71; Schloss Pommersfelden (*h.*20.8; Weihrauch, 1967, fig. 247); H.M. the Queen (ex-Kensington Palace, 1818); private collection, New York (*h.*20.3, *l.*32.7); private collection, Paris (Landais, 1958, p. 60); sale, Sotheby, London, 28 November, 1968, no. 42. (Nymph alone) Cat. 70; Staatliche Museen, Berlin-Dahlem (2743, see Bode, 1930, no. 157); Bayerisches Nationalmuseum, Munich (gilt, Weihrauch, 1956, no. 112); Herzog Anton Ulrich-Museum (Bro. 136, see Jacob, 1972, no. 25, probably a northern cast, the couch and cushions fashioned out of wood, reproduced by Bode, 1912, pl. CXCV as in the Albertinum, Dresden; Victoria & Albert Museum, London (A.75–1956); H. Nadeau and B. Black, Monte Carlo (with hole for attachment of satyr). (Satyr alone) C. Castiglioni collection, Vienna (Planiscig, 1925, pl. LXXXIII, *h.*13).
ADDITIONAL BIBLIOGRAPHY: Stedelijk Museum, Amsterdam, *Italiaanse kunst in Nederlands bezit*, 1934, no. 920; D. Hannema, *Catalogue of the D. G. Van Beuningen collection*, Rotterdam, 1949, no. 176, pl. 238.
PROVENANCE: Stefan von Auspitz collection, Vienna.

C.A.

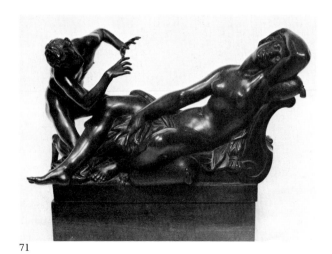

71

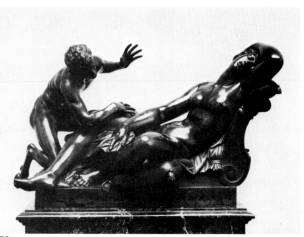

72

73
Bireno and Olimpia
by **Ferdinando Tacca** (1619–86)
*h.*37.9 *l.*39.9
Bronze, light golden lacquer, now very dirty.
Lent anonymously

The subject has been identified by Dr Jennifer Montagu as the desertion of Olimpia by Bireno (Ariosto, *Orlando Furioso*, canto X). The figure of Olimpia and the couch on which she lies are cast from the model of the *Sleeping nymph* by Giambologna (Cat. 69–72) with small variations in the drapery and the decorative details of the couch, and, as observed by Anthea Brook, the torso, upper right arm and upper left leg of Bireno are cast from the model of *Mars Gradivus* by Giambologna (Cat. 42–8). Ferdinando Tacca is known to have possessed models by Giambologna (Lankheit, 1962, p. 244, doc. 52). Characteristic of bronzes by Ferdinando Tacca (for which see Radcliffe, 1976) are the facial type, the hair and the attitude of Bireno, the pattern of punching on the extension to the base on which he stands and the narrative subject derived from Ariosto. The finish is finer and the patina lighter in tone than in other known two-figure bronze groups by Ferdinando, approximating more closely to bronzes from the Susini shop. This consideration, together with the heavy reliance on Giambologna models, may indicate an early work. Giambologna's *Sleeping nymph* is referred to by Ferdinando in two other compositions, both, unlike the present bronze, from wholly original models: *Diana and a satyr* in the Minneapolis Institute of Arts (Radcliffe, 1976, p. 20, fig. 9) and the smaller *Sleeping nymph with satyr* (Cat. 74).

A.R.

74
Sleeping nymph with satyr
by **Ferdinando Tacca** (1619–86)
*h.*31.2 *l.*17.5
Bronze, red-gold lacquer.
Lent anonymously

The group is a small derivative of Giambologna's *Sleeping nymph with satyr* (Cat. 69–72). The type and attitude of the satyr, the type of the nymph, the rocky base and the fringed drapery covering it all relate directly to those features in Ferdinando Tacca's bronze of *Diana and a satyr* in Minneapolis (Radcliffe, 1976, p. 20, fig. 9). The pattern of punching on the base is characteristic of bronzes by Ferdinando. The method of fixing the separately-cast satyr by means of a bronze rod passed through the base and secured with a fresh run of bronze is, as noted by Dr Jonathan Ashley-Smith, typical of late Florentine bronzes (*e.g.* groups by Foggini). Anthea Brook has observed that a model of the group with the satyr in a variant pose is in the Doccia Museum (1076). A bronze cast of the nymph alone is in the Fitzwilliam Museum, Cambridge (M.1.1961; L.16.4), hitherto classified as Italo-Flemish, late 16th century.

FURTHER VERSIONS: collection of Professor Michael Jaffé, Cambridge (the nymph alone).

A.R.

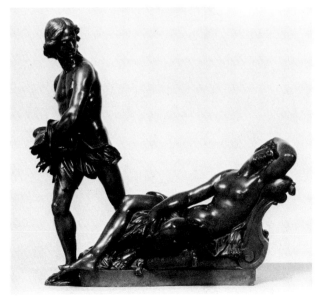

73

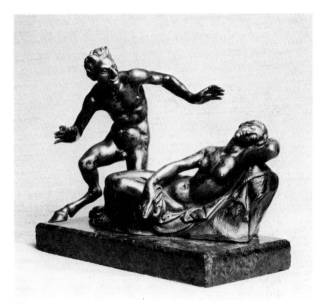

74

The Labours of Hercules
General note

In a letter of 27 October, 1581 to the Duke of Urbino Simone Fortuna writes of twelve *Labours of Hercules* which Giambologna has made not long before for Francesco I (Dhanens, 1956, pp. 189, 345). The material is not specified. Between 1576 and 1589 a set of six *Labours of Hercules* was cast in silver from models by Giambologna for Francesco I: these were placed in the Tribuna of the Uffizi, and are all now lost (Heikamp, 1963, pp. 203, 204, 212, 213, 260 n. 14). They were inventoried in detail, and all six subjects recorded are known in bronze versions which relate to the style of Giambologna. All are represented in this exhibition (Cat. 75, 76, 78/9, 81/2, 87) with the exception of *Hercules supporting the Heavens*, which is known in a single good version in the Museo del Castello Sforzesco, Milan (Br. 142; Bode, 1912, pl. CXCVII). It has been generally supposed that Fortuna was referring to the series of *Labours* cast in silver for the Tribuna of the Uffizi, but this is not necessarily the case. It is clear (Heikamp) that no more than six *Labours* were ever in the Tribuna, while Fortuna mentions twelve. However, a full twelve Hercules subjects are known in bronzes which relate to the style of Giambologna. While the inventories of the Tribuna (Heikamp, p. 206 n. 14) record heights varying between $\frac{2}{3}$ and $\frac{3}{4}$ *braccio*, Fortuna gives for his series an average height of $\frac{1}{2}$ *braccio*, which, allowing for variations in pose, is about the average height of the surviving bronzes. One original model by Giambologna for a statuette of a *Labour* survives: the wax *Hercules and the Hydra* in the Palazzo Vecchio (Lensi, 1934, pp. 51, 52, pl. XXXV). The corresponding bronze version (Cat. 76) follows it precisely in composition and scale. The extent to which the other known bronzes reflect the original models by Giambologna remains open to question.

Lo Vullo Bianchi notes that in 1612 Pietro Tacca was in process of making a series of *Labours of Hercules* (number unspecified), and that in 1633 he was requesting payment of the Grand Duke for models for a set of five *Labours of Hercules* to be cast in bronze and sent to the King of England. Subsequent documents (1633–34) request payments variously for sets of five and twelve *Labours of Hercules* (Lo Vullo Bianchi, 1931, pp. 181–3, 208–13). While it is assumed by Lo Vullo Bianchi and others that the documents of 1612 and 1633–34 refer to the same commission, this is not necessarily so. The account as published is confused but, pending a reassessment of the sources by a more professional student, it remains clear that Pietro Tacca made bronzes of the *Labours of Hercules*, either, as Lo Vullo Bianchi supposed, from his own original models, or based on earlier models by Giambologna. There seems reason to suppose that some of the surviving small bronze versions of the *Labours* were cast in the workshop of Ferdinando Tacca (see Cat. 76), and that some variant versions on a larger scale (Louvre and Wallace Collection: see Cat. 80) originated with him. Baldinucci (Ranalli, II, pp. 73, 74) lists the *Hercules and a centaur* and four other unspecified *Labours of Hercules* amongst the bronzes produced by Giambologna and the same items amongst those produced by Gianfrancesco Susini (Ranalli, IV, p. 118).

The inventory of 1684 of King Louis XIV of France lists fifteen bronzes of *Labours of Hercules* (Guiffrey, 1886, pp. 32, 34, 35, 36, 40). One of these is exhibited here (Cat. 84, no. 58 in the inventory), and another, a version of *Hercules and Antaeus*, survives in the Wallace Collection (no. 49 in the inventory; Mann, 1931, pp. 45; 46, no. S120). Some of the others appear to have been versions of bronzes exhibited here: *e.g.* inventory nos. 1 and 57 (Cat. 87), 7

(Cat. 78), 9 (Cat. 83), 13 (Cat. 86), 16 (Cat. 77), 18 (Cat. 75), 33 (Cat. 81), 34 (Cat. 76), 50 (Cat. 85).

Not all of the twelve canonical Labours of Hercules are susceptible to sculptural representation. Some (*e.g.* the *Seizure of the Girdle of Hippolyte* and the *Cleansing of the Augean Stables*) are not represented at all in the series of bronzes, while others are represented by *parerga*, or by-labours (*e.g.* the *Erection of the Pillars*, Cat. 83, is a *parergon* to the tenth Labour, the *Capture of the Oxen of Geryon*). In order to make up the number to twelve it was necessary to include several *parerga* (*e.g.* two *parerga* to the eleventh Labour: see Cat. 84) and the subject of *Hercules and Antaeus* (Cat. 87) which is extraneous to the canonical twelve Labours.

A.R.

75

75

Hercules and the Nemean Lion
*h.*31.8
Bronze. Heavily filed, dark red-brown lacquer.
National Gallery of Ireland, Dublin (8124)

The present bronze represents the first Labour of Hercules, and a silver version of this subject, cast in 1580 by Michele Mazzafirri, was among the six silver *Labours* from models by Giambologna in the Tribuna of the Uffizi (Heikamp, 1963, p. 260 n. 14). The bronze is, together with Cat. 76 and 83 and a bronze of *Hercules and the Erymanthian Boar* in Dublin (8123, not exhibited here; *cf.* Cat. 78), one of a set of four *Labours of Hercules*, all of identical facture, acquired by the first Earl of Milltown in Florence in the mid-18th century. It has been noted by Radcliffe (1972) that the pattern of punching on the naturalistic base of one of this set (Cat. 76) is found in bronzes by Ferdinando Tacca, and the broad handling of these bronzes is characteristic of his work. While the cast may date from the mid-17th century, the model must be earlier. A superior version now in the Bayerisches Nationalmuseum, Munich (Weihrauch/Volk, 1974, p. 30, no. 16), formerly one of a set in the possession of Durlacher Bros, London (Bode, 1912, p. 8, fig. 11; see Cat. 85, 86), in which the head is set at a less awkward angle, is probably an earlier cast, and is more acceptable as a direct reflection of a Giambologna original.

FURTHER VERSIONS: Museo Nazionale, Bargello, Florence (*h.*30.5; an inferior cast from the same model as the Munich bronze); formerly King Louis XIV of France collection (Guiffrey, 1886, p. 34, no. 18).
ADDITIONAL BIBLIOGRAPHY: Churchill, 1913–14, p. 348; Dhanens, 1956, pp. 190, 191; Weihrauch, 1967, p. 217; Potterton, 1974, pp. 143, 145; Wynne, 1975, p. 16.
PROVENANCE: Joseph Leeson, 1st Earl of Milltown (1701–83), Russborough, Co. Wicklow; given by Geraldine, Countess of Milltown, 1902.

A.R.

76

Hercules and the Lernaean Hydra

*h.*41

Bronze. Heavily filed, dark red-brown lacquer.
National Gallery of Ireland, Dublin (8121)

The subject is the second Labour of Hercules. A silver version cast in 1580 by Michele Mazzafirri was among the six silver *Labours* from models by Giambologna in the Tribuna of the Uffizi (see Cat. 75, general note). The bronze is, together with Cat. 75, 83 and a further bronze in Dublin, one of a set of four *Labours of Hercules*, all of identical facture, acquired by the first Earl of Milltown in Florence in the mid-18th century. It has been noted by Radcliffe (1972) that the pattern of punching on the naturalistic base of this bronze is found in bronzes by Ferdinando Tacca, and the broad handling of these bronzes is characteristic of his work. The cast therefore probably dates from the mid-17th century.

The model, however, is much earlier. The bronze corresponds precisely with the wax model of *Hercules and the Hydra* in the Palazzo Vecchio, Florence (Loeser collection; Lensi, 1934, pp. 51, 52, pl. XXXV) in composition and dimensions (the latter allowing for the sagging right arm of the wax). The wax, formerly in the collection of Bernardo Vecchietti, is certainly an original model by Giambologna. It does not have the character of a *bozzetto*, but that of a finished model to be piece-moulded for casting bronzes, and it is the only surviving model for any of the bronze *Labours*.

As noted by Dhanens (1956, p. 191) a version was in the collection of King Louis XIV in 1684 (Guiffrey, 1886, p. 34, no. 34). A bronze in the Louvre described by Dhanens (following Migeon, 1904, p. 160, no. 157) as *Hercules and the Hydra* is in fact Cat. 84, which represents *Hercules and the Dragon*.

A variant bronze ascribed to Giambologna, in which Hercules grasps one of the heads, instead of the tail, of the Hydra, was in the collection of Joseph Smith, British consul in Venice, by 1704 (Maffei, *Raccolta di statue antiche e moderne*, Rome, 1704, pl. CLXIII). This bronze, more than once engraved (Gori, II, 1767), is last recorded in 1776 (sale, Christie, London, 16 May, 1776, no. 43; F. Vivian, *Il Console Smith*, Vicenza, 1971, pp. 216, 217), and no other version of the variant is known.

FURTHER VERSIONS: formerly Durlacher Bros, London (Bode, 1912, p. 10, fig. 13); National Gallery, Prague (Larsson, 1967, fig. 39).
ADDITIONAL BIBLIOGRAPHY: Churchill, 1913–14, p. 348; Potterton, 1974, pp. 143, 145; Wynne, 1975, p. 15.
PROVENANCE: Joseph Leeson, 1st Earl of Milltown (1701–83), Russborough, Co. Wicklow; given by Geraldine, Countess of Milltown, 1902.

A.R.

77

Hercules and the Arcadian Stag

*h.*38

Bronze.
State Hermitage, Leningrad (222)

The subject is the third Labour of Hercules. It was not represented among the silver *Labours* in the Tribuna of the Uffizi.

The bronze is probably the finest of several known versions, and seems to be unique in having a more elaborate form of antler than the others.

As noted by Dhanens (1956, p. 192), an example was in the collection of King Louis XIV of France by 1684 (Guiffrey, 1886, p. 33, no. 16). A much larger variant (*h.*69) in the Louvre, which appears in later French Crown inventories (no. 306; Migeon, 1904, p. 159, no. 155) possibly originated in the Tacca workshop in the mid-17th century (see Cat. 80).

FURTHER VERSIONS: Wallace Collection, London (S123; Mann, 1931, p. 47, pl. 34; Bode, 1912, pl. CXCIX); Museo Nazionale, Bargello, Florence; Hovingham Hall, Yorkshire (brought from Venice before 1770 by Lord Fauconberg and given to Thomas Worsley, Surveyor-General).
ADDITIONAL BIBLIOGRAPHY: Androsov, 1977, no. 33.
PROVENANCE: A. D. Lanskoy (favourite of Empress Catherine II), 1787.

A.R.

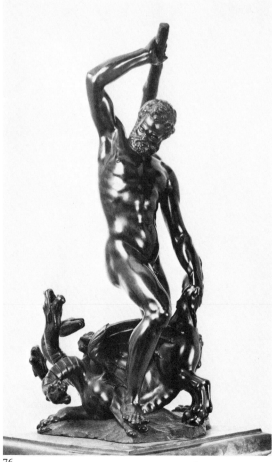

76

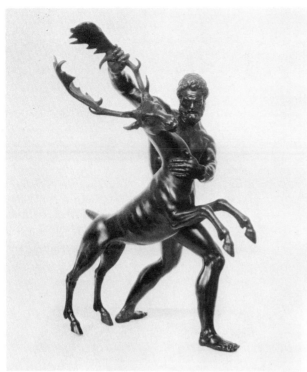

77

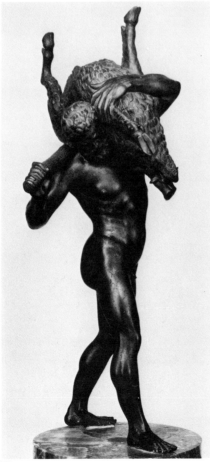

78

78

Hercules and the Erymanthian Boar
h.44.5
Bronze. Dark greenish paint, much rubbed; unchased.
Museo e Gallerie Nazionali di Capodimonte, Naples (10785)

The subject, which is the fourth Labour of Hercules, was among the six represented in silver versions in the Tribuna of the Uffizi (see Cat. 75). The wax model for casting the silver for the Tribuna was possibly prepared in 1587 by Antonio Susini (Heikamo, 1963, p. 260, n. 14). Together with a silver version of *Hercules supporting the Heavens*, also destined for the Tribuna, it was cast by Jacopo Bylivelt and was finished by May, 1589. This is proved by entries in the inventory of the Guardaroba of Ferdinando I (Florence, Archivo di Stato, *Guardaroba Medicea*, vol. 132, *Inventario Generale a Capi, 1587–91, c.156s*), transcribed and kindly made available by Prof. James Holderbaum, which read as follows: '*Una statuetta d'un erchole, co' una palla del mondo sopra, sotto, una piastra aovata tutto d'argento pesa lb xi onc. 8 day m Jacopo delf gioelliere di S.A.S. p(er) metter nella tribuna chome al Quaderno A 0/2 a 247 addi 14 maggio 1589.*'

'*Una statuetta di un' altro erchole con un' porcho sopra, sotto una piastra aovata dal sudetto tutta darge(en) to lb 14 onc. 1 dal d(etto?) Quaderno ad(etta) 247.*'

The earliest documented bronze version is that in Vienna (Cat. 79), which is identifiable in the inventory of Emperor Rudolph II, compiled in 1607–11. This is also the only surviving version of high quality, and differs from the other known versions in several details, in particular in the fillet around the head of Hercules, which none of the others have. It must be presumed to reflect the lost silver original most accurately.

The present bronze represents the form in which the model is generally reproduced. Although it comes from the Farnese collection, it is not associable with the two early documented bronzes by Giambologna from the same collection (Cat. 35, 56), and is not consistent in facture with bronzes from the Borgo Pinti or the Susini shops.

A version in the Museo del Castello Sforzesco, Milan, is paired with a unique good version of *Hercules supporting the Heavens* (Br. 141, 142, Bode, 1912, pl. CXCVII). A version in the National Gallery of Ireland, Dublin is possibly from the workshop of Ferdinando Tacca (8123, Wynne, 1975, p. 15; see Cat. 75, 76, 83). A silver version expressly ascribed to Giambologna and a bronze version were in the collection of King Louis XIV of France by 1684 (Guiffrey, 1885, p. 68, no. 538, 1886, p. 32, no. 7).

FURTHER VERSIONS: Cat. 79; Museo Nazionale, Bargello, Florence (Supino, 1898, p. 394, Planiscig, 1930, pl. CCVIII, no. 355); Wallace Collection, London (S125, Mann, 1931, p. 47); Widener Collection, National Gallery of Art, Washington, D.C. (A–115, *Paintings and sculpture from the Widener Collection*, Washington, 1959, p. 152).
ADDITIONAL BIBLIOGRAPHY: De Rinaldis, 1911, p. 556, no. 711; Dhanens, 1956, p. 193; Amsterdam, 1961/2, no. 121; Weihrauch, 1967, p. 217.
PROVENANCE: Farnese collection, Palazzo Farnese, Rome; Charles III Bourbon, King of the Two Sicilies (inherited in 1731 from Antonio Farnese and transferred to Naples in 1737–8); Museo Borbonico, (1738–1759, Naples.

A.R.

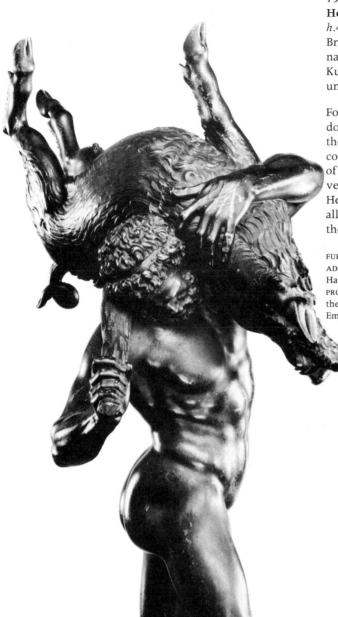

79
Hercules and the Erymanthian Boar
h.43.9
Bronze. Dark red-brown smoke-lacquer and light brown natural patina.
Kunsthistorisches Museum, Vienna, Sammlung für Plastik und Kunstgewerbe (5846)

For the origin of the model see Cat. 78. This is the earliest documented bronze version, identifiable with no. 1887 in the inventory of the *Kunstkammer* of Emperor Rudolph II compiled in 1607–11. It is also the only surviving version of high quality, and differs from all the other known versions in several details, the most notable being that here Hercules wears a fillet around his head, which is absent in all other versions. It seems likely that this bronze affords the most accurate reflection of the lost original.

FURTHER VERSIONS: see Cat. 78.
ADDITIONAL BIBLIOGRAPHY: Planiscig, 1924, p. 156, no. 259. Bauer and Haupt, 1976, p. 100, no. 1887.
PROVENANCE: Emperor Rudolph II, Prague (identifiable with no. 1887 in the inventory of his *Kunstkammer*, compiled in 1607–11); through Emperor Matthias to the Vienna *Kunstkammer* or *Schatzkammer*.

A.R., M.L-J.

79

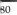

80
Hercules and the Erymanthian Boar
*h.*74.2
Bronze. Dark patina.
Engraved: '*No. 307*'.
Musée du Louvre, Paris, Département des Objets d'Art (5425)

The engraved number is that of the French Crown collections. The bronze is nearly twice the size of Cat. 78 and 79, the boar is carried the opposite way around, and the figure of Hercules is wholly different.

The bronze, of which a variant version exists in the Wallace Collection (S126; Mann, 1931, pp. 47, 48), has as a companion piece in the Louvre an enlarged variant version of *Hercules with the Arcadian Stag* (5421; Crown inventory no. 306; Migeon, 1904, p. 159, no. 155) with the same facture and patina. Together with two further bronzes in the Wallace Collection on the same scale of *Hercules and a centaur* and *Hercules and the Cretan Bull* (both gilt; S118, S124; Mann, 1931, pp. 45, 47), they form a group of large versions of the Labours of Hercules related in varying degrees to the smaller models of Giambologna.

As noted by Dhanens (1956, p. 193), the present model cannot be considered an invention of Giambologna. The figure corresponds closely in style with the figure of Hercules in a group of *Hercules and Iole* by Ferdinando Tacca (Radcliffe, 1976, p. 20, fig. 10), and the broad treatment of the lion skin and of the surfaces in general and the dark patination are also consistent with bronzes by Ferdinando. The naturalistic bases of the companion bronze in the Louvre and the two gilt bronzes in the Wallace Collection are worked with a pattern of punching which Radcliffe has observed to be characteristic of bronzes by Ferdinando (1976, p. 18). Another version (sale Sotheby, Monte Carlo, 25, 26 May, 1975, no. 184) stands on part of a naturalistic base with the same pattern of punching.

ADDITIONAL BIBLIOGRAPHY: Migeon, 1904, p. 158, no. 154.
PROVENANCE: French Crown collections (Inventory of 1713).
A.R.

81

Hercules and a centaur

h.40.2

Bronze. Light gold-brown lacquer, light brown natural patina.

Kunsthistorisches Museum, Vienna, Sammlung für Plastik und Kunstgewerbe (5834)

The subject, described in early sources as 'Hercules and a centaur', has variously been identified as Hercules striking down Nessus and as Hercules's battle with the centaurs, a *parergon* to the fourth Labour, the *Capture of the Erymanthian Boar*. Since Hercules slew Nessus with an arrow, the latter identification is to be preferred.

The silver for the casting of a silver group of *Hercules and a centaur* was received by Giambologna from Giorgio d'Antonio on 3 July, 1576 (Churchill, 1913–14, p. 349). The silver version, now lost, was later placed in the Tribuna of the Uffizi. Its height was recorded in the inventory of the Tribuna as 2/3 *braccia* (39 cm; Heikamp, 1963, p. 260, n. 14). This approximates to the height of the present bronze.

The earliest unequivocal documentary reference to a bronze version occurs in the inventory of the inheritance of Lorenzo Salviati, compiled in 1609, where the bronze is said to be from the hand of Antonio Susini and the height is given as about 2/3 *braccia*, corresponding with both the silver version and the present bronze (Watson and Avery, 1973, p. 504, doc. I, no. 1081).

The model of the present bronze corresponds closely with that of the marble version carved in 1594–9, now in the Loggia de' Lanzi (see Dhanens, 1956, pp. 194–7). Baldinucci (Ranalli, IV, 1846, p. 111) suggests that Antonio Susini's bronze of the subject was a copy of the marble. However, that this model was already in existence by 1588 is proved by the fact that it was closely copied by Michele Mazzafirri on the reverse of his medal of Ferdinando I of that year (Cat. 229), and it seems reasonable to suppose that it was the silver version which Mazzafirri was copying at that date, the more so since he was himself involved in the casting of some of the silver *Labours* for the Tribuna (Churchill, *loc. cit.*). The silver would in this case have been the prototype for the eventual marble, and it would seem, taking into account the close correspondence in size, that the present bronze is a direct derivative of the silver, rather than, as many writers have thought, a reduced replica of the marble.

While it is frequently stated that the model is a pendant to the *Nessus and Deianira* (Cat. 60), there is no evidence for an early pairing, and the two models appear to have originated independently.

Dismissed by Planiscig (1924, p. 158, no. 262) as a reduced replica of Cat. 82, the present bronze is in fact one of the best and most apparently authentic known examples. An unfinished rough cast in the Palazzo Bianco at Genoa is unaccountably regarded by Dhanens (1956, p. 197) as autograph. The mention by Weihrauch (1967, p. 216) of a signed version in the Huntington Collection, San Marino, California, is a mistake resulting from confusion with the signed *Nessus and Deianira* there (see Cat. 60). According to Baldinucci (Ranalli, IV, 1846, p. 118) versions were also cast by Gianfrancesco Susini.

Some larger variant versions (*h*.70 cm) appear to be considerably later in origin (Cat. 82). A variant model on the same small scale, in which the hind quarters of the centaur lie on the ground, instead of being raised as here (Museo Nazionale, Bargello, Florence, formerly Pitti Palace, Weihrauch, 1967, fig. 254; Wallace Collection, S.119, Mann, 1931, p. 45; Liechtenstein Collection, Vaduz, Bregenz, 1967, no. 156) corresponds with a fragmentary wax *bozzetto* in the Victoria & Albert Museum (Cat. 227) ascribed to Giambologna. The wax is regarded by Keutner (1958, p. 328) as a variation by Gianfrancesco Susini on Giambologna's group, and the bronzes of this type are associated by Tietze-Conrat (1917, pp. 52–4, 96) and Weihrauch (1967, p. 216) with Gianfrancesco Susini. The wax is, however, consistent in handling and facture with other *bozzetti* by Giambologna, and may represent a rejected alternative project for the marble, which the variant bronzes reflect.

FURTHER VERSIONS: many, among which the most notable are: formerly Markus Zeh, Augsburg, 1611 (Dhanens, 1956, p. 73); formerly Henry, Prince of Wales, from 1612, later King Charles I of England (Watson and Avery, 1973, p. 506, no. 5); formerly Cornelis van der Geest, Antwerp, before 1620 (painting by Willem van Haecht the younger, Rubenshuis, Antwerp); formerly King Louis XIV of France, by 1684, (a silver version, Guiffrey, 1885, p. 68, p. 544, and two bronzes, Guiffrey, 1886, p. 34, no. 33, p. 36, no. 55, the latter a poor cast now in the Louvre, Migeon, 1904, pp. 152, 154, no. 146); Staatliche Museen, Berlin-Dahlem (Bode, 1930, no. 166); Museum of Fine Arts, Budapest (Balogh, 1975, no. 166); Schloss Pommersfelden (Weihrauch, 1967, p. 216, fig. 253); private collection, Denmark (Olsen, 1961, p. 103, pl. CXXVIa).

ADDITIONAL BIBLIOGRAPHY: Leithe-Jasper, 1976, p. 87, no. 85.

PROVENANCE: probably old Imperial property, but first identifiable with certainty only at the beginning of the 19th century in the inventories of the Imperial Cabinet of Coins and Antiquities.

A.R., M.L-J.

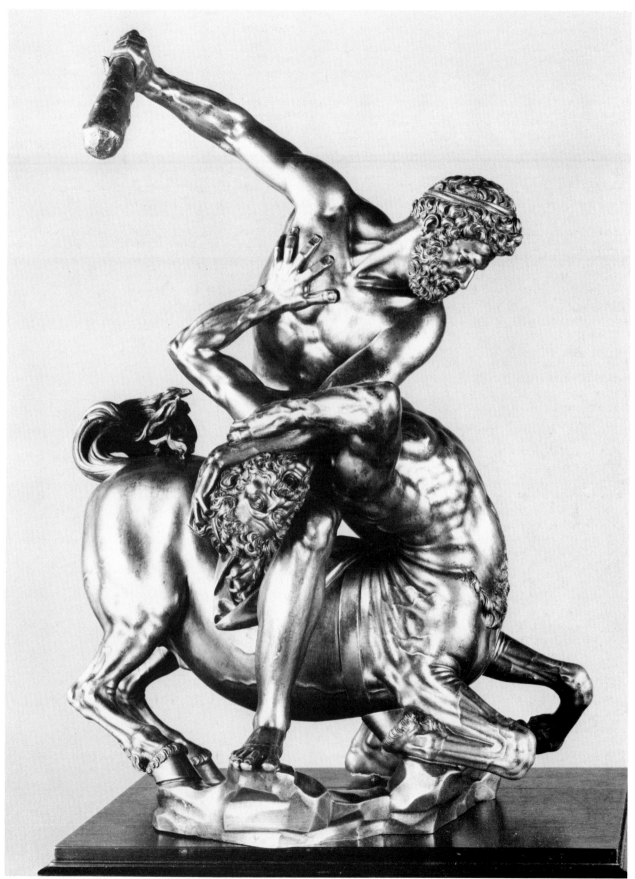

82

Hercules and a centaur

*h.*70

Bronze. Brown lacquer; the club broken.
Kunsthistorisches Museum, Vienna, Sammlung für Plastik
und Kunstgewerbe (6030)

An enlarged variant of Cat. 81. The handling of the surface
is more naturalistic, and variations in the composition
render the group more dramatic. Here Hercules bends
further forward and looks the centaur in the face, while the
centaur appears to be attempting to rise, and the struggle is
more convincing.

The character of this variant is rightly described by
Weihrauch (1967, p. 216) as 'high baroque'. The greatly
elaborated naturalistic base is worked with a pattern of
punching which Radcliffe has observed to be charac-
teristic of bronzes by Ferdinando Tacca (1976, p. 18), and
the group belongs to a set of enlarged variant versions of
the *Labours of Hercules* related in varying degrees to the
smaller models of Giambologna which possibly originated
in the Tacca workshop in the mid-17th century. A gilt
version of the same facture is in the Wallace Collection
paired with a similar bronze of *Hercules and the Cretan Bull*
(S. 118, S. 124, Mann, 1931, pp. 45, 47), and two further
bronzes from this set are in the Louvre (see Cat. 80).

ADDITIONAL BIBLIOGRAPHY: Bode, 1912, p. 3, pl. CLXXXIX; Planiscig,
1924, p. 157, no. 261; Dhanens, 1956, p. 198.
PROVENANCE: old Habsburg property, identifiable with certainty in the
inventory of the Ambras Collection of 1788.

A.R., M.L-J.

83

Hercules and the Pillars

*h.*33.3

Bronze. Heavily filed, dark red-brown lacquer; the pillars
cast separately and the upper arms joined.
National Gallery of Ireland, Dublin (8125)

The subject, the erection of the Pillars, is a *parergon* to the
Tenth Labour, the Capture of the Oxen of Geryon, and thus
represents that Labour in the series. The model, which is
unrecorded, is known in only one other version, identical
in facture, in the Palacio de Oriente, Madrid. The bronze is
one of a set of four with subjects from the Labours of
Hercules, all of identical facture, acquired by the first Earl
of Milltown in Florence in the mid-18th century (see Cat.
75, 76). While the model may have originated with Pietro
Tacca, it has been noted by Radcliffe (1972) that the pattern
of punching on the naturalistic base of one of this set (Cat.
76) is found in bronzes from the workshop of Ferdinando
Tacca, and the broad handling of detail in these bronzes is
characteristic of Ferdinando's work.

ADDITIONAL BIBLIOGRAPHY: Potterton, 1974, pp. 143, 145; Wynne, 1975,
p. 16.
PROVENANCE: Joseph Leeson, 1st Earl of Milltown (1701–83),
Russborough, Co. Wicklow; given by Geraldine, Countess of Milltown,
1902.

A.R.

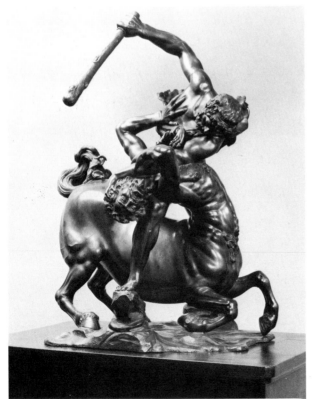

82

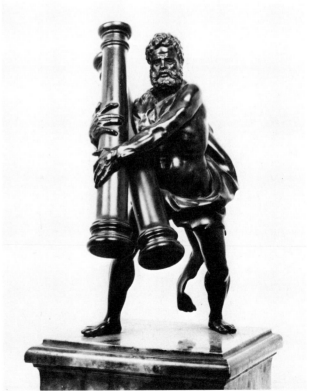

83

84

Hercules and the dragon

h.42.3 (Hercules) 25.7 (dragon)

Bronze. On old wooden socle, on which the dragon has been repositioned.

Engraved on Hercules: *No 58*; on dragon: *DU No 58*.

Musée du Louvre, Paris, Département des Objets d'Art (OA 5439 bis)

The engraved numbers are those of the French Crown Collections, and the group was in the collection of King Louis XIV of France by 1684 (Guiffrey, 1886, p. 36, no. 58). The subject, which is identified by Migeon (1904, p. 160, no. 157) and Dhanens (1956, p. 191) as *Hercules and the hydra*, appears in fact to be, as in Cat. 85, the slaying of the dragon Ladon, a *parergon* to the eleventh Labour.

The figure of Hercules is an exceptionally fine version of the same model as Cat. 90 (*q.v.* for the origin of the model). Another version of the same Hercules figure combined with a figure of Cerberus was in the French Crown Collections by 1713 (inventory No. 317). This group is now dispersed, the Hercules being in a New York private collection (sale, Parke-Bernet, New York, 26 March, 1970, no. 201; the figure combined with an inappropriate lion) and the Cerberus now in the Louvre (OA 8934, Landais, 1961, p. 141, fig. 3; wrongly identified with a bronze formerly in the Girardon Collection). The Cerberus bears no apparent relationship to the work of Giambologna or his workshop.

FURTHER VERSIONS: Musée Royal d'Art et d'Histoire (Cinquantenaire), Brussels (Leg. Vermeersch, V.2527, Squilbeck, 1944, p. 6, fig. 5; late cast on elaborate naturalistic bronze base).
PROVENANCE: King Louis XIV of France; French Crown Collections (*Inventaire des diamants de la Couronne*, 1791, p. 237)

A.R.

85

Hercules and the dragon

h.41.2

Bronze.

Walters Art Gallery, Baltimore, Maryland (54.695)

The subject is the killing of the dragon Ladon, a *parergon* to the eleventh Labour, the *Apples of the Hesperides*. It was not represented among the silver *Labours* in the Tribuna of the Uffizi.

The bronze, together with its companion in Baltimore, Cat. 86, and another bronze now in Munich (see Cat. 75) was formerly part of a set of bronze *Labours* in the possession of Durlacher Bros in London in 1912 (Bode, 1912, pl. CCIX).

A bronze of this description was by 1684 in the collection of King Louis XIV of France: '*50 – Un autre group d'un Hercules qui assomme un dragon qu'il arreste par le col de sa main gauche, hault de 15 à 16 pouces environ*' (Guiffrey, 1886, p. 35). The model thus described is wrongly identified by Dhanens (1956, p. 191) with a rare variant version of Giambologna's *Mars* as Hercules (Tietze-Conrat, 1917, pp. 45, 46; Planiscig, 1930, pl. CCXXI, no. 376).

FURTHER VERSIONS: Museo Nazionale, Bargello, Florence.
PROVENANCE: Durlacher Bros, London (1912); acquired by Henry Walters in February, 1926.

A.R.

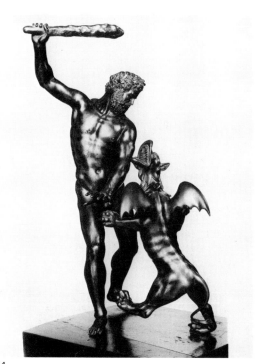

84

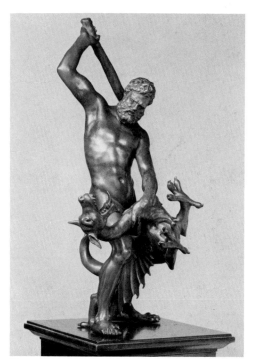

85

86
Hercules and Cerberus
h.28.8
Bronze.
Walters Art Gallery, Baltimore, Maryland (54.694)

The subject is the twelfth Labour of Hercules. It was not represented among the six silver *Labours* in the Tribuna of the Uffizi.

The bronze, together with its companion in Baltimore, Cat. 85, and another bronze now in Munich (see Cat. 75) was formerly part of a set of bronze *Labours* in the possession of Durlacher Bros in London in 1912 (Bode, 1912, pl. CCIX).

A bronze of this description was by 1684 in the collection of King Louis XIV of France: *'13 – Un group d'un Hercules qui dompte le Cerbère, hault de 13 pouces'* (Guiffrey, 1886, p. 32). This is not to be confused with no. 317 of later Crown inventories, which was a combination of the model of *Hercules wielding the club* (see Cat. 84, 90) with a different model of Cerberus (this group now dispersed: the *Cerberus* in the Louvre, OA8934; Landais, 1961, p. 137, fig. 3: the *Hercules* in a private collection, New York; sale Parke-Bernet, New York, 26 March, 1970, no. 201).

PROVENANCE: Durlacher Bros, London (1912); acquired by Henry Walters in February, 1926.

A.R.

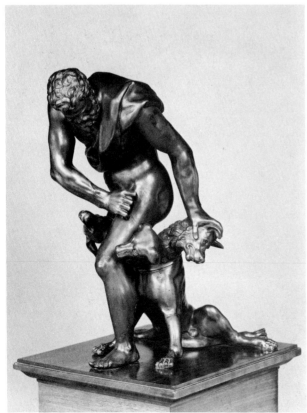

86

87
Hercules and Antaeus
h.41
Bronze. Light red-brown lacquer, transluscent in places, light brown natural patina.
Kunsthistorisches Museum, Vienna, Sammlung für Plastik und Kunstgewerbe (5845)

The subject does not form part of the canonical Twelve Labours, but a silver version, cast by Giorgio d'Antonio in 1578 from a model by Giambologna, was among the set of six silver *Hercules* groups in the Tribuna of the Uffizi (Heikamp, 1963, p. 260, n. 14).

The pose of the figure of Hercules derives in reverse from the antique marble group in the courtyard of the Pitti Palace, brought from Rome in 1560, while that of Antaeus relates to the bronze representations of the subject by Antonio del Pollajuolo (*circa* 1460; Museo Nazionale, Bargello, Florence) and Bartolommeo Ammanati (1559–60, from a model by Tribolo; Fountain of Hercules, Villa di Castello).

The model became one of the most popular of Giambologna's *Hercules* groups, and is known in a great number of versions and variants of widely differing quality, clearly from several different periods and workshops. The present version is rightly cited by Dhanens as the best (1956, pp. 193, 194). It was in the collection of Rudolph II (d. 1612). Another good version is in the Wallace Collection (S120, Mann, 1931, pp. 45, 46). It bears the engraved French Crown inventory number 49, and was one of three versions of this subject in the collection of King Louis XIV in 1684 (Guiffrey, 1886, p. 32, no. 1; p. 35, no. 49; p. 36, no. 57). A version in the Museo Nazionale, Bargello, Florence (until recently in the Pitti Palace) is assigned by Weihrauch to the Susini workshop (1967, p. 217), while for the present version and another in the Louvre he suggests that Adriaen de Vries, while in Giambologna's shop, might have prepared the models for bronze casting after the silver version. This cannot be substantiated. The Louvre version (Migeon, 1904, p. 158, no. 153; Bode, 1912, pl. CXCVIII) is much inferior to the present bronze and probably a late cast.

A variant of the model, known in two examples (J. W. Frederiks collection, now on loan to the Museum Boymans-van Beuningen, Rotterdam, L26, and former Castiglioni collection, Vienna, now in Denmark; Planiscig, 1930, pl. CCX, no. 359; Olsen, 1961, pp. 103, 104), in which Hercules wears an oak wreath and Antaeus a curly moustache of the type fashionable in the first half of the 17th century, is again connected by Weihrauch with de Vries (1967, p. 353).

FURTHER VERSIONS: Hovingham Hall, Yorkshire (brought from Venice before 1770 by Lord Fauconberg and given to Thomas Worsley, Surveyor-General); formerly William Salomon collection, New York (sale A.A.A., New York, 4–7 April, 1923, no. 432, one of a set with Durlacher Bros, London in 1912.)
ADDITIONAL BIBLIOGRAPHY: Churchill, 1913–14, p. 349; Planiscig, 1924, p. 156, no. 260; Bauer and Haupt, 1976, p. 100, no. 5845.
PROVENANCE: Emperor Rudolph II, Prague (inventory of his *Kunstkammer*, 1607–11, no. 1885); through Emperor Matthias to the Vienna *Kunstkammer* or *Schatzkammer*.

A.R., M.L.-J.

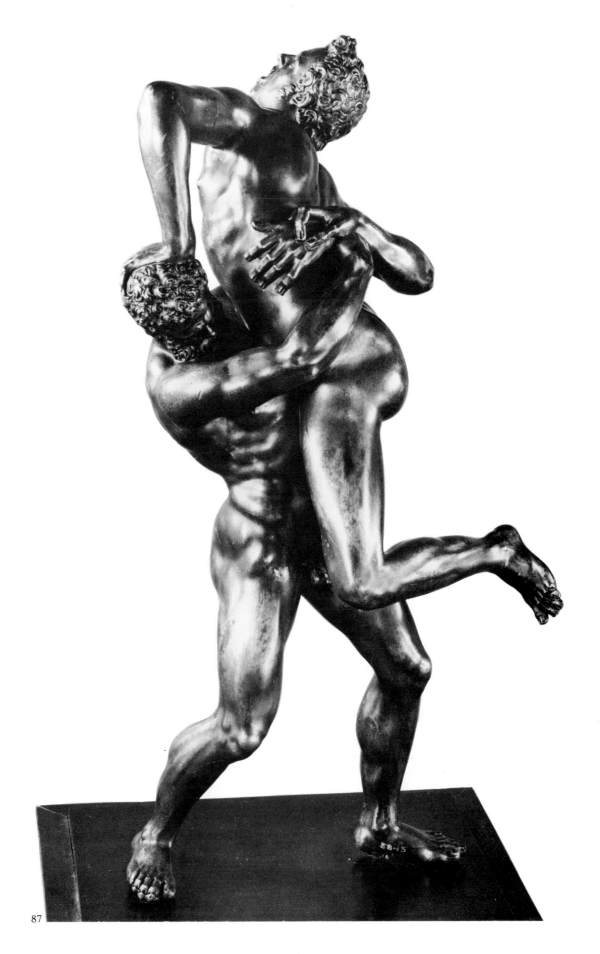

87

88

Hercules and Antaeus

*h.*49.5

Bronze. Brown patina with remains of red-brown lacquer.

Art Institute, Chicago, Illinois (1968.612)

The subject is the same as that of Cat. 87, but the model is quite unrelated, and the bronze is on a somewhat larger scale. It forms a pair with Cat. 89, which has the complementary subject of *Hercules and Lichas*. Both bronzes are apparently unique, and were considered by Bode (1912, p. 4, pl. CXCVI) to be autograph works by Giambologna. Weihrauch, however (1967, p. 217), relates them to the model of *Hercules and Antaeus* by Stefano Maderno (signed terracotta dated 1622 in the Ca'd'Oro, Venice; Brinckmann, 1923–5, II, pp. 26–31).

A group of *Hercules and Lichas* cast in silver by Michele Mazzafirri is mentioned in the inventory of the *Guardaroba* of Ferdinando I in 1591 (see Cat. 89). This was no doubt from a model by Giambologna. The pendant to the present bronze, Cat. 89, is the only known representation of *Hercules and Lichas* which can be related to Giambologna, and it seems possible that it reflects the silver.

That Cat. 87, rather than the present bronze, is likely to reflect the silver *Hercules and Antaeus* cast in 1578 for the Tribuna of the Uffizi is suggested by their relative dimensions. The height of silver in the Tribuna is recorded as $\frac{3}{4}$ *braccia* (Heikamp, 1963, p. 260, n. 14), which approximates to that of Cat. 87, while the present bronze is somewhat larger. The present model would appear to be a later reworking of the theme, possibly dating, with the *Hercules and Lichas*, from around 1590.

A variant version in stucco in the Museum of Fine Arts, Budapest, in which the legs of Antaeus are differently posed, is classified by Balogh (1975, pp. 134, 135, no. 169, fig. 214) as a late replica after Giambologna.

PROVENANCE: Dr Eduard Simon, Berlin (sale Cassirer and Helbing, Berlin, 10, 11 October, 1929, no. 52); Max Epstein, Chicago; acquired 1968 (Robert Allerton Fund).

A.R.

89

Hercules and Lichas

*h.*50.5

Bronze. Brown patina.

Art Institute, Chicago, Illinois (1968.613)

The subject has generally been described as *Hercules and Cacus*, but the bronze clearly represents Hercules hurling into the sea his servant Lichas who has brought him the shirt poisoned with the blood of Nessus. It forms a pair with Cat. 88, which has the complementary subject of *Hercules and Antaeus*. Both bronzes are apparently unique, and were considered by Bode (1912, p. 4, pl. CXCVI) to be autograph works by Giambologna.

A group of *Hercules and Lichas* cast in silver by Michele Mazzafirri is mentioned in the inventory of the *Guardaroba* of Ferdinando I in 1591 (Florence, Archivio di Stato, *Guardaroba Medicea*, vol. 132, *Inventario Generale a Capi*, 1587–91, c.156s). The entry, transcribed by Professor James Holderbaum and kindly made available by him, reads as follows: '*Una statua dunaltro erchole darg(en)to che butta in terra il ser(vito)re che li porto la camicia pesa lb quindici onc. – .18 con suo piano evite riauta fattoci da michel mazzafirri adi 19 di febb(rai)o al Q(uadern)o 0/3.*' (A statue of another Hercules in silver who hurls to the ground the servant who brought him the shirt. . . .)

The silver was no doubt cast from a model by Giambologna. The present bronze is the only known representation of *Hercules and Lichas* which can be related to Giambologna, and it seems possible that it reflects the silver.

ADDITIONAL BIBLIOGRAPHY: Buffalo, 1937, no. 142.

PROVENANCE: Dr Eduard Simon, Berlin (sale, Cassirer and Helbing, Berlin, 10, 11 October, 1929, no. 53); Max Epstein, Chicago; acquired 1968 (Robert Allerton Fund).

A.R.

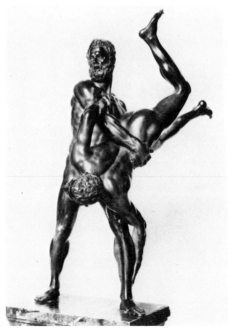

89

90

Hercules wielding the club

*h.*43.2

Bronze

Museo Nazionale, Bargello, Florence (362)

The model seems to have no connection with the set of silver *Labours of Hercules* made for Francesco I between 1576 and 1586 (for these see general note Cat. 75). Dhanens (1956, pp. 191, 192) considers the bronze to be autograph, and identifies it with an item in an entry in the inventory of the *Guardaroba* of Cardinal Ferdinando de' Medici (later Grand Duke Ferdinando I) dated 7 April, 1584. The item, a bronze figurine by Giambologna, is there merely described as *'un Ercole ritto'*. The earliest explicit mention of a bronze of this type occurs in the bill of lading for the bronzes made by Pietro Tacca sent to Henry Prince of Wales in 1612, and subsequent descriptions in the inventories of King Charles I of Great Britain corroborate this (Watson and Avery, 1973, p. 507, no. 9). The bronze sent to Prince Henry is not identifiable with a version now in the collection of H.M. the Queen at Windsor Castle, which appears to be a late cast.

As noted by Weihrauch (1956, p. 87, 1967, p. 215), the bronze is closely related in pose to the figure of Samson in Giambologna's marble group of *Samson slaying a Philistine* now in the Victoria and Albert Museum. It may be, therefore, that the model originated as early as the late 1560s.

The figure is known in examples in which it is combined in a group with a dragon or with Cerberus (see Cat. 84). It is suggested by Weihrauch (1967, p. 215) that the present bronze may at one time have been combined with such another figure. This would have been attached at the left knee, where Weihrauch notes apparent traces of a fixture.

FURTHER VERSIONS: ? formerly in the collection of King Louis XIV of France (Guiffrey, 1886, p. 37, no. 86); Bayerisches Nationalmuseum, Munich (R.3240, Weihrauch, 1956, pp. 87, 88, no. 111); Schloss Kirchheim (Weihrauch, *loc. cit.*); Museo Lazaro Galdiano, Madrid (Pardo Canalis, 1956, p. 7, repro. 2).

ADDITIONAL BIBLIOGRAPHY: Supino, 1898, p. 394; Bode, 1912, pl. CXCIX (the present bronze wrongly captioned as in the Louvre); Planiscig, 1930, p. 48, pl. CCVIII, no. 356; Amsterdam, 1955, no. 304.

PROVENANCE: old Medici collections.

A.R.

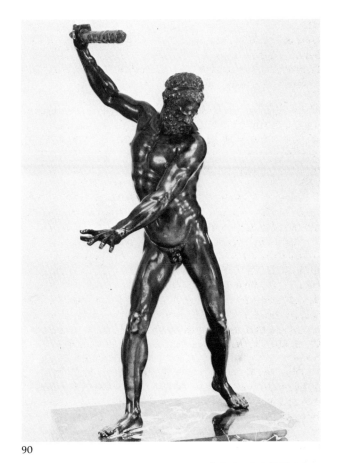

90

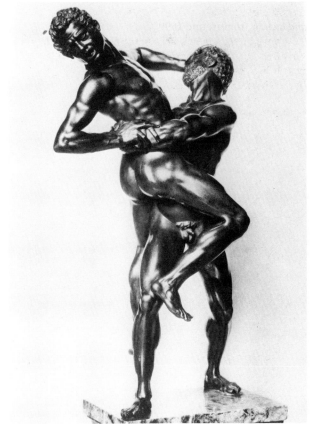

†91

St John the Baptist

*h.*66

Bronze. Dark patination.

Santa Maria degli Angiolini, Florence

This important statuette from a holy-water stoup in the convent of Santa Maria degli Angiolini was first published and connected with Giambologna in modern times by Guido Carocci ('La chiesa e il monastero, oggi R. Educatorio di S. M. degli Angioli o degli Angiolini', *Illustratore Fiorentino*, 1907, pp. 111–16). Dhanens (1956, p. 259) stresses that it is a 'wholly autograph work', unusual in Giambologna's busy late career. She traces its compositional origins back to the alabaster statue of *King David* which she believes he carved while working for Dubroeucq on the rood-loft for Ste Waudru, Mons (Dhanens, 1956, fig. 1). Her further claim that the statuette was a 'bronze model' for a marble statue of the Baptist in the Salviati chapel is not very plausible, for the statue was carved by 1588, the date on a dedicatory inscription in the chapel, and must therefore have been begun well before the present statuette was cast (see below). Both are probably derived from a common source, an earlier wax model, possibly quite small, that was made in connection with a silver statuette of the Baptist with one arm held higher than his head and weighing 22 Tuscan pounds, which was actually cast in Rome by Bastiano Tragittatore detto il Bolognia and presented by Cardinal Ferdinando de' Medici to St John Lateran in about 1586; (information from Professor James Holderbaum, citing A.S.F. *Guardaroba Medicea* Vol. 79, cc. 420s and d; see also letter cited by Desjardins, 1883, p. 154 [now untraced] and this Cat. 112). Professor Holderbaum has kindly made available his transcription of an unpublished document recording the casting of the bronze statuette of the Baptist for Giambologna in the foundry of Portigiani:

A.S.F., Conventi 103 San Marco 48: First Account Book of Fra Domenico Portigiani

c. 34d

Et a di maggio [1588] £ *ventotto piccioli sone per havere gittato a Giambologna una figura d'un Sancto Giovanni di lb. cento a suo bronzo reco. f. Domenico portigiani conti a cassa* 36 £28 – –

Holderbaum notes: 'this is the only instance in all my notes of the Portigiani documents where the bronze used was not from Portigiani's own supply, but, rather, from Giambologna's. Obviously the weight recorded, 100 pounds (Tuscan), is not that of the cast statuette but of a standard commercial block of bronze sent by Giambologna for the purpose. The other castings in the documents are weighed (with the word *'peso'* – not used here) to the fraction of an ounce, usually with the precise amounts left in the conduits and lost in waste and rough-finishing also exactly recorded (*'calo'*). Obviously the statue must weigh well under 90 Tuscan pounds, but one would guess not much less than say 50'.

Professor Keutner (in a personal communication) has pointed out a special relationship between the convent and the sculptor, who lived and worked just down the road

(Borgo Pinti): Giambologna produced for the nuns not only this statue of the Baptist, but a *Crucifix* (Cat. 105) and a church-bell (still apparently hanging and in use in the small gable over the west end of the church, but inaccessible to students).

C.A.

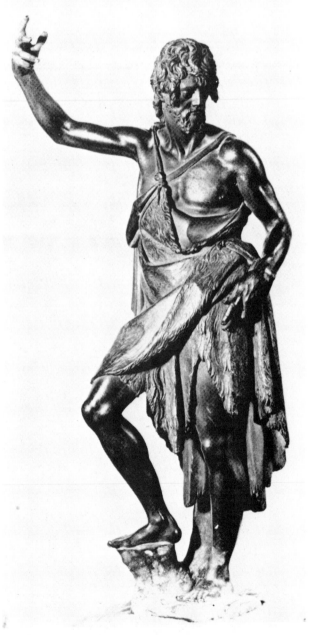

91

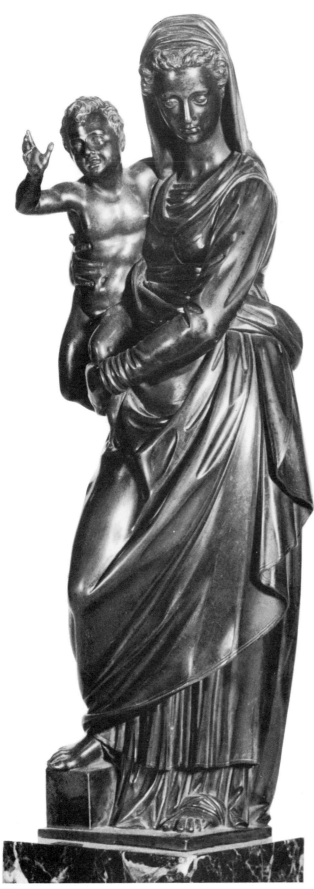

92

Virgin and Child

by **Antonio Susini** (active 1580; d. 1624)

h.38.4

Bronze.

The Edith A. and Percy S. Strauss Collection, Museum of Fine Arts, Houston, Texas

The only documentary references to the *Virgin and Child* as the subject of a bronze statuette, refer to Antonio Susini (Watson and Avery, 1973, p. 504). In a posthumous inventory of the effects of Lorenzo di Jacopo Salviati (d. 1609) there was listed among bronzes in the family palace on the via del Corso, Florence: *'974 Una Madonna di bronzo di tonto* (sic) *rilievo con il Nostro Signore in braccio con la sua base di legno, nero, di mano di Antonio Susini e sua inventione'*. This inventory is characterized by careful distinctions between authorship and execution by Giambologna and Susini, and there is little doubt that the entry applied to the composition preserved in the four known bronzes of the *Virgin and Child* associable with the general style of Giambologna: Cat. 92; formerly Barker collection, London; Museo Nazionale, Florence (Supino, p. 399, no. 63: as Giambologna); Staatliche Museen, Berlin-Dahlem (M 109). The last example was catalogued by Bode (1930, no. 177, pl. 49) as the work of Antonio Susini on the basis of a stylistic comparison pointed out by Kriegbaum with the standing female in the signed bronze group of the *'Farnese Bull'* (Cat. 180, 181), dated 1613. Bode added that the incised pupils of the eyes are characteristic. This attribution is corroborated by a payment to 'Ant. Susini' for *'una madonna; di bronzo e altre figure e un cavallo di bronzo'* probably made in February 1611 (A.S.F. *Guardaroba Medice*, 319, c.7). If this beautiful model is indeed wholly the work of Antonio Susini, as explicitly stated in the Salviati inventory, it is clear that he enjoyed complete control of all his master's means of expression and artistic idiosyncracies, particularly in the stylized patterns of the drapery, which recall the technique of wood-carving. The composition is not recorded before 1609, and may be an invention of around the turn of the century. Cat. 92, when in the Von Rhò and Castiglioni collections, was published by Planiscig (1928, p. 384) as by Giambologna and as the best of the three known examples, with a further interesting suggestion that the cast in the Museo Nazionale, Florence, might be by Soldani (see Bode, 1911, p. 634; 1912 pl. CLXXXIV).

OTHER VERSIONS: Gilt bronze lent to the South Kensington Museum by A. Barker, Esq., 1865 (photograph in Museum archives).
ADDITIONAL BIBLIOGRAPHY: Planiscig, 1930, p. 47, no. 352, pl. 205; Dhanens, 1956, p.210; Hackenbroch, 'Italian Renaissance Bronzes in the Museum of Fine Arts at Houston', *Connoisseur*, June, 1971, pp.128–9, fig. 11; Hiesinger, 'Renaissance Bronzes in Houston', *Forum*, v. 9, no. 1, 1971, pp.77–8, fig. 5.
PROVENANCE: Guido von Rhò, Vienna; Jacques Seligmann & Co., Inc., New York; Edith A. and Percy S. Strauss, New York, 1929–44.

C.A.

92

93
Christ Child blessing
*h.*14.1
Bronze.
Museo Nazionale, Bargello, Florence (68)

The statuette is regarded by Dhanens, 1956, p. 210, as perhaps an autograph work, to be dated near the *Apollo* in the early 1570s. The physical type of the Christ Child is similar, however, to that of the Child held by the Virgin (Cat. 92), which seems to have been a model by Antonio Susini. He may also be compared with the baby angels cast for the Grimaldi chapel in Genoa.

FURTHER VERSIONS: Victoria & Albert Museum, London (A.64–1956: formerly Newall collection, reproduced by Bode, 1912, pl. CCIV). Technical examination and radiography have shown that this is a 19th-century cast; probably a reproduction of the (possibly unique) example in the Bargello.
PROVENANCE: old Medici collections.

C.A.

94
Christ at the Column
*h.*29
Bronze. With reddish-golden lacquer, darkened.
Museo Nazionale, Bargello, Florence (418)

The graceful *contrapposto* and physical type of this rendering of Christ nearly nude indicate how closely Giambologna had studied Michelangelo's marble statue of *Christ holding the Cross* in Santa Maria sopra Minerva, Rome (*circa* 1520). The only significant difference is the position of the arms, occasioned by the changed iconography. Even the physiognomy is similar, with the carefully curled hair and beard. Within Giambologna's *oeuvre* it may be associated with his *Risen Christ* of 1577–79 in Lucca. The drapery of the loincloth shows his stylized handling of drapery in complex folds which look as though they had been gouged out of wood.

ADDITIONAL BIBLIOGRAPHY: Supino, 1898, p. 392; Bode, 1911, p. 634; Bode, 1912, pl. CLXXXIII; Dhanens, 1956, p. 210.
PROVENANCE: old Medici collections.

C.A.

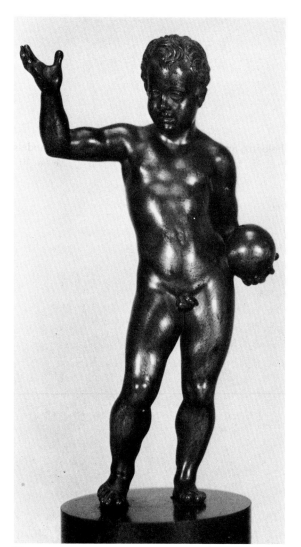

93

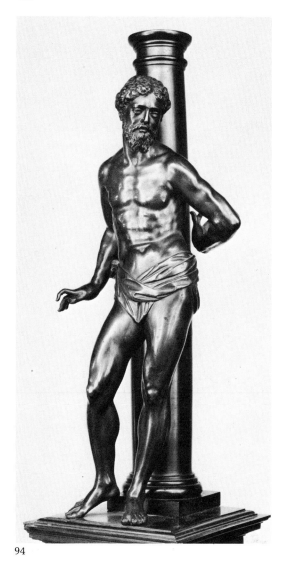

94

95

Christ at the Column

h.35.6 *w*.34 *d*.29.5

Bronze. Reddish-gold, translucent lacquer directly over raw metal.

Staatliche Museen, Berlin-Dahlem (M.45)

The bronze, which is unique and was purchased in Florence, is described by Bode (1930, no. 150) as a vice-versa variant of the unique composition by Giambologna in the Museo Nazionale, Bargello (Cat. 94). This is true of the lower half, up to the waist, but there are considerable variations from a mirror-image above, for the same, left arm is shown bent sharply up and back, as though lashed to the column, while the right arm is also tied back lower down, and not brought forward in a demonstrative gesture. The much smoother rendering of anatomy and the fine detailing of the hair and beard which may be paralleled in some of the *Crucifixes*, bespeak the intervention of Antonio Susini. This appears to be one of the models which Susini made himself, though relying heavily on a prototype by his master, in this case the central figure in Giambologna's panel showing the *Flagellation*, commissioned by Luca Grimaldi in 1579 (Cat. 125).

ADDITIONAL BIBLIOGRAPHY: Bode, 1912, p. 3, pl. CLXXXIII; Planiscig, 1928, p. 384.

PROVENANCE: bought Florence, 1904.

C.A.

96

Christ at the Column

h.16.5

Bronze. Traces of dark lacquer

Lent anonymously

The bronze statuette was formerly in the Von Rhò collection, Vienna, on the same base (Braun, 1908, pl. XVII). It was attributed to Giambologna on the strength of the modelling of the body and the treatment of the hands. The channelled treatment of the loincloth is also distantly reminiscent of the workshop, but the more dramatic and *mouvementé* composition points rather to one of Giambologna's younger followers, *e.g.* those who were involved on the west doors of Pisa Cathedral. A similar pose was used for the figure of Christ in the *Flagellation* panel by Gregorio Pagani (1558–1605), the model for which was delivered about 1600 (Avery, 1975/77, II, fig. 1), though Pagani handles drapery in a more painterly and less Giambolognesque way.

FURTHER VERSIONS: Beit collection, London (Bode, 1913, no. 211).

PROVENANCE: Von Rhò, Vienna.

C.A.

97

Christ at the Column

h.63

Bronze.

State Hermitage, Leningrad (1201)

The bronze, which has been ascribed to the circle of Giambologna, appears to be a distant variant of his models of *Christ at the Column*, possibly produced by one of his younger followers in the 17th century.

ADDITIONAL BIBLIOGRAPHY: Androsov, 1977, no. 37.

PROVENANCE: collection Moussine-Pouchkin, 1920.

C.A.

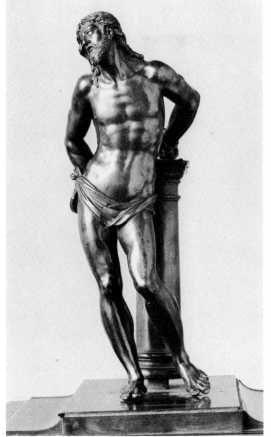

95

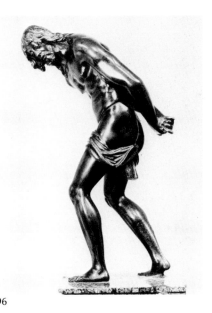

96

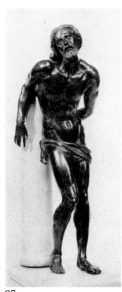

97

98

Christ crucified, alive

*h.*29.5 *w.*26.5

Bronze, on cross of iron. Natural patina. Good condition; the halo is probably original, but there may have been a crown of thorns, now missing.

Convent of Santissima Annunziata, Florence

Christ is held on the cross by three nails, one through each palm, and a third one driven through both feet. He turns His head to the right and glances upward, with lips parted. The eyes are blank. He has a moustache and beard, which ends in two tufts at the chin; His long hair falls in a curly strand on His right shoulder and, to the left, is pulled back, off His neck and behind, where another curl is formed. His left shoulder is held slightly higher than the right. The turning motion of the body is conveyed through extremely subtle shifts of weight: the chest moves slightly to the right; the hips pivot to the left; the right hip and the whole right leg is raised higher than the left, while the right foot is nailed on top of the left.

The chasing of the drapery folds, chiselling of the fringe on the loin cloth, and the chiselling and finishing of the beard and hair, appear to be less intricate than the same detailing on other related crucifixes.

Both the cross and Christ were recently (Casalini, 1964, pp. 266–76) identified as belonging to a 'little ciborium' commissioned for the high altar of Ss. Annunziata in 1578. (At the same time, the patron of the ciborium, Sebastiano del Favilla, ordered Giambologna's *Carità* to be placed over the principal door into the tribune of the church). In 1820, the ciborium was transferred to the altar of the Chapel of S. Maria Maddalena in the same church, and lost during the 1885 restoration of that chapel. Casalini suggests that the crucifix had already been removed from the ciborium in 1820 and placed in the Convent's refectory.

If Casalini's dating can be accepted, the crucifix is of importance iconographically as one of the rare examples of the *Cristo vivo* in the art of this period, and the earliest occurrence of the motif in the *oeuvre* of Giambologna. (For discussion of the iconography of the *Cristo vivo* and its possible rôle as 'Crocifisso eucaristico', see Casalini, 1964, pp. 273–6 and Utz, 1971, pp. 74–6). Hildegard Utz (1971, pp. 69–70) concludes that the Ss. Annunziata crucifix is an authentic work by Giambologna and that it is the arche-type of the *Cristo vivo*, which must then date to 1578. She suggests that the new kind of Christ was commissioned by Cardinal Ferdinando in Rome, to whom a 'metal crucifix', now lost, was sent in the same year, perhaps also '*vivo*'. Herbert Keutner (personal communication, May, 1978) feels that the Ss. Annunziata crucifix may be of later date, as the type of Christ seems to appear in the work of the sculptor only about 1590.

FURTHER VERSIONS: Cat. 99, 100; private collection, New York (bronze, *h.*23.5); Altar of Annunciation, Convento de las Descalzas Reales, Madrid, *h.*35 (feet to top of head) – possibly the gilt cross '*ancor vivo*' of 1603 sent to Spain (Dhanens, 1956, p. 369).

K.J.W.

99

Christ crucified, alive

*h.*30 *w.*27.3

Gilt bronze. The surface has been abraded in certain areas so that some detailing, such as curls of hair on the back of the head or the fringe on the loin cloth, has been dulled. There are small areas of dark encrustation scattered over the bronze's surface. The right arm appears to have been broken at the shoulder at an original joint, and mended; there is also a second join on the same arm above the elbow. The left leg is badly cracked at the ankle; the toe of the left foot is missing; the bent fourth finger of the right hand is badly cracked at the base; the bent thumb of the left hand is in the same condition.

Lent anonymously

This *Christ*, which is unpublished, is very close to that from Santissima Annunziata (Cat. 98) but is more finely finished in the areas of hair, beard and loin cloth. On the drapery of the cloth to Christ's left is a double-lined border and fringe associated with the goldsmith-like work evident on Antonio Susini's signed bronzes. One peculiarity is the positioning of Christ's right eye, which is placed too near the arc of the brow and seems larger than the left one; this may be intended to compensate for the foreshortening of the eye when seen by a spectator from in front.

FURTHER VERSIONS: Cat. 98.
PROVENANCE: Art Market.

K.J.W.

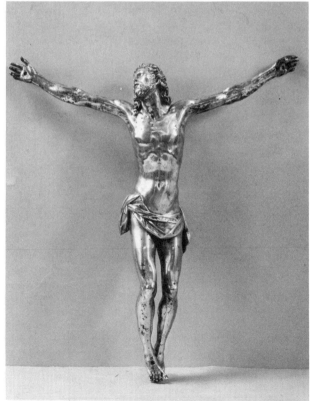

99

100

Christ crucified, alive

h.23.3 w.20.5

Bronze. Light brown natural patination with traces of translucent lacquer.

Lent anonymously

Among the crucifixes of Giambologna considered in this catalogue, the figure relates most closely to the living *Christ* type discussed above (Cat. 98, 99). But the small size of this version distinguishes it from the others, as do the arrangement and surface handling of the loin cloth and hair, while the position of the legs, and the angle at which the head is held, shift the shoulders to a new position. In fact, the head, shoulders and arms of this model more closely resemble the type of *Christ* discussed below (Cat. 101, 102, 103).

Another bronze *Christ* from the same private collection (not exhibited), of similar measurements, is the closest parallel to the current example; the two, for the moment, form a sub-category in the group of Crucifixes with the living Christ attributed to Giambologna.

PROVENANCE: Art market.

K.J.W.

101

Christ crucified, alive

h.29 w.27.6

Bronze. Traces of dark lacquer, natural patina. In good condition; prong on head indicates that there was a crown of thorns, now missing.

Lent anonymously

This figure of Christ, which is unpublished, is closely related to those discussed above (Cat. 98, 99). The measurements and general composition of all three are similar. However, there are differences between this example and the other two beyond the immediate contrasts of surface treatment or arrangement of the loin cloth. The bone structure and musculature of the torso are handled in different ways; the knees, placed closer together than in the other three, swing to Christ's left, thus lowering His right hip. The angle of the head also differs. As a result of these variations, the body of this example gives a sense of motion, of straining upward, which is not so evident in the other crucifixes.

The figure is very close in size and composition to the *Christ*s from Ss. Annunziata (Cat. 102), Smith College (Cat. 103) and from a private collection in Siena (Utz, 1971, pp. 66–80). The finishes of all four differ. The surface of the cloth, hair and beard, and body of this example is unusual; the flesh seems to have been worked with a wire brush, and the loin cloth has been completely striated with fine parallel lines, indicating the weave.

The attribution is problematic. Hildegard Utz's argument that the Siena *Christ* is by Pietro Tacca is not impossible, but the composition differs markedly from that of the Christ type usually associated with his name; also Tacca would hardly have had the time or inclination to finish the intricate surfaces of the Siena *Christ*. The more probable attribution of this model is to Antonio Susini (Cat. 102 for discussion). The design is a variant of Cat. 98, 99, and Cat. 102, 103 are the same composition.

FURTHER VERSIONS: Cat 102, 103; private collection, Siena (silver, *h.*29.5, *w.*25.7, Utz, 1971, pp. 66–80).

PROVENANCE: Art market.

K.J.W.

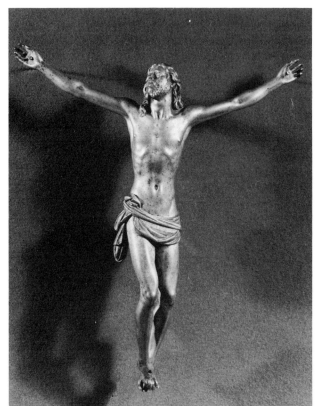

100

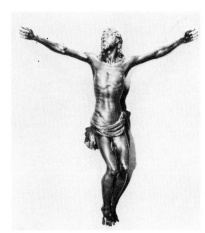

101

102

Christ crucified, alive

h.29 (without crown) *w*.27
Bronze on wood cross with mouldings, inserted in cast
bronze base (Golgotha). Red gold translucent lacquer,
turned black in some areas. In good condition.
Convent of Santissima Annunziata, Florence

The crucifix resembles examples in the collection of the
Smith College Museum of Art (Cat. 103) and formerly in a
private collection, Siena (Utz, 1971, pp. 66–80). It was
published in 1973 by Casalini who was convinced that the
similarities between this crucifix and that owned by Smith
College argued for the same workshop and perhaps the
same 'author' for both. Because Ferdinando Tacca had cast
a bell with a lizard motif for Monte Senario, Casalini
concluded that the Ss. Annunziata and Smith crucifixes
which have salamanders on the bases could be by the same
hand.

However, if details of foliage and rock from the
'Calvary' of the two crosses are compared with similar
details from the holy water basins in the atrium of
Santissima Annunziata, signed and dated 1615 by Antonio
Susini, a strong case is made for the attribution of the
design for the bases of the crucifixes to Antonio Susini.
The Ss. Annunziata crucifix may indeed date from 1615,
the year in which the holy water basins were finished.

The figure is a variation on other *Christs* attributed to
Giambologna or members of his circle, and may have been
invented by Antonio Susini himself (Smith College, 1964,
no. 25). In the 1609 inventory of the possessions of Lorenzo
Salviati (Watson and Avery, 1973, p. 504), there is listed:
'*un crocifisso di bronzo di 0/2 braccio* (29 cm) *con croce di
ebano con un monte di bronzo e panchetta di ebano, di mano di
Antonio Susini*' which may well be the Ss. Annunziata-
Smith College model as suggested by Watson and Avery,
p. 504.

ADDITIONAL BIBLIOGRAPHY: Avery and Keeble, 1975, pp. 12, 13.
PROVENANCE: Ss. Annunziata; placed for about thirty years in the convent
of the Addolorata (Figline Valdarno) and recently returned to Ss.
Annunziata.

K.J.W.

104

Christ crucified, alive

h.23.2 *w*.20.5
Bronze
Musée Municipal, Douai

ADDITIONAL BIBLIOGRAPHY: Leroy, 1937, p. 128, no. 865.
PROVENANCE: Amedée Foucques de Vagnonville collection; donated to
Museum in 1877.

C.A.

103

Christ crucified, alive

attributed to **Antonio Susini** (active 1580–d. 1624)
h.28.2 *w*.27
Bronze. Dark brown. The surfaces have been worn, so that
some of the finer detailing is lost on the body of Christ,
particularly on the face and in the area of the beard and
moustache. The separately-cast skull once in the cave on
the base, visible still on the Ss. Annunziata crucifix (Cat.
102), is now missing.
Smith College Museum of Art, Northampton,
Massachusetts (U.S.A.). Given by Mrs Maurice van Dyck
Emetaz in memory of Mary Waring Fitch '93 (1966:9)

See Cat. 101, 102 for discussion with bibliography of
crucifixes related to the Smith one. As with the Ss.
Annunziata example (Cat. 102), an attribution to Antonio
Susini for both the base and Christ seems plausible.

FURTHER VERSIONS: Cat. 102.
ADDITIONAL BIBLIOGRAPHY: Smith College, 1964, no. 25.
PROVENANCE: Emetaz collection.

K.J.W.

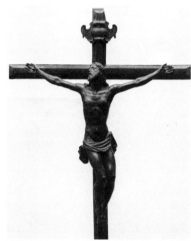

103

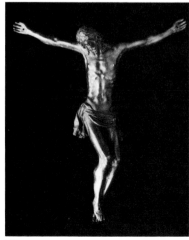

104

†105

Christ crucified, dead

*h.*46.8 *w.*37.2

Bronze. Natural metal with vestiges of brown lacquer
(turned dark in crevices and concave areas) over traces of
gilt. Mid-finger of left hand broken, tip missing; fourth
finger bent; serious crack in both legs below knee-cap at
back.

Convent of Santa Maria degli Angiolini, Florence

The crucifix in Santa Maria degli Angiolini was probably
executed at the same time as the statuette of *St John the
Baptist* and a bell donated by Giambologna to the convent
in 1588 (Cat. 91). The *Christ* is nearly identical to the one
intended for the altar of the Salviati Chapel in San Marco
(Cat. 107) of before 1588. It is interesting to note that *St
John the Baptist* in S. Maria degli Angiolini was perhaps
done from the model for the marble statue of *St John* which
stands in one of the niches in the Salviati Chapel. This
indicates some interplay in the sculptor's mind between
the two commissions. The measurements of the two cruci-
fixes are similar; the composition, anatomy, patterns of
hair, beard, and loin-cloth are very close. However, the S.
M. degli Angiolini *Christ* is of dark bronze, and the San
Marco figure is gilt, but the traces of gold on the former

may indicate that it, too, was once gilded. The San Marco
Christ is more lavishly worked; the curls of hair and beard
more tightly chiselled, the folds of the loin-cloth sharper
and a decorative border added. These differences may
reflect the contrast in the nature of the projects and
patrons. The S. M. degli Angiolini crucifix was possibly a
private gift on the part of Giambologna to the convent; the
Salviati Chapel was one of the most important commissions
of his career, ordered by a family of great wealth and
power. The composition of this particular version, how-
ever different the scale and physical proportions, is closely
related to the powerful, life-size *Christs* of the 1590s and
early 1600s. The Santa Maria degli Angiolini *Christ* has not
been published, but was recognized by Professor Keutner
some years ago; it is never mentioned in guide books,
although the statue of San Giovanni is referred to in several
sources (Cat. 91). Casalini made passing references to it, but
without a definite attribution, in his article of 1964, p. 270,
n. 30.

FURTHER VERSIONS: Cat. 107; Frauberger, *Die Kunstsammlung des Herrn
Wilhelm Pieter Metzler*, Frankfurt, 1897, p. 53, pl. 48.
ADDITIONAL BIBLIOGRAPHY: Avery and Keeble, 1975, pp. 12–14.

K.J.W.

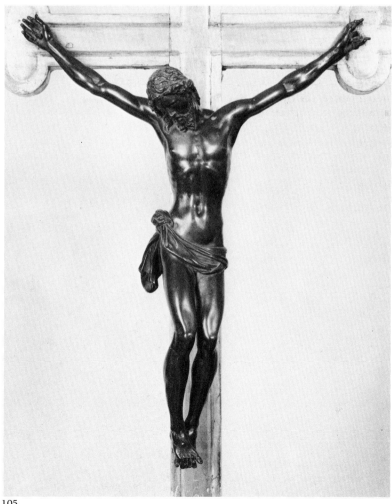

105

106
Christ crucified, dead
h.23.8 *w*.20.3
Silver, on ebony cross. Halo missing.
Palazzo Apostolico, Loreto

In a letter to the Duke of Urbino on 9 April, 1583, Simone Fortuna referred to four crucifixes which Giambologna had executed. Among these was one for the Grand Duchess (Giovanna d'Austria) *'che andò à Loreto'* (Dhanens, 1956, pp. 204–5, 208–9). A pilgrimage to Loreto by Giovanna, between 18 April and 9 May, 1573, is recorded in the archival notices collected by Settimani and Lapini. The Grand Duchess's gift to the *Santa Casa* of some silver candlesticks and a silver crucifix with ebony cross is listed in a source of 1597. This cross has always been associated with one still in the Palazzo Apostolico at Loreto (Grimaldi, 1977, p. 37). If this connection can be accepted, the Loreto crucifix is the earliest surviving one in the *oeuvre* of Giambologna.

The work easily falls into the general category of Giambologna crucifixes of the *morto* type. Christ's head hangs down to His right; His chest turns right; His knees turn left, creating a torsion and tension in the body. Although the legs are positioned in a solution he was to use repeatedly, for both small and large scale *Christs*, the modelling of the torso and placing of the loin-cloth are hesitant, as if the sculptor were experimenting with a first solution to the compositional problem. The body is heavier and fleshier than the later small crucifixes and relates more closely to Giambologna's large *Christs*; the drapery of the loin-cloth is somewhat awkwardly arranged. In contrast to the handling of anatomy and cloth, the head – hair, beard, crown of thorns – has the delicacy of a goldsmith's touch. The Loreto crucifix appears an authentic work by Giambologna, an early, in some ways, tentative statement of the composition for the *Cristo morto* which he was to repeat, refine, and vary in size and material for the rest of his life.

FURTHER VERSIONS: W. Gramberg collection, Hamburg (gilt bronze, *h*.23.8, *w*.18.8, four fingers of right hand broken off), published *Sechs Sammler Stellen aus*, Hamburg, 1961, Kat. Nr. 43.

K.J.W.

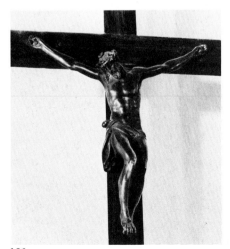

106

107
Christ crucified, dead
h.45.8 *w*.36.3
Gilt bronze. In good condition.
Convent of San Marco, Florence

The crucifix (Dhanens, 1956, pp. 204, 209) was executed for the altar of the Salviati Chapel in San Marco before 1588 (Dhanens, 1956, pp. 253–61 with literature). It is extremely close to the bronze crucifix from S. Maria degli Angiolini (Cat. 105) but the San Marco *Christ* is about 1 cm smaller (illustrated in colour p. 26). This may indicate the S. Maria degli Angiolini one is the original by Giambologna, his personal gift to the convent, and that the San Marco *Christ* was cast from moulds formed on it, or that both were cast from the same model. Antonio Susini's assistance with the reliefs in the Salviati Chapel is documented (Dhanens, 1956, p. 256), and the beautiful finish of the San Marco crucifix, which distinguishes it from that in S. Maria degli Angiolini, may be due to him, though the model is certainly by Giambologna.

FURTHER VERSIONS: Cat. 105.

K.J.W.

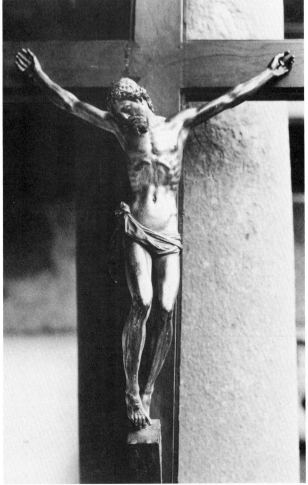

107

108

Christ crucified, dead

h.31.5 *w*.26

Bronze

Musée Municipal de la Chartreuse, Douai

The crucifix is said to have been acquired from the Vecchietti family by A. Foucques de Vagnonville in the 19th century. It has been assumed that the crucifix passed through the family from Bernardo Vecchietti, the early patron and friend of Giambologna. Desjardins, 1883, who was using the notes of Vagnonville as the basis of his book on Giambologna, mentioned *'Le Crucifix de la villa del Riposo'* in his list of crucifixes, p. 127, but it is not clear whether this was identical with the one given to Douai.

FURTHER VERSIONS: see Cat. 109.

ADDITIONAL BIBLIOGRAPHY: S. Leroy, 1937, p. 127, no. 853; Dhanens, 1956, p. 205, illus. 95, as replica of San Marco crucifix; Avery and Keeble, 1975, pp. 12–13; 'Neuerwerbungen der Frankfurter Museen 1945–1966, Liebieghaus', *Staedel-Jahrbuch*, N.F.A., 1967, p. 254 ff.

PROVENANCE: Vecchietti collection, Florence; acquired by Amédée Foucques de Vagnonville in 1851; donated to Museum, 1877.

K.J.W.

109

Christ crucified, dead

h.27.1 *w*.24.6

Bronze

Liebieghaus, Frankfurt (1523)

The Liebieghaus crucifix is a close variant of the S. Maria degli Angiolini and San Marco examples, but there are differences in the measurements and in the handling of details. The hair and beard of the present example are worked in a looser fashion, so that the curls and wave patterns appear coarser in comparison with the same details on the other two works. The drapery and folds of the loin-cloths also contrast. There are a number of versions of this composition, the most important of which (now in Douai) has by tradition been traced to the Vecchietti family, descendants of the patron of Giambologna (Cat. 108). Such a provenance, if accepted, would strengthen an attribution of this particular model to the sculptor. The contrasts between the crucifix and those in San Marco and S. Maria degli Angiolini might be interpreted as indications either of an earlier dating (before 1588) for the Douai-Liebieghaus model, or of the intervention of an assistant.

FURTHER VERSIONS: Cat. 108, 110, 111; private collection, *h*.31.3 (gilt bronze); Christie's, London, 1968, *h*.26.5; Heim Gallery, London, 1971.

ADDITIONAL BIBLIOGRAPHY: Dhanens, 1956, pp. 204–5, fig. 95 (Douai cross); 'Neuerwerbungen der Frankfurter Museen 1945–1966, Liebieghaus', *Staedel-Jahrbuch*, N.F.1, 1967, p. 254 ff. (as *circa* 1590); Legner, 1967, pp. 60–1; Avery and Keeble, 1975, pp. 12–14.

PROVENANCE: private collection, Florence.

K.J.W.

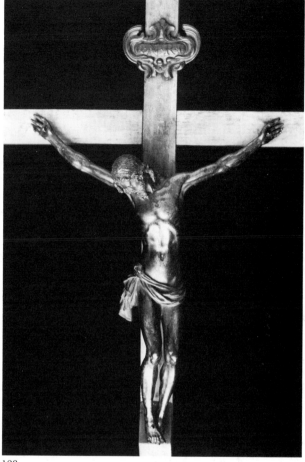

108

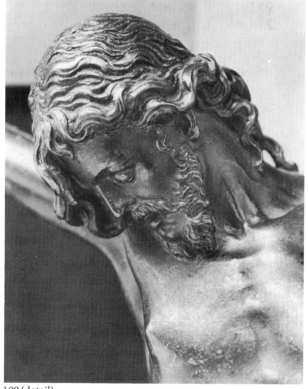

109 (detail)

110

Christ crucified, dead

*h.*31 *w.*25.6

Bronze. Dark red lacquer (blackened), abraded to reveal
natural bronze.

Lent anonymously

See Catalogue numbers 108, 109.

PROVENANCE: art market.

K.J.W.

111

Christ crucified, dead

*h.*29.3 *w.*26

Bronze. Reddish metal, light-brown patina, traces of black
lacquer.

Royal Ontario Museum (from the collection of Margaret
and Ian Ross)

The crucifix is catalogued in Avery and Keeble, 1975, pp.
12–14: 'The present bronze corresponds in general terms to
one now in the Musée la Chartreuse at Douai (Cat. 108;
Dhanens, 1956, pl. 95; S. Leroy, 1937, p. 127, no. 853). This
came from the collection of the Vecchietti in Florence and
so may be presumed to be an outstanding example, in view
of the fact that Bernardo Vecchietti had been Bologna's
first patron and had introduced him to Francesco de'
Medici in about 1560. Two other examples of this compo-
sition are known: one in the Liebieghaus (Cat. 109) and the
other with the Heim Gallery, London, 1971 (on an elabo-
rate lapis lazuli cross with gilt bronze mounts and a pietra
dura base in the style of Foggini). These three examples
share a more precise delineation of the musculature in the
torso. The present bronze has a more abstract concept,
which tends to lay emphasis on the head and face, which
are sharply chiselled by contrast. Nevertheless, the pattern
of folds in the loincloth still corresponds closely with the
other examples. It is thus probable that we have to do here
with a bronze cast, perhaps by Antonio Susini, from a
model made by Giovanni Bologna later in his career and
embodying a subtle modification of the earlier, more
naturalistic scheme, with the intention of increasing its
mystical intensity for the devout, in accordance with the
tenets propounded at the Council of Trent for the Counter-
Reformation.'

PROVENANCE: art market.

C.A.

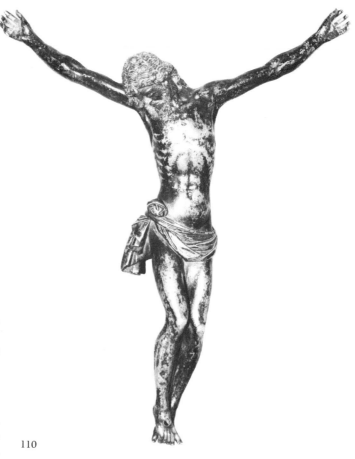

110

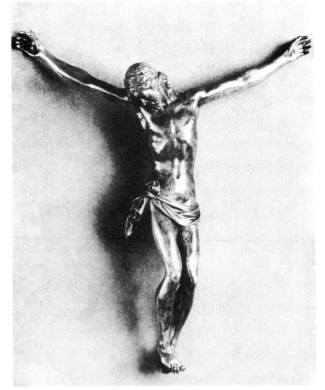

111

112

Risen Christ

by **Antonio Susini**, after **Giambologna**

h.30.3

Bronze.

Metropolitan Museum, New York. Edith Perry Chapman Fund, 1963 (63.39)

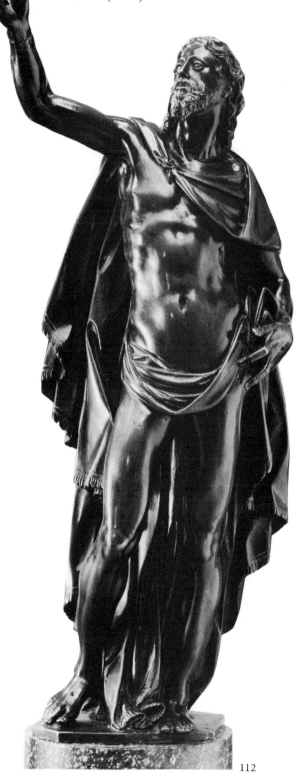

112

This statuette of the *Risen Christ* formerly crowned a sacramental tabernacle (ciborium) in the monastery of the Certosa at Galluzzo, outside Florence (Keutner, 1955). It was accompanied by bronze statuettes of the four Evangelists (Cat. 113, 114 and compare Cat. 115, 116) and six angels (formerly art market, Berlin, whereabouts now unknown, see Keutner 1955, figs 9–10). The commission for eleven statuettes is documented to 1596 by payments recorded in the account-books of the Certosa and was in the name of Giambologna, although the production of the bronzes was specifically stated to be by Antonio Susini. Baldinucci (Ranalli, IV, p. 110) in his life of Susini inaccurately dates the commission for four Evangelists and six angels (omitting the *Risen Christ*) for an unlocated tabernacle to the year 1600. The first and last source to mention the statuettes *in situ* is Domenico Moreni (*Notizie storiche dei contorni di Firenze*, Florence, 1791, II, p. 119), for they seem to have disappeared during the Napoleonic régime in Italy and are cited as lost by *e.g.* Desjardins (1883, p. 154, 'Ouvrages perdus', no. 7). Baldinucci states that for one of the *Evangelists* Susini made use of Giambologna's model for the *St Luke* on Orsanmichele, but that the rest were cast from his own models. The *Risen Christ* is, however, related just as intimately to Giambologna's life-size marble statue of 1577 for the Altar of Liberty in Lucca, but possibly Baldinucci overlooked this connection because the source was outside Florence. Furthermore, Giambologna is recorded as having produced statue(tte)s in silver of both *St John the Baptist* and *St John the Evangelist*, which were presented by Ferdinando I to St John Lateran in Rome, but were sold in the 18th century and have disappeared (Desjardins, 1883, p. 154). No record of their appearance survives, but the identical subject suggests that the *St John the Evangelist* might have been the prototype for the statuette in the Certosa. One of the angels now known only from a photograph is also little more than a reduction from Giambologna's large bronze *Angel* in the Chapel of St Antonio in San Marco which had been cast in 1586 (illustrated in colour p. 27). Otherwise, the statuettes may indeed have been designed by Susini and they resemble stylistically his *Virgin and Child* (Cat. 92). All four models of *Evangelists* were adapted by him in 1599 to fill niches in the frame of the south door on the west of Pisa Cathedral, and were also re-used for the church of Ss Concezione di Maria Vergine, Livorno (Kansas, 1971). Two or three further complete series of the *Evangelists* exist: in Braunschweig (Cat. 115, 116); a gilded set (ascribed to Pompeo Leoni) in the Museo Lazaro Galdiano, Madrid (Camòn Aznar, 1967, p. 59); another gilded set (unless identical with those now in Madrid) sent in 1603 to the Duchess of Lemos (Dhanens, 1956, p. 292).

ADDITIONAL BIBLIOGRAPHY: Dhanens, 1956, p. 291; Keutner, 1957; Phillips, 1958/59 & 1963; Weihrauch, 1967, pp. 64, 222.
PROVENANCE: Certosa at Galluzzo (until *circa* 1799); Julius Böhler, Munich.

C.A.

113
St John the Evangelist
by **Antonio Susini** (? after **Giambologna**)
h.27.9
Bronze.
Metropolitan Museum, New York, Pulitzer Bequest Fund,
1957 (57.136.1)

See Cat. 112 for details of the commission and the probable
division of artistic responsibility between Giambologna
and Susini. Possibly related to Giambologna's silver
statue(tte) of *St John the Evangelist*, formerly in St John
Lateran.

FURTHER VERSIONS: Herzog Anton Ulrich-Museum, Braunschweig (Bro.
101; Jacob, 1972, p. 14); Museo Lazaro-Galdiano, Madrid (Camòn Aznar,
1967, p. 59, gilt); formerly (?) Duchess of Lemos, Spain (Dhanens, 1956, p.
292); formerly Charles Loeser collection Florence (unless identical with
Cat. 113; photograph by Reali in files of the Kunsthistorisches Institut,
Florence); Akademie der bildenden Künste, Vienna (acc. Weihrauch,
1967, p. 222).
ADDITIONAL BIBLIOGRAPHY: Phillips, 1958/59, p. 221 f.
PROVENANCE: Certosa at Galluzzo (until *circa* 1799); Julius Böhler,
Munich.

C.A.

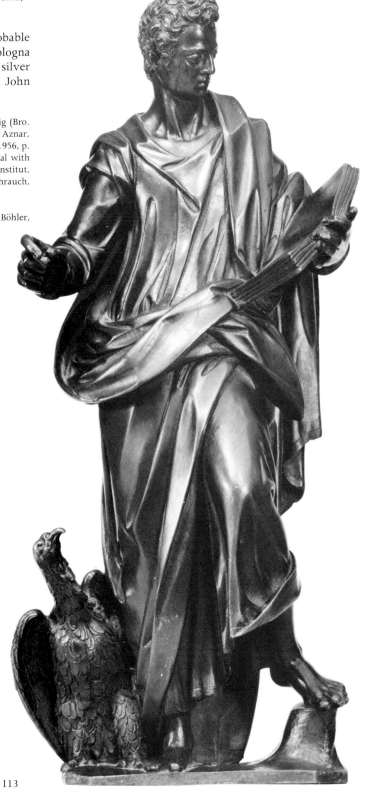

113

114
St Matthew
by **Antonio Susini** (? after **Giambologna**)
*h.*27.9
Bronze.
Metropolitan Museum, New York, Pulitzer Bequest Fund,
1957 (57.136.2)

See Cat. 112 for details of the commission and the probable division of artistic responsibility between Giambologna and Antonio Susini. No independent model by Giambologna is recorded, and his monumental statue of *St Matthew* commissioned in 1595 for Orvieto Cathedral and carved by Francavilla is related to his design for the *St Luke* on Orsanmichele (Dhanens pp. 288, 289) rather than to the present composition. It is remarkable that he should have resorted to using practically the same model for different *Evangelists* in different media, distinguishing the *St*

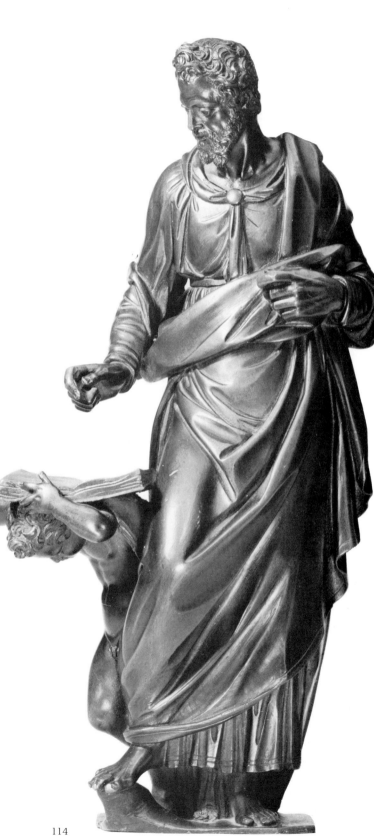

Matthew in Orvieto only by a symbolic angel. The sculptor was, however, at one of the busiest crises in his career, being involved simultaneously with the bronze equestrian statue of *Cosimo I* and with the marble group of *Hercules and a centaur*, as well as these two life-size Evangelists, all of which he was under Granducal and/or contractual pressure to bring to rapid completion. No doubt the Orvietan commission seemed the least important and he dealt with it by remote control, through sculptural assistants (Dhanens, p. 289), probably being forced to economize his own labour by utilizing only a single large model. It is not out of the question that in the initial stages he had produced in good faith a small model like the present bronze for the *St Matthew* for Orvieto, which he was forced subsequently to abandon, only for it to be utilized by Susini for the concurrent Certosa commission.

FURTHER VERSIONS: Herzog Anton Ulrich-Museum, Braunschweig (Bro.104; Jacob, 1972, p. 14); Museo Lazaro-Galdiano, Madrid (Camòn Aznar, 1967, p. 59: gilt); formerly (?) Duchess of Lemos, Spain (see Dhanens, 1956, p. 292); formerly Charles Loeser collection, Florence (unless identical with Cat. 114; photograph by Reali in files of the Kunsthistorisches Institut, Florence).
ADDITIONAL BIBLIOGRAPHY: Phillips, 1958/59, p. 221 f.
PROVENANCE: Certosa at Galluzzo (until *circa* 1799); Julius Böhler, Munich.

C.A.

114

115
St Mark or **St Luke**
by **Antonio Susini** (? after **Giambologna**)
*h.*23 *w.*13 *d.*12
Bronze. Light golden lacquer, under 19th-century slate-grey repatination.
Herzog Anton Ulrich-Museum, Braunschweig (Bro. 103)

See Cat. 112 for the relationship of the Braunschweig *Evangelists* to those from the Certosa at Galluzzo and documentation about authorship. The identities of this and the following *Evangelist* (Cat. 116) are hard to determine in the absence of the traditional distinguishing symbols of a winged bull (St Luke) or winged lion (St Mark). When Antonio Susini adapted the two models as niche figures for the Pisa doors (see Cat. 112) he included the symbols, giving the bull to the present model and the lion to the type of Cat. 116 (Keutner, 1955, fig. 13). This identification however contradicts the visual evidence that relates Cat. 116 intimately to the monumental bronze *St Luke* on Orsanmichele. Keutner (1955, captions to figs. 3 and 6), followed by Jacob (1972, p. 14), avoids the issue without discussion. Keutner (1957) called the present type *St Luke* on the basis of its similarity to a marble statue of *St Luke* by Francavilla in the Senarega Chapel in Genoa. He is followed in this by various authors discussing the example in Lawrence, Kansas (Kansas, 1971). Weihrauch (1967, captions to figs. 268, 269) evidently prefers to accept the relationship of Cat. 116 to the large *St Luke*, and therefore by elimination calls the present model *St Mark*.

FURTHER VERSIONS: Museum of Art, University of Kansas, Lawrence, Kansas (55.72, ex-Certosa at Galluzzo, via Böhler, Munich); Museo Lazaro-Galdiano, Madrid (Camòn Aznar, 1967, p. 59); formerly (?) Duchess of Lemos, Spain (see Dhanens, 1956, p. 292).
PROVENANCE: ancestral collection of the Dukes of Braunschweig-Wolfenbüttel.

C.A.

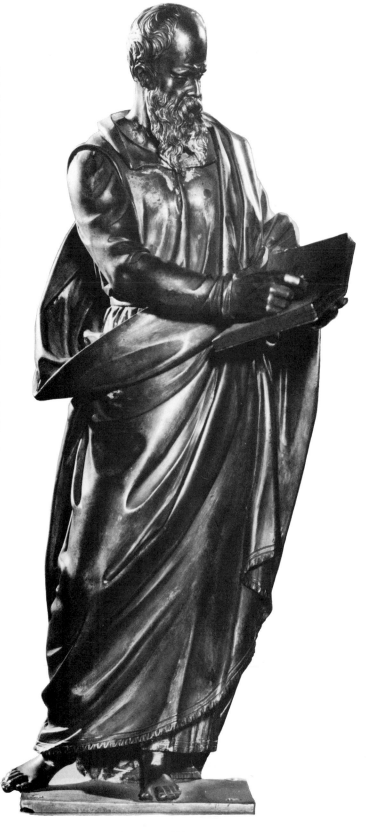

115

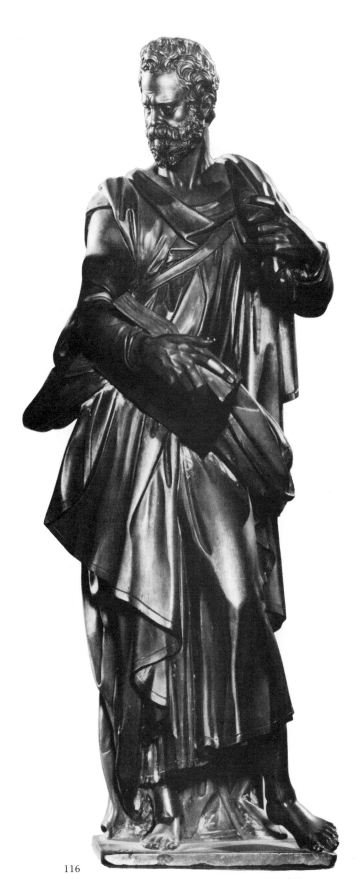

116
St Luke or **St Mark**
by **Antonio Susini** after **Giambologna**
h.23 w.12 d.11
Bronze, light golden lacquer, under 19th-century slate-grey repatination.
Herzog Anton Ulrich-Museum, Braunschweig (Bro. 102)

See Cat. 112 for relationship of the Braunschweig *Evangelists* to those from the Certosa at Galluzzo and documentation about authorship. For the problem of the identity of the present figure, see Cat. 115. In composition it is intimately related to Giambologna's monumental bronze statue of *St Luke* on Orsanmichele, Florence.

FURTHER VERSIONS: Museo Lazaro-Galdiano, Madrid (Camòn Aznar, 1967, p. 59); formerly (?) Duchess of Lemos, Spain (see Dhanens, 1956, p. 292).
ADDITIONAL BIBLIOGRAPHY: Jacob, 1972, p. 14.
PROVENANCE: ancestral collection of the Dukes of Braunschweig-Wolfenbüttel.

C.A.

117
Angel kneeling, with torch (pair)
h.28.5
Bronze. Brown patination.
Lehman Collection, Metropolitan Museum, New York

Stylistic analogies between the pair of angels and the *Virgin and Child* (Cat. 92) have been remarked and in type they are related to the two candle-bearing angels modelled in 1599 by Giambologna for Pisa Cathedral (Dhanens, 1956, pp. 292–4, fig. 207, 208).

ADDITIONAL BIBLIOGRAPHY: Musée de l'Orangerie, *Exposition de la collection Lehman de New York*, Paris, 1957, p. 128, pl. LXXXV.
PROVENANCE: Lord Swansea, Singleton Abbey, Wales.

C.A.

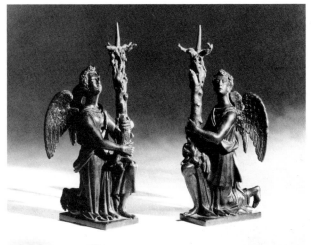

116

117

118
Allegory of Prince Francesco de' Medici
h.30.7 w.45.6
Bronze. Small casting flaws and holes, especially on the shoulders of Francesco and Mercury; soldering on the back.
Kunsthistorisches Museum, Vienna, Sammlung für Plastik und Kunstgewerbe (5814)

For the iconography see Cat. 120, 121. The relief seems to be an after-cast of the alabaster example in Madrid, the chief evidence for this being the receding edge underneath and at the sides. However, it differs in some important respects from the Madrid version, which is clearer in conception and sharper in detail. It is notable, for instance, that in the Madrid relief the dais on which the naked figure on the right reclines extends to the edge of the picture, overlapping with the architecture; in that version, too, the figure of Francesco is closest to being a portrait.

The bronze relief in Vienna is believed to be one of the three works by Giambologna which Francesco de' Medici presented in 1565 to his prospective brother-in-law, Emperor Maximilian II. All that we know for certain, however, is that Rudolph II received it as a gift from Cesare d'Este, Duke of Modena, in 1604 and carried it off to his private gallery exclaiming 'Now it is mine!' Apparently Rudolph had a silver cast made of the relief (Cat. 119), and at some later date the present relief was silvered. It has recently been cleaned.

The relief may have come into the possession of the house of Este through Barbara of Austria, sister of Maximilian II, who married Alfonso II d'Este and was Francesco de' Medici's sister-in-law.

BIBLIOGRAPHY: Venturi, 1885, pp. 16 ff.; Schlosser, 1901, XXVII; Tietze-Conrat, 1918, pp. 25 ff.; Planiscig, 1924, p. 155, no. 156; Dhanens, 1956, pp. 136–8; Bauer and Haupt, 1976, no. 1979, and p. XII.
PROVENANCE: presented by Cesare d'Este, Duke of Modena, to Rudolph II in 1604, and listed in the inventory of the latter's collection in Prague, 1607–11.

M.L.–J.

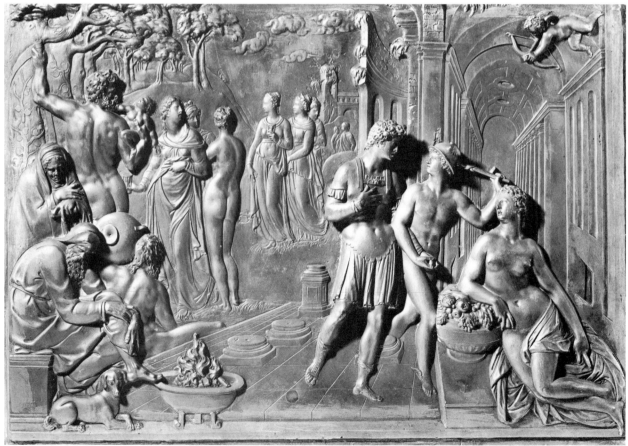

118

119

Allegory of Prince Francesco de' Medici

*h.*29.7 *w.*43.3

Silver. Small casting flaws and cracks especially where the high relief work begins. Mercury's caduceus, cast separately, is missing.

Kunsthistorisches Museum, Vienna, Sammlung für Plastik und Kunstgewerbe (1195)

The inventory of Emperor Rudolph II's collection (1607–11) states clearly that this relief was cast in silver from the bronze version that he also possessed (Cat. 118). We cannot be certain when this was done, but according to Venturi, who used the reports of the Duke's envoy Manzuolo from Prague in the Archivio di Stato at Modena, it would seem that the Emperor already possessed this copy before he received the bronze relief as a gift from Cesare d'Este in 1604. The silver version must therefore have been cast in Italy or even in Vienna, if the bronze was really the one which Francesco de' Medici presented to Maximilian II in 1565, and which no doubt later passed to the house of Este through Barbara of Austria. It is true that, according to Venturi, Manzuolo stated that the silver copy was made by a pupil of Giambologna, which suggests that it came from Italy, but stylistic indications, especially the chiselling and considerable ornamental additions in the copy, point rather to its being the work of a German craftsman. The silver relief is more delicate in execution and shows more variety of detail than the bronze original, but loses correspondingly in force and directness. Planiscig must in any case be wrong in holding that the bronze version is a copy of the silver one. In the first place the relief is smaller, both as a whole and in detail; this is the effect produced in after-casts, as the metal shrinks when cooling. Further evidence may be found in the clearly visible corrections on the edges of the silver relief, extending the boundary lines of the model, and in minor misunderstandings, *e.g.* in the area of the vault behind the flying Cupid. All this is sufficient to refute Planiscig's view and to confirm the inventory statement cited above.

BIBLIOGRAPHY: Venturi, 1885, pp. 16 ff.; Schlosser, 1901, T. XXVII; Tietze-Conrat, 1918, pp. 25 ff.; Planiscig, 1924, pp. 152 ff., no. 255; Dhanens 1956, pp. 136–8; Bauer and Haupt 1976, nos. 1686 and 1979.
PROVENANCE: listed in the inventory of the collection of Emperor Rudolph II in Prague, 1607–11.

M.L.-J.

120

Allegory of Prince Francesco de' Medici

*h.*30 *w.*44

Bronze.

Museo Nazionale, Bargello, Florence (128)

The panel was catalogued by Supino (1898, p. 399, no. 65) as the work of an unidentified Tuscan master but since then it has been correctly associated with the silver and bronze casts in Vienna and the alabaster in Madrid (see Cat. 118, 119, 121). The iconography is complex, but it is generally accepted that the protagonist is Prince Francesco de' Medici. Giambologna was exploring the medium of the sculptural relief by 1564, according to a letter of 26 July from his patron Bernardo Vecchietti to Francesco (Dhanens, pp. 330–1: '... *non solo ne rilevi, ma che ancora cammina avanti nelle historiette de le pitture, che non poco in vero mi han satisfatto.'*) The present composition almost certainly refers to plans for Francesco's marriage into the Imperial household (see Cat. 121) which were in hand in 1564 and the association of this relief with the works praised in Vecchietti's letter to the Prince is tempting. Nothing is known of the history of the present bronze cast, but presumably it was kept in the Medici collection as a record of what had been sent north.

FURTHER VERSIONS: Cat. 118, 119, 121.
ADDITIONAL BIBLIOGRAPHY: Dhanens, 1956, pp. 136–8.
PROVENANCE: old Medici collections.

C.A.

119

121

Allegory of Prince Francesco de' Medici

*h.*31 *w.*45

Alabaster.

Museo del Prado, Madrid (296)

The present example has not hitherto figured in the discussion of the several versions of the relief, assembled for the first time in this exhibition. Schlosser (1910, p. 10) and Planiscig (1924, p. 155) knew of its existence but cited it only in passing as an imitation in alabaster of the metal relief. Gramberg (1936) did not devote a single word to the work, and Dhanens (1956, p. 136) considered it lost. In 1969, in the first catalogue of the modern sculpture in the Prado, it was attributed to Giambologna under the title, *'Las cuatro estaciones'* (Blanc-Lorente, 1969, pp. 207, 208).

My conviction is that the alabaster relief is not only a certain, autograph work of the sculptor, but is his first version of this allegorical representation, which refers to Prince Francesco. This judgement is based on a detail noticeable only in the present example: the youth led by Mercury is a portrait of the Prince, while in all the other examples he has been transformed into an unidentifiable ideal portrait. Moreover, only in the alabaster version does the platform, or step, on which the Ceres or Abundance (?) lies, overlap at the right edge of the relief the background architecture (a passage, incidentally, that the artist wrongly resolved). Yet in the other examples the back section of the step is removed, with the opening in the now uncovered rear wall being completed in incorrect perspective (a detail corrected in the silver example, Cat. 119). Furthermore, only in the present example can one see through the portico into a mountain landscape – a feature that disappears in the bronze examples – and only here,

too, are the most distant figures characterized as wayfarers – both wear the traveller's cap, one carries a bundle over his shoulder – while in the others the stick and bundle are missing. These and other less striking particulars indicate that the alabaster relief was made at an earlier date than the metal versions.

As a consequence, the traditional assumption (most recently Dhanens, 1956, p. 136), based on an ambiguous document and on Borghini, that the original composition of the relief was elaborated around 1564–65 as a gift for Maximilian II, comes into question; in view of the portrait of the Prince it is untenable. Francesco (b. 1541) does not wear the trimmed full beard of his dated medal of 1564 by Domenico Poggini, but instead he is the still beardless youth of his first medal, struck by Pastorino in 1560 (I. B. Supino, *Il Medagliere Mediceo*, Florence, 1899, p. 123). While the defects in the metal version are sufficient to suggest a prior dating for the alabaster relief, the prince's age permits its exact dating to around 1560–61.

When and how the relief reached Madrid is not a matter of record. It is possible that Francesco himself presented it to Philip II, along with other gifts, in 1562–63 on the occasion of his fifteen-month sojourn at the Spanish Court. (Between 1560 and 1562 Cosimo I negotiated Francesco's marriage to Philip's sister, Joanna of Spain, b. 1535). But it is just as conceivable that Giambologna carved the relief at the suggestion of his patron Bernardo Vecchietti to offer to the Prince as a testimonial of their esteem and gratitude – its content pays homage to Francesco as the future ruler of Tuscany; its format, material, and execution make it a typical *Kunstkammer* piece. By 1561 Vecchietti had obtained through Francesco the definitive assumption of Giambologna to the post of court sculptor. In the latter case the relief may simply have remained in Florence, only

121

later, as Lorente assumes (but without secure documentary evidence), coming into the possession of Queen Christina of Sweden, and finally, under Philip V (1701–46), into the Spanish Royal Collections (Blanco-Lorente, 1969, p. 207).

In Madrid the subject of the relief is designated as '*Las cuatro estaciones*', in Florence as '*Il parto di Cibele*', and in Vienna, less specifically, as '*Allegorie auf den Prinzen Francesco de' Medici*'. In a copy of the representation on a maiolica plate, formerly in the collection of Ole Oleson, Copenhagen, an inscription explains the theme as '*Pa(x) et Bell(um) Con(veniunt)*'. Since a clear definition of the theme, which doubtless emerges from the ideal world of courtly allegories, does not for the present appear possible, it seems best to retain the generic designation, '*An allegory of Francesco de' Medici*'. The first step towards arriving at a more suitable understanding of the relief must entail explaining in exactly what situation Prince Francesco finds himself in the scene at the right, for clearly it is he who must be the central figure in any interpretation.

Tietze-Conrat (1918, pp. 25–9) and following her, Dhanens (1956, pp. 136–8), proceed from the idea that the scene constitutes a play upon Francesco's courtship of his betrothed, here elevated and embroidered in mythological terms. According to their understanding of the relief, Mercury, here as Hymenaios, leads the Prince to his intended, an explanation which, however, cannot be correct. In my view, it is more just to assume that in the principal group, whose actions take place on a new foundation, laid out with stone slabs, and before a newly erected or renovated building, there is an allusion to Francesco's rôle as the future ruler of Tuscany. Mercury escorts the Prince, whose right hand manifests his readiness to assume office, to a copious Fiorenza, here personified analogously to Ceres or Abundance, who looks up to him expectantly. And, above, Amor's action kindles the reciprocity of their attachment to one another.

At the other side of the relief, a much larger number of persons are found, set before ruins, in open nature, and on the two banks of a river bed. They sit, stand, and wander, unrelated to one another, reflecting and looking about, withdrawn into themselves. Saturn, who devours his child, is here the centre of meaning, and from him the other figures derive their significance – the two groups of women on either side of the river, each led by the figure of an Hour carrying an hourglass, as well as the old couple before the flaming brazier. All this, taken together, suggests the arc of time, the succession of the ages, the waxing and waning in the existence of Nature and Man.

The Hour in the foremost group of women now glances over to Amor who lets fly his arrow, thus making the only visible connection between the scenes on the two sides of the relief. Thus their intellectual reference to one another perhaps requires no further explanation.

FURTHER VERSIONS: Cat. 118, 119, 120.
ADDITIONAL BIBLIOGRAPHY: G. de Tervarent, *Attributs et symboles dans l'art profane, 1450–1600*, Geneva, 1959, col. 216–17.
PROVENANCE: the Royal Spanish collections.

H.K.

122
Christ before Caiaphas
h.50 *w*.73.
Bronze. Golden brown lacquer.
Bayerisches Nationalmuseum, Munich (R.3930).

The series of six reliefs showing Christ's Passion have been thoroughly catalogued by Weihrauch (1956, nos. 115–20; see Dhanens, 1956, pp. 241–53). It is the third such series, the first having been made by Giambologna for the Grimaldi chapel in San Francesco di Casteletto, Genoa, in about 1579 (now in Genoa University); and the second for Ferdinando I, though subsequently returned to the sculptor for inclusion in his memorial chapel in Santissima Annunziata (see Cat. 230–2 for further details). The present series is probably identical with the six bronze panels which the art dealer Bernhard Zäch in Augsburg was negotiating to sell to Amsterdam in 1630, and which the Nürnberg city council unsuccessfully tried to obtain as a gift for the Elector Maximilian I of Bavaria (A. Ernstberger, 'Kurfürst Maximilian I und Albrecht Dürer: zur Geschichte einer grossen Sammlerleidenschaft', *Anzeiger der Germanisches Nationalmuseum*, 1940–53, Nürnberg, 1954, p. 167). They were later probably acquired by the Elector Johann Wilhelm von der Pfalz (1690–1716), together with his celebrated collection of paintings, from the Netherlands.

FURTHER VERSIONS: Chapel, University of Genoa; Cappella del Soccorso, Santissima Annunziata, Florence (see above).
PROVENANCE: Bernhard Zäch, Augsburg, 1630; Düsseldorf Gallery; Vereinigten Sammlungen, 1846; acquired 1866.

C.A.

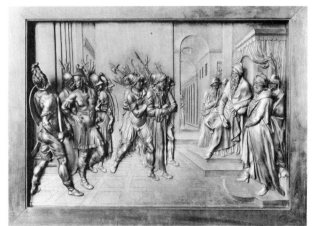

122

123
Christ shown to the multitude ('Ecce homo')
h.49.5 *w*.73.6
Bronze. Golden brown lacquer.
Bayerisches Nationalmuseum, Munich (R.3933)

See Catalogue numbers 122, 231; 208, 209.

FURTHER VERSIONS: see Cat. 122.
PROVENANCE: see Cat. 122.

C.A.

124
Christ led from judgement (Pilate washing his hands)
h.50 *w*.73
Bronze. Golden brown lacquer.
Bayerisches Nationalmuseum, Munich (R.3929)

See Catalogue numbers 122, 232.

FURTHER VERSIONS: see Cat. 122.
PROVENANCE: see Cat. 122.

C.A.

125
The flagellation of Christ
h.51.5 *w*.73
Bronze. Golden brown lacquer.
Bayerisches Nationalmuseum, Munich (R.3931)

See Catalogue number 122.

FURTHER VERSIONS: Markus Zeh, 1611, as an epitaph in the crossing of the Barfüsserkirche, Augsburg (1617); see Cat. 122.
ADDITIONAL BIBLIOGRAPHY: R. A. Peltzer, 'Ein Bronzerelief von Giovanni da Bologna in der Barfüsser Kirche zu Augsburg', *Zeitschrift für bildenden Künste*, 59, 1925/26, p. 187; Pope-Hennessy, 1966; Avery, 1975/77, I, p. 470, fig. 5.
PROVENANCE: see Cat. 122.

C.A.

126
The mocking of Christ
h.49.5 *w*.73.5
Bronze. Golden brown lacquer.
Bayerisches Nationalmuseum, Munich (R.3932)

See Catalogue number 122.

FURTHER VERSIONS: see Cat. 122.
PROVENANCE: see Cat. 122.

C.A.

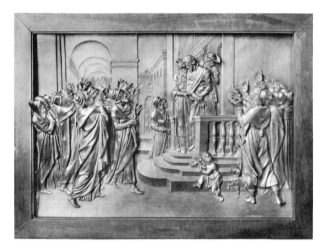

123

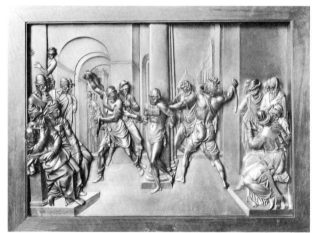

125

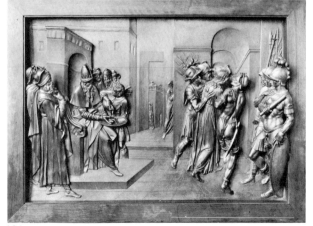

124

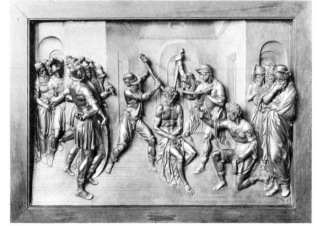

126

127

Christ carrying the Cross

*h.*49.5 *w.*72.5.

Bronze. Golden brown lacquer.

Bayerisches Nationalmuseum, Munich (R.3934)

See Catalogue number 122.

FURTHER VERSIONS: see Cat. 122.
PROVENANCE: see Cat. 122.

C.A.

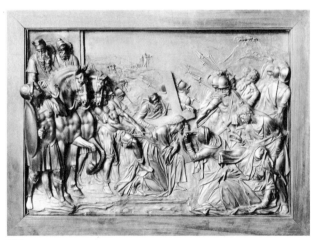

127

128

The acts of Francesco I

Bronze, intaglio.

a. Duke Cosimo I makes Francesco Regent (11 June, 1564)
b. A design for a fountain is presented to Francesco at the Villa of Pratolino (? *circa* 1580)
c. The draining of the Pisan marshes
d. Francesco publishes the Imperial decree by which he is created Grand Duke (13 February, 1576)
e. Francesco is shown by Buontalenti a design for a new façade for Florence Cathedral (1587)

Museo Nazionale, Bargello, Florence

This series of bronze moulds relates on the one hand to a series of wax models in relief also in the Museo Nazionale, Bargello, and on the other to a set of gold, *ajouré* reliefs set on backgrounds of semi-precious stone in the Museo degli Argenti, Florence (C. Piacenti Aschengreen, 1968, p. 142, nos. 264–70). None of the three sets is complete, but eight reliefs, four rectangular and four lunette-shaped were originally produced to decorate an elaborate centrepiece of furniture (*studiolo*) designed by Bernardo Buontalenti in the newly-constructed *Tribuna* of the Uffizi (Heikamp, 1963, esp. pp. 210, 211; 246, 247; docs. 11, 12; p. 261, n. 22; this contains a fuller discussion, with some corrections and complete documentation, as compared with Dhanens, 1956, pp. 262, 263). Work on the reliefs was in hand by May, 1585, when payments were made for special materials and labour *'per formare storiette di bassorilievo di Gianbolognia che vanno gittate d'oro come per polizza di messer Bernardo Buontalenti'*; and to Antonio Susini *'a formare gittare e rinettare storiette ... per lo studiuolo suddetto per comessione di S.A.S. come per poliza di Giovanni Bolognia'*. It is clear from this evidence, as well as from the style of the reliefs, that the wax models are autograph works by Giambologna, and that the present moulds were produced by Antonio Susini and Cesare Targone, a goldsmith, who then cast the *ajouré* gold versions and worked them up. Work continued until 1587. Though small in scale, the reliefs were a most important commission from Francesco de' Medici and it is clear that Giambologna and Susini exerted themselves to produce masterpieces in miniature. The subjects are the deeds and achievements of the Grand Duke and Heikamp remarks that the emphasis is, interestingly, on the patronage of architecture and sculpture, while politics are played down, and that the spatial rendering of the narrative scenes is like the contemporary style of Poccetti's frescoes.

C.A.

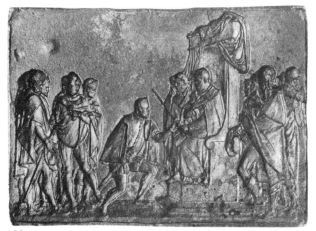

128a

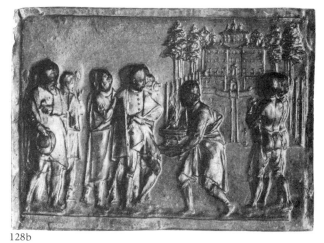

128b

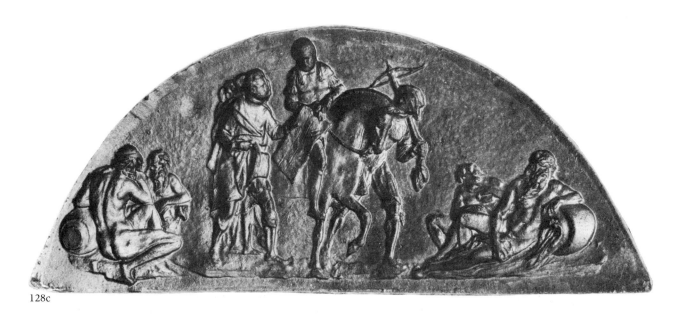

128c

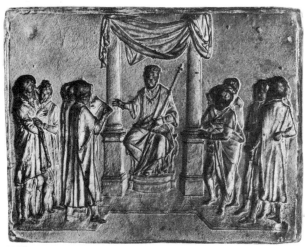

128d

128e

†129

The Jerusalem reliefs
Bronze. Black patination.

a. The Raising of the Saviour's Cross (7247)
 *h.*27.8 *w.*28.4
b. The Crucifixion (7248) *h.*27.5 *w.*28
c. The Deposition (7249) *h.*27.5 *w.*27.9
d. The Anointment (7245) *h.*28.6 *w.*28.6
e. The Entombment (7246) *h.*28.3 *w.*28
f. The Resurrection (7250) *h.*27.3 *w.*28.8

Staatliche Museen zu Berlin, DDR

This series of six reliefs is a duplicate of that made for incorporation in a bronze enclosure for the Stone of Unction in Jerusalem at the command of Ferdinando I in 1588 (see A. Ronen, 1970, with earlier literature and listing of versions). The principal documentation for the commission is to be found in the account book of Fra Domenico Portigiani, which records that on 10 February, 1591, he was paid for '*un ornamento di bronzo fatto per mandare al sco. sepolcro in Jerusalem . . . nel quale viena drento sei storie di bassorilievo scolpitovi drento la passione dl.nro. Sig . . .*'. Among payments for work on the bronze doors for Pisa Cathedral mention is also found on 2 March, 1596, of four small reliefs (three of the Passion and one of the Resurrection) still in Portigiani's possession, specified as being by Francavilla. Four of the six Jerusalem reliefs, including the *Resurrection*, are in a distinct and mediocre style, which may therefore be that of Francavilla, while the remaining two, the *Anointment* and the *Entombment*, as indicated by Kriegbaum (1927) and accepted by Dhanens (1956, p. 270), may be by Giambologna himself. The scene of the *Anointment*, unusual in Passion cycles, was the most important of this series, in view of the fact that the reliefs were to decorate the stone in Jerusalem on which the Anointment was supposed to have taken place. It was paired with the *Entombment* on one of the long sides of the enclosure. Both are designed with the main action taking place in the foreground and parallel with the surface plane, while the participants are arranged like a frieze, in front of a background of steeply rising rocky landscape. *The Raising of the Saviour's Cross* and the *Resurrection* attempt a dramatic recession based on contemporary painting, but fail to convince, while the *Crucifixion* and *Deposition* tend to occupy the whole surface of the relief, as in contemporary plaquettes. It is difficult to accept the less than competent artistry of the four mediocre panels as Francavilla's, for his only relevant works in relief are panels on the Pisan doors which have little in common with them. It is also curious that Giambologna is not recorded as having participated in the commission, when two of the reliefs are so clearly superior and presumably were meant as prototypes for the series. Much of the rather crude afterworking must be Portigiani's responsibility, and it is surprising that it passed muster with the Cardinal Grand Duke Ferdinando wishing to venerate a shrine in the Holy Land.

PROVENANCE: private collection, Frankfurt am Main; bought 1926.

C.A.

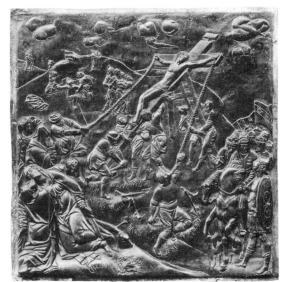

129a

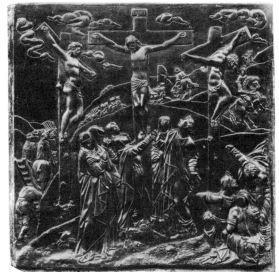

129b

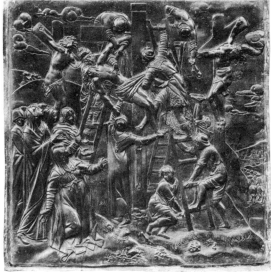

129c

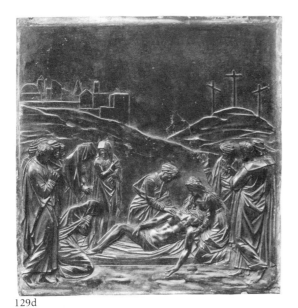

129d

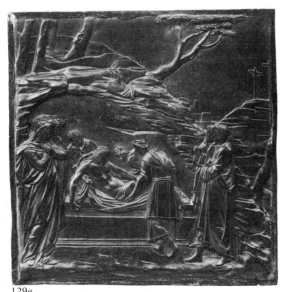

129e

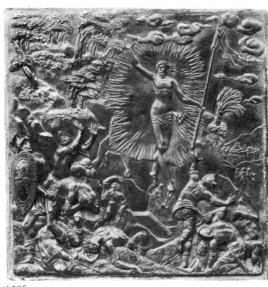

129f

130
Bird-catcher (Type 1)
h.32
Bronze, raw metal naturally oxidized, on storiated oval
base. Missing implements from the hands.
Museo Nazionale, Bargello, Florence (56)

The subject of a peasant with a fowling-lantern features in
both lists of authentic bronze statuettes by Giambologna
(see Introduction, p. 44): Zeh (1611), *'Un contadino che và à
fragnuolo'*; and Baldinucci (Ranalli, II, p. 583), *'Il Villano
con Frugnolo'*. Dhanens (1956, p. 211) noted that when
Philip Hainhofer visited the Archduke Leopold in Inns-
bruck he remarked in the *Schatzkammer*: *'Ain silbirner
baur von Gio Bologna gemacht, zu ainem nachtliecht und uhr
zu gebrauchen'* (Döring, 1901, p. 95) – 'a silver peasant by
Giambologna, adapted for use as a nightlight and clock'.
The model was among those sent by the Medici to Prince
Henry of Wales in 1611 and also featured in the Salviati
collection in 1609, no. 1086, qualified as *'di mano del detto'*
(*i.e.* Susini) (Watson and Avery, 1973, pp. 501, 504, 507).

Two principal and distinct models associable with
Giambologna exist, differing in whether the left arm
holding a lantern is raised and the right leg advanced (*Type
1*); or the left arm is lowered and the left leg advanced (*Type
2*). Dhanens (1956, pp. 211, 212) accepted as a composition
of Giambologna only *Type 2* (Cat. 134), although she could
not find an autograph example; and dismissed *Type 1* as
showing 'how a motif of the master was copied in an un-
artistic and naïve way'. None of the descriptions in the
early documents is precise enough to determine which
model was meant. However, there is far greater cumulative
evidence for *Type 1* as being by his hand, it corresponds
better in the handling of drapery with Giambologna's
other genre figures, and several examples have a degree of
finish that points at least to Antonio Susini.

The *Bird-catcher* is the biggest and most impressive of
the three main models of genre figures produced by
Giambologna, the others being the *Bagpiper, seated* (Cat.
135, 136) and the *Peasant resting on his staff* (Cat. 137, 138).
A rarer *Bagpiper, standing* may be associable with the shop
(Cat. 139), while a unique example of the long-lost *Duck-
girl* mentioned in a document of 1574 (Dhanens, 1956,
p. 186) has recently been identified in a private collection.
Genre-figures like these had long featured in German and
Flemish wood-sculpture, frequently in the guise of the
shepherds attending Christ's Nativity, and otherwise as
bystanders in New Testament scenes. They had been
popularized by the engravings of Dürer (see Cat. 136),
Beham and others. The identification with nature, agri-
culture and the 'simple life' which is characteristic of the
Tuscan, even when an aristocrat, led to an interest in
artistic renderings, such as the tapestries produced in the
Arazzeria Medicea to designs of Stradanus, and statues
showing peasants at work or play to be placed in natural
settings in gardens. There were many at the Medici villa of
Pratolino, most of which have now been assembled in the
Boboli Gardens (Gurrieri and Chatfield, 1972, fig. 188). It is
interesting to trace in some cases an unexpected con-
nection with Graeco-Roman statues. For example, from

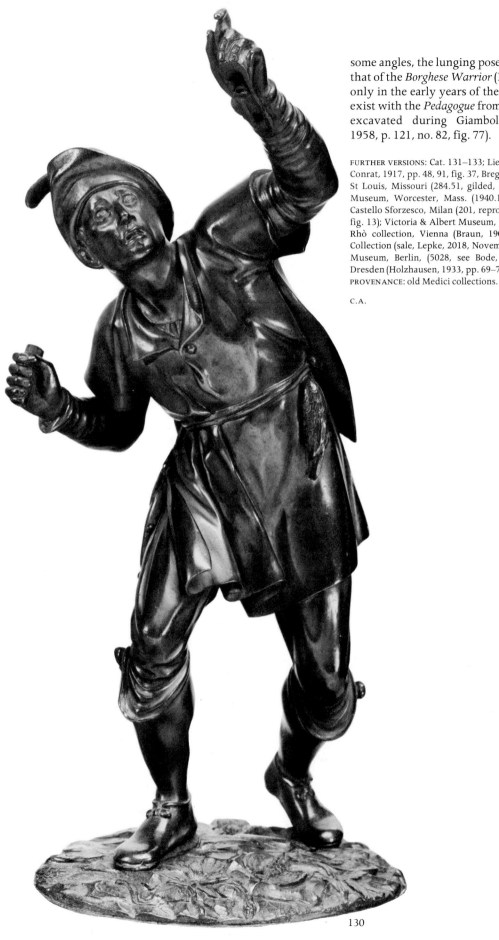

some angles, the lunging pose of the *Bird-catcher* resembles that of the *Borghese Warrior* (Louvre) which was excavated only in the early years of the 17th century. Analogies also exist with the *Pedagogue* from the group of the *Niobids* also excavated during Giambologna's lifetime (Mansuelli, 1958, p. 121, no. 82, fig. 77).

FURTHER VERSIONS: Cat. 131–133; Liechtenstein collection (*h*.31.9, Tietze-Conrat, 1917, pp. 48, 91, fig. 37, Bregenz, 1967, no. 15); City Art Museum, St Louis, Missouri (284.51, gilded, *h*.30.6, with lantern and stick); Art Museum, Worcester, Mass. (1940.151, on oval, moulded plain base); Castello Sforzesco, Milan (201, reproduced by Watson and Avery, 1973, fig. 13); Victoria & Albert Museum, London (A.129–1956); formerly Von Rhò collection, Vienna (Braun, 1908, p. XVI, *h*.27); formerly Basner Collection (sale, Lepke, 2018, November, 1929, no. 101); Kaiser-Friedrich Museum, Berlin, (5028, see Bode, 1930, no. 167); Grünes Gewölbe, Dresden (Holzhausen, 1933, pp. 69–70); etc.

PROVENANCE: old Medici collections.

C.A.

130

131
Bird-catcher (Type 1)
h. 30.4
Bronze. With thick, translucent, orange lacquer.
Engraved: *N° 78.*
Musée du Louvre, Paris, Département des Objets d'Art
(OA 9946)

This is an exceptionally fine and complete example, for the
model of which see Cat. 130. It featured in the collection of
Louis XIV in the 1684 inventory (Guiffrey, 1886, p. 37: no.
78 *'Un homme vestu en paysan, qui tient de sa main gauche
une lampe et de sa main droite une Raquette, haulte de 11
pouces ½'*). Landais (1961, p. 137) identifies this with an
example in the collection of the Duchesse d'Aiguillon,
Richelieu's niece, listed in her post mortem inventory, and
later in that of Girardon (Charpentier, 1710, pl. III, no. 6:
*'une petite figure de Bronze chassant de nuit aux oyseaux faite
par J. de Boulogne'*; Souchal, 1973, p. 73): however, this
clearly cannot be identical with the Louvre bronze which
was already in the Royal Collection by 1684. It is inter-
esting to note that no mention of Antonio Susini is made in
the present instance.

FURTHER VERSIONS: see Cat. 130.
ADDITIONAL BIBLIOGRAPHY: Musée des Arts Décoratifs, Paris, *Chefs
d'oeuvre de la curiosité . . .*, 1954, no. 288; *Vingt ans d'acquisition au Musée
du Louvre, 1947–67*, Paris, 1967–68, no. 273.
PROVENANCE: French Crown Collections No. 78, by 1684 (see above);
confiscated under the Revolution; collection Fiérard, sale Paris, 23–26
January, 1837, no. 67; collection Cambacères; gift of Nicolas Landau,
1957.

A.R.

132
Bird-catcher (Type 1)
h. 31.5
Bronze. Brassy yellow colour, naturally patinated.
Nationalmuseum, Stockholm (Sk.335)

See Cat. 130 for information about the type and problems
of authorship. The present example seems to have reached
Sweden with the booty from Prague in 1648. It was listed
in Queen Christina's inventory of 1652, no. 62 (Granberg,
1929, p. 185). It is one of the few examples that still has the
lamp in the holder: the matt-punched club in the right
hand may be a replacement, as it does not fit exactly the
cylindrical section gripped in the hand. Furthermore, it is
not certain what the *Bird-catcher* should hold, for in most
cases this separately cast component is missing; the
example sent to Prince Henry and later in Charles I's
collection held a 'strikeing ladle'; one formerly in the Von
Rhò collection, Vienna, held a straight stick; while that in
the French Royal Collection holds a racquet-like net (Cat.
131).

ADDITIONAL BIBLIOGRAPHY: Nationalmuseum, *Peintures et sculptures des
écoles étrangères*, Stockholm, p. 250, no. 335; Council of Europe, *Christina,
Queen of Sweden*, Stockholm, 1966, no. 1324.
PROVENANCE: (?) Emperor Rudolph II, Prague; Queen Christina,
Stockholm, 1652; King Gustavus III; the Swedish Royal Collection, 1817,
no. 205; 1860, no. 173.

L.O.L./C.A.

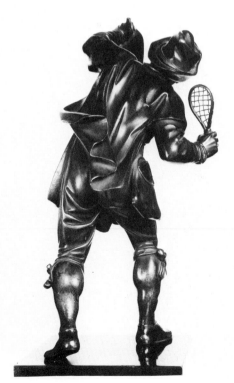

131 (frontal view in colour p. 29)

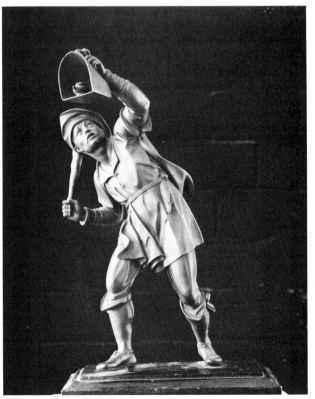

132

133
Bird-catcher (Type 1)
*h.*32.5

Bronze. Thin-walled, coppery-coloured cast, made in one
piece, with flaws in the interstices (compare Cat. 134).
Separately cast, architecturally moulded base, with two
dead birds on upper surface, modelled in low relief.
The Detroit Institute of Arts, Detroit, Michigan (40.133)

While in composition the statuette conforms to *Type 1* of
the *Bird-catcher*, for the origins of which see Cat. 130, the
high, elaborately moulded base with the dead birds, as well
as the facture of the whole, relate it to bronzes of *Type 2*, see
Cat. 134. The casting is not consistent with an origin in the
Florentine workshops of Giambologna or Susini and was
perhaps produced in northern Europe in the 17th century.
Nevertheless, it is of high quality in aesthetic terms.

FURTHER VERSIONS: see Cat. 130.
PROVENANCE: Gift of Mr Robert H. Tannahill.

C.A.

134
Bird-catcher (Type 2)
*h.*27 *w.*14

Bronze. Thin-walled, coppery-coloured cast, made in one
piece, with flaws in the interstices (compare Cat. 133).
Separately cast, architecturally moulded base, with two
dead birds on upper surface, modelled in low relief. Few
traces of after-working.
Bernard Black, Monte Carlo, Monaco

The only example in the present exhibition of a very
popular composition, which appears to have been
modelled as a pair to the other *Bird-catcher (Type 1)*. Its
movements are complementary, but it lacks the sophis-
ticated *contrapposto* of the other type, which is derived
from antique prototypes such as the *Borghese Gladiator* (see
Cat. 130). The origins of this type are probably to be sought
in Germany, for no examples are specifically documented
in early Italian collections. Dhanens, 1956, pp. 211, 212,
accepts this model as by Giambologna, while admitting
that she could not find an 'autograph' example.

FURTHER VERSIONS: Museo Nazionale, Bargello, Florence; Staatliche
Museen, Berlin-Dahlem (843); Collezioni Civiche, Ferrara (Varese, 1974,
no. 129); Sammlung 'A.W.', Berlin, sale 7 December, 1926, no. 17; with
Albrecht Neuhaus, Würzburg, 1977 (*The Burlington Magazine*, May 1977,
p. lxix, *h.*22.5 (without base); Victoria & Albert Museum (A.119–1956).
PROVENANCE: Mr David Black, London.

C.A.

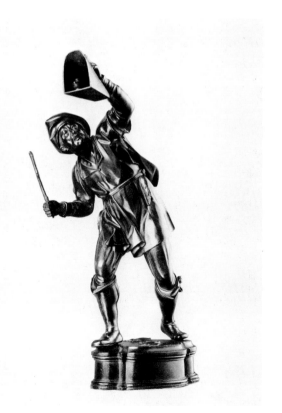

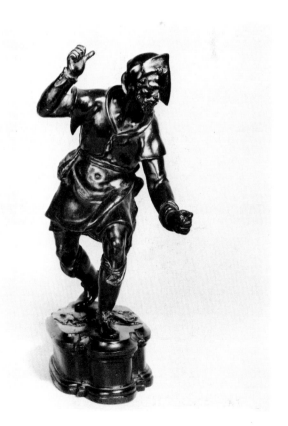

134

133

135
Bagpiper, seated
h.12
Bronze. Gilded.
Museo Nazionale, Bargello, Florence (464)

This is one of the finest versions, probably emanating from
the Medici collections, of a popular model of a figurine by
Giambologna, see Cat. 136. Its careful chasing and gilding
suggest that it may be the prime version, perhaps removed
from a lost piece of furniture, or art-cabinet.

OTHER VERSIONS: see Cat. 136.
PROVENANCE: old Medici collections.

C.A.

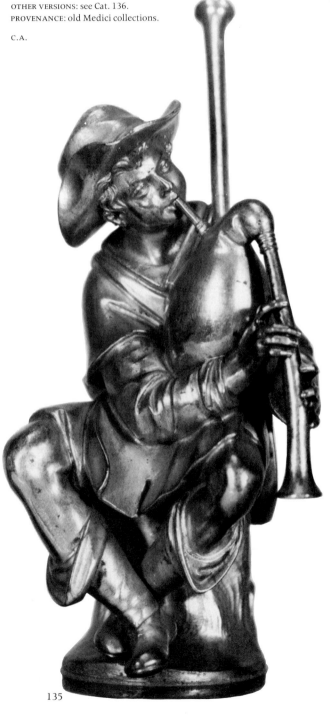

135

136
Bagpiper, seated
h.10.2
Bronze. Rich brown patina over remains of light golden
lacquer.
Museo di Palazzo Venezia, Rome (PV 10810)

The earliest specific reference to this model is in a bill of
lading of March, 1611, recording bronze statuettes sent by
the Medici to Prince Henry of Wales (Watson and Avery,
1973, p. 505, appendix VIII; and p. 507, no. 13: *'Uno
pastore che suona la Piva'*). However, the bronze was not
recorded later in the collection of King Charles I. The
Bagpiper may be identical with a *'pastore'* (apparently
distinct from the *Peasant, resting on his staff*) which
appears in a document of 1601 (see Cat. 137), but no
additional description is supplied; and with a *'pastorino'*
by Giambologna in the 1609 inventory of Benedetto Gondi
(as assumed by Dhanens, 1956, p. 212) though this is as
likely to be the *Peasant, resting on his staff* (see Cat. 137).

The model was regarded by Desjardins (1883, p. 155
under *'ouvrages perdus'*) and Bode (1912, pl. CCV; 1930, p.
36, no. 170) as by Giambologna, followed by Dhanens
(1956, pp. 211–13) and Santangelo (1964, p. 28, pl.
XXXVIII).

The motif is derived from an engraving of *The Bagpiper*
by Dürer, dated 1514 (*e.g.* Metropolitan Museum, New
York, Mr and Mrs Isaac D. Fletcher Collection, Fletcher
Fund, 1919).

A *Bagpiper* featured in the inventory of the Antwerp
collector N. C. Cheus (1621): *'een (figure) van moesler oft
ruyspyper'* (Denucé, 1932, p. 35).

FURTHER VERSIONS: Cat. 135; Victoria and Albert Museum, A. 59–1956;
Fitzwilliam Museum, Cambridge M2-1961 (with variations of detail, *e.g.*
feather in hat, and finishing); etc.
PROVENANCE: H.E. Giacinto Auriti, Vienna.

C.A.

137

Peasant, resting on his staff

h.13

Bronze. Rich brown patina over remains of bright golden lacquer; oval bronze base with central fixing pin.
Museo di Palazzo Venezia, Rome (PV 10809)

The earliest reference to this model is in a document of 1601 recording the fact that four silver statuettes, not necessarily of recent authorship, which had been in the *Galleria* of the Uffizi, were sent out on loan to Antonio Susini, presumably to serve as models for reproduction in bronze; (communication of Professor James Holderbaum, 1978: A.S.F. *Guardaroba Medicea* Vol. 208: *Memoriale di Manifatori di Guardaroba*, Sept. 1598–Aug. 601, c.152). They included: '*Una figuretta d'arg(en)to di un villano co(n) Capello co(n) bastoncino che sappoggia il su il* (sic) *bastone pesa onc. 11.23*'; followed by: '*Une figuretta d'Arg(en)to di un pastore ... pesa onc. 11.8'*. The former is clearly identifiable with the present model and the latter possibly with the *Bagpiper* (Cat. 136), with an example of which Cat. 137 forms a pair in the Palazzo Venezia.

The other model is probably identical with '*... un pastorino ... di mano e l'originale del Cavaliere Gian Bologna*' in the inventory of the collection of Benedetto Gondi, Florence, 4 November, 1609 (Corti, 1976, p. 633). Tietze-Conrat assumed that this referred to the present model (1918, pp. 49–50) and further noted an example of the *Peasant resting on his staff* in the collection of King Charles I, which had been inherited from his elder brother Prince Henry in 1612. That particular example had been sent from Florence in 1611 (Watson and Avery,1973, pp. 502, 507, no. 14). The Gondi inventory clearly states that Giambologna was responsible for either the *Peasant* or the *Bagpiper*, as has normally been supposed on stylistic grounds. Since both models are so intimately related in subject and style as to be by a single hand, it follows that both must now be accepted as by Giambologna, rather than Pietro Tacca, as Watson and Avery supposed (1973, p. 502, n. 43).

FURTHER VERSIONS: Cat. 138; numerous derivatives, many being after-casts of smaller dimensions and usually lacking the staff and the oval base, *e.g.* Victoria & Albert Museum, A. 19-1971, *h*.11.5
ADDITIONAL BIBLIOGRAPHY: Bode, 1912, p. 6, pl. CCV (as Giambologna); 1930, p.37, no. 176 (as style of Giambologna); Dhanens, 1956, p. 213 (as 'scarcely acceptable as Giambologna') Santangelo, 1964, p.28, pl. XXXVII (as Giambologna).
PROVENANCE: H.E. Giacinto Auriti, Vienna.

C.A., A.R.

138

Peasant, resting on his staff

h.12.7

Bronze. Light brown patina (perhaps repatinated); the neck broken and repaired; oval bronze base with central fixing pin.
S. Franses, London

See entry for Catalogue no. 137. The two bronzes are of equivalent facture and quality.

A.R.

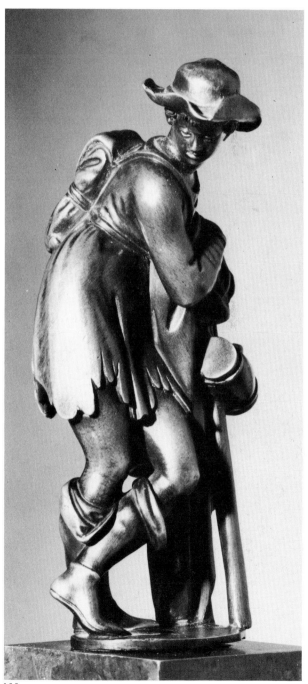

138

139
Bagpiper standing
*h.*14.6
Bronze. With dark lacquer, rubbed off on high points.
Staatliche Museen, Berlin-Dahlem (M.47)

The statuette, which was acquired in Munich in 1904, was attributed by Bode to Giambologna (1930, no. 171), on the grounds of its similarity in subject matter to his bronzes of genre figures (see Cat. 130–8). Dhanens (1956, p. 213) does not accept the attribution. The statuette is included in this exhibition for the sake of completeness and to permit direct comparisons with other examples of this group. It may prove to be a later variation on the theme.

OTHER VERSIONS: Williams College Museum of Art, Williamstown, Mass. (64.8).
PROVENANCE: art market, Munich, 1904.

C.A.

140
Grand Duke Cosimo I
*h.*70
Bronze. With dark lacquer.
Galleria degli Uffizi, Florence.

The bust was first ascribed to Giambologna by Gramberg (1936, p. 61) followed by Dhanens (1956, p. 108). It must date from after 1546, when Cosimo was made a Knight of the Order of the Golden Fleece, and indeed was probably one of Giambologna's first commissions from the Medici, possibly in the late 1550s. It is his earliest portrait bust, and awaits serious research.

PROVENANCE: old Medici collections.

C.A.

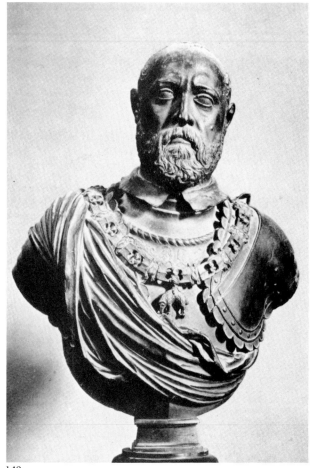

140

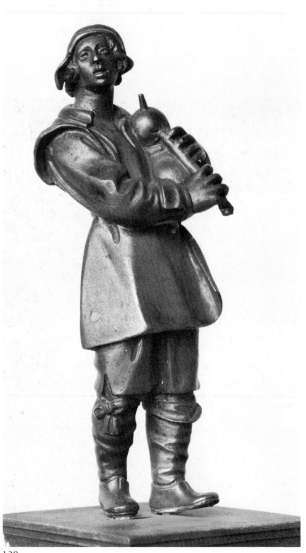

139

141

Cosimo I, small bust with helmet

*h.*24.5

Bronze

Engraved behind right shoulder, at edge of casting:
IHOAN. BOLOG. F. Inside bust: *COSIMO PRIMO DA
GIOVANNI DI BOLOGNA*

Lent anonymously

The bust, which is unpublished, appeared on the London art market in 1967. The double inscription is disconcerting. That engraved on the shoulder is convincing in epigraphy and spelling, and corresponds with the range of Giambologna's signatures collated by Dhanens (1956, pp. 26–7). That inside the hollow-cast bust has the look of a later addition to identify the sitter, which would have been unnecessary at the time, while the unauthorized *'di'* inserted between the artist's names bespeaks a posthumous, and probably 19th-century, origin.

The bust corresponds closely with the head and shoulders of Giambologna's marble statue of *Cosimo I* which replaced Vincenzo Danti's unpopular one (now in the Museo Nazionale) between the two recumbent statues on the *testata* of the Uffizi – above the arches leading towards the Arno (Dhanens, 1956, pp. 231–2). The statue is referred to in a letter of Simone Fortuna (27 October, 1581), and in Borghini's *Il Riposo* (1584, p. 587): '*Di marmo ha scolpito il Gran Duca Cosimo, che si dee porre agli Vffici nuovi donde fu levato quello di Vincentio Danti Perugino*'. It was set in position on 11 February, 1585, and unveiled on 23 March (Settimanni, IV, 1574–87, fo. 363 & 365 verso; Lapini, 1900, pp. 239–40).

Giambologna had been paid on 3 June, 1574, for having taken plaster moulds of the head and hands of Cosimo, after his decease, on 17 May: '*A Giovanni bologna scultore per havere formato la testa et mani di sua altezza . . . lire 8.6*' (E. Borsook, *Mitteilungen des K.H.I.*, XII, p. 38, n. 38).

A red wax model possibly for the statue, though differing in pose and detail (*e.g.* the Duke was bareheaded), was formerly in Berlin, but was destroyed in 1945 (Schottmüller, 1933, p. 168, no. 2284). The present bronze may reflect another, more detailed, model for the statue; or be a reduction from it produced in Giambologna's studio.

C.A.

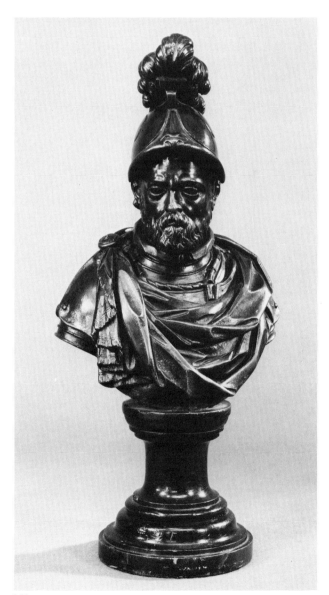

141

141 (detail)

142

Ferdinando I, bust
by **Pietro Tacca** (1577–1640), after **Giambologna**
h.75
Bronze
Museo Nazionale, Bargello, Florence (75)

The traditional attribution of this bust to Tacca was first challenged by Lewy (1928, p. 85), who rejects it on the chronological grounds that the death of the Grand Duke in 1609 took place too early in Tacca's career for it to be an independent composition. Lo Vullo Bianchi (1931, p. 184) agrees with this, adding her opinion of the quality of the bust, which she thinks indicates it was made by a studio assistant with an inferior talent to that of Tacca. She also suggests that the bust is a copy of the marble bust of Ferdinando I to be found above the door of the workshop of Borgo Pinti. Torriti (1975, pp. 20, 21) while agreeing with general critical opinion that the work is of less than excellent facture, feels that it is still of sufficient quality to merit attribution to Tacca, though making it clear that in his opinion the composition relates to the *modelli* of this subject already created by Giambologna in the workshop. Dhanens (1956, p. 299) agrees that the work is not by Tacca on chronological grounds, although she mentions the bust's resemblance to the portrait of Cosimo I by Tacca in the Cappella dei Principi in S. Lorenzo. As she also observes, the air-vents and the chiselling of this bust have been left unfinished, but the realism and quality of detail suggest, she feels, that this was a portrait done from life, without much idealisation. She concludes that it was executed by Giambologna when the equestrian portrait of Ferdinando was commissioned (*i.e.* about 1601).

Comparison of this work with the marble bust in the Borgo Pinti shows in fact that while there are important differences in detail such as the direction of the head, the two busts are clearly based on the same compositional type. In view of this, one may conclude that the execution of the bust was a routine task assigned to one of the workshop assistants, who followed a model made by Giambologna. That the assistant in question was Tacca is questionable on grounds of quality, despite its traditional attribution.

ADDITIONAL BIBLIOGRAPHY: Supino, 1898, p. 400, no. 75; *Mostra Medicea*, Palazzo Medici, Florence, 1939, no. 21.
PROVENANCE: old Medici collections.

A.B.

143

Giambologna, small bust
h.9 *w*.8.3. *d*.4
Bronze
Rijksmuseum, Amsterdam (R.B.K. 15117)

The bust was ascribed on stylistic grounds to Hendrick de Keyser by Leeuwenberg ('Drie werken met meer of minder zekerheid aan Hendrick de Keyser toegeschreven', *Maandblad voor Beeldende Kunsten*, XXIV (1948), p. 299) and the subject identified as a Knight of the Utrecht Chapter of the Teutonic Order, because of the cross on the left breast of the mantle. This was accepted by Weihrauch (1967) p. 361; by E. Smodis-Eszláry, 'Un petit bronze inconnu de Hendrick de Keyser', *Bulletin du Musée Hongrois des Beaux-Arts*, 34–5 (1970), pp. 99, 102; and perpetuated in J. Leeuwenberg and W. Halsema-Kubes, *Beeldhouwkunst in het Rijksmuseum*, Amsterdam (1973), pp. 184–5, no. 230.

An alternative identification of the subject as Giambologna himself, wearing the cross of the Knights of Christ, which he was awarded by the Pope in 1599, and a proposal that the bust, if not a self-portrait, at least originated in the workshop of Giambologna was published by Avery (1973) pp. 5–7. This was refuted by J. Leeuwenberg and W. Halsema-Kubes, *op. cit.* p. 516; but re-stated in Avery's review of that catalogue in *Burlington Magazine*.

A comparison with accepted portraits showing Giambologna towards the turn of the century, *e.g.* Cat. 213, 214, leaves little room for doubt, while the cross of the Knights of Christ carved on the coat-of-arms over the door of Giambologna's house, 26 Borgo Pinti, is clearly identical with that worn by the subject of the bust. Its conformation as a Greek, and not a Latin, cross distinguishes it from that of The Order of Teutonic Knights.

PROVENANCE: H. Koster, Amsterdam, 1937.

C.A.

144

Giambologna, small bust
h.9.2 *w*.8.4 *d*.4.1
Bronze. Reddish lacquer, blackened. Metal rubbed bare on high points.
Musée des Beaux-Arts, Dijon (1361)

See entry for Catalogue no. 143.

ADDITIONAL BIBLIOGRAPHY: catalogues of the museum: an VII (1799), no. 101; 1834, no. 617; 1842, no. 659; 1860, no. 750; 1869, no. 796; 1883, no. 1361. Exhibition catalogue: *Un Cabinet d'amateur dijonnais au XVIIIe siècle, La collection Jehannin de Chamblanc*, Dijon, 1958, no. 280, pl. VI.
PROVENANCE: J.-B.-F. Jehannin de Chamblanc, Dijon; entered the museum in 1799 after confiscation in the French Revolution.

C.A.

145

Giambologna, small bust
h.9.2 *w*.8.3
Bronze.
Sir John Pope-Hennessy, New York

See entry for Catalogue no. 143.

C.A.

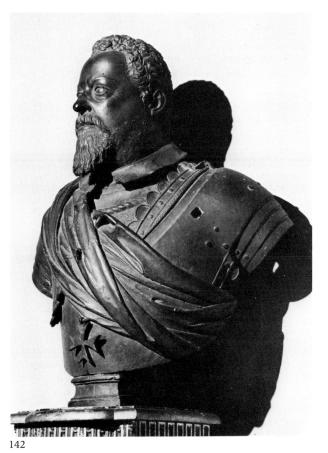

142

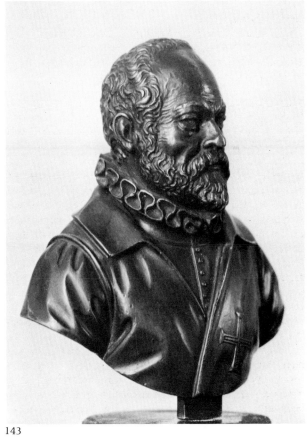

143

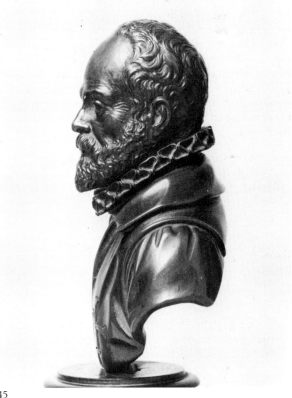

144

145

146

Giambologna

*h.*0.70

Bronze head in alabaster bust on marble pedestal.

Musée du Louvre, Paris, Département des Sculptures (812)

Neither the authorship nor the identity of this bust is yet resolved, and it is introduced into the exhibition for evaluation. The relative rarity of portraits of Giambologna (see Cat. 147) enhances its importance. A bust of Giambologna was included in the inventory of the effects of the Duc de Richelieu in the Palais-Cardinal in 1643 (Boislisle, 1881, p. 100) as follows: '*174. Un portrait de Jean de Boulongne, avec son buste de marbre blanc, sur son piédestal de marbre rouge et vert, prisé 200 1.*' Lenoir (*Musée des Monuments Français*, Paris, 1805, pp. 144–145), described a '*buste en marbre et en bronze numéroté 563*', as representing Giambologna, adding '*le buste que l'on croit être de Francheville son élève ... est fait de main de maître*'. Courajod, in the course of his comments on the documents published by Boislisle (Courajod, 1882, p. 220) unequivocally linked the bust formerly in Richelieu's possession with the bust of Giambologna in the Louvre. Describing the history of the bust, Courajod suggested that it passed, together with the contents of the Palais-Cardinal, into the hands of Louis XIII, who later presented the renamed Palais-Royal to Philippe d'Orléans. After the Revolution it reappeared in the possession of a M. Cailar who sold it to the Musée des Petits-Augustins; it passed into the Musée des Monuments Français, later renamed the Musée du Louvre. There is, however, a reference in the inventory of the effects of Richelieu's heiress designate, the Duchesse d'Aiguillon, made in 1675 (Boislisle, 1881, p. 110), as follows: '*49. Une tête de bronze représentant un vieillard, d'un pied 4 pouces de haut, prisée 75 1.*' Boislisle, in the same paper, (pp.104, 105), described how the Duchesse d'Aiguillon had transported to the Petit-Luxembourg '*ce que restait de sculptures*'. He also remarks on the extraordinary diminution in value of the sculptures throughout the estimates of the 1675 inventory. What is more difficult to explain is the apparent disparity in the height given in this inventory (equivalent to *h.*43.2) and the height of the object in the Louvre (*h.*70). Courajod, in 1882, also questioned Lenoir's attribution to Francavilla, on grounds of comparison with that sculptor's work; it had, he felt, been executed by a hand far more faithful to the style of the master, and he proposed Pietro Tacca. Desjardins, (1883, p. 184) citing Courajod's opinion, commented '*Ce n'est la qu'une présomption dénuée de preuves*', adding that the bust could fall within the stylistic range of Francavilla's earliest works, executed while still close to Giambologna. Courajod (*Mémoires de la Société des Antiquaires de France*, 46, 5ᵉ Série, t. 6, 1885, pp. 156–60) responded to Desjardins by quoting the Tacca-Vinta letter of 1608 (Gaye, III, 1840, p.537) published in Desjardin's work (p. 184) as reinforcement for his earlier (1882) attribution of the bust to Tacca. Dubrulle (*Gazette des Beaux-Arts*, LIV, 1912, pp. 334, 335), accepting the premise that the bust represented here was executed by a sculptor associated with the Giambologna workshop, also

cited the Tacca-Vinta letter of 1608. Dhanens (1956, p. 87), citing the same Tacca-Vinta letter of 1608, inclines towards Pietro Tacca. Francqueville (1968, pp. 111, 112) follows Dhanens's lead, making the comment that the pedestal, on grounds of comparison with those for busts by Francavilla, was probably made by that sculptor. If one accepts the attribution of Pietro Tacca, this indicates a case for the bust being brought into France by Francavilla during, possibly, the installation of the equestrian statue of Henri IV, this being the reason for the subsequent identification of this bust with his name.

ADDITONAL BIBLIOGRAPHY: Campori, 1873, p. 223; L. Gonse, *La Sculpture Française*, 1895, p. 147; A. Melani, *Scultura Italiana*, Milan, 1899; Vitry, 1922, p. 99; R. A. Peltzer, *Zeitschrift für Bildende Kunst*, 59, 1925/26, p. 187; A. Michel, *Histoire de l'Art*, V, II; Lewy, 1929, pp. 85–6; Gramberg, 1936, pp. 128–9.

PROVENANCE: (?) Cardinal le Duc de Richelieu; (?) Louis XIII; (?) Philippe Duc d'Orléans ... thence by descent; M. Cailar; Musée des Petits-Augustins; Musée des Monuments Français, later Musée du Louvre.

A.B.

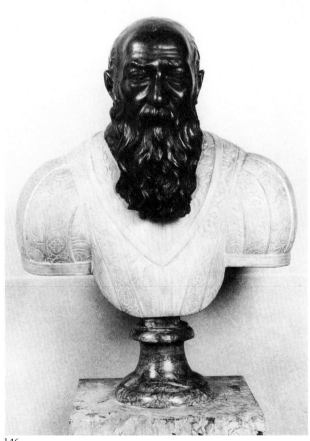

146

147

Giambologna (?)
Attributed to **Pietro Tacca** (1577–1640)
h.33.5
Terracotta.
Museo Nazionale, Bargello, Florence

The bust was first noticed by Marcello Tommasi in his unpublished Laurea thesis on Pietro Tacca (University of Florence, 1964) and related to the terracotta bust formerly in the Pinacoteca di Bologna (lost) which once belonged to Lorenzo Weber. This bust, published by Patrizi (1905, pp. 241–5) was suggested as a candidate for the portrait which, according to the Tacca-Vinta letter of 22 January, 1608 (Gaye, 1840, p. 537) may have been executed by Pietro Tacca around that date (see Cat. 146). Patrizi published the documents concerning the bust: a letter dated 29 July 1763 (Biblioteca Universitaria di Bologna) from L.-M. Weber to E. Lelli describes how Weber offered the Accademia Clementina a portrait bust of Giambologna purchased from the heirs of Pietro Tacca as by his hand. In the letter he describes the bust in detail, including a reference to the initials '*G.B.*' incised on the back of the bust. Lelli took expert advice which agreed with Weber that the bust was in fact by Tacca; a drawing (lost) said to be for this bust by Tacca was cited as additional evidence. Lewy (1929, pp. 85–6) mentions these documents without carrying the discussion further. Lo Vullo Bianchi (1931, pp. 137–40),

who studied the bust (by then lost) from photographs belonging to the Soprintendenza, Florence (one of which she published), reported that the bust did in fact conform to the details given in Weber's description. The photograph shows that the bust formerly in Bologna was closely similar to, but not identical with, the present bust. Lo Vullo Bianchi argues that the bust described as commissioned in 1608 by Cristina di Lorena ought to have represented Giambologna in his extreme old age. She believes that both this bust and that in the Louvre (Cat. 146) represent Giambologna. She also remarks on the difference in ages apparent in the two portraits and notes the difference in technique: '*Il primo e maestoso, il secondo un tozzo.*' She sensibly concludes that one, but not both, may be by Tacca, favouring the Louvre bust. The bust in Bologna, she adds, may be linked on comparative grounds with the name of Alessandro Vittoria. Gramberg (1936, pp. 127–8) also felt that the presence of a bust in the possession of Pietro Tacca did not necessarily indicate that an attribution to him should follow, preferring to place it outside Florence altogether, with the suggestion that the bust may have been executed by a Netherlandish artist working within the sphere of Roman influence.

ADDITIONAL BIBLIOGRAPHY: see Cat. 146
PROVENANCE: Bt. from Luigi Fanani, a sculptor, in 1925.

A.B.

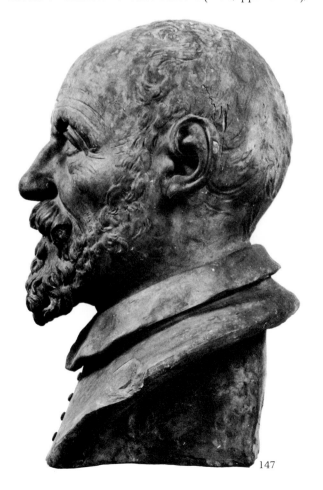

147

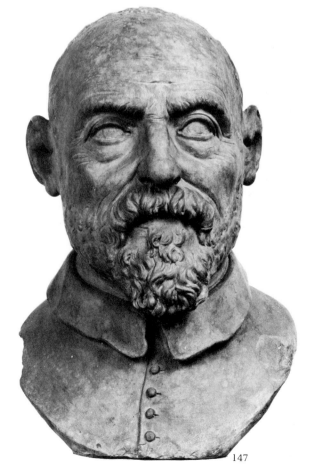

147

149

The Emperor Rudolph II (1552–1612) on horseback

h.63

Bronze. Reddish brown lacquer, abraded in places.
Nationalmuseum, Stockholm (SK.749)

The statuette is a faithful reduction of the equestrian monument to Cosimo I in Florence, finished in 1593 (Dhanens, 1956, p. 274f.), and the portrait has not unnaturally been regarded as that of Cosimo I (Weihrauch, 1967, p. 225). There is little doubt, however, that the subject is an idealized Rudolph II (Larsson, 1967, p. 44). Giambologna had been in touch with the Emperor since his accession in 1576 and had been granted a coat-of-arms in 1588 (Dhanens, 1956, p. 57), and the statuette may have been sent as a gift towards the end of the century. It may be identical with an item in the Prague *Kunstkammer* inventory of 1621, which however gives no artist's name.

Cat. 149 is recorded in Stockholm at the beginning of the 18th century (see Provenance) and identified as Rudolph (Granberg, 1930 pp. 99, 101f.: *'La statue equestre de bronze du Comte Flemming, laquelle represante L'Empereur Rudolfe'*). It is likely to have previously formed part of the Swedish royal collection, and, prior to that, part of the Swedish booty captured from Prague in 1648. Three *'hommes à cheval'* are listed among the bronzes in Queen Christina's inventory of 1652, though none is specified as representing Rudolph (Granberg, 1929).

ADDITIONAL BIBLIOGRAPHY: Nationalmuseum, *Peintures et sculptures des écoles étrangères*, 1958, no. 749; Council of Europe, *Christina, Queen of Sweden,* Stockholm, 1966, p. 527, no. 1332.
PROVENANCE: (?) Emperor Rudolf II, Prague 1621 (Inventory, no. 709); (?) Queen Christina, Stockholm 1652 (Inventory, Sculpture no. 25 or 71); Count Herrman Fleming (*circa* 1715–29); State Historical Museum, Stockholm; lent to Nationalmuseum 1884.

L.O.L./C.A.

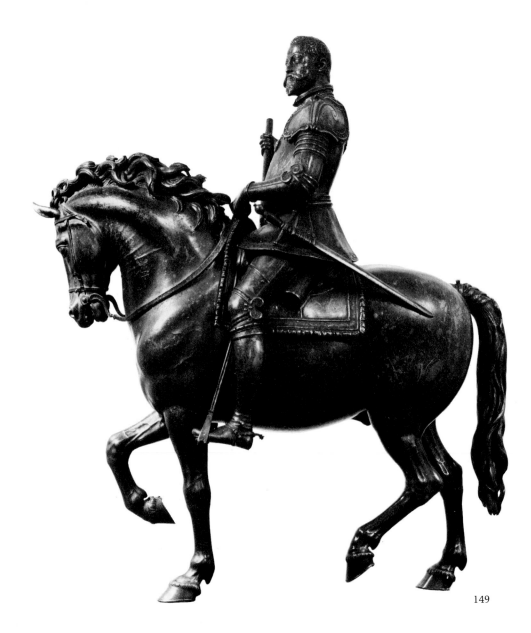

149

150

Ferdinando I on horseback

Without base *h*.64 *l*.57.4
Base: *h*.1.8 *l*.35.2 *w*.12.2
Bronze, on original oval bronze base, cast separately. Light gold lacquer; surface much abraded and darkened; multiple fractures; tip of horse's left ear broken off.
Engraved on saddle girth under belly: *IOAN. BOLO. BELG*. Painted in red on base: *F661*.
Sammlungen des Regierenden Fürsten von Liechtenstein, Schloss Vaduz

The monument to Cosimo I (1587–99) was the culmination of a series of studies for a pacing horse begun by Giambologna early in his career (Dhanens, 1956, pp. 274–285). The equestrian statues of Ferdinando I, Henri IV, and Philip III, together with many of the equestrian statuettes and small pacing horses, derive from models for the earlier project executed by Giambologna with the collaboration of Cigoli, Gregorio Pagani and Antonio Susini. One of the most beautiful of the statuettes is the present, signed example.

The bronze is composed of two major pieces, cast separately, then joined: the rider and saddle, and the horse, which follows the casting practice for the monumental equestrian statues produced in Giambologna's workshop. The head of Ferdinando, the handle of the sword, the cross of Santo Stefano, and the bit and reins are made individually and added. Detailing such as the decorative friezes on the saddle and armour appears to have been cast in rather than incised on the surface.

The bronze was acquired by Prince Josef Wenzel von Liechtenstein (1696–1772) and is published in Fanti (1767, p. 65) as '*La statua equestre di bronzo di Cosimo Primo, Gran Duca di Toscan, alta piedi 2, e once 2, fatta da Giovan Bologna . . .*' The horse and rider derive from the design for the monumental equestrian statue of Cosimo I and are similar to the unsigned bronzes of the Emperor Rudolph II in Stockholm (Cat. 149) and Henri IV in the Wallace Collection (Mann, 1931, pp. 58–9; Radcliffe, 1966, p. 93; Montagu, 1963, p. 83). All three seem to have been cast in the same piece-moulds. The slight differences, for instance – detailing of saddle, addition of sash, or handle of sword – could easily have been added to the wax layer before casting. The heads seem to have been cast separately, then soldered to the bodies. The Liechtenstein bronze may date

150 (illustrated in colour p. 31)

to May, 1600, as there is a payment notice in the Florentine State Archives '*per gittatura d'un cavallino configura, servi il Gran Duca Ferdinando*' of that time (Bregenz, 1967, p. 27 from Keutner; personal communication James Holderbaum; see also Francqueville, 1968, pp. 149–50). If the notices refer to the Liechtenstein statuette, it was cast in the San Marco foundry, not the Borgo Pinti workshop, before the equestrian monument to Ferdinando I was begun.

The commission for the monument in Piazza Ss. Annunziata dates to 1601; a receipt of December mentions models to serve for the 'new horse' of Giovanni Bologna (A.S.F. *Fabbriche Medicee*, f. 122, c. 113v; Watson, 1978, p. 160 ff.). Pietro Tacca carried out the project. The full-scale gesso model of the horse was completed by 2 July, 1602, and it had been cast in bronze by 24 October (A.S.F. *Fabbriche Medicee*, f. 122, c. 148v). The statue of the Grand Duke was almost finished by April, 1607, but the monument was not unveiled to the public until October, 1608, as part of the city's decoration in celebration of the wedding of Prince Cosimo to Maria Maddalena of Austria (A.S.F. *Conventi Sopressi*, 119, f. 54, c. 32r).

Traditionally, scholars have attempted to link the Liechtenstein statuette with the monument: E. Tietze-Conrat, 1918, p. 6, was of the opinion that the Liechtenstein bronze was a model for the equestrian monument, presented to the Grand Duke by the aged artist; A. E. Popp, 1919, p. 558, in a review of Tietze-Conrat's article challenged that opinion and suggested that the model of the horse was older, but that the rider might be a work of Pietro Tacca of about 1610–15.

James Holderbaum (personal communication) assumes that the document of 1600 refers to the Liechtenstein work and that it remained in the *Galleria* until 1618 when it was sent as a present to the Duke of Lorraine, a descendant of whom would have presumably given or sold it to the Prince of Liechtenstein.

From the evidence in hand, it is possible to suggest that the statuette was cast in 1600 from Giambologna's model with the assistance and supervision of Pietro Tacca, who may have added the sash at the wax stage. The work could have been cast in the Portigiani foundry because of other more pressing commitments in the Borgo Pinti workshop. The casting of the small equestrian bronze, which juxtaposes the horse and rider of Cosimo I with the portrait of Ferdinando I, may have been an experiment to give the Grand Duke some idea of one solution, but his final choice of a horse, perhaps based on drawings by Cigoli and models by Antonio Susini for a discarded design for the *Cosimo I*, is very different from the Liechtenstein bronze. Ferdinando's decision might have been prompted by the wish to differentiate between himself and his father, between their contrasting roles in the governance of Florence, a contrast emphasized by the nature of the locations which he selected for the two monuments.

ADDITIONAL BIBLIOGRAPHY: Tietze-Conrat. 1918, p. 18 ff; Popp, 1919, p. 557; Holzhausen, 1933, p. 65 ff.; Planiscig, 1930, p. 47, illus. 354; Lucerne, 1948, p. 56, no. 243; Dhanens, 1956, p. 297 ff.; Weihrauch, 1967, p. 224 ff.; Bregenz, 1967, p. 26 ff.
PROVENANCE: Prince Josef Wenzel von Liechtenstein (1696–1772).

K.J.W.

151

Horse pacing

h.23.5

Bronze. Light brown patina; on contemporary painted wood socle with unidentified coat-of-arms.

Victoria & Albert Museum, London (A.148–1910)

One of the major types of small bronzes produced in Giambologna's workshop is the pacing horse similar in composition to the horse of the equestrian monument to Cosimo I. This model is listed by Baldinucci and has been repeatedly cast through the centuries. The present example is especially important as recent thermoluminescent tests on core material extracted from it indicate a terminal date for the casting of 1605. The bronze was therefore cast within the lifetime of Giambologna. Details from the Cosimo I equestrian statue, such as the arrangement of the mane or the decorative braiding at the top of the tail, are repeated with minor variations on the statuette. Weihrauch (1967, p. 224, fig. 557) suggested that the horse was intended to form a pair with the Giambologna *Bull* (Cat. 177, 178), as on a cabinet in the Galleria Colonna, Rome. The pacing horse has also been paired with a rearing one (Watson and Avery, p. 503; Wixom, 1975, no. 146).

Baldinucci (Ranalli, II, p. 569) wrote that Cigoli and Goro Pagani did drawings as studies for the monument; and (IV, pp. 109, 110) that Antonio Susini executed the models and the moulds, and was responsible for the casting and finishing of the horse and rider. This account, whether it can be completely accepted or not (see discussion Cat. 162), does suggest that although the model for the present example is by Giambologna, it is most probably the result of collaboration with as many as three other artists.

Simone Fortuna in a letter to the Duke of Urbino of 27 October, 1581 (Dhanens, 1956, p. 345 f.) mentioned that Giambologna was working on a project for a monumental horse: '... *un cavallo traiano, che getta di bronzo, due volte grande quanto quello di Campidolgio, a fronte del gigante di Mich. Agnolo*'. The meaning of the phrase '*cavallo traiano*' is not quite clear, but the mention of its being twice the size of the ancient Roman equestrian statue of Marcus Aurelius in Rome strongly suggests that this was to be the classical model. This interpretation is borne out by the type of horse as finally executed for the monument of Cosimo I. It may also be significant that the *Marcus Aurelius* was by this time the centrepiece of Michelangelo's scheme for the Capitoline piazza, which may have inspired Giambologna and his patrons to think in terms of making a bronze horse *all'antica* as a new focus for the Piazza della Signoria in Florence, emulating Michelangelo's *David*. The project ultimately resulted in the erection of the monument to Cosimo I.

FURTHER VERSIONS: Cat. 152; Chicago, Art Institute (60.887); Dresden, Grünes Gewölbe; London Cyril Humphris, 1975; Madrid, Museo Arqueologico Nacional (52856); Modena, Galleria Estense; Schloss Pommersfelden; Stockholm, Nationalmuseum; Stuttgart, Landesmuseum; Vienna, Kunsthistorisches Museum (5843), etc.

ADDITONAL BIBLIOGRAPHY: Holzhausen, 1933, pp. 65–8; Planiscig, 1924, pp. 211, 212.

PROVENANCE: George Salting, London; bequeathed 1910.

K.J.W.

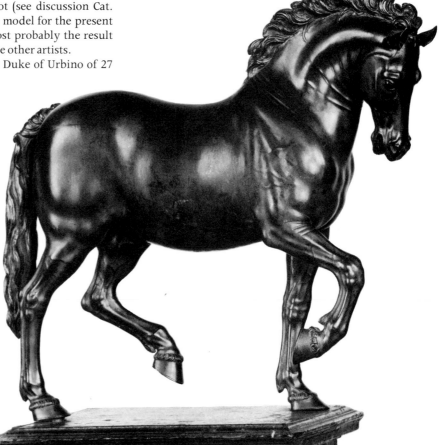

151

152
Horse pacing
*h.*24.2
Bronze. Dark lacquer.
Her Majesty the Queen.

See Catalogue numbers 151, 153; published by Watson and Avery, 1973, p. 503, fig. 19.

PROVENANCE: Kensington Palace, 1818; and possibly earlier in the collection of Prince Henry of Wales and King Charles I.

C.A.

153
Horse rearing
*h.*25.5 *l.*27.5
Bronze
Her Majesty the Queen

It was first suggested by Watson and Avery (1973, p. 503) that this type of horse might be identified with that listed by Baldinucci as '*Il cavallo che sta in su due piedi*', which precedes his entry on the standard, pacing horse: '*L'altro cavallo camminante*' (see Introduction, p. 44). It is curious that the rearing horse is known only in a single cast of respectable quality – and even this may not be contemporary – while the pacing horse is one of the commonest of Giambologna's models. Possibly the rearing horse was found to make a less visually satisfactory pair with its pacing counterpart than did the *Bull* (Cat. 177–8). That the present model is the one listed by Baldinucci cannot be proved, but the idea is corroborated by a stylistic comparison with the equine component of the rearing centaur Nessus in Giambologna's groups (Cat. 60–7). Its composition also fits well into the development of equestrian sculpture at the time, for it provides a possible prototype for Pietro Tacca's rearing horses. (Cat. 163, 164, 167).

FURTHER VERSION: Villa Mansi, Lucca (inferior cast).
PROVENANCE: Kensington Palace, 1818; and possibly earlier in the collection of Prince Henry of Wales and King Charles I.

C.A.

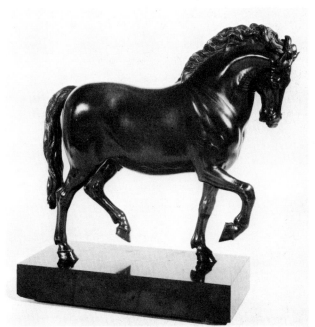

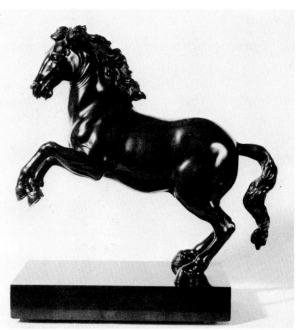

152

153

154

Horse pacing, with clipped mane

*h.*24.8 *l.*28.3 (oval base: 8.6 × 18.4)

Bronze. Remains of brown lacquer, on original oval bronze base.

Metropolitan Museum of Art, New York (24.212.23)

The statuette is the same in type and composition as the horse of the monument to Cosimo I, though it has a classical, clipped mane, and is closely related to statuettes of horses with saddle-cloths attributed to Giambologna (Cat. 155, 156). The stylized mane and bound forelock clearly derive from antique survivals such as the horses of San Marco, Venice, or the head of a horse which in the 16th century served as a fountain in the courtyard of the Palazzo Medici in Florence (now in the Museo Archaeologico, Florence). This particular kind of pacing horse first appears in one of Giambologna's reliefs in the Salviati Chapel, which could have been modelled as early as 1581 with the collaboration of Antonio Susini (Dhanens, 1956, p. 256, fig. 166). The rearing, charging horses of the relief of the *Rape of the Sabines* (1582–85) are also of the same general type.

The present bronze probably records one of a number of studies made by Giambologna about 1580, when he was involved with the project for a *'cavallo traiano'* for the Piazza della Signoria (see Cat. 151). Horses with the classical, clipped mane also feature in one of the reliefs on the base of the monument of Cosimo I (see Cat. 155, 156).

PROVENANCE: C. Bowyer (National Exhibition of Works of Art, Leeds, 1868); Ogden Mills Esq; given 1924.

K.J.W.

155

Horse pacing, with saddle-cloth

*h.*23.5

Bronze. Gold patina, on original oval bronze base.

Museo Nazionale, Bargello, Florence (348)

As with Cat. 151, 152, the general model of this horse may derive from the designs for a monumental *'cavallo traiano'* of *circa* 1581 or for the mount of the equestrian monument to Cosimo I of the late 1580s. It appears, complete with saddle-cloth, on the relief of *Cosimo I's triumphant entry into Siena* on the base of the equestrian monument.

FURTHER VERSIONS: Cat. 156, 157; Art Institute, Chicago (possibly later cast); Museo Arqueologico Nacional, Madrid; Nationalmuseum, Stockholm.
ADDITIONAL BIBLIOGRAPHY: Cat. 156.
PROVENANCE: old Medici collections.

K.J.W.

156

Pacing horse with saddle-cloth

*h.*24.5

Bronze. Red-brown lacquer under later dark-brown lacquer, light brown natural patina. In perfect condition.

Kunsthistorisches Museum, Vienna, Sammlung für Plastik und Kunstgewerbe (5839)

An excellent studio reproduction, perhaps by Antonio Susini of the horse ascribed to Giambologna himself which is now in the Museo Nazionale del Bargello in Florence (Cat. 155), and which may have been a preliminary study for the equestrian statue of Cosimo I in Florence, cast in 1591–93. In any case the horse is not by Adriaen de Vries as Planiscig thought.

BIBLIOGRAPHY: Planiscig 1924, p. 212, no. 337; Dhanens 1956, p. 281; Weihrauch 1967, p. 228; Leithe-Jasper 1976, p. 111, no. 158; Bauer and Haupt 1976, p. 101, no. 194.
PROVENANCE: old Habsburg possession, probably from Emperor Rudolph II's *Kunstkammer* and to be identified with its Inventory no. 1902 or 1911; later in the *Schatzkammer*, Vienna.

M. L-J.

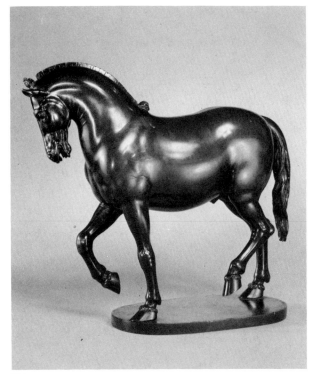

154

157 (detail)

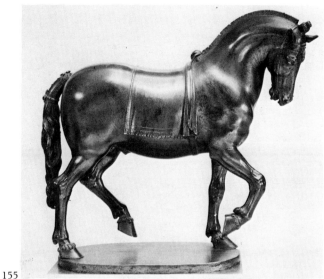

155

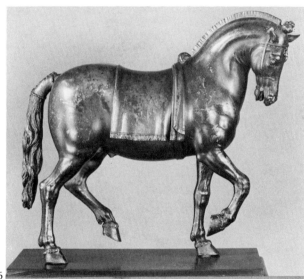

156

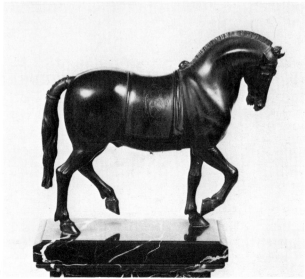

157

157

Horse pacing, with saddle-cloth

*h.*27.5 *l.*25.1 *d.*8.9
Bronze. Dark patination.
Sterling and Francine Clark Art Institute, Williamstown,
Massachusetts

See Cat. 155, 156. The cartouches, which were inscribed
with a stylus on the wax model before casting, are closely
similar to that with the Medici coat of arms on the saddle-
cloth of the nearer of the horses which draw the triumphal
car in the relief on the base of the equestrian monument to
Cosimo I. The present coat of arms remains to be identified.

FURTHER VERSIONS: Cat. 155.
PROVENANCE: Elia Volpi; purchased by Robert Sterling Clark, 1913.

C.A.

158

Horse pacing, small

*h.*15.7 (without socle)
Bronze, on ebony socle with metal inlay. Red lacquer
(blackened), abraded to reveal natural patinated bronze.
Raised right foreleg bent outwards.
Museo Nazionale, Bargello, Florence

The horse steps forward with right foreleg and left rear
raised and its head turned slightly to the right. The mane is
cropped close to the neck and forms a smooth curve, with-
out indication of texture; there is a curled forelock on the
horse's head and a curl at the end of the mane, where the
saddle would normally be placed. At the top of the horse's
tail is an elaborately braided and corded ornament. The
veining stands out sharply from the volumes of the body,
exaggerated by the blackened lacquer which has collected
in the crevices.

This small horse (*cavallino*) without saddle appears to be
unique among the models of pacing horses attributed to
Giambologna or his workshop, although it is very close in
composition to the larger horse with clipped mane and
saddle cloth (Cat. 155, 156) which, in turn, is basically the
mount of the monument to Cosimo I. At present it is the
only one of its size known.

The socle appears to be of the late-16th or early-17th
century. The balance of proportions between it and the
sculpture, with the horse extending beyond the base area
into space, is typical of small as well as monumental
equestrian statues of the period.

BIBLIOGRAPHY: Supino, 1898, p. 83, no. 22: '*Cavallo gradiente . . . Scuola del
Riccio*'.
PROVENANCE: Carrand Collection, no. 222, 1888/89.

K.J.W.

159

Henri IV on horseback (Fragments)
MR 3449 Left leg of figure (Barbet de Jouy 59)
h.100 *w*.25 *d*.58
MR 3450 Right forearm of figure (Barbet de Jouy 58)
h.80 *w*.40 *d*.67
MR 3451 Left foreleg of horse (Barbet de Jouy 60)
h.103 *w*.26 *d*.37
MR 3453 Left hand of figure (Barbet de Jouy 57)
h.31 *w*.19 *d*.18
Bronze.
Musée du Louvre, Paris, Département des Sculptures

An equestrian statuette of Henri IV was among the sugar figures decorating the tables at the time of Marie de Médicis' wedding in October, 1600 (Watson, 1978). This ephemeral image, perhaps quite by chance, was a first study for the equestrian monument to the French King ordered by Marie from Giambologna some time before 1604 for the Pont Neuf in Paris (Francqueville, 1968, p. 78 ff.; Pope-Hennessy, 1970, pp.392, 393; Watson, 1979, p. 187 ff.). In that year, a small bronze version of the equestrian statue was sent to Paris; two years later a wax portrait bust, intended as a model for the head of the King, was sent from Paris to Florence. By September, 1607, the horse had been cast, but the figure was cast only after the assassination of the King on 14 May, 1610. After a series of mishaps and delays, the equestrian statue finally arrived in Paris by 24 July, 1614, and was dedicated on 23 August. The bronze statues of *Slaves* on the base, executed by Francavilla, possibly from a design by Cigoli, and originally intended for the base of the monument to Ferdinando I, were added in 1618. The reliefs were added in 1628. By decree of the National Assembly on 14 August, 1792, the equestrian monument to Henri IV was destroyed. The bronze was consigned to a cannon foundry, but the four statues of the base, three pieces of the figure of the King, and one of the horse, were saved and are today in the Louvre. (For views of the monument before destruction, see the drawings by Edmé Bouchardon, Cabinet des Dessins, Louvre, nos. 24356–24359, 24714, 24717.)

The left boot of the figure MR 3449 still contains core; part of the fringed saddle is attached from the King's knee forward. MR 3450, the right forearm of the figure, has ornamental reliefs of weapons and shields. At the wrist there is a cuff of braid, and at the elbow where the jointing forms a kind of double cartouche, more braid. The iron *ossatura* is still imbedded in the core inside the arm. Only the upper part of the baton, upon which the King's hand rests, has survived. MR 3451, the left foreleg of the horse, shows pronounced veining at the knee and tufts of hair above the hoof; square-headed nails attach the horse-shoe to the hoof. The fourth fragment, MR 3453, is the left hand which holds the reins between thumb and forefinger. The interior is filled with core. All four fragments seem to closely resemble comparable parts on the equestrian statue of Ferdinando I.

ADDITIONAL BIBLIOGRAPHY: Barbet de Jouy, 1855, p. 33; Friis, 1933, p. 257, figs. 156, 157.
PROVENANCE: Pont Neuf, Paris.
K.J.W.

160

Henri IV on horseback
h.38 *l*.32.5 *d*.17
Bronze. Yellowish metal with traces of wire-brushing and translucent reddish lacquer.
Musée des Beaux-Arts, Dijon (191)

The statuette is related to the commission for an equestrian monument to King Henri IV, which may have been conceived about 1600 (see Cat. 159). A small bronze version was sent to Paris in 1604, while an equestrian statuette of approximately this size showing Henri IV is recorded in the French royal inventory under No. 143: '*Une figure de Henri 4 à cheval telle qu'elle est dessus le Pont Neuf, de 14 pouces* ½' (approximately 39 cm; Guiffrey, 1886, p. 40, no. 143). The horse is closely similar to the one signed by Antonio Susini in the Victoria & Albert Museum, which also once had a rider (Cat. 162), while the armoured rider, except for a different portrait head and an alternative position of the right hand with the baton, is almost identical with that in the statuette of Philip III in Kassel (Cat. 161). The model is quite distinct from that in the Wallace Collection (Mann, 1931, p. 58, S.158, *h*.64.7), where the horse relates to Giambologna's original one for Cosimo I in the Piazza della Signoria. The details of eyelids, beard and moustache, etc., are finely chiselled, and items such as the snaffles and the rowels on the spurs are separately cast and may be moved. The saddle with the rider is detachable, and the reins butt up against the left hand, but are not joined. The head is probably a separate cast joined below the down-turned collar. The cross of the Ordre du St Esprit is integrally cast.

ADDITIONAL BIBLIOGRAPHY: Catalogues of the Museum: An VII (1799), no. 114, stating that the horse is by Daniele da Volterra; 1834, no. 625; 1842, no. 667; 1860, no. 757, 'after Dupré'; 1869 no. 804, 'after Dupré'; 1883, no. 1369 'after Dupré; 1960, no. 191, 'after Pietro Tacca'. Exhibited *Exposition rétrospective de l'art français*, Paris, 1900.
PROVENANCE: Rozand, Dijon, seized during the French Revolution; entered Museum 1799.

C.A.

159 (M3453)

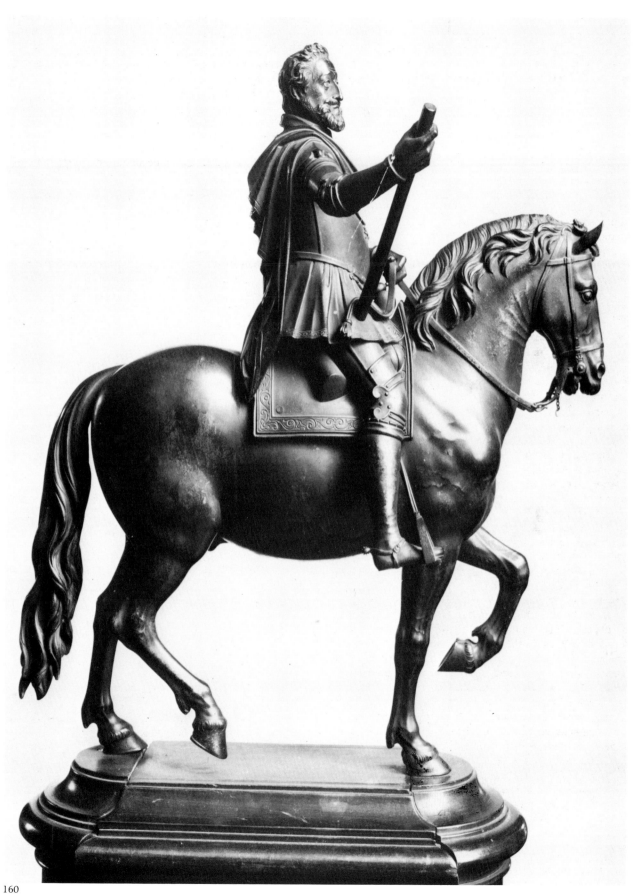

160

161

Philip III of Spain on horseback

h.60

Bronze.

Verwaltung der Staatlichen Schlösser und Gärten Hessen
(G.K. III 3490 [old number])

The rider of the equestrian statuette was identified as
Albert, Archduke of Austria, in an inventory of the
museum in the Löwenburg, Kassel, dated 23 December,
1803. The bronze was possibly acquired by the Landgrave
Frederick II of Hessen-Kassel in Paris at the same time as
Pietro Tacca's signed equestrian statuette of Carlo
Emmanuele, Duke of Savoy (Cat. 163). Justi, who pub-
lished the works (1886, p. 115, 116; 1908, II, p. 264),
considered them to be pendants.

 This identification of the present bronze was challenged
by Julius von Schlosser (who mistakenly wrote that Justi
had described both equestrian bronzes as having Tacca's
signature). Schlosser felt that the rider was Philip III of
Spain and the work a model by Pietro Tacca relating to the
equestrian statue of the King in Madrid, which he had
executed from Giambologna's model (Schlosser, 1913–14,
pp. 124–5). Despite the various theories as to its identity,
and apart from the portrait head which does seem to be the
Spanish monarch, the statuette appears to be a version of a
model for, or a reduction from, the equestrian monument
to Ferdinando in Florence, and differs from the monument
in Madrid. The composition of the Liechtenstein eques-
trian bronze (Cat. 150), which represents Ferdinando I,
may have had something to do with the preliminary stages
of his monument, and was based on the earlier statue of
Cosimo I: similarly the Löwenburg bronze may have been a
presentation piece for the monument to Philip III, but was
cast from a model for the preceding equestrian statue of
Ferdinando I.

 Ferdinando I commissioned the equestrian *Philip III*
from Giambologna in 1606 as a gift for the King of Spain
(Baldinucci/Ranalli, 1846, II, p. 578). At the same time, a
portrait painted by Pantoja de la Cruz was sent to Florence
to serve as a model for the likeness of the King (Justi, 1883,
p. 308). Possibly, at this stage of the project, a small bronze
was cast in order to give Philip an idea of the appearance of
the large-scale work. From the beginning, Pietro Tacca
directed the execution of the commission: the horse was
probably cast by Giambologna's death in 1608; the figure
of the King had still not been completed by 1611 (Döring,
1896, p. 118). The bronze horse and rider were officially
presented to the King of Spain on 24 November, 1616, by
Pietro Tacca's brother. The public unveiling of the statue
took place the following January in the Casa del Campo
under the castle walls on the other side of the River
Manzanares, part of the Royal Palace Gardens (Justi, 1883,
p. 310).

 The Kassel bronze is remarkably similar to the bronze in
Dijon (Cat. 160) which may be the presentation model sent
to France in 1604 for the equestrian monument to Henri IV.
The major difference between the two is the portrait head,
indicating that the practice described by Baldinucci
(Ranalli, IV, p. 118) in his *Notizie* of Gianfrancesco Susini

was probably begun earlier in the Giambologna workshop,
perhaps by Pietro Tacca (Radcliffe, 1966, p. 93). The horses
follow the horse of the equestrian monument to Ferdi-
nando I, which, on the basis of the signed statuette in the
Victoria & Albert Museum (Cat. 162), may be an Antonio
Susini model used by Giambologna and Tacca. It is possible
to theorize that Susini did collaborate with Pietro Tacca as
he did with Giambologna – and that he is largely respon-
sible for the design of the Henri IV and Philip III equestrian
statuettes. Pietro Tacca signed the monument to Philip, a
gesture emphasizing his responsibility for the final sculp-
ture, which differs in rendering of surface and ornament,
as well as in some details of composition, from the small
bronze in Kassel and the monuments to Ferdinando and
Henri IV.

 These differences may further indicate that the original
model used for the horses of the monuments to Ferdinando
I and Henri IV and the statuette of Philip III was by a hand
other than Tacca's – or by Antonio Susini.

PROVENANCE: Landgrave Frederick II of Hessen-Kassel.

K.J.W.

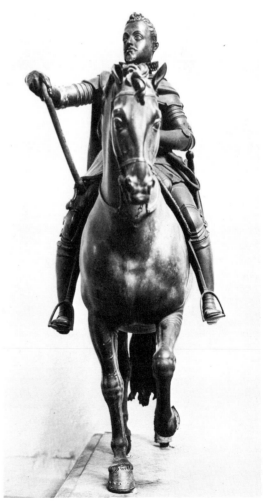

161

162

Horse pacing

by **Antonio Susini** (active 1580; d. 1624)

*h.*29

Bronze. Black lacquer (later addition) on natural patina; the tail was resoldered to the body; as a result, it falls in an unnatural angle. Probably an ornament, now missing, was at the base of the tail. There is a square hole, filled in, on the horse's back, where the saddle with rider would have been placed (Cat. 160, 161). Engraved on saddle girth under belly: *ANT*[11]*: SVSINII FLOR*[1]*: FE.*

Victoria & Albert Museum, London (A.11–1924)

The Antonio Susini signature on the horse, which so closely resembles in facture that on the *'Farnese Bull'* bronzes (Cat. 180, 181), has particular importance, as it almost certainly means that the original model was by that sculptor: the horse thus becomes a key to clarifying some of the issues associated with the equestrian statues and statuettes by Giambologna or members of his workshop. Baldinucci (Cat. 161; Ranalli, IV, pp. 109, 110) described the essential rôle of Susini in the design and execution of the monument to Cosimo I, but did not refer to him in his accounts of the subsequent equestrian statues of Ferdinando I, Henri IV, and Philip III (Susini is documented as having been present at the casting of the Cosimo I horse, see this Catalogue Introduction p. 41, n. 4). As a result of these references, it is difficult to distinguish whether the present type relates to a discarded model for the Cosimo, or is a design created specifically for the equestrian monument to Ferdinando I, the horse of which it so closely resembles. Although Pietro Tacca was largely responsible for executing the Ferdinando statue, the model for at least the horse must have been the work of Susini, judging from the evidence of the present bronze.

Two drawings in the Gabinetto dei Disegni of the Uffizi attributed to Cigoli relate to the present composition; N. 8660RN shows a carefully measured horse with saddle, pacing left; N. 8670RN is the same horse, with fewer details indicated, marked for measurements but without numbers. These puzzling works seem to fall between the horses of the Cosimo I and Ferdinando I monuments, but are more closely related to the former, although the position of the horse's legs is reversed. Baldinucci wrote that Cigoli, along with Susini and Pagani, was involved with the design of the earlier statue, but the extent of his collaboration has yet to be defined. The drawings and copies after drawings for an equestrian monument usually identified as that of Henri IV complete with sculptures round the base (Uffizi: 970F, 17660RN; Louvre: Inv. 120–1; Ashmolean Museum, Oxford, Parker, 1956, no. 198) offer equal difficulty; the horse of these designs resembles the mounts of the two drawings referred to above, as well as the present bronze. The drawings may have been part of a series done in preparation for the monument to Ferdinando, rather than that of Cosimo I, and then actually used for the monument to Henri IV; but this suggestion must remain hypothetical.

The mounts of the equestrian statuettes of Henri IV (Cat. 160) and Philip III (Cat. 161) are clearly the Antonio Susini model; but the execution in about 1604 and 1606 would probably have taken place under the direction of Pietro Tacca, who was at that date acting director of the Giambologna workshop (which Susini had left as early as *circa* 1600, Baldinucci/Ranalli, IV, p. 110). The present example was also begun as an equestrian statuette, as is indicated by the reins which end in mid-air, but it is not certain that a rider was ever added. From the evidence of the Victoria & Albert Museum signed horse, it can be concluded that Antonio Susini's designs for equestrian statues were essential to the solutions for the major monuments of Giambologna's last years; he must have also been responsible for the execution and finishing of many of the small versions usually given to Giambologna. The importance of the horse in his *oeuvre* is emphasized by the fact that the one portrait of Susini described by Baldinucci includes as a symbol of the sculptor *'un cavallino finto di metallo'*.

ADDITIONAL BIBLIOGRAPHY: Weihrauch, 1967, pp. 227, 228.
PROVENANCE: George Salting, London; bequeathed 1910.

K.J.W.

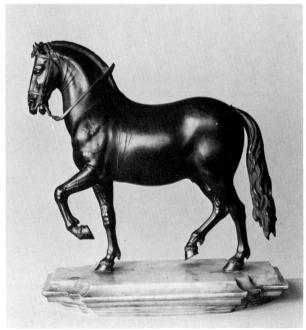

162

163

Carlo Emmanuele of Savoy on rearing horse

h.75

Bronze. Engraved, on saddle girth: *PETRUS.TACCA.F.*
Verwaltung der Staatlichen Schlösser und Gärten Hessen
(GK III 3489; old number)

By 1619, the equestrian monuments from Giambologna's
workshop placed not only in Florence, but in Paris and
Madrid, had become symbols of authority known through-
out Europe. At that time, Carlo Emmanuele, Duke of
Savoy, wrote to Pietro Tacca requesting a similar statue of
himself (Baldinucci/ Ranalli, IV, pp. 87–9, for account
repeated below). Tacca did a model one and one-half
braccia in height (*circa* 87 cm) of a rearing horse (*corvetta*)
with the figure of the Duke.

The design of the mount and rider was the result of
collaboration between Pietro Tacca and Grand Duke
Cosimo II's *'cavallerizzo Lorenzino'*, with whom the
sculptor studied the movement and anatomy of horses.
The completed model was sent to the Duke, who acknow-
ledged its arrival in a letter of 3 June, 1619; he was
enthusiastic and suggested that Tacca execute the monu-
ment in Turin in order to avoid the inevitable transporta-
tion difficulties.

The sculptor preferred to remain in Florence and never
executed the monumental equestrian group, but did cast in
bronze the model, sent as a gift to the Duke, whose letter of
gratitude, dated 5 October, 1621, again asked the sculptor
to come to Turin.

The bronze statuette referred to by Baldinucci is now in

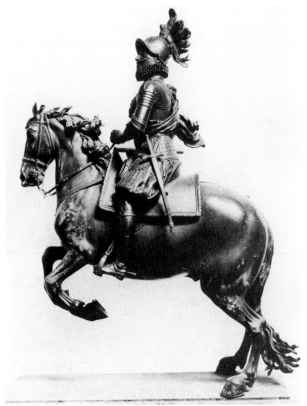

163

the collection of the Löwenburg at Kassel. Carl Justi (1886,
pp. 115–9) first published and correctly identified the
bronze as the one described by Baldinucci. The work was
acquired, possibly with Cat. 161, in Paris by Prince Fried-
rich II of Hessen-Kassel as Vittorio Amadeo of Savoy
(1630–37), and it was so listed in an inventory of the
Löwenburg collections of 1803 (Cat. 161; Justi, 1886, p.
115). The earlier identification was corrected by Justi
through comparison of portraits and reference to
Baldinucci.

The Kassel bronze is a splendid conclusion to a problem
of design which had interested Giambologna. Even on the
pacing equestrian monument to Cosimo I there is a relief of
a rearing horse with rider on the shoulder of the Grand
Duke's armour which seems a commentary on Leonardo's
studies for the Trivulzio and Sforza monuments (Pope-
Hennessy, 1971, pp. 52–60). The relief suggests that
Giambologna felt the challenge of Leonardo's unfinished
commissions for equestrian statues – as he certainly felt
competition in general with Michelangelo (Simone Fortuna
to the Duke of Urbino, 27 October, 1581, cited by Dhanens,
1956, p. 345). But the sculptor never executed a monu-
mental equestrian group with a rearing horse in bronze,
and very few statuettes (Cat. 153) of this composition can
be attributed to him; the challenge remained for his assis-
tant and successor Pietro Tacca, whose rearing equestrian
monument to Philip IV was realized only at the end of his
career.

The first commission that Tacca undertook related to
the present composition was a statuette of *Louis XIII of
France* (Museo Nazionale, Bargello, Florence). The horse
and rider are accompanied by a second statuette, a rearing
horse; apparently, from a contemporary document, the
figure of the King was intended to fit both horses (Justi,
1908, II, p. 264). Even though their measurements of
height and breadth, and their anatomical proportions
differ. The treatment of the chest and neck area, in
particular, varies; it is as if both horses were carefully
considered solutions to the same problem, and an exercise
in skill on the part of the sculptor.

The Löwenburg equestrian bronze is closely related to
the Bargello one and was also probably accompanied by a
lone horse as well, the statuette today in the Staatliche
Museen, Berlin (7252, Bode, 1930, no. 190, *h*.59). Both
equestrian statuettes are probably cast from the same
moulds. The Louis XIII figure and mount, is almost exactly
the size of the Kassel work, except for the height (7 cm)
added to the latter because of the helmet. With the statu-
ette of the Duke of Savoy, the ornamentation is carried
further than on the earlier bronze and every possible
surface is engraved with new detailing. The mane and tail
are longer and tossed more violently in the air; the hairs of
the mane are incised on the horse's neck; the saddle and
stirrups are engraved with floral patterns; and every strip
of the slashed pantaloons is embroidered. But these dif-
ferences are superficial additions to the same model.

When Pietro Tacca was unable to carry out the
commission for a monumental equestrian statue of the
Duke of Savoy, he sent the statuette now in the Löwenburg
to Turin. The finality of this gesture – as a substitute for

the desired monument – is indicated by the presence of Tacca's signature, which he must have added to increase the value of the bronze in the eyes of the Duke. The equestrian statuette of Carlo Emmanuele was executed in place of the monumental sculpture, and remains the unique signed small bronze in Tacca's *oeuvre* that is known today.

ADDITIONAL BIBLIOGRAPHY: Schlosser, 1913/14, pp. 123,124; Lewy, 1929, pp. 62–5; Lo Vullo Bianchi, 1931, pp. 146–57; Weihrauch, 1967, pp. 233, 234; Torriti, 1975, pp. 29, 31.
PROVENANCE: Carlo Emmanuele, Duke of Savoy (1621); Prince Friedrich II of Hessen-Kassel (pre-1803),

K.J.W.

164
Horse rearing
h.23.5 (adjusted to rearing position)
Bronze. Red-gold translucent lacquer which has darkened where handled.
Museo di Palazzo Venezia, Rome (9292)

The bronze horse is paired with Cat. 165; both are in positions close to those of the *'cavallo da maneggio'* of the 16th century. The present example, mounted on the original sprues, has been photographed tipping forward on its base, at an angle which seems to be the *corvetta*; actually, the horse is rearing in a position close to the *posata* (Justi, 1908, II, p. 266 for positions of the rearing horse). The mane is caught at the back with a bow; the tail is doubled and fixed with a ribbon rosette; and a rosette is placed between the ears. Photographs of the horse rarely indicate the high quality of the surfaces, particularly the areas of mane and tail. Both horses were given by Pollak (1922, p. 97, illus. XXX) to Pietro Tacca, an attribution accepted by Santangelo (1954, p. 53) and for the 1961/62 bronze catalogue. However, there are parallels between the pair and details of Ferdinando Tacca's work – for instance, the

motif of the ribbon tied in the hair – which do not appear in the known works of Tacca, and the structure of the horses' heads has no parallel in his *oeuvre*.

A similar pair, but of different surface handling, formerly in the collection of R. von Mendelssohn, Berlin, was published by Bode (1912, CCII) as 'Gian Bologna (or Tacca)'; another pair, related to the Mendelssohn and Museo di Palazzo Venezia bronzes, is in the Museo Nazionale, Bargello, Florence. A horse similar to this one is in the Seattle Art Museum (Sherman Lee, 1950, pp. 260–1 'close to a follower of Giovanni da Bologna, perhaps Pietro Tacca').

ADDITIONAL BIBLIOGRAPHY: Pollak, *Raccolta Alfredo Barsanti*, 1924, no. 65; Santangelo, 1954, p. 53, figs. 48–9; Amsterdam, 1961–62, 134A and B; Torriti, 1975, p. 28, 69–71.
PROVENANCE: A. Barsanti, Rome.

K.J.W.

165
Horse leaping
h.22
Bronze. Red-gold translucent lacquer which has darkened where handled.
Museo di Palazzo Venezia, Rome (9293)

See Catalogue number 164. The horse is leaping in the position of *corvetta* with mane and tail flying free, and without the bow and rosettes of the rearing horse. It is of the same breed as the other and the surfaces are handled in a similar way.

FURTHER VERSIONS: see Cat. 164.
ADDITIONAL BIBLIOGRAPHY: Pollak, *Raccolta Alfredo Barsanti*, 1924, no. 66; Santangelo, 1954, p. 53; Amsterdam, 1961/62, 134; Torriti, 1975, pp. 28, 69–71.
PROVENANCE: A. Barsanti, Rome.

K.J.W.

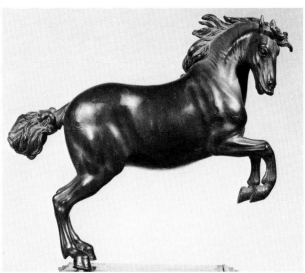

164

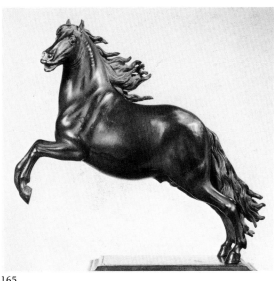

165

166

Lion hunt

h.28 l.42.4

Bronze. Reddish-gold lacquer partially visible on underside; elsewhere modern brown patination. The animals are cast separately and joined at the lion's 'wrist'. The horse's tail is separately cast and screwed on.
Museo di Palazzo Venezia, Rome (P.V. 9289)

The group is unique and undocumented but the composition seems to be derived from the Giambologna-Susini groups of lions attacking horses (see Cat. 170, 172, 174). A rider is evidently missing from the horse, as is indicated by the hole in its back and the girth and reins, which stop short of where a saddle-cloth would have covered them. Judging from the groups of a similar subject by Francesco Fanelli, the rider might have been a Turk (Pope-Hennessy, 1968, pp. 166–71, fig. 192). The present group may have been produced in the late workshop of Pietro Tacca, for there are stylistic analogies with his rearing horses (Cat. 164, 167), as well as similarities in detail, such as the bow on the mane.

ADDITIONAL BIBLIOGRAPHY: Santangelo, 1954, p. 55.
PROVENANCE: Alfredo Barsanti, Rome (L. Pollak, *Bronzi Italiani: Raccolta Barsanti*, Rome, 1922, no. 62, pl. 29.

C.A.

167

Horse rearing

h.27

Bronze. Gold-red lacquer.
Museo Civico, Bologna (1505)

This rearing horse is generically related to bronzes of the same composition by Pietro Tacca (Cat. 163), but is clearly of later date. The coarsening of the strands of the mane and tail, combined with a sensitive, skilful filing of the surfaces, particularly of the paunch and back, relate to Ferdinando Tacca's treatment of the same details on such works as the Santo Stefano relief. The bronze is unique and little known; it may be the one referred to by Weihrauch, 1965, p. 224.

K.J.W.

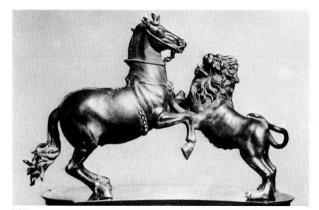

166

168

Horse rearing

h.29.5 l.28.5

Bronze. Light golden lacquer, now visible only on underside, much rubbed and darkened on upper parts; the tail broken at the top and secured by a modern bolt to the socle.
Lent anonymously

One of four once well-known bronze horses formerly in the Mendelssohn collection, the horse was considered by Bode (1911, p. 687, 1912, pp. 4, 5, pl. CCI, the photograph printed in reverse) to be an autograph work by Giambologna, representing the model recorded by Baldinucci (Ranalli, II, p. 583) as '*Il Cavallino, che sta in su due piedi*'. Stylistically and technically it belongs rather with bronze horses produced later in the Tacca workshop.

PROVENANCE: Robert von Mendelssohn collection, Berlin.

A.R.

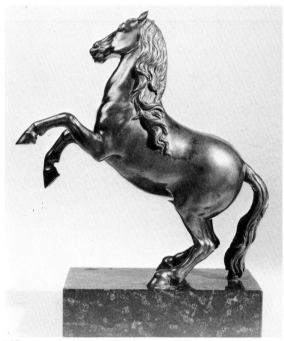

168

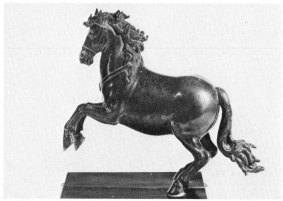

167

169
Horse flayed
*h.*90.2
Bronze. Black patina, not worked up; left foreleg and right rear leg broken at casting flaws and repaired with iron bolts; tip of right ear missing; casting defect in rear right hoof made up in bronze and lead; many minor casting flaws; many nail-holes left unplugged; unstable and supported by an iron rod under belly.
The University of Edinburgh (Torrie Collection)

Essentially a flayed derivative of the horse in the antique equestrian statue of Marcus Aurelius on the Capitoline, the horse is one of four known bronze versions on this scale. One in the Palazzo Vecchio, Florence (Don. Loeser, 1930; *h.* 91.5), formerly variously ascribed to Verrocchio, Leonardo and Rustici (Lensi, 1934, pp. 34–7), is regarded by Dhanens (1956, p. 279; 1963, p. 173) as a study made by Giambologna in connection with his equestrian statue of Cosimo I. This is contested by Weihrauch (1967, p. 437), who notes the existence of a further version with an ascription to the Roman architect and bronze-founder Giuseppe Valadier (1762–1839), and assigns the model to the late 18th century. This third version, the location of which was unknown to Weihrauch, was presented to the Museum of Fine Arts, Springfield, Mass., in 1968 (68.S07; *h.* 91). It was bought in Venice in 1900 with a traditional ascription to Valadier, and is currently ascribed to the goldsmith and bronze-founder Luigi Valadier (1726–85), uncle of Giuseppe and his predecessor as owner of the family foundry (Robinson, 1969).

A fourth version (*h.* 91.1), formerly in the collection of the Baron de Redé, Hotel Lambert, Paris (Salmann, 1969, p. 22; sale Sotheby, Monte Carlo, 26 May, 1975, no. 187), and now in Teheran, was acquired in London with a traditional provenance from the collections of the Dukes of Northumberland. This, which probably belonged originally to Algernon Percy, Earl of Beverley, second son of the first Duke of Northumberland, has the same curious glossy patina, mottled black, green and red, as three large bronzes after the antique signed by Luigi Valadier acquired by the first Duke and installed at Syon House by 1773. The

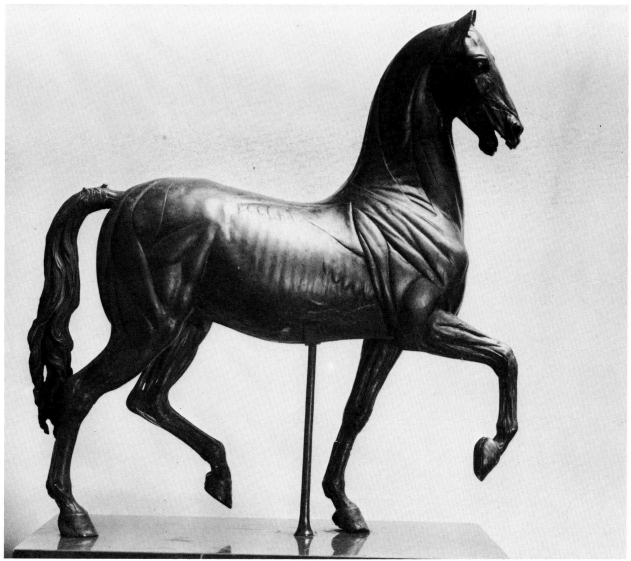

169

version now in Florence was acquired by Charles Loeser in London in 1913, with a tradition that it had been sold in 1832 as the work of a sculptor of the early 19th century to England from France, where it had been in the house of a certain cardinal (Lensi, p. 37). It may be identical with a version formerly in the collection of Cardinal Fesch (sale Paris, 17 June, 1816, no. 263).

The Edinburgh version was acquired by Sir James Erskine of Torrie from the Villa Mattei in Rome before 1804, when it was offered for sale by him in London with this provenance and bought-in (Christie, 1 May, 1804, no. 76). When in the Mattei collection the horse was well known and believed to be antique. The Royal Academy in London possessed a plaster cast of it by 1779 (dated drawing by Burney) described as from '... a bronze in great esteem, to be seen in the Villa Mattei at Rome, supposed to have belonged to some ancient school of Anatomy' (Baretti, 1781, p. 30). Another plaster cast in the Academy of Arts at Stockholm, wrongly ascribed to P.-H. L'Archevêque (Lindblom, 1923, pp. 113–15, fig. 34; Friis, 1933, p. 426), probably entered the Academy during the directorship of Jacques-Philippe Bouchardon (1741–53). The fact that the Roman bronze-founder Francesco Righetti, a pupil of Luigi Valadier, was offering for sale both full-sized and reduced versions in bronze of the 'Cheval écorché de Mattei' in 1795 (price-list in Victoria & Albert Museum) is evidence for its reproduction in bronze at this time, and would explain the smaller versions listed below.

That a version of the model was in existence by 1598 is proved by its reproduction in three plates in Carlo Ruini's book on the anatomy of the horse (Bologna, 1598, I, pp. 243, 245, 247), and that the model cannot be earlier than the late 16th century is proved by the form of the tail, which first appears with Giambologna's equestrian statue of Cosimo I. The Edinburgh horse, which differs markedly from the other versions in quality of casting and finish, and would seem when in the Mattei collection to have been the original from which they were copied, may also have been the original from which Ruini's plates were taken. Whether or not it originated as a study for Giambologna's statue of Cosimo I must remain an open question, but this would seem to be a possibility, particularly in view of Baldinucci's statement that Lodovico Cigoli, who is known as an anatomical sculptor, was involved in the project as an advisor (Ranalli, II, p. 568).

FURTHER VERSIONS: (all reduced scale) private collection, Brussels (h. 48); Cincinnati Art Museum (1955.746, Guide to the collections, 1959, pp. 15, 17); private collection, Paris (h. 22.6); Piero Tozzi collection, New York (h. 22, formerly Filangieri di Candida collection, Naples); formerly French & Co., New York (h. 22.3, variant with short tail, formerly Lüthy collection, Basel, exhib. Detroit, 1959, no. 254).

ADDITIONAL BIBLIOGRAPHY: W. Suida, 'A bronze horse attributed to Leonardo', International Studio, XCIX , June, 1931, pp. 15–17, 72.

PROVENANCE: Mattei di Giove family, Villa Mattei, Rome; Sir James Erskine of Torrie (1772–1825; by 1804); Sir John Drummond Erskine of Torrie (d. 1836); bequeathed to the College of Edinburgh; deposited on loan at the Royal Institution, Edinburgh, from 1845, and at the National Gallery of Scotland 1859–1976.

A.R.

170

Lion attacking a horse
by **Antonio Susini** after **Giambologna**
h.23.5 (approx.) *l*.30 (approx.)
Engraved on the base, below right rear paw of lion: *ANT.ᵉ SVSINI FLORE. OPVS*
The Detroit Institute of Arts, Detroit, Michigan (25.20)

The models of a *Lion attacking a horse* and a *Lion attacking a bull* have to be considered together, for they are patently designed as a pair. No known examples of either composition bears the signature of Giambologna, but they are both listed among his authentic models by Markus Zeh (1611) – '*Un gruppo d'un lione ch'ammazo un cavallo*'; '*Un gruppo d'un lione ch'uccide un toro*' – and by Baldinucci (1688) – '*Il Cavallo ucciso dal Leone*'; '*Il Toro ucciso dal Tigre*' (Dhanens, 1956, pp. 73–4; p. 391). They also feature in Baldinucci's list of statuettes cast by Gianfrancesco Susini after Giambologna's models (Baldinucci/Ranalli, IV, p. 118: it is not clear whether he really meant 'a tiger' in the group with a bull, for a lion is the animal normally shown, though a variant does exist: see Cat. 171). The *Lion attacking a horse* is freely derived from a full-scale Graeco-Roman prototype depicting exactly this subject now in the Garden of the Palazzo dei Conservatori in Rome (see Cat. 174): the variations of the present model from this original presumably reflect the difference between Giambologna's attempt at restoring the missing heads and that of the

sculptor who actually repaired the original in 1594.

The bronze group of a *Lion attacking a bull* is patently designed to act as a pendant, and it too is derived from Graeco-Roman prototypes (see M. Sturgeon, 'A Hellenistic Lion-Bull Group in Oberlin', *Allen Memorial Art Museum Bulletin*, XXXIII, 1975–76, pp. 28–43). The two closely integrated compositions bear witness to Giambologna's continuing fascination with ancient sculpture, as well as his awakening interest in animal subjects, once he had mastered the human form.

In the absence of any signed primary examples of these bronzes, it is dangerous to be dogmatic about the various slightly different treatments of pose, detail and surface, as well as bases, that are to be found in different versions.

FURTHER VERSIONS: Cat. 172; Museo Nazionale, Bargello, Florence (434b); Herzog Anton Ulrich-Museum, Braunschweig (115, Bode, 1913, III, 200); Royal Ontario Museum, Toronto (L971.23.12b, Avery and Keeble, 1975, pp. 15–16, *h*.25.5, *l*.30.5, possibly northern cast); Bayerisches Nationalmuseum, Munich (R3230, Weihrauch, 1956, p. 96, no. 121); Museum of Fine Arts, Springfield, Mass.; Walters Gallery, Baltimore.

ADDITIONAL BIBLIOGRAPHY: (on this example) W. R. Valentiner, 'A bronze group by Antonio Susini (after a model by Giovanni da Bologna)', *Bulletin of the Detroit Institute of Arts*, VI, 7, April 1925, pp. 72–3; idem, *The Burlington Magazine*, XLVI, 1925, p. 315; *Zeitschrift für Kunstgeschichte*, 1943–44, p. 55; A. W. Frothingham, 'Alcora statuettes after bronzes by Giovanni Bologna', *The Connoisseur*, CXXXIX, 1957, pp. 59–63.

PROVENANCE: Julius Goldschmidt.

C.A.

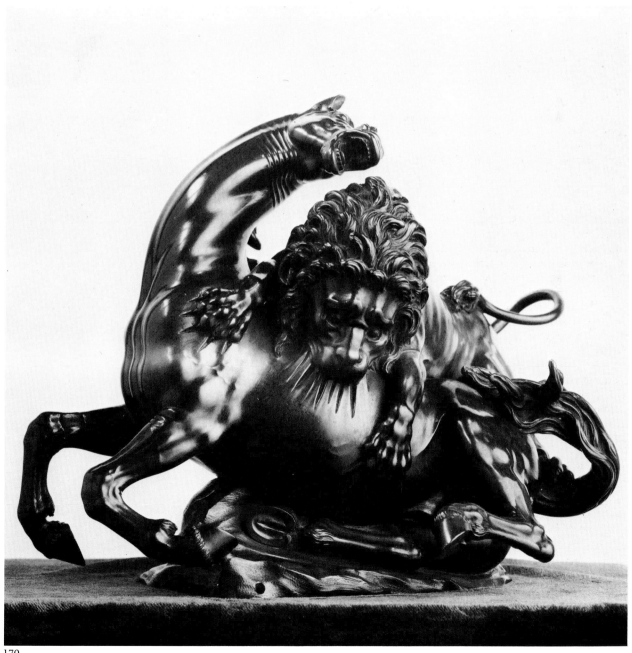

170

171

Lion attacking a bull

by **Antonio Susini**, after **Giambologna**

h.21 *l*.26.5

Bronze.

Engraved under the right front hoof of the bull: *ANT-/SVSI/NI.F.*; also engraved: *Nº 19.*

Musée du Louvre, Paris, Département des Objets d'Art (OA 6062)

The recently discovered signature on this bronze is important inasmuch as it establishes a criterion by which to judge the authorship of the many other examples of the group, as do those on Cat. 173, and Cat. 170, 172 for the complementary group of *Lion and horse.*

For the origins and documentation of this model, see Cat. 170. As with all the animal groups by or after Giam-

bologna, there are wide variations between different examples, betraying reworking in the wax-models before casting. Among the earliest examples must be the groups signed by Antonio Susini, who died in 1624, though it cannot be ruled out that there may be some by Giambologna: no signed or especially outstanding examples have, however, come to light. The groups do not feature in the inventories of the Florentine collections so far published, such as the Medici, Salviati, or Gondi, of about the turn of the century. They do appear, on the other hand, in the 1658 inventory of the Liechtenstein collection (Tietze-Conrat, 1917, p. 86) and in the French Crown Collections before 1684.

ADDITIONAL BIBLIOGRAPHY: Guiffrey, 1886, p. 34, no. 19.
PROVENANCE: French Crown Collections, 1684

C.A.

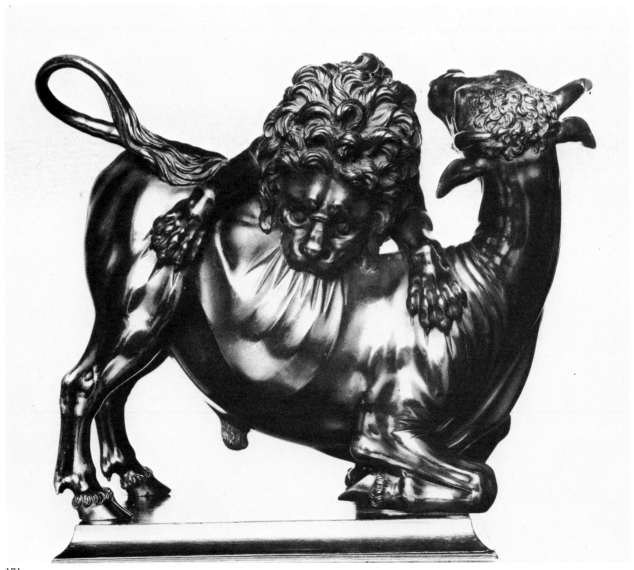

171

172
Lion attacking a horse
*h.*23.5
Bronze. Traces of golden lacquer underneath, but rubbed
off on top.
Engraved signature: *ANT. SVSI/NI OPVS/FLORE.*;
engraved on back of base: *P.C.* (*i.e.* Corsini).
Museo di Palazzo Venezia, Rome (F.N. 171)

See Catalogue number 170.

ADDITIONAL BIBLIOGRAPHY: Amsterdam, 1961/62, no. 127.
PROVENANCE: Corsini Collection.

C.A.

173
Lion attacking a bull
*h.*20.4
Bronze. Traces of golden lacquer below, but rubbed off
elsewhere.
Engraved signature: *ANT./SVSINI/F.*; engraved on right
side of base: *P.C.* (*i.e.* Corsini).
Museo di Palazzo Venezia, Rome (F.N. 172)

See Catalogue number 171.

FURTHER VERSIONS: Cat. 171; Museo Nazionale, Bargello, Florence;
Nationalmuseum, Stockholm (Sk 341, horns and tail of bull broken);
Kunsthistorisches Museum, Vienna (5837); Royal Ontario Museum,
Toronto (L971.23.12b, Avery and Keeble, 1975, pp. 15, 16, *h.*26.5, *w.*24,
possibly northern cast); Staatliche Museen, Berlin-Dahlem (338).
ADDITIONAL BIBLIOGRAPHY: Amsterdam, 1961/62, no. 128.
PROVENANCE: Corsini Collection.

C.A.

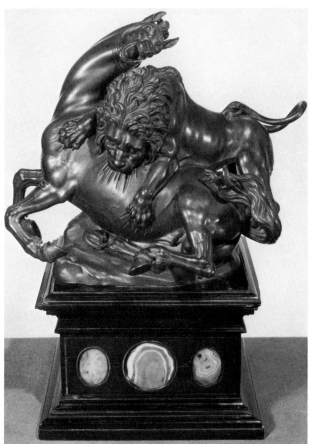

172

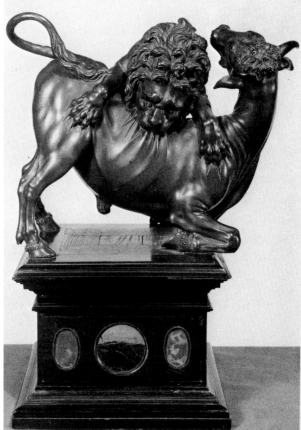
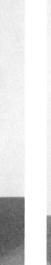

173

174

Lion attacking a horse

*h.*21

Bronze. Red-brown smoke varnish, light brown patina; in excellent condition.

Engraved on the underside of the base: the initials *NM*, ligatured NM.

Kunsthistorisches Museum, Vienna, Sammlung für Plastik und Kunstgewerbe (6018)

The lion is clawing and biting the horse, which has already collapsed under its attacker's weight. The group projects well beyond the oval base, on which the ground is suggested by matt-punching.

The group relates to a model by Giambologna, cited by Baldinucci, which the artist entrusted to his assistant Antonio Susini to make bronze replicas from (Cat. 170). The present composition adheres closely to the antique Roman marble group now in the court of the Palazzo dei Conservatori, which Giambologna may have studied while staying in Rome with Susini. A variant of this prototype, in which the tormented horse bends its head backwards, (Cat. 170, 172), is more frequent than the present model.

FURTHER VERSION: The AA Institute, Chicago, Illinois (64.157).
BIBLIOGRAPHY: Planiscig 1924, p. 163, no. 267; Weihrauch 1967, p. 221; Leith-Jasper 1976, p. 112, no. 162; Bauer and Haupt 1976, p. 100, no. 1878.

M.L.–J.

174

175

Lion walking

*h.*13.5; 14.7 with the oval bronze plinth, which was cast separately but shows the same patina.
Bronze. Brown lacquer, which has largely become golden-brown and translucent as the result of rubbing; brown natural patina. In flawless condition.
Kunsthistorisches Museum, Vienna, Sammlung für Plastik und Kunstgewerbe (5876)

The lion is moving slowly forward; its tail hangs down beside the oval plinth. In all probability this statuette was cast in Antonio Susini's studio from a model provided by Giambologna. Many replicas are known.

BIBLIOGRAPHY: Leithe-Jasper 1976, p. 108, no. 149 (but not in Planiscig); Bauer and Haupt 1976, p. 103, no. 1953.
PROVENANCE: *Kunstkammer* of Emperor Rudolph II, listed under Inventory no. 1953 with a gilt pendant that also now belongs to the Museum; afterwards in the Imperial *Schatzkammer*.

M. L-J.

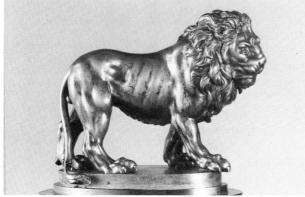

175

176

Lion

*h.*16 *l.*16 (base) *d.*7
Bronze
Museo Nazionale, Bargello, Florence (361)

Virtually identical to Cat. 175. The model is probably to be identified with Baldinucci's *Il leone camminante* (see Introduction p. 44), on the basis of the location of examples of this type in old collections with strong links with Giambologna, *e.g.* Florence and Vienna. Furthermore the typology of the lion is consistent with those that appear in the groups showing them pouncing on horses or bulls (*e.g.* Cat. 166, 170–4), which certainly originate from Giambologna. There is also a close relationship with lions as shown in ancient Roman sculpture, with which Giambologna was familiar. It is to be noted that the present example and Cat. 175 both have the oval base which seems to be characteristic of the best examples of animal sculpture from Giambologna's and Susini's shops (see Cat. 154, 177, etc.). The walking lion is included in Baldinucci's list of models after Giambologna that were cast by Gianfrancesco Susini (Ranalli, IV, p. 118). Dhanens (1956, pp. 215–6) cites a number of examples listed in contemporary collections: *e.g.* villa La Magia, 1587; Philip II von Pommern-Stettin, 1612 (Döring, 1894, p. 97, 239–40); N. C. Cheeus, Antwerp, d. 1621, two examples (Denucé, 1932, p. 35).

FURTHER VERSIONS: Schloss Pommersfelden; Castello Sforzesco, Milan (Bronzi, no. 168); formerly Kunsthistorisches Museum, Vienna (Planiscig, 1924, no. 266: sold); Liechtenstein collection (Tietze-Conrat, 1917, pp. 101–2, as 'Gianfrancesco Susini (?)').
PROVENANCE: old Medici collections.

C.A.

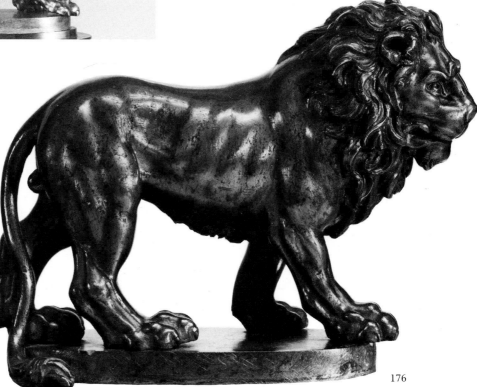

176

177
Bull
*h.*22 *l.*25
Bronze. Golden, translucent lacquer.
Museo Nazionale, Bargello, Florence (287)

This statuette is the only example of a widely divulgated model which Dhanens (1956, pp. 215, 216, fig. 197) considers autograph, on grounds of its high quality. The model is not included in either of the early lists of authentic models by the master, by Zeh or Baldinucci (see Introduction, p. 44), but it is close in type to the bull in the group where it is pounced on by a lion (Cat. 173–4), which *is* included on *both* lists. In facture Cat. 177 is identical to Cat. 176 and is mounted on the same oval type of base which is characteristic of the best examples of animals in the style of Giambologna (whether it be typical of him, of Antonio or of Gianfrancesco Susini).

That Giambologna did in fact produce a model of a bull is proven by a reference in the inventory of the collection of Benedetto Gondi taken in 1609 to: *'un toro di cera dimano del detto'* (a bull in wax by the hand of the aforesaid: *i.e.* Giambologna) (Corti, 1976, p. 634). Examples of bulls in bronze appear in contemporary collections (Dhanens, 1956, pp. 215, 216): *e.g.* villa La Magia, 1587; Salviati, 1609 (Watson and Avery, 1973, p. 504, Appendix I, no. 1079: *'Un toro di bronzo, di mano del detto'* (*i.e.* Antonio Susini), *'un poco minore del centauro con basa simile'* (*i.e.* a little less than half a *braccio* high); Prince Henry of Wales (later King Charles I), 1612, example of cast by Pietro Tacca after the Salviati example by Antonio Susini (Watson and Avery, 1973, esp. pp. 503–6); Don Antonio de' Medici, 1621 (Dhanens, p. 215); N. C. Cheeus, Antwerp, d. 1621; and Jan van Meurs, Antwerp, d. 1652, paired with a horse (Denucé, 1932, pp. 35, 135).

PROVENANCE: old Medici collections.

C.A.

178
Bull
*h.*23 *l.*27
Bronze. Wire-brushed surface, with reddish-gold translucent lacquer, turned dark in interstices and rubbed off on high points. Some patches and plugs show through the lacquer in outline.
Smith College Museum of Art, Northampton, Massachusetts. Gift of Mr and Mrs Ernest Gottlieb (1956.62)

This statuette is a good example of a very popular type which apparently emanated originally from the Giambologna workshop, was cast successively by Antonio and Gianfrancesco Susini, and probably in northern Europe as well, being especially favoured in the Netherlands. The question of its origins is discussed under Cat. 177, with early recorded examples listed: these may just as well have been the present model and not the heavier type of animal with a more pronounced dewlap as in the Bargello example. There are many variants even of this model and the movements of the tails, which are normally added after casting, differ considerably. The model is after the Antique.

FURTHER VERSIONS (apart from those listed in Cat. 177): Victoria & Albert Museum (A.75–1949); Museo Nazionale, Bargello, Florence (277), *h.*22, *l.*24.7; Liechtenstein collection (Tietze-Conrat, 1917, p. 94, fig. 75, *h.*24); H.M. the Queen, Windsor Castle; Württembergisches Landesmuseum (Weihrauch, 1967, p. 224, fig. 275); Bayerisches Nationalmuseum, Munich (nos. 69/37, *h.*21.4, *l.*25.5; 69/38: Weihrauch/Volk, 1974, no. 17); Rijksmuseum, Amsterdam (R.B.K. 15784, *h.*21.6); etc.
ADDITIONAL BIBLIOGRAPHY: on this example, see Smith College Museum of Art, *Renaissance Bronzes in American Collections*, 1964, no. 22.
PROVENANCE: Richard von Kaufmann, Berlin; E. Gottlieb, New York.

C.A.

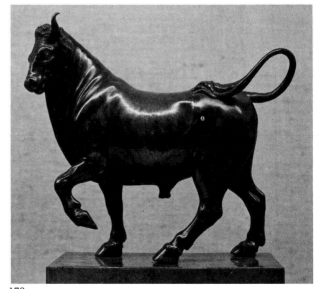

177

178

179

Bull, sacrificial

Bronze.

Museo Nazionale, Bargello, Florence (304)

This model is unique in the present state of knowledge: while closely following ancient Graeco-Roman prototypes of bulls in sacrificial processions in the submissive gait and the garland and ribbons wound round its horns, the presence of Flemish naturalism is strongly felt. Whether this indicates the authorship of Giambologna, which the provenance of the bronze from the old Medici collections suggests, or another Fleming, remains to be decided by comparison with the whole range of animal sculpture by him and his followers in the present exhibition.

PROVENANCE: old Medici collections.

C.A.

181

The 'Farnese Bull' (Punishment of Dirce)

by **Antonio Susini** (active 1580; d. 1624)

h.48 *w*.35 *d*.36

Bronze.

Engraved: *ANT*ⁱⁱ*SVSIN*¹¹ *FLOR*¹¹*OPVS* / *A. D. MDCXIII*

State Hermitage, Leningrad (1210)

See Catalogue number 180.

FURTHER VERSION: see Cat. 180

ADDITIONAL BIBLIOGRAPHY: Androsov, 1977, no. 39.

PROVENANCE: collection Moussine-Pouchkin, 1920.

C.A.

180

The 'Farnese Bull' (Punishment of Dirce)

by **Antonio Susini** (active 1580; d. 1624)

h.47.5

Engraved: *ANT*¹¹ *SVSINII FLOR*¹: *OPVS* / *A D MDCXIII*

Bronze. Deep gold lacquer.

Galleria Borghese, Rome (CCXLIX)

Baldinucci wrote in his *Notizie* of Antonio Susini (Ranalli, IV, p. 110) that the sculptor was greatly esteemed by Giovanni Bologna who sent him to Rome to make copies of the finest statues in that city. Among these was the *Hercules Farnese* of which Susini made five casts. He would have also known the monumental marble group from the same collection referred to as the *'Farnese Bull'* which had been found in 1546 in the Baths of Caracalla and restored by Gian Battista Bianchi in 1579. In fact, Susini made several bronze statuettes (Cat. 181) of the ancient marble which Baldinucci described at some length as one of the works by Gianfrancesco Susini (Ranalli, IV, p. 118).

The present example, signed and dated to 1613 on the base between the feet of the man with a rope, was already noted in the Borghese Collection in 1625 by Crulli, *Grandezze di Roma*, 1625, p. 50 v. Subsequent references of the 18th century mentioned that the bronze was placed on a pedestal of ebony ornamented with hard stones, which has since been lost. The bronze is a careful reduction of the monumental marble group and its base reliefs; Winckelmann (*Monumenti antichi*, 1767 [1830], V, p. 23) noted only a few discrepancies from the original on the Borghese statuette. Every tiny detail, each fingernail, for instance, is meticulously executed; extraordinary variety is achieved in drapery patterns and rendering of texture. The small work is a *tour de force* technically and offers a vocabulary of Susini's bronze finishing methods which were highly praised by his contemporaries.

FURTHER VERSIONS: Cat. 181; Liechtenstein Collection (in inventory of 1658: see Tietze-Conrat, 1917, pp. 31, 32, 87, fig. 24, ascribing it to G. F. Susini); Grünes Gewölbe, Dresden (bought by Le Plat in Paris in 1715, see Holzhausen, 1933, pp. 70–2, fig. 11).

ADDITIONAL BIBLIOGRAPHY: I. Faldi, *Galleria Borghese. Le sculture dal secolo XVI al XIX*, Rome, 1954, no. 59.

PROVENANCE: Borghese Collection.

K.J.W.

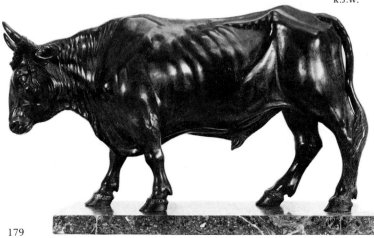

179

182
Monkey
*h.*42
Bronze. Black lacquer.
Staatliche Museen, Berlin-Dahlem (3/63)

For the probable connection of this model with the ornamental base of Giambologna's fountain of *Samson and a Philistine*, see Cat. 183. This example has many small excrescences all over the casting and traces of the joints of a piece-mould, which proves that it was not cast directly from an original wax model, but from a plaster, intermediate mould. This would have been needed if it was desired to cast four identical monkeys for the niches of the quadrangular base. Very little after-working is visible and, for example, the interstices between the monkey's fingers and toes have not been cleared out with a chisel: on the London fragment of a monkey, especially round the eyes, tools have been used on the metal.

FURTHER VERSIONS: excerpt of head and neck in the form of a bust, private collection, New York.
ADDITIONAL BIBLIOGRAPHY: Metz, 1966, p. 107, no. 620.
PROVENANCE: purchased 1963.

C.A.

183
Monkey (macaca sylvana)
h. 26.7
Bronze. The figure is broken away through its right shoulder, beneath the chest and half way down the upper part of the left arm.
Victoria & Albert Museum, London (A.50–1937)

This fragment of a monkey cast in bronze may be stylistically connected with Giambologna by the free modelling of the animal's fur, which recalls the handling of feathers in certain of his bronze birds from Castello, now in the Bargello (Cat. 185). It is closely related to the complete monkey (Cat. 182). Monkeys appear in the (four) niches round the base of the *Fountain of Samson* in a drawing in the Uffizi (Cat. 199) and the present fragment has been connected with that commission by Pope-Hennessy (1954, p. 16), followed by Dhanens (1956, p. 157). Attractive though this hypothesis is, a sample of core-material from inside the casting, submitted for testing by thermoluminescence at the Oxford Research Laboratory (Dr Stuart Fleming), gave a result of 'less than 125 years old'. Research is still in progress.

FURTHER VERSIONS: Staatliche Museen, Berlin-Dahlem (Cat. 182).
ADDITIONAL BIBLIOGRAPHY: Pope-Hennessy, 1964, p. 465, no. 487.
PROVENANCE: Art market, London (A. Spero).

C.A.

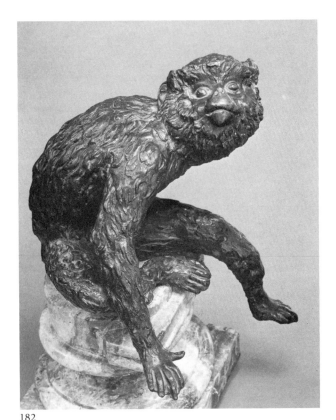

182

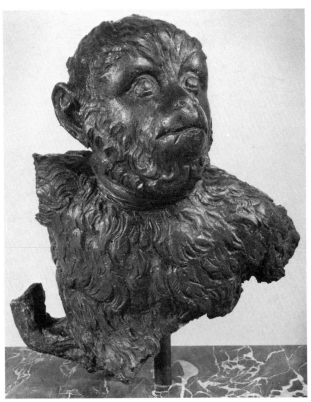

183

184
Spaniel
h. 20.5 *l.* 28.4
Bronze, dark brown patina; many casting flaws and un-
plugged core-pin holes; a large section of the back broken
away apparently along a casting flaw.
Lent anonymously

The bronze, which represents a King Charles spaniel of a
type popular in the early 17th century, is not known in
any version or pendant. There are signs of corrosion under
the modern repatination. It was probably in the open air,
and two round holes may have been for bolts to fix it
firmly to a stone surface. It seems likely that it was at one
time on a fountain. The unchased modelling of the surface
resembles that of Giambologna's animal studies, and there
are close similarities of handling with that of the
fragmentary monkey (Cat. 183).

A.R.

185
Pigeon
Life size.
Bronze. Rough-cast.
Museo Nazionale, Bargello, Florence

This is one of several bronze casts of birds in the Bargello
which are supposed to have come from the grotto of the
Medici villa of Castello (Dhanens, p. 159 f.). These are
normally associated with a passage in a fascinating letter
from Giambologna to Prince Francesco of 4 May, 1567
(Dhanens, 1956, pp. 337, 338): '... *io potrò avanzare spesa
et molto tempo, quale meterò nela fine di questo ucelli* (sic),
*che adesso a le stagion calda, seccando assai la tera, si
avanseranno molto'*. The sculptor was begging to be re-
leased from the necessity of going to the quarries at
Seravezza to choose marble for the carving of *Florence
triumphant over Pisa* and suggesting that Vincenzo Danti
should be asked to do this, in order that he himself might
take advantage of the warm weather to dry out the cores of
the lost-wax models of birds that he was preparing.

FURTHER VERSIONS: Museo Nazionale, Bargello, Florence; Cat. 186.
PROVENANCE: old Medici collections, allegedly from the grotto of the villa
of Castello.

C.A.

186
Pigeon
h. 28 *w.* 18 *d.* 11
Bronze.
Musée du Louvre, Paris, Département des Objets d'Art,
(187)

See Catalogue number 185.

PROVENANCE: acquired in Florence in 1867 by Baron Davillier;
bequeathed 1883.

C.A.

184

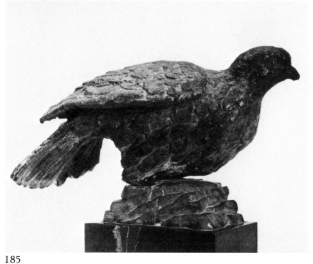

185

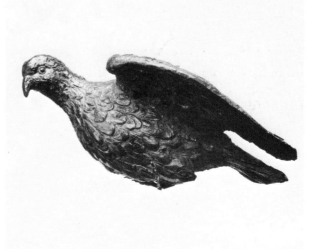

186

187

The Florentine Boar ('Il Porcellino'), with statuettes
h.47.6 (total)
Bronze. Brown patina, on an old base inlaid with *pietre dure*.
Museo Nazionale, Bargello, Florence (115–119)

The central bronze is a reduction of the celebrated antique marble statue of a full-size Boar (*h*.95) in the Uffizi Gallery (Mansuelli, 1958, no. 50). The circumstances and date of excavation of the marble original are unclear, owing to a conflict between contemporary accounts, but it seems to have been dug up in the vineyard of Paolo Ponti and given by Pope Pius IV to Cosimo I. It was noted by Vasari in the Pitti Palace as *un porco cignale in atto di sospetto* and featured in the A.S.F. Guardaroba documents, 132:214, . . . *un porco cignale di marmo in galleria'* (Mansuelli, *op. cit.*). Baldinucci (Ranalli, IV, p. 118) states that Gianfrancesco Susini, after returning from a period of study in Rome, made a small model of the *Boar*, which was then in the Granducal gallery. The present example has been regarded as his work (Amsterdam, 1961/2, no. 130) though it is not signed or otherwise documented. Baldinucci's accuracy is, for once, called into question by the existence of at least one authentic example bearing the signature: *ANT°. SVSINI . F* (*l*.22.8, Christie, London, sale 22 October, 1974, recently acquired by the Staatliche Museen, Berlin-Dahlem). This suggests that any small versions produced by Gianfrancesco Susini were no more than reproductions from Antonio's moulds.

A full-scale bronze cast of the *Boar* (now in the Mercato Nuovo, Florence; Torriti, 1975, p. 39) and an original wax prepared for casting some years earlier, both by Pietro Tacca, were estimated by Gianfrancesco Susini and Baccio Lupicini on 20 September, 1633 (Lo Vullo Bianchi, 1931, pp. 209–13, documents XX–XXIV).

The four statuettes surrounding the *Boar* are of different style and facture and have nothing to do with Giambologna or his followers.

FURTHER VERSIONS: Victoria & Albert Museum, London (A.1–1960, with traces cast in of Antonio Susini's signature and probably an after-cast from an example such as that now in Berlin; A.153–1910, probably a modern cast); Blenheim Palace; collection George Howard, Castle Howard, Yorkshire.
PROVENANCE: old Medici collections.

C.A.

188

Irene and Pluto
by **Giovanni Francesco Susini** (active 1592; d. 1646)
h.38.2
Bronze. Originally light natural patina, now darkened.
Engraved on front of base: *IO.FR.SVSINI.FLOR.A.DXCII.*
Antony Embden, Mareuil-sur-Arnon

The engraved date is to be read as 1592, and the bronze, which is not in any way related to the style of Giambologna, is included in the exhibition as providing the earliest known document for the activity of Gianfrancesco Susini, whose date of birth is unknown. Were it not for the signature, which there seems no good reason to doubt, it would be impossible to relate this bronze to the mature work of Gianfrancesco. Another version, not necessarily from the same hand, with a green patination resembling that used by Pietro da Barga (see Cat. 48), is in the Bargello, Florence (465, *h*.40).

A.R.

189

Hermaphrodite
by **Giovanni Francesco Susini** (d. 1646)
l.41.3 *d*.19.7 *w*.19.7
Bronze. Dark brown patination.
Inscribed: inside the figure, *IO. FR. SVSINI. FLO. F / 1639*; on front of base, *DVPLEX COR VNO IN PECTORE / SAEPE INVENIES. / CAVE INSIDIAS.*; on back of base, *DVPLICEM FORMAM / VNO IN CORPORE VIDES./ MIRARE PVLCHRITVDINEM.*
The Metropolitan Museum of Art, New York, (1977.339)·

This model is listed by Baldinucci (Ranalli IV, p. 118) in his brief account of G. F. Susini as *'un ermaphrodito che dorme'*. It is included by Baldinucci amongst the copies Susini made after the antique, the model in this case being the *Hermaphrodite* formerly in the Borghese Collection, now in the Louvre. The base however is Susini's own invention, and was cast separately from the upper part.

ADDITIONAL BIBLIOGRAPHY: C.I.N.O.A., *'The Grand Gallery'*, The Metropolitan Museum of Art, 1974–75, no. 183.
PROVENANCE: Mr and Mrs Claus von Bülow Gift Fund, 1977.

A.B.

187

188

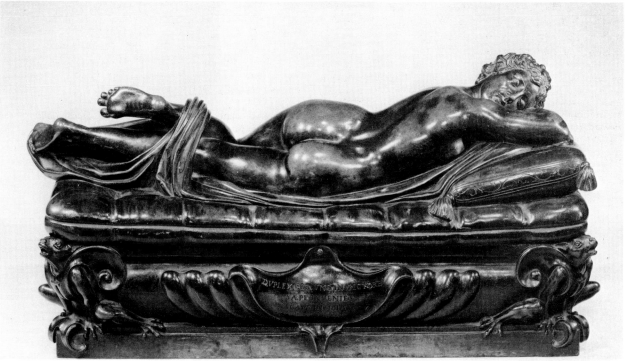

189

197

190

Venus burning the arrows of Cupid
by **Giovanni Francesco Susini** (active 1592; d. 1646)
h.55.5 (including integral bronze base
h.54.8 (figure alone)
Bronze. Light gold-brown lacquer.
Engraved: on the quiver, *IO.FR.SVSINI / F MDCXXXIX*; on the base, *No 181*.
Musée du Louvre, Paris, Département des Objets d'Art (OA 8277)

The bronze is a pendant to Cat. 191, which bears the same signature, and the same date, 1639. Another pair from the same models, with minor variations, are in the Liechtenstein collection, Vaduz (Tietze-Conrat, 1917, pp. 21–7, 96; Bregenz, 1967, nos. 152, 153). The Liechtenstein bronzes are signed in the same way, but bear the earlier date of 1638. A marble version of the present model, signed by Gianfrancesco Susini and dated 1642 (? 1632) is in the collection of Sir Harold Acton, Villa La Pietra, Florence.

ADDITIONAL BIBLIOGRAPHY: Landais, 1949, p. 61.
PROVENANCE: André le Nostre; given to King Louis XIV of France in 1693; French Crown collections (inventory No. 181); alienated under the Directoire; Comtesse de Maillé (sale, Paris 28 February, 1921, no. 66); François Guérault; acquired by the Louvre at his sale, Paris, 21 May, 1935, no. 34.

A.R.

191

Venus chastising Cupid with flowers
by **Giovanni Francesco Susini** (active 1592; d. 1646)
h.58.2 (including integral bronze base)
Bronze. Light gold-brown lacquer.
Engraved: on the tree-trunk, *IO.FR.SVSINI FLOR / FAC MDCXXXVIIII*: on the leg of Venus, *No 190*.
Musée du Louvre, Paris, Département des Objets d'Art (OA 8276)

The bronze is a pendant to Cat. 190 *(q.v.)*. Several other versions of this model exist on a circular, naturalistically-treated bronze base, in which a leafy branch from the tree-stump is developed to act as a *cache-sexe* for Venus (*e.g.* one formerly in the L. von Rothschild collection, Vienna; Tietze-Conrat, 1917, p. 25, fig. 17). These all appear to be of later origin.

ADDITIONAL BIBLIOGRAPHY: see Cat. 190.
PROVENANCE: see Cat. 190

A.R.

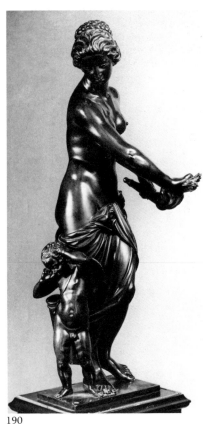

190

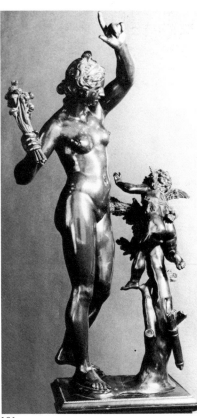

191

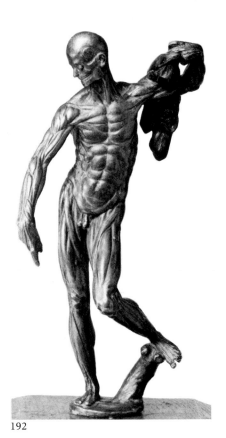

192

192

Écorché

attributed to **Pietro Francavilla** (1547–1615)

*h.*25.5

Bronze figure on bronze base attached to oak socle.

Jagiellonian Library, Cracow

No documents exist to explain how this bronze *écorché* statuette, one of three belonging to the Jagiellonian Library (see Cat. 193, 194) came to be in the Library's collection. Ameisenowa (1963, p. 10) offers the theory that they may have come over from Italy in the 18th century, possibly during the reign of Stanislaus Augustus Poniatowski, whose collection reveals a taste for anatomical drawings. Bertolotti (1885, pp. 371–6) published documents showing that statuettes including teaching models were brought over from Italy in the 18th century by Ignazio Brocchi, architect to the King of Poland. Ameisenowa (p. 9), setting out the manuscripts in the Jagiellonian Library in which these *écorché* statuettes are mentioned, finds they are first recorded in 1783 when they were preserved in the Obiedzinski Hall (the 'Museum of Rarities'), in the Collegium Maius of the University of Cracow. A manuscript of 1801–03 indicates that their original purpose may have already been forgotten by that date since they are described as *'diis Sarmaticis'* (Slav gods). It seems probable that the *écorché* statuettes were originally part of a teaching collection but were consigned to the 'Museum of Rarities' at an early date, either by changes in fashion in the teaching of anatomy or through recognition of their virtue as aesthetic objects. At some time between 1919 and 1923 they were removed to the office of the Director of the Jagiellonian Library.

They were first associated with the name of Francavilla by Ameisenowa (1963, pp. 49–54): their extreme mannerist style and their points of contact with the manner of Giambologna indicate a sculptor within his sphere of influence, and Francavilla's preoccupation with the study of anatomy is recorded in Baldinucci (Ranalli, III, p. 65). Francavilla wrote and illustrated a treatise on anatomy, *Il Microcosmo*; he is also recorded as making two *écorché* models in terracotta, one 58 cm high, which was much reproduced, and the other about 78 cm high (*due notomie modellò di sua mano, di terra, in varie attitudini, una alta un braccio, la quale cotta che fu, essendo stata formata, e molte volte gettata, servì per istudio degli artefici, l'altra di circa un braccio e un terzo rimase in mano di Gio. Batista Maglietti suo nipote*). The disparity between the approximate heights given by Baldinucci and those of the statuettes presented here means that, if the latter follow the same models as those recorded by Baldinucci, they must have been cast from wax models considerably reduced in scale . A portrait of Francavilla painted in 1576 by an unknown Florentine artist (Cat. 220), published by Keutner (1968, pp. 305, 306), shows the sculptor holding in his left hand a small statuette which is similar in composition to this *écorché* statuette. Its small scale suggests that it might be a wax *modello* related to one of the terracottas. Since it does not relate to any known composition by Giambologna, it seems reasonable to give the composition to Francavilla himself, with whose style it is compatible, and this would supply further grounds for an attribution of the present statuette to this sculptor, with 1576 as its extreme date of conception. The placing of the statuette in the portrait in a position of some prominence indicates the importance Francavilla attached to it, and hence presumably to the *écorché* version as well. Ameisenowa also suggests (p. 46) a prototype for the composition of the present statuette in an illustration to a treatise by the Spanish anatomist Juan Valverde de Hamasco, *Historia del Composición del Cuerpo Humano,* first published in 1556 in Rome *(Tavola I del libro II)* which she reproduces (fig. 5). It is one of the illustrations drawn by Gaspare Becerra, a pupil of Michelangelo, and it is clearly related to this bronze, although the pose is slightly modified and the gestures of the hands transposed. Francqueville (1968, p. 39) publishes the portrait without referring to the statuette or the *écorchés.*

PROVENANCE: Obiedzinski Hall, Collegium Maius of the University of Cracow; the Jagiellonian Library, Cracow.

A.B.

†193

Écorché

attributed to **Pietro Francavilla** (1547–1615)

*h.*42.8

Bronze figure, left foot attached by a screw to an oak socle.

Jagiellonian Library, Cracow

For details see Cat. 192. This *écorché* has a clear prototype in the *Mercury* of Giambologna, first conceived about 1563 (Cat. 33–5). Apart from the difference in scale from Cat. 192, there are disparities in the quality of the execution between this and the smaller statuette in the Jagiellonian Library collection which incline one to hesitate before ascribing all three to Francavilla. Keutner (1968, pp. 305–6) is reluctant to relate any but Cat. 192 to Francavilla.

PROVENANCE: Obiedzinski Hall, Collegium Maius of the University of Cracow; the Jagiellonian Library, Cracow.

A.B.

194
Écorché
attributed to **Pietro Francavilla** (1547–1615)
*h.*42.8
Bronze figure on bronze base screwed on to oak socle.
Jagiellonian Library, Cracow

For details see Cat. 192. In this statuette the mannerist delight in the intricacies of *contrapposto* is taken to unusual lengths. The static poses of earlier anatomical illustrations of the 15th and 16th centuries were developed by the time of Vesalius's *Treatise* (1543) into a more mannerist style, in which the bend of the heads and the gestures of the hands are expressive and pathetic. It would indeed be difficult to find a more instructive example of mannerist sculpture than the present statuette. Baldinucci (Ranalli, III, p. 65) reported that *'il Passignano però nel vedere una di questa Anatomie,* (of Francavilla's) *come quegli, che nell, ignudo ebbe un gusto superiore a molti gran Maestri de' suoi tempi, la giudico alquanto ammanierata'.* This statement, together with the superlative quality of treatment argues for an attribution of Cat. 194 to Francavilla, in spite of the reluctance of Keutner (1968, pp. 305–6).

PROVENANCE: Obiedzinski Hall, Collegium Maius of the University of Cracow; the Jagiellonian Library, Cracow.

A.B.

195
Victory
*h.*24.7
Bronze
Lent anonymously

The statuette, which is unpublished, may be tentatively attributed to Francavilla on the strength of analogies with the model which he is shown holding in his hands in the portrait of 1598 by Paggi (Fransolet, 1937). The main difference is that in the bronze version, the raised hand does not support a trumpet, but may have held a wreath, and therefore represents not 'Fame', so much as 'Victory'. The treatment of facial features and wavy hair may be compared with that of Francavilla's life-size *Young slave* from the monument of Henry IV, now in the Louvre (Francqueville, 1968, fig. 44).

The lack of other bronze statuettes associable with Francavilla, apart from the recently identified *écorchés* in Cracow (Cat. 192–4), means that there is little comparative material to check the attribution, which must remain a working hypothesis. The fact that the composition is clearly based on an antique prototype also encourages caution in assigning all statuettes of this type to Francavilla.

FURTHER VERSIONS: A statuette similar in all respects except for the attributes held in the hands (? a sheaf of corn and a cup) is in the Fortnum Collection in the Ashmolean Museum, Oxford (B.433) – communication Anthony Radcliffe. It has an integrally cast, hexagonal base, with architectural mouldings, and is of rather different facture from Cat. 195; Victoria & Albert Museum (71–1866, Fortnum, 1876, p. 18); Binder collection, on loan to Kunstmuseum, Düsseldorf; Brinsley Ford collection, London; G. von Rhò collection, Vienna (Braun, 1908, pl. XXB).
PROVENANCE: Alain Moatti, Paris, 1971 (*Revue du Louvre*, 21, 1971, no. 3, advertisement)

C.A.

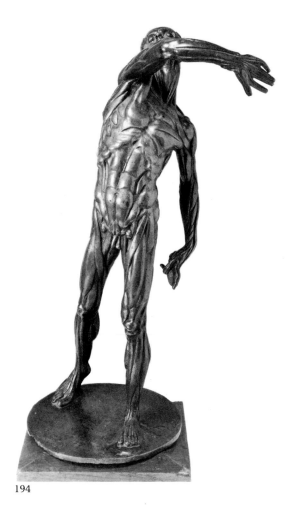

194

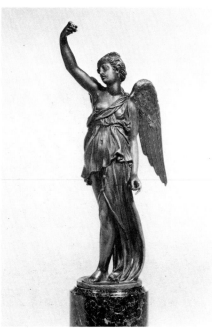

195

196
Monster, fountain spout
h.33.5 *w*.53
Bronze.
Museo Nazionale, Bargello, Florence (458)

The bronze is one of a virtually identical pair in the Bargello, and is related to two similar casts now in London (Cat. 197, 198). The grotesque mixture of elements forming the monster recalls the bronze *Diavolino* (now in the Palazzo Vecchio, Florence) modelled by Giambologna about 1580 as a sconce to be mounted on the corner of Bernardo Vecchietti's palace in Florence (L. Ginori, *I Palazzi di Firenze nella storia e nell' arte*, Florence, 1972, I, no. 28, pp. 255–6). Dhanens (1956, pp. 223–4) notes the probable stylistic origins of the *Diavolino* in Flemish grotesque wood- and metal-work of the mid-16th century, which was in turn derived from the pattern-books of Pieter Coecke and Cornelis Floris. The kind of harness composed of strapwork which is worn round the shoulders of the present monsters is derived from the same sources. All the examples of this monster are pierced to spout water from the mouth and have their undersides flattened at the front in order to accommodate them to a flat piece of architecture. They are analogous to the monsters shown on the six outer corners of the surround to Giambologna's *Fountain of Oceanus* (Cat. 205), though on a much smaller scale. They probably were made in the shop of Giambologna to decorate one of the several smaller gardens, *e.g.* in the Casino di San Marco. They have often been attributed to Pietro Tacca on the basis of their similarity to his fountain now in Piazza Santissima Annunziata (1627), but seem simpler and perhaps earlier and therefore may possibly be the invention of his master, Giambologna (Lewy, 1929; Venturi, X, 3, pp. 856–857; Torriti, 1975, pp. 72, 73, 87, fig. 24).

PROVENANCE: old Medici collections.
C.A.

197
Monster, fountain spout
h.26.3 *w*.51
Bronze, oxidized. Deposit of lime inside (from flowing water).
Victoria & Albert Museum, London (Loan)

See Catalogue number 196: minor variations in the modelling of the crest and eyebrows.

FURTHER VERSIONS: Cat. 196, 198.
PROVENANCE: Sotheby, London, 7 April, 1977.

C.A.

198
Monster, fountain spout
h.24 *w*.51
Bronze, with dark green patina and traces of weathering.
Staatliche Museen, Berlin-Dahlem

See Catalogue number 196.

FURTHER VERSIONS: Cat. 196, 197.
PROVENANCE: Otto Lanz, Amsterdam; M. H. Oelze (sale, P. Brandt, Amsterdam, 23 April, 1968, no. 41).

C.A.

198

197

199
Fountain of Samson and a Philistine
Ink and wash.
Uffizi, Florence, Gabinetto Disegni

This and the following drawing (Cat. 200) record the original appearance of Giambologna's fountain of *Samson and a Philistine*, the basin of which is now in the Royal Gardens at Aranjuez, Spain, and the sculptural group from which is in the Victoria & Albert Museum, London (A.7–1954). Cat. 199 was first ascribed to the 'school of Giambologna' and Cat. 200 to Pietro Tacca in the anonymous *Catalogo della Raccolta di Disegni autografi donata dal E. Santarelli alla R. Galleria di Firenze*, Florence, 1870, nos. 1411, 1416. Desjardins (1883, pp. 149–50) connected them with the fountain of *Samson and a Philistine*, and P. N. Ferri, (*Catalogo Riassuntivo della Raccolta di disegni antichi e moderni. R. Galleria degli Uffizi di Firenze*, Rome, 1890, nos. 1402, 1411) optimistically attributed them to Giambologna himself. Cat. 199 was probably drawn in 1601 when the whole fountain was sawn up and crated for shipment from Florence to Spain as a diplomatic gift (Pope-Hennessy, 1954, pp. 11–13).

PROVENANCE: Santarelli collection

C.A.

200
Fountain of Samson and a Philistine
Bistre wash.
Uffizi, Florence, Gabinetto Disegni

See Catalogue number 199, for critical history. The drawing gives a unique impression of the appearance of Giambologna's fountain of *Samson and a Philistine*, probably before it left the Giardino de' Semplici in 1601. It probably has nothing to do with the ideation of the original scheme in the 1560s and is not by Giambologna.

PROVENANCE: Santarelli collection, 1870.

C.A.

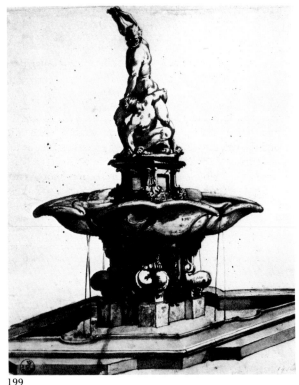

199

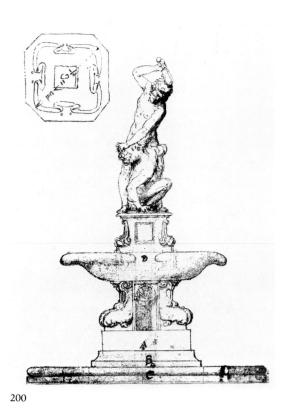

200

201

Samson fountain and other designs
circle of **Pietro Tacca** (1577–1640)
h.30 *w*.22
Ink on paper.
Cyril Humphris, London

The sheet contains five studies relating to three separate projects:

a. top left: Giambologna's marble group of *Samson and a Philistine* (which left Florence in 1601) is shown mounted on a completely different basin and pedestal from that on which it was originally set (now in the Royal Gardens, Aranjuez, Spain). While a quadrilobate shape for the basin is retained, the profile is yet more sinuous and an-architectonic, like the basins of Pietro Tacca's bronze fountains in Piazza Santissima Annunziata (1627). Each of the four projecting corners rests on the bent back of a triton astride a dolphin (see Cat. 41). The general design thus recalls Giambologna's *Fountain of Neptune* in Bologna (Introduction, repr. p. 12).

b. top centre and right: profile and frontal views of a small fountain consisting of a grotesque, monkey-faced monster bending over a shell-shaped basin which it holds in its lap (not unlike the marble one at the junction of Via Maggio, Borgo San Jacopo and via della Sprone, Florence, in the style of Buontalenti). The monster is a close relative of the type known in at least four different casts in bronze (see Cat. 196–8): they however originally perched on a flat surface, probably the surround of a large fountain, and spurted water inwards. Their features are not unlike, and they share the motif of a kind of harness worn over the shoulders composed of strap-work.

c. lower left and right: alternative schemes for the pedestal at the foot of a column. That on the left shows slaves shackled to the corners, as had been initially projected by Cigoli for the base of the monument to Ferdinando I in Piazza Santissima Annunziata, and as were eventually executed by Francavilla for the base of the monument to Henri IV in Paris, and later still by Pietro Tacca to surround the statue of Ferdinando I in Livorno. On the right two alternative designs for the sculptures at the corners are indicated: a lion with a fish-tail, or a cupid riding on a sea-horse. Dr K. Watson suggests that the column in question might have been that on which Giambologna's statue of Johanna of Austria was to have stood in Piazza San Marco; or a decorative motif for the wedding of Marie de Médicis (1600); or the ceremonial entry into Florence of Maria Maddalena of Austria (1608): she notes that the column remained in the Piazza until 1625. The drawing is filled with interesting detail, all apparently connected with projects executed in or around the Giambologna workshop around 1600. However, it lacks spontaneity and looks like a careful record of various original, possibly separate, sketches.

PROVENANCE: Sotheby, London, 9 July, 1973, no. 17.

C.A. / K.J.W.

202

Neptune fountain
h.41.5 *w*.19.6
Chalk drawing.
Inscribed in ink at bottom: *Iovanno de Boulo . . . a Bolognie.*
Lent anonymously

The drawing was regarded by Dhanens (1956, p. 111, fig. 25) as a possible sketch for the *Fountain of Neptune* in Bologna (*circa* 1563), despite discrepancies with the finished design. However, neither its graphic style, as far as can at present be judged, nor the composition of the principal figure seems consistent with Giambologna. Many fountains with Neptune as a centrepiece were commissioned in the 16th century apart from those in Florence and Bologna.

ADDITIONAL BIBLIOGRAPHY: F. Malaguzzi Valeri, 'Le collezioni private Lombarde: La collezione Dubini di disegni antichi', *Rassegna d'Arte*, VIII, 1908, pp. 3–9.
PROVENANCE: Dubini, Milan; Sotheby sale 17 Dec. 1976, no. 22.

C.A.

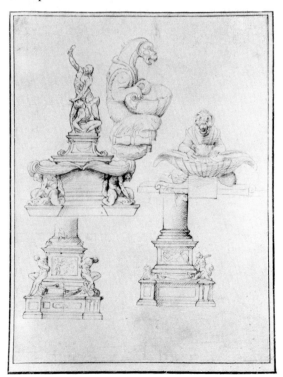

201

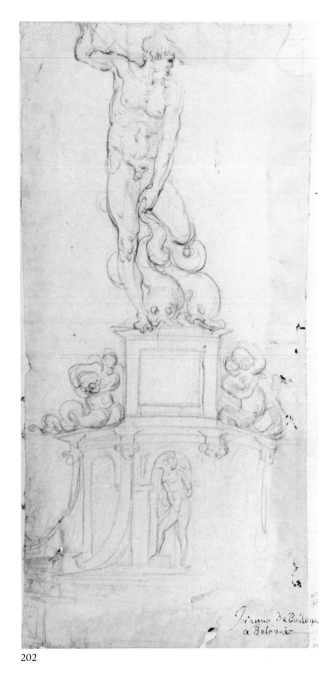

202

203
Mercury fountain
Pen and sepia ink, with buff wash for shadows and feint black chalk underdrawing.
Kunstbibliothek, Berlin (Hdz 5108)

The drawing is interesting, for it shows a large *Mercury* associable with Giambologna set above a fountain basin, below which are seated two fishing boys similar to the pair now in the Museo Nazionale, Florence (Dhanens, 1956, pp. 100–3).

Borghini (1584 p. 586) recorded that after the *Fountain of Samson and a Philistine* in the Giardino de' Semplici in the Casino di San Marco, *i.e.* in the early 1560s: *'per un'altra fonte gittò tre fanciulli di bronzo'*. Baldinucci, however, recorded the number as *two* only, but defined that they were fishing with rods (Ranalli II, pp. 558–9): *'Per un'altra fonte pure nel Casino da S. Marco gettò due fanciulli di bronzo in atto di pescare all'amo'*. By the date of an inventory of 1667 the three *putti* had been removed from the fountain and were in the Medici collection (Dhanens, 1956, p. 101, n. 6). The fate of the third *putto* is not known. Neither of the early sources recorded that a *Mercury* stood over the fountain with the fishing boys, and the present sketch may be a project that did not find favour: from the quadrangular base it would seem that only the two visible *putti* were involved.

The perspective is projected incorrectly, but the anatomical lines are assured. The sheet has the air of a demonstration drawing made while explaining a project and subsequently worked up a little.

PROVENANCE: (?) Marc Rosenberg, sale J. Baer & Co., Frankfurt am Main, 6 March, 1927.

C.A.

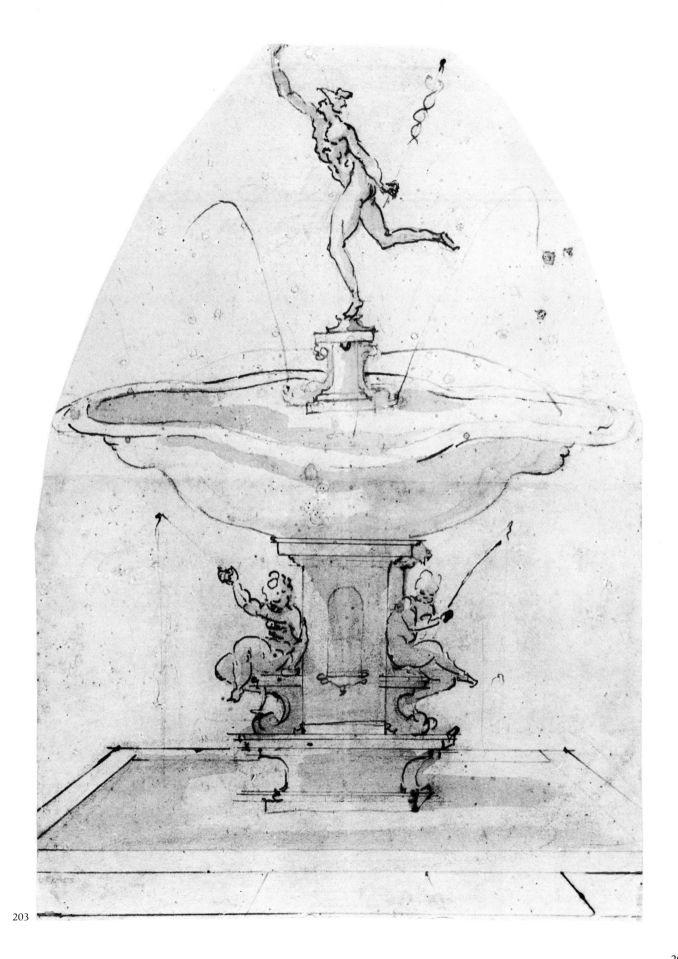

204

Palazzo Pitti with Oceanus Fountain
by **Bernardo Buontalenti** (1531–1608)
*h.*22.5 *w.*28.4
Pen on paper.
Uffizi, Florence, Gabinetto Disegni (2303a)

The question of the involvement of Buontalenti in the project for the Piazzi Pitti commissioned by the Grand Duke Ferdinand I from Cigoli and Buontalenti *circa* 1590 is not yet fully resolved, but the extent of Buontalenti's participation depends on a series of drawings in the Gabinetto Disegni e Stampe degli Uffizi, of which this is the first. It seems likely that Cigoli's designs were based on those of Buontalenti, but be that as it may, Buontalenti's included a single fountain inspired by the design of the Neptune Fountain executed by Giambologna for the Boboli Gardens 1572–76.

ADDITIONAL BIBLIOGRAPHY: G. Cardi, *Vita del Cigoli*, San Miniato, 1628 (ed. 1913); Baldinucci (Ranalli, III) pp. 258, 259; P. Ferri, *Indice geografico-analitico dei disegni ... degli Uffizi in Firenze*, Rome, 1885, p. 61; V. Giovannozzi, 'Ricerche su Bernardo Buontalenti', *Rivista d'arte*, XV, 1933, p. 302, fig. 3; Venturi, 1939, II, pp. 486–93, fig. 441; I. Gamberini, *Per un rilievo integrale di Palazzo Pitti*, Florence, 1947, p. 38; V. Fasoli, 'Un pittore architetto: il Cigoli', *Quaderni dell'Istituto di storia dell'architettura*, I, N. 2, 1953, p. 13; *Mostra del Cigoli e del suo ambiente*, San Miniato, 1959, pp. 172, 173; *Catalogo della Mostra documentaria etc. di Palazzo Pitti e del giardino di Boboli*, 1960, p. 19; I. Botto, 'Alcuni aspetti dell'architettura fiorentina della seconda metà del Cinquecento', *Proporzioni*, IV, p. 44, note 52; L. Berti, *Il Principe dello studiolo*, Florence, 1967, fig. 128; *Mostra di disegni di Bernardo Buontalenti (1531–1608)*, p. 61, no. 44.
PROVENANCE: old Medici collections.

A.B.

205

Fountain of Oceanus

h. 20.3 *w.* 33
Pen and brown ink over preliminary indications in black chalk and indentations with the stilus.
Four measurements are inscribed in the artist's hand; the height of Neptune, *figoura b* $5\frac{1}{2}$; the diameter of the basin, *bracio doudice incerco*; the radius from the edge of the basin to the outer edge of the steps round the lower basin, *b 8 incerco*; and the height of the parapet round the outer basin, *b 2*.
The Visitors of the Ashmolean Museum, Oxford

Popp (1927), followed by Parker (1956, II, p. 65, no. 118), identified the design with Giambologna's *Fountain of Oceanus* for the Boboli Gardens. According to Vasari (*Life of Tribolo*, ed. Milanesi, p. 416) the large granite basin round which the fountain was conceived was quarried in Elba in the year of Tribolo's death, 1550. It reached Florence only in 1567 (Dhanens, 1956, p. 167f.). In 1571 four marble blocks for the principal figures were ordered from the quarries. The statue was erected originally in the amphitheatre behind the Pitti Palace, 1574–76. It was moved to its present position on the *Isolotto* at the southern end of the Boboli Gardens in 1618.

The drawing is thought to be by Giambologna himself, because of the correspondence of the writing with his autograph hand, and probably dates from about 1575, when the fountain was about to be installed. It is not known whether the outer, hexagonal basin, with marine monsters at its angles, facing inwards and spouting water, was ever erected.

PROVENANCE: Henry Oppenheimer (sale Christie, 10 July, 1936, no. 35).

C.A.

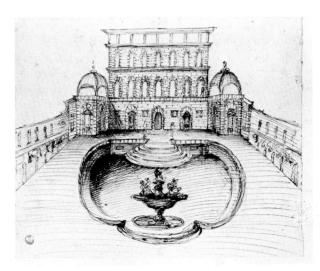

204

206

206
Salviati Chapel, in San Marco, Florence
h.54 *w*.42.6
Pen drawing.
Uffizi, Florence, Gabinetto Disegni (237 A, *recto*)

This fine drawing records an early stage in the design of the chapel in San Marco dedicated by the brothers Averardo and Antonio Salviati to St Antoninus, Archbishop of Florence (1389–1459). Giambologna was put in charge of both architecture and sculpture (see colour p. 27) and the chapel was dedicated in 1589. The drawing has been discussed by Dhanens, 1956, p. 256, and L. Marcucci, *Mostra di disegni d'arte decorativa*, Florence, 1951, no. 53.

On the verso is a ground-plan of the chapel with an autograph inscription: *'pianta de la deta / facata'*.

C.A.

207
Horse
Musée du Louvre, Paris, Cabinet des Dessins (19902)

The drawing is one of the very few connected with Giambologna which may possibly be considered autograph. (Personal communication, Ulrich Middeldorf).

C.A.

208
Pilate washing his hands
by **Andrea Andreani** (active 1584–1610)
h.39.5 *w*.31.5
Chiaroscuro woodcut.
On step in front of Pilate: *MDLXXXV*.
Victoria & Albert Museum, London (22598)

This woodcut, together with another (Cat. 209), for which see A. Bartsch, *Le Peintre-Graveur*, Paris, XII, 1808, pp. 41–2, 19, is derived from one of Giambologna's *Passion* reliefs invented for Luca Grimaldi (see Cat. 124, 232).

FURTHER VERSIONS: British Museum (1895–1–22–1241; 1860–4–14–85).
ADDITIONAL BIBLIOGRAPHY: Dhanens, 1956, pp. 247–8.

C.A.

209
Christ led from judgement
by **Andrea Andreani** (active 1584–1610)
h.35 *w*.31
Chiaroscuro woodcut.
On shield of soldier in right foreground: *Gianbologna scolp. Andrea Andriano lo'intagliatore A Giovambatista Deti Gentil' huomo fiorentino.*
Victoria & Albert Museum (22599)

See Catalogue no. 208, with which this sheet forms a complete image of Giambologna's relief.

C.A.

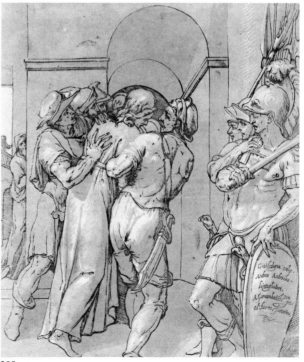

208

209

210

Rape of the Sabines relief
by **Andrea Andreani** (active 1584–1610)
*h.*75.4 *w.*93.7
Chiaroscuro woodcut.
Centre foreground, right: *Haec est hystoria raptar. Sabinar.*
in aere sculptar. per Do.um Jo. Bolognam sereniss. Magni
Er.e Ducis, sculptorem celeberr; left: *Andreas Andreano*
Mantuano eam incisit, impressit. Anno Domini
M.D.LXXXV. Florentiae.
The Trustees of the British Museum (1895–6–17–87)

Giambologna's relief showing the *Rape of the Sabines* was
engraved by Andreani, together with three different views
of the marble group, each composed out of several blocks
(A. Bartsch, *Le Peintre-Graveur*, Paris, XII, 1808, pp. 93–5,
1–4). One example of the latter was exhibited in
Italiaansche Kunst in Nederlandsch Bezit, Stedelijk
Museum, Amsterdam, 1936, no. 710, repro.

ADDITIONAL BIBLIOGRAPHY: Dhanens, 1956, p. 233.

C.A.

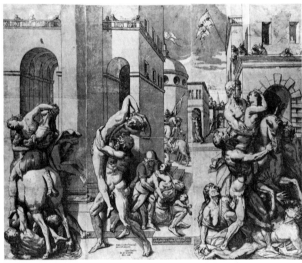

210

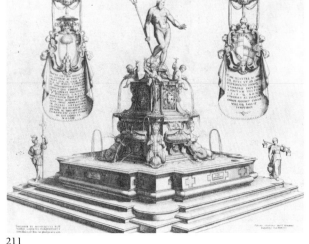

211

211

View of the Neptune Fountain
by **Domenico Tibaldi** (1541–83)
*h.*38.2 *w.*50.8
Engraving
Inscribed below left: *Inventor et architectus fuit Thomas*
Lauretus Panormitanus. Domi. Tibal. incidit Bono: cum
privilegio. M.D.L.X.X.; below right: *Aereas statuas fecit*
Joannes Bologna Flandrius.
Lent by the Trustees of the British Museum

A painter, engraver and architect, Tibaldi was born and
died in Bologna. Although his most important function
was that of architect, he was involved in engraving to the
extent of maintaining a school to teach the art.
Stylistically, Tibaldi inclines towards Modena, although
his master in this art was the Bolognese Bonasone.
Agostino Carracci attended Tibaldi's school, and a rapport
between the style of master and pupil developed to a point
where their styles became virtually indistinguishable,
which, together with the fact that Tibaldi signed only nine
of his plates, including this one, means that far more of his
work exists than is at present accounted for. This plate is
mentioned in the various accounts of Tibaldi's life,
including Bartsch (XVIII,, 1818, pp. 16, 17), Malvasia (I,
1841, p. 159) and Amorini (III, 1843, p. 73).

ADDITIONAL BIBLIOGRAPHY: Thieme and Becker, XXXIII, 1939, p. 128.

A.B.

212

Giambologna
by **Federico Zuccaro** (*c.* 1540–1609)
*h.*26.1 *w.*18.8
Black and red chalk on paper.
National Gallery, Edinburgh (D.1851)

The drawing was first attributed to F. Zuccaro by
A. E. Popham (see K. Andrews, *National Gallery of*
Scotland: Catalogue of Italian Drawings, Cambridge, 1968,
fig. 872). In their reviews of this catalogue, W. Vitzthum
(*Burlington Magazine*, 1969, p. 69) and J. Bean (*Master*
Drawings, VII, 1, p. 57) noted that John Gere had in the
meantime identified the drawing as a preliminary sketch
by Zuccaro for his portrait of Giambologna in the frescoes
for the cupola of the Florence Cathedral, with which he
completed in 1575–76 the cycle left unfinished at Vasari's
death (see D. Heikamp, 'Federico Zuccari a Firenze',
Paragone, XVIII, no. 205, 1967, p. 50, fig. 15). Vitzthum
specifically identified the statuette held in Giambologna's
hand as a model for his *Samson and the Philistine*, which
was replaced in the fresco, perhaps for the sake of
legibility, by a set-square and mallet. The model, which
might be the terracotta noted by Baldinucci in the collec-
tion of Giovanni Francesco Grazini, has been lost (Ranalli,
II, p. 558).

PROVENANCE: (? Allan Ramsay); Lady Murray; presented 1860.

C.A.

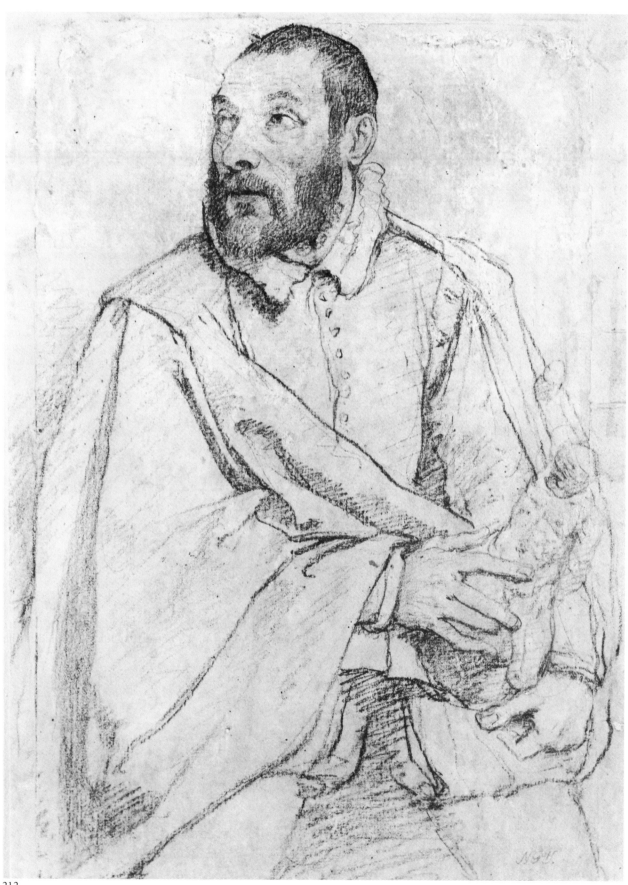

212

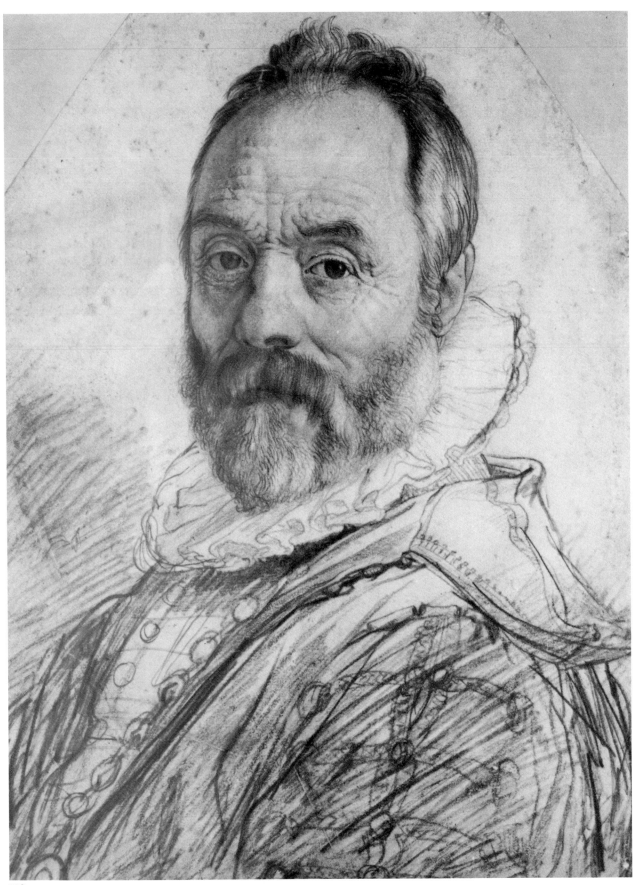

213

213

Giambologna

by **Hendrick Goltzius** (1558–1616)

h.37 *w*.30

Black chalk, red chalk, in some places slightly washed with brown and brown/green.

Inscribed: *Giovan de Bolonia Beelthouwer tot florencen gheconterf . . . H. Goltzius 1591.*

Teylers Museum, Harlem

The identity of the sitter is correctly given in the inscription on the reverse, for the features correspond with the other portraits of the sculptor, especially those by Bassano and Van Veen (Cat. 214, 215). Goltzius drew Giambologna probably in late August 1591, when he was in Florence on his return journey to the Netherlands. Keutner suggests that the chain with a pendant medallion, which Giambologna is shown wearing, may be the one presented to him in 1587 by the Elector Christian I of Saxony, in gratitude for the gift of a statuette of *Mars* (Cat. 43). Reznicek (1961, p. 355, no. 263) had thought that the medallion might have been given by the Emperor Rudolph II in 1588 when he conferred a title on Giambologna.

ADDITIONAL BIBLIOGRAPHY: Dhanens, 1956, p. 86.
PROVENANCE: Queen Christina of Sweden; Azzolino; Odescalchi; Dukes of Bracciano; acquired in 1790.

C.A.

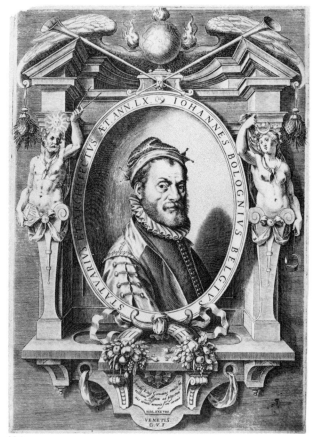

214

214

Giambologna

by **Gijsbrecht van Veen** (1562–1628)

h. 29 *w*. 20.5

Engraving.

Inscribed: *'IOHANNES BOLOGNIVS BELGIVS STATVARIVS ET ARCHITECTVS AET. ANN. LX.'* *'Jacobus Kinig Germanus amici honestissimi effigiem ad perpetua ejus virtutis memoria fieri curavit.' VENETIS G.V.F. MDLXXXVIIII.*

Charles Avery, London

The initials are those of Gijsbrecht van Veen, brother of Otto. The date 1589, combined with the age of 60 recorded round the oval, is one of the strands of evidence that Giambologna was born in 1529 (Dhanens, 1956, pp. 29–30). Unfortunately the author of the original painting on which the engraving is based is not recorded: the prototype appears to be Cat. 215, probably by Jacopo Bassano. If one is correct in believing that Baldinucci owned that painting, then this may be the related engraving to which he refers after discussing it (Baldinucci, Ranalli, II, p. 583): *'Questo ritratto, che a parer de' Professori dell'arte, è de' piu belli, che veder si possano di quel gran Maestro* (i.e. J. Bassano), *è quello stesso, che fino in quei tempi fu intagliato, e dato alle pubbliche stampe, siccome ne mostra una carta, che pure tiene appresso di sè lo stesso Scrittore di queste notizie'.*

The 'Jacobus Kinig', who commissioned this engraving, may be identified with Jakob Kenig of Fischen, a jeweller and art-lover, who in 1589 published, also at Venice, the *Triumph* of Dürer; and possibly also with Jakob König von Königsfeld who was nominated 'Valet de Chambre' by Emperor Rudolph II in 1605 (Florisoone, 1956, pp. 109, 111–12).

FURTHER VERSIONS: Print Room Royal Library, Brussels.
PROVENANCE: Sir Joshua Reynolds (collector's mark on verso); art market, London.

C.A.

215

Giambologna

by **Jacopo Bassano** (1510/15–1592)
*h.*61 *w.*52
Oil on canvas
Musée du Louvre, Paris (437) on loan to Musée Municipal, Douai

The complex problems of the authorship, provenance and date of this portrait have been discussed by Florisoone (1956) and by Heiden (1970, pp.221–2, D.1). Its provenance as far back as Baldinucci's collection is reasonably well established (Baldinucci, Ranalli, II, pp. 582–3: '*Dico finalmente, che un ritratto al vivo di Gio. Bologna dipinto per mano del Bassan vecchio, testa con busto, fatto [siccome credesi senz'alcun dubbio] nel tempo, ch'egli viaggiò in Lombardia, conserve fra le sue più care cose quegli che scrive.*') It may well be identical with one of similar size owned by Giambologna himself and listed in the posthumous inventory of his effects (Corti, 1976, p. 632: '*Uno [ritratto] del Signor Cavaliere Gian Bologna, simile*' [i.e. '*circa un braccio, con cornice di noce semplice*']). A date prior to 1589 is established by the engraving by G. van Veen (Cat. 214), which patently depends from this portrait and is dated in that year.

PROVENANCE: (?) Giambologna; Baldinucci (*c.* 1688); Pandolfini; Filippo Strozzi; F. X. Fabre (1805); Musée Napoléon (V. Denon) (1808).

C.A.

216

Giambologna in his studio

attributed to **Hans von Aachen** (1552–1615)
*h.*138 *w.*97.5 (approx.)
Oil on canvas
Lent anonymously

Through an open doorway behind the sculptor is seen his studio with a large model of *Neptune* for the *Fountain of Oceanus*, a project dating between 1567 and 1575. In the background, on a three-legged modelling stool, stands a model for the statue of *Florence* (Cat. 29) for the Medici villa of Castello (now at Petraia): this is usually regarded as an early work, following an abandoned model by Tribolo, but its inclusion in the present portrait suggests a possible later dating, parallel with the production of the *Fountain of Oceanus*.

The painting corresponds in dimensions with a portrait which Giambologna himself owned, described in the posthumous inventory as 'two *braccia* by one and a half', i.e. approximately 117 × 88 cm. (Corti, 1976, p. 632: '*Il ritratto del Signor Cavaliere quando era giovane, di due braccia alto et uno et mezzo largo, con cornice d'albero tinte* (sic)'). The phrase 'when he was young' could be applied to the appearance of Giambologna in this portrait, and he looks distinctly 'older' in most of the other known portraits (Cat. 213, 214, 216).

Carel van Mander (1617/1906, II, p. 285) mentions that Von Aachen visited Florence, without giving any dates, and names Giambologna as the subject of one of the portraits painted there. This has been tentatively identified with the present portrait by An Der Heiden (1970, pp. 147, 181, fig. 124) and dated about 1585 on circumstantial evidence.

It was previously regarded by Gramberg (1936, p. 124 f.) as the portrait of Giambologna painted by Francavilla, which is recorded by Baldinucci (Ranalli, III, p. 69). Lack of evidence for Francavilla's activity as a painter precludes a stylistic comparison.

ADDITIONAL BIBLIOGRAPHY: Desjardins, 1883, p. 54, n. 4.
PROVENANCE: (?) Giambologna; Palazzo Guadagni, Bologna (sold after the death of Marchese Guadagni in 1864); Spencer; Coutis; present owner.

C.A.

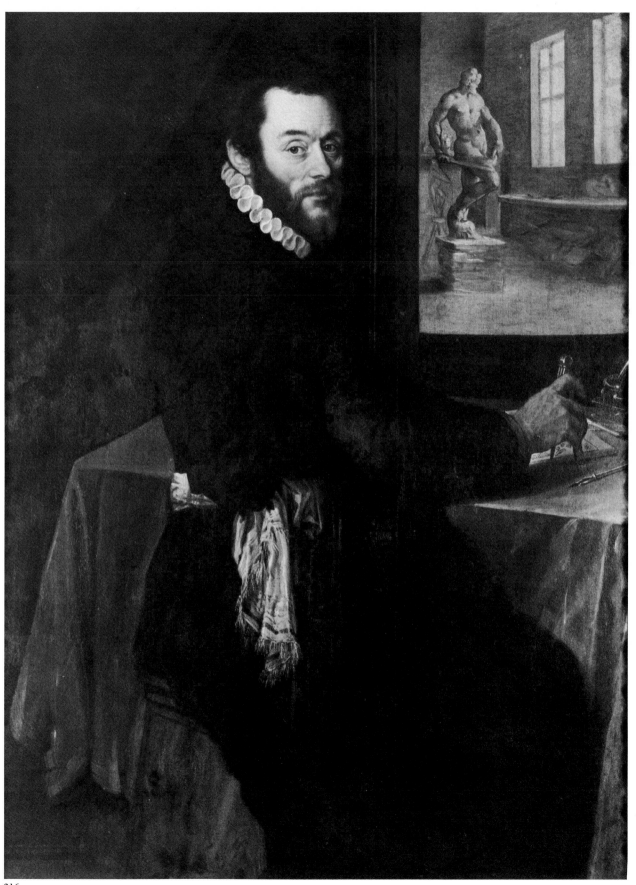

217
Pietro Francavilla (1547–1615)
by **Hendrick Goltzius** (1558–1616)
h.41.5 *w*.30.8
Black and red chalk.
Inscribed (on verso): monogram and date in a later hand;
the name '*Federico Zuccaro*' in another later hand.
Rijksmuseum, Amsterdam (61:71)

The sitter, traditionally supposed to be Federico Zuccaro,
was identified by J. Bruyn ('Een portrettekening door
Hendrick Goltzius', *Bulletin van het Rijksmuseum*, IX,
1961, pp. 135–9) as Francavilla by comparison with the
portrait by Paggi of 1589. The date and monogram are
apocryphal and the portrait must have been made at the
same time as that of Giambologna (Cat. 213). Reznicek
(1961, p. 359, no. 271) remarks that most of Goltzius's
portraits sketched during the visit to Florence in 1591,
which he made on his return homewards, showed artists of
Flemish origin.

PROVENANCE: Anonymous collection 1757. For later history see J. Q. van
Regteren Altena and L. C. J. Frerichs *Selected Drawings from the
Printroom*, Rijksmuseum, Amsterdam, 1965, no. 35, p. 33.

C.A.

218
Pietro Francavilla (1547–1615)
by an unidentified artist
h.107 *w*.88
Oil on canvas
Galleria Palatina, Pitti Palace, Florence (447)

The portrait has traditionally been identified as
Giambologna, owing to the appearance in the background
of a model for his group of *Florence triumphant over Pisa*
(Jahn-Rusconi, 1937, p. 264, inv. no. 447). It has recently
been recognized as Francavilla by comparison with other
portraits (Keutner, 1968, especially pp. 303–4). The
presence of the model in the background is explained by
the fact that Giambologna's full-scale clay model (now in
the Accademia, Florence) exhibited at the wedding
celebrations of Francesco in 1565 was translated into
marble by Francavilla between 1569 and 1572 (see Cat. 223,
224), probably his first task when he arrived in Florence
from the north.

The miniature which the sculptor holds meaningfully
in his left hand resembles Johanna of Austria, Francesco's
wife and niece of Francavilla's first great patron in
Innsbruck, Archduke Ferdinand of Tyrol. From the
presence of a wooden modelling tool in his right hand, it
may be assumed that the portrait was a small relief in
coloured wax, a medium popular at the time both in Italy
and Germany.

ADDITIONAL BIBLIOGRAPHY: A. Jahn-Rusconi, *La R. Galleria Pitti in
Firenze*, Rome, 1937, p. 264.
PROVENANCE: Medici Collection (?).
C.A.

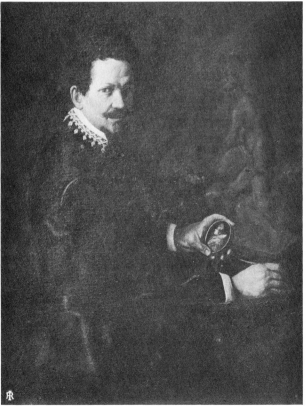

218

219
Pietro Francavilla (1547–1615)
h.70 *w*.58
Oil on canvas
Galleria Palatina, Pitti Palace, Florence

This portrait of Francavilla was described by Baldinucci (Ranalli, III, p. 64: *'ma giacchè ci ha portato l'ordine de' tempi a far menzione del ritratto del Francavilla, e da sapersi, come due altri bellisimi di sua persona se ne veggono in Firenze nel palazzo serenissimo, raccolti dalla gl. mem. del serenissimo cardinal Leopoldo: uno di mezza figura, che mostra l'età di 75 anni in circa, fatto al vivo; la figura e in atto di sedere sopra seggiola, e vestito di palandrano verde con mezze maniche, e quelle del giubbone paonazze; colla destra mano apre ancor esso un libro, e colla sinistra tiene altresi un modelletto finto di cera, che rappresenta la Fama. Il colorito è bellisimo di mano di pittor fiammingo, del quale non è venuto a nostra notizia il nome.'*

The composition is derived from a portrait by Paggi of 1598 (Fransolet, 1937) but shows Francavilla some years older: it is, however, likely to have been painted before he left Florence in 1605 to serve the French court. Francavilla did not in any case live until he was seventy-five, but died aged sixty-eight.

ADDITIONAL BIBLIOGRAPHY: Francqueville, 1968, p. 38, fig. 2.
PROVENANCE: Cardinal Leopoldo de' Medici collection.

C.A.

220
Pietro Francavilla (1547–1615)
by an unidentified Florentine painter
h.83 *w*.65
Oil on canvas
Inscribed on upper left corner: *PETRVS. DE. FRANCQVEVILLE. AETATIS. SVAE. xxix. 1576*
Fraschetti Collection, Florence

The portrait was first published by its owner in 1958 (*La Nazione*, 24 March, 1958, p. 4). It was integrated into the series of portraits of Francavilla by Keutner (1968, pp. 304–6, fig. 5). A calculation based on its date and the reported age of the sitter indicates that Francavilla was born in 1546 or 1547, a year or two earlier than supposed by *e.g.* Baldinucci (1548). This is corroborated by a similar calculation derived from an inscription on another portrait, one by Paggi dated 1589 (Fransolet, 1937).

The statuette of a nude male figure standing in a strong *contrapposto* held in the sculptor's left hand is directly related to one of three bronze écorché figures by Francavilla now in the Jagiellonian Library, Cracow (Cat. 192–4). Keutner notes that the appearance of the same composition in the present portrait proves that Francavilla was interested in the study of anatomy by 1576, some twenty years earlier than supposed; and that the bronzes in Poland are his earliest recorded, and only identified, bronze statuettes.

PROVENANCE: W. Blondell Spence, Palazzo da Firenzuola Giugni, Florence (1860); bought with the palace by the Fraschetti 1896 (Francqueville, 1968, p. 39).

C.A.

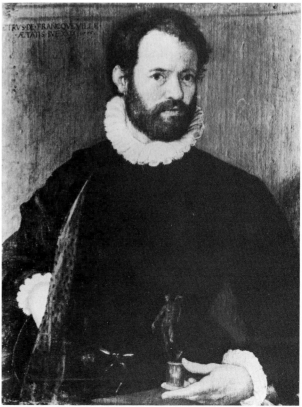

220

221

Julius Caesar

h.46 (figure alone) *h*.51.5 (with socle)

Lime-wood, on iron-wood socle. Covered with a thick
brown soft varnish, under which are traces of a pink wax
ground; many worm-holes stopped with wax: the figure
has been stripped, with some abrasion, and re-surfaced.
Inscribed under wooden socle: *I.CAE.A.I /
D.B.VECCHIETTI. / I.BOLOGNA.B.IN.C(?G).A.S. /
MDLI.*

Lent anonymously

This handsome statuette, with its complex inscription, has
only recently come to light. It is the only piece of wood
carving ever to be associated with Giambologna, and as
such is at present enigmatic, although it has been remarked
by Avery that the style of drapery characteristic of
Giambologna and Susini is analogous with the carving of
folds in wood with a gouge-chisel (Cat. 92). The inscription
is engraved on the underside of the separate socle and not
directly on the base of the statuette, but there seems little
doubt that the components belong together. The
inscription is so obscure as to be incomprehensible to any
but a student of Giambologna and is therefore unlikely to
be other than genuine. The mention of his life-long patron,
Bernardo Vecchietti, and the date of 1551 suggest that the
statuette probably dates from early in Giambologna's stay
in Italy or had been brought down from the north. The
meaning of the abbreviated phrase *'IN C(?G).A.S.'* remains
to be elucidated. The graceful *contrapposto*, the handling of
the anatomy and the treatment of details such as finger-
and toe-nails are consistent with the style of Giambologna.
The possibility that he was a wood-carver opens
fascinating new avenues of research.

PROVENANCE: art market.

C.A.

221 (detail)

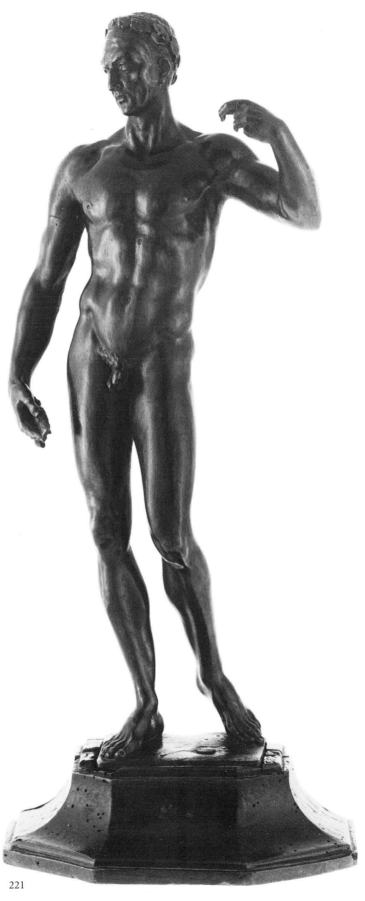

221

222

Neptune

h.47.9

Clay *(terra secca)*, mixed with frayed textile, on a wire armature; both hands broken off; painted to resemble bronze (?).

Inscribed on manuscript label beneath wooden base: *The terracotta figure of Neptune is the first idea of the celebrated Fountain which stands in the Market-place at Bologna. In the finished work the right leg is bent instead of the left and is supported by a Dolphin. This model is the undoubted work of John of Bologna and was purchased in that city from the collection of Count Gini.*

Victoria & Albert Museum, London (1091–1854)

The status of this model has been thoroughly discussed by Pope-Hennessy (1964, pp. 465–6, no. 488); it has been accepted as the work of Giambologna by most scholars, apart from J. C. Robinson (1862, p. 163) and Keutner (1958, p. 328), who preferred Ammanati as author. Gramberg (1936, p. 36, no. 18) identified it as a preliminary sketch for the full-size model of *Neptune* produced in clay by Giambologna for the competition held in 1560 over who should carve the statue of *Neptune* for the projected fountain in the Piazza della Signoria. Dhanens (1956, pp. 96–7) noted that the composition seems well adapted to the restrictions of the ready-hewn marble block (whose approximate shape may be gauged from Ammanati's finished statue) and projects less dramatically into space than does the later bronze *Neptune* on Giambologna's fountain in Bologna, or the smaller bronze version which relates to it (Cat. 31). The provenance of the statuette from Bologna is suggestive, but it might nevertheless be a model brought from Florence by Giambologna when he received the Bolognese commission. Gramberg (1936, pp. 96–7) records a payment on 31 December, 1563, for a little walnut pedestal for a small model of *Neptune*: *'p. po. basamento piccolo di Nocie fatto per mandare aroma per il modello piccolo de nettuno'*. If the model in question was the present one, such a base has disappeared. The pose, with the left knee flexed and the right arm down, is related to the bronze statuette of *Neptune* now in Stockholm (Cat. 32).

The model may have been in the collection of William Lock before that of Samuel Woodburn (see below): most of Lock's models were acquired from the Vecchietti heirs, but this would be an exception. Count Gini remains to be identified.

ADDITIONAL BIBLIOGRAPHY: Avery, 1975/77, pp. 463–4, fig. 1 (wrongly captioned as 'wax').

PROVENANCE: Count Gini, Bologna; William Lock (sale 'Fitzhugh', Christie, 16 April, 1785, no. 32: 'Neptune, by Giov. di Bologna', bt. Price, £1.9s.,); S. Woodburn (sale, Christie, 19 May, 1854, no. 513: 'Neptune – a fine cinquecento terra-cotta', bt. Eastwood); bt. Museum, 10s.

C.A.

223

Florence triumphant over Pisa

h.22.2

Wax, over a wire armature. The right arm and right foot of the female figure and both feet of the crushed male have been broken off; other minor breaks; surface deterioration with crystalline exudation.

Victoria & Albert Museum, London (4118–1854)

This sketch-model is the earliest recorded stage in the evolution of Giambologna's pendant to Michangelo's *Victory* (Dhanens, 1956, p. 150). It has been discussed in detail by Pope-Hennessy (1964, pp. 467–8, no. 489; 1970, I p. 13). It may be identical with a wax model of *Fiorenza* by Giambologna listed in 1587 in an inventory of the Villa La Magia (E. Müntz, *Histoire de l'art pendant la Renaissance*, Paris, III, 1895, p. 426, n. 1), and/or with one listed in an inventory of March/April 1588 of the Casino di San Marco (communication of Professor Keutner): A. S. F. *Guardaroba*, fil. 136, c. 154v: *'Una Firenza di cera di Gia. bologna su una base di noce, alta br. 0/3.'*

The next stage in the evolution of the monumental composition is represented in a terracotta model (Cat. 224).

ADDITIONAL BIBLIOGRAPHY: Avery, 1978.

PROVENANCE: Medici Grand-Ducal collection, Casino di San Marco (?); or Villa La Magia (?); Gherardini Collection, Florence.

C.A.

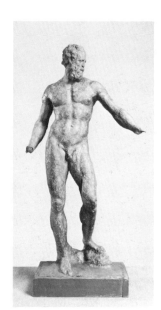

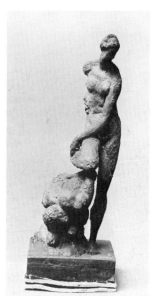

222 223

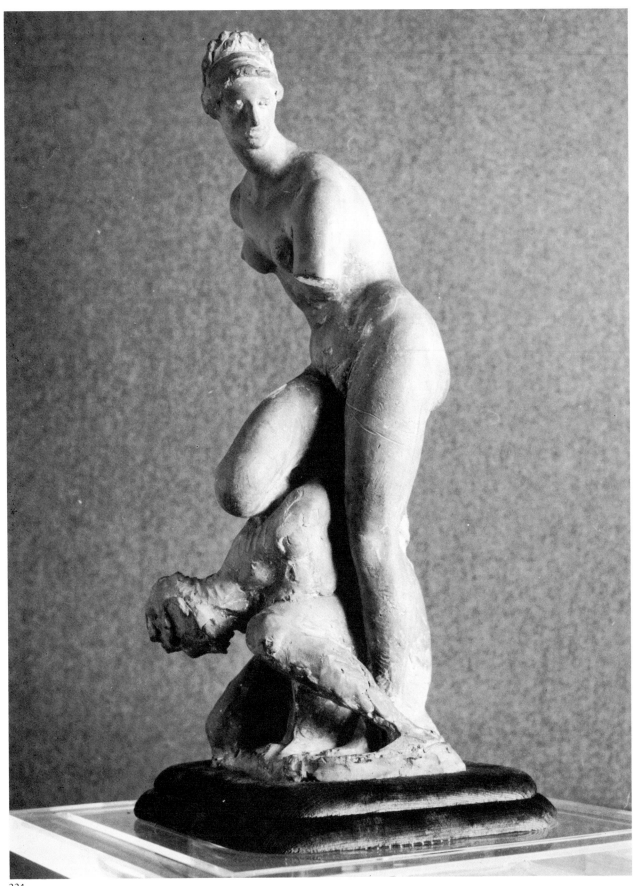

224

224

Florence triumphant over Pisa

*h.*38

Terracotta. Both arms of Florence missing below shoulders. Other minor abrasions.

Lent anonymously

This terracotta sketch-model is the next stage in the evolution of the composition after the tiny, exploratory wax (Cat. 223). Recorded by Kriegbaum in Gramberg (1936, p.83, n.38); not seen by Dhanens; exhibited, *Mostra dei Tesori segreti delle Case Fiorentine*, Florence, 1960, p. 72, no. 174, fig. 120 (with a restored left arm, since removed). While the male figure has been left at a stage where the process of building it up out of lumps and pellets of clay is visible, the female figure has been smoothed over to indicate more clearly the precise volumes and contours. On this scale, the faces are barely suggested. Fragmentary heads of *Florence* (*h.* 9.5) and *Pisa* (*h.* 8) acquired by the Bargello in 1916 may be remnants from a yet larger terracotta model (*h. circa* 80), or separate studies of details of facial features and expression (Nicola, G. de, 1916; Brinckmann, 1923/24, pp. 68–9, pl. 24). From one or other terracotta model the dimensions must have been enlarged for the full-scale plaster now in the Accademia, Florence (*h.* 260). That then permitted direct transfer of measurements to the marble block for the final sculpture (Bargello, Florence). There, the interstices between the figures are more deeply excavated. Other terracotta statuettes which appear to be reductions from the marble, or variants (possibly to permit production of bronzes), rather than preparatory models are listed by Pope-Hennessy (1964, p. 467), to which may be added one in the Acton collection, Florence.

ADDITIONAL BIBLIOGRAPHY: Avery, 1978.
PROVENANCE: private collection.

C.A.

225

Rape of a Sabine (two figures)

*h.*12.1

Wax, over an armature of an iron nail. Both heads, the arms and left foot of the woman, and part of the left arm and the lower part of both legs of the man are missing; surface deterioration, craquelure and crystalline exudation.

Victoria & Albert Museum, London (4125–1854)

The model is discussed by Pope-Hennessy (1964, p. 468, no. 490; 1970, p. 18) and by Dhanens (1956, p. 237). It marks an intervening stage in the development of the composition from the bronze version with two figures cast in 1579 for Ottavio Farnese (Cat. 56; see Cat. 57) towards that with three figures, as finally carved for the Loggia dei Lanzi, Florence (see Cat. 58, 59). It is exactly like the two other tiny, wax sketches in the Victoria & Albert Museum (Cat. 223; 226) and is an early, if not a first, thought for the changed composition intended for the monumental rendering. The position of the woman is close to that finally adopted, and quite different from that adopted in the bronze version. It is not clear whether the crouching male figure ultimately inserted between the open legs of the standing man was originally indicated in this preliminary sketch, for the relevant part has been broken away.

ADDITIONAL BIBLIOGRAPHY: Avery, 1978.
PROVENANCE: Gherardini Collection, Florence.

C.A.

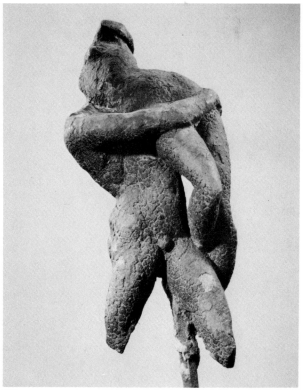

225

226

Rape of a Sabine (three figures)

h. (with base) 47 (without base) 30.8

Wax over a wire armature. Extensively damaged; all three heads and several extremities broken off.

Victoria & Albert Museum, London (1092–1854)

The group was purchased in London from an unknown vendor, probably together with the model for *Neptune* (Cat. 222), for its accession number is consecutive. Models answering to their descriptions were also consecutive lots in the Woodburn sale in the same year (see below). It may also share the same provenance from the sale of William Lock (see below), which suggests a possible origin from the collection of Vecchietti at Il Riposo (Avery, 1975/77, p. 472).

It has been fully discussed by Pope-Hennessy (1964, pp. 468–9, no. 491) and is accepted by him and by Holderbaum as an autograph model for the marble group, produced shortly before the full-scale plaster model (Accademia, Florence). It is rejected by Dhanens (1956, p.239) as a reduction made after the finished group in connection with the production of bronze statuettes (see Cat. 58, 59).

Radiography has revealed not only the structure of the wire armature, but the unexpected fact that, while the male figures are modelled solid, the body of the Sabine woman is hollow, and must be a cast. Presumably her position had been determined satisfactorily in an earlier model and a piece-mould was made to permit exact reproduction for use in the present context.

PROVENANCE: (?) Vecchietti; (?) William Lock (Sale 'Fitzhugh', Christie, 16 April 1785, no. 14: 'Samson and the rape of the Sabines, by Giov. di Bologna', bt. Nollekens, 6s.); (?) Nollekens (not in Nollekens' sale, Christie, 4/5 July 1823); Sir Thomas Lawrence (Sale, Christie, 19 June 1830, no. 349: 'An original Model, in wax, for the celebrated group of the Rape of the Sabines, by Giovanni Bologna', bt. Woodburn, £16. 16s.); S. Woodburn (Sale, Christie, 19 May 1854, no. 514: 'The rape of the Sabines, of G. di Bologna', bt. Eastwood [with 513], £7.).

C.A.

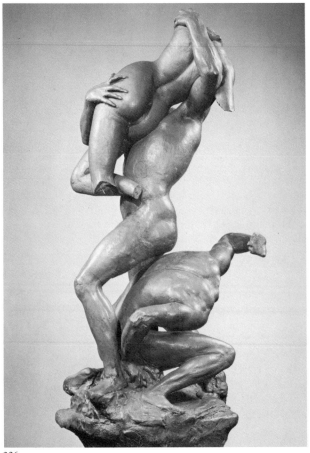

226

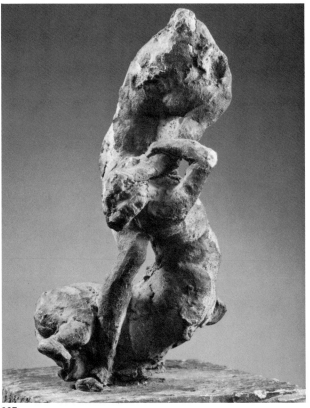

227

227

Hercules and a centaur

h.13.3

Wax, over a wire armature. The head and right arm of
Hercules and the left arm and legs of the centaur are
missing. Surface deterioration with crystalline exudation.
Victoria & Albert Museum, London (4126–1854)

The model has been fully discussed by Pope-Hennessy
(1964, p. 474, no. 497; 1970, p. 18) who regarded it as a
sketch for either the version of the subject in silver on
which Giambologna was engaged in 1576, or for the monu-
mental marble group formerly at the Canto dei Carnesecchi
and now in the Loggia dei Lanzi, Florence (completed
November 1599).

The right leg of Hercules is straighter than in the marble
group and the bronze variants made from it, and the gap
between the right knee of Hercules and the back of the cen-
taur is greater. As in Vincenzo de' Rossi's group of the
same subject made in 1568 (Palazzo Vecchio, Florence), the
hind-quarters of the centaur are resting on the ground,
whereas in a medal (Bargello, Florence) for which an
original wax model survives in the British Museum (Cat.
229) the rump is raised as in the final group. This model
therefore probably ante-dates the medal (1587–88).

The group is accepted as an autograph sketch-model by
Dhanens (1956, pp. 189–98), but is ascribed to Antonio
Susini by Keutner (1958, p. 328). Its handling and
appearance is identical with that of the two other tiny wax
sketches from the Gherardini Collection (Cat. 223, 225) and
all are likely to have the same status, as autograph sketch-
models by Giambologna.

This or another small wax model was recorded in an
inventory of 1640 (pp. 510–11) of the Dresden Kunst-
kammer: 'Hercules und Centaurus *gar klein von rotem
Wachs uff einen höltzernen stöcklein protoplasticum von
Johanne de Polonio.*' (W. Holzhausen and E. V. Watzdorf,
'Brandenburgisch-sächsische Wachsplastik des 16. Jahr-
hunderts', *Jahrbuch der Preussischen Kunstsammlungen*,
52, 1931, p. 241: this reference was kindly brought to our
attention by Dr C. Theuerkauff).

ADDITIONAL BIBLIOGRAPHY: Avery, 1975/77, pp. 470–4.
PROVENANCE: Gherardini Collection, Florence.

C.A.

228

Hercules and a centaur

h.27 (approx.)

Terracotta. Greenish-brown spots on surface. Break at
wrist of hand of the centaur on the chest of Hercules.
Trustees of the British Museum, London (1859 7–19, 3)

The model was purchased without an attribution from
the Casa Buonarotti, Florence, along with two models
probably by Michelangelo (1859 7–19, 1 & 2), through Sir
Charles Eastlake in 1859. It has been published as a work of
Giambologna only in the *Guide to Mediaeval Antiquities
and Objects of Later Date in the Department of British and
Mediaeval Antiquities*, London, 1924, p. 261: '... part of a
terracotta group, *Hercules and Antaeus*, by John of
Bologna'. It seems not to have been known to Dhanens.
Careful comparison with Giambologna's *Labours of
Hercules* makes it clear that this is a sectional model of
Hercules and a centaur (Cat. 81–2): the truncations of the
four limbs of Hercules were cut with a wire in the clay
while still in a leathery state, presumably prior to making
piece-moulds of the separate components, in order to cast
bronze versions. The only actual break is at the wrist of the
centaur, where it touched Hercules's chest: it too was
probably cut just where it cleared the body. The spotting
on the surface may have been caused by the material in
which the piece-mould was taken, or the separating agent.
The free modelling of the hair in a lumpy mass and the
delicate forms of the fingers suggest that this may be the
remains of an autograph terracotta model.

PROVENANCE: Casa Buonarotti, Florence: bt. by Museum, 1859.

C.A.

228

229

Hercules and a centaur
by **Michele Mazzafirri** (*circa* 1530–97).
Diameter (of outer inscribed circle) 4.2
White wax on slate: the club of Hercules, thorax of centaur and two letters of the inscription are damaged or missing.
Inscribed: *SIC ITVR AD ASTRA*
Lent by the Trustees of the British Museum (Department of Coins and Medals, 1933–11–12–50)

This is a rare surviving example of a wax model for a 16th-century medal. It is for the reverse of a medal of Ferdinando I by Mazzafirri dated 1588 (A. Armand, *Les Médailleurs Italiens*, 1883–87, I, p. 284, no. 8). The model was first published by Sir George Hill ('Notes on Italian Medals, XVI', *Burlington Magazine*, XXIV, 1913–14, p. 217) as the work of Mazzafirri. Dhanens (1956, p. 195) suggested that the design of the reverse might be by Giambologna himself, but in view of Mazzafirri's involvement as a goldsmith in producing the small-scale versions of this very model (see Cat. 75), it seems more likely to be his own work.

PROVENANCE: T. Whitcombe Greene.

C.A.

229

230

Christ before Caiaphas
*h.*48.3 *w.*73.7
Red wax on a wooden ground. Considerable craquelure.
Victoria & Albert Museum, London (328–1879)

This and the two following reliefs (Cat. 231, 232) are studies for three of the six bronze panels made by Giambologna for the Grimaldi Chapel in San Francesco di Castelletto, Genoa (Pope-Hennessy, 1964, pp. 469–72, nos. 492–4). The dates of this major commission, which included a *Crucifix*, six *putti* and six statues of *Virtues* at life-size, were established by Dhanens (1956, pp. 241–53). The contract between Grimaldi and the sculptor was signed in 1579, the sculptures were made in Florence, and Giambologna was still working on the chapel in 1584. On the demolition of San Francesco di Castelletto in 1815, the statues and reliefs were removed to the University of Genoa and installed in the chapel and *Aula Magna*.

At a later date, versions of the six reliefs with minor modifications were cast for Ferdinando I de' Medici, and made available by him for inclusion in Giambologna's memorial chapel, the Cappella del Soccorso in Santissima Annunziata, Florence, on which he was at work between 1594 and 1598. A third series of these reliefs is in the Bayerisches Nationalmuseum, Munich (Cat. 122–7).

A fourth red wax relief, depicting the *Flagellation of Christ*, originally associated with the present series, is now in the Queensland Art Gallery, Brisbane, Australia (Pope-Hennessy, 1966; Avery, 1975/77, p. 470, fig. 5).

The compositions correspond closely with the Genoese set of bronze panels and are Giambologna's original sketch-models. The perspectival scheme is established by lines scored into the wooden ground and by the projection of the plane of the floor at an angle. Some of the apparent differences between the models and the bronze reliefs may be the result of inaccurate repairs made to the waxes when they deteriorated subsequently. Others reflect a different adjustment of components that were cast separately from the main panel and attached mechanically.

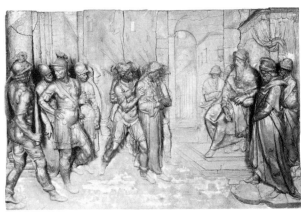

230

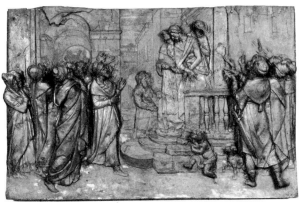

231

PROVENANCE: (?) Vecchietti; William Lock (sale 'Fitzhugh', Christie, 16 April, 1785, no. 23: 'Four Basso rilievos in wax, by *Giov. di Bologna*', bt. Nollekens, £5. 5s.); Nollekens (sale, Christie, 4/5 July, 1823, nos. 34–7: 'TERRA COTTA [From the Front Parlour]. 34 . G. DI BOLOGNA Christ before Pilate, in a glazed Case – This, and the 3 following very fine and original Terra Cottas were purchased at Mr. Locke's Sale.

35 DITTO The Flagellation.
36 DITTO Pilate washing his hands.
37 DITTO Christ exposed to the Multitude.' Bt. Palmer, £53. 4s.); Sir James Vallentin, by 1858 (sale, Christie, 28 July, 1870, nos. 333–5, bt. Benjamin £2. 10s.); Calvetti; Pinti; Riblet; Francis Austen, bt. 1878, from whom purchased by the Museum

C.A.

231
Ecce homo
h.48.3 *w*.73.7
Red wax on a wooden ground. Considerable craquelure.
Victoria & Albert Museum, London (329–1879)

See entry for Catalogue no. 230

C.A.

232
Christ led from judgement (Pilate washing his hands)
h.48.3 *w*.73.7
Red wax on a wooden ground. Considerable craquelure.
Victoria & Albert Museum, London (330–1879)

See entry for Catalogue no. 230.

C.A.

233
Mask for Palazzo Vecchietti
h.7.6
Dried clay (*terra secca*). Cracks and losses, *e.g.* on the nose and drapery.
Victoria & Albert Museum, London (4107–1854)

The mask is discussed by Pope-Hennessy (1964, pp. 473–4, no. 496), who relates its critical history as a model by Michelangelo, and its eventual recognition as a model for grotesque masks decorating the Palazzo Vecchietti in Florence (Grippi, 1956). Baldinucci (Ranalli, II, p. 574) states that the façade of the palace was designed by Giambologna and this is corroborated by its style. The date 1578 appears in Latin numerals after the name of Bernardo Vecchietti on the architraves of the external windows and Lapini (1900, p. 199) confirms that the construction of the façade towards Via Strozzi was in progress in this year. The model was independently identified by Dhanens (1956, pp. 222–4) as a sketch-model by Giambologna for the Palazzo Vecchietti. It has been suggested (Avery 1975/77, pp. 469–74) that the model might have been owned by the granducal master-mason, Bernardo di Mona Mattea, whom Vasari cites as possessing, like Vecchietti, some of Giambologna's models.

ADDITIONAL BIBLIOGRAPHY: Avery, 1978.
PROVENANCE: Gherardini Collection, Florence.

C.A.

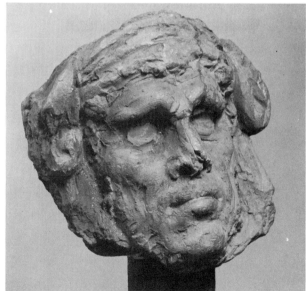

233

Mask on Palazzo Vecchietti, Florence

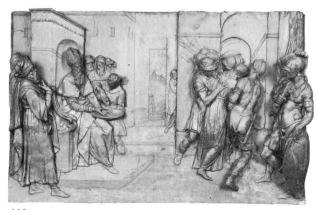

232

234

Francesco I (?) or Mars, miniature bust

*h.*11.3

Terracotta. Polychrome, with glass eyes, mounted on
original terracotta base.

Inscribed in ink, on back: *Gian Bologna / FRANCESCO I /
DE MEDICI / †1587*

Lent anonymously

The bust, which is unpublished, is a rarity in the *oeuvre* of
Giambologna and his workshop in that it is polychromed
naturalistically. The features are not inconsistent with
those of Francesco I, though the likeness is not beyond
dispute, when compared with the marble bust by
Giambologna now over the doorway to the former
Medicean theatre in the Uffizi (L. Berti, *Il Principe dello
Studiolo*, Florence, 1967, colour plate II) which probably
dates from just before 1585 (as it shows Francesco without
the Order of the Golden Fleece, which he received in that
year), or that over the portal of Palazzo Corsi, 7 via
Tornabuoni (Dhanens, 1956, pp. 230–1). The type of
heavily bearded face with a high lock of hair rising over
the centre of the forehead, the nude chest and the position
of the arms are extremely close to the corresponding parts
of Giambologna's *Mars* (Cat. 42–7). Whether there is any
relationship between that enigmatic statuette and Duke
Francesco is an open question.

PROVENANCE: Art market.

C.A.

235

River-god

h. 30.3 *l.* 39.4 *d.* 24.8

Terracotta. The left arm between biceps and wrist is
broken away.

Victoria & Albert Museum, London (250–1876)

The model has been cleaned and conserved (1976); a
wooden base-board with plaster make-up and a restoration
to the left arm (possibly made by the vendor Santarelli,
who was a sculptor) were removed. That the board was not
original, as suggested by Pope-Hennessy (1964, pp. 472–3,
no. 495), is proven by an imprinted wood-grain on the
underside of the terracotta, which runs at right angles to
that of the board. Pope-Hennessy, *loc. cit.*, discusses old
attributions to the school of Michelangelo, Montorsoli and
Tribolo, and the subsequent identification as a work of
Giambologna by Brinckmann (1923, I, pp. 76–7, pl. 28).
The model is certainly by the same hand as a terracotta in
the Museo Nazionale, Florence, for the colossal *Appenine*,
designed by Giambologna in about 1580 for the garden of
the Medici villa at Pratolino. It may be a model for a
colossal *River Nile*, the subject initially intended for
Pratolino, before the more unusual idea of the mountain
god was conceived (Keutner, 1958, p. 327). However, the
model has been dated using thermo-luminescence to
1585–1695. Substantial fragments of a still larger terracotta
model for the *Appenine* have been noticed by Avery in the
attic of the Musée de Douai (Cat. 236). The model shows
Giambologna's technique of modelling in clay at its most
direct and exciting.

ADDITIONAL BIBLIOGRAPHY: Avery, 1978 (a).

PROVENANCE: Cav. E. Santarelli, Florence.

C.A.

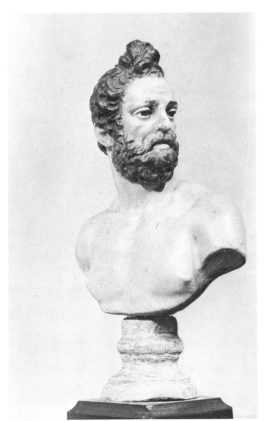

234

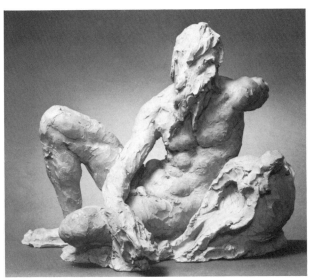

235

236

Appenine

Terra secca. Gravely damaged and fragmented, only the lower parts surviving.
Musée Municipal, Douai

This fragmentary sketch-model apparently for the *Appenine*, designed by Giambologna for the Medici villa of Pratolino about 1580, is unpublished, other than in the museum catalogue (Leroy, 1937, p. 129, no. 875). It is on a larger scale than the model in the Museo Nazionale, Florence (*h*. 33, *l*. 51), discussed by Dhanens (1956, pp. 224–30), and presumably represented the next stage in the evolution of the design.

C.A.

237

Architecture

h. 31 (overall) 28.4 (figure alone) *w*. 13 *d*. 11
Red wax, hollow cast. Surface deterioration.
Victoria & Albert Museum, London (anonymous loan)

The model, which is unpublished, is connected with the marble statue in the Museo Nazionale, Florence; and with a well-known type of bronze statuette, the best, signed, example of which is Cat. 17. It is unusual in being hollow-cast from a piece-mould, with a wall of more or less uniform thickness. It is considerably smaller than the bronze versions and cannot therefore have played a part in the lost-wax process of casting them. There are also significant differences in detail. This, together with the free handling, suggests that the wax is cast from an original clay model made in preparation for the marble *Architecture*. No other preliminary sketch-model exists and this is therefore a unique record of the sculptor's earliest thoughts. The reason for making a wax cast of a clay model might be that it could be easily re-worked, whereas terracotta cannot. A tiny paper label stuck to the back of the base bears in ink the remains of the number 350 (see Provenance).

PROVENANCE: Sir Thomas Lawrence (sale, Christie, 19 June, 1830, no. 350: 'A naked Female Figure, seated; an original model in wax, by the same artist', bt. Woodburn, £16.16s.); S. Woodburn (not in his sale, Christie 19 May, 1854); (?) Warwick Castle (reported by vendor to present owner, but not confirmed as a result of written enquiry to the curator).

C.A.

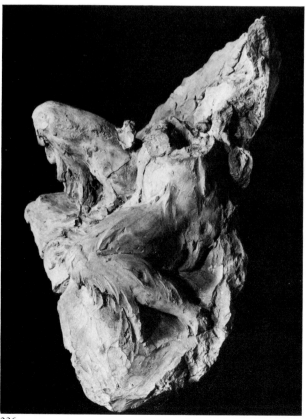

236

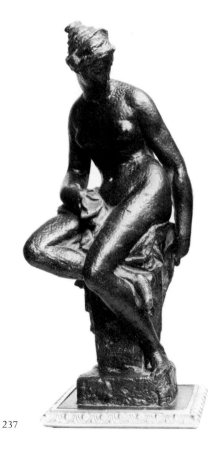

237

238

Woman seated

*h.*52.5

Wax, gilded. Surface considerably re-worked and smoothed since photograph of 1860 in Victoria & Albert Museum archives. Head broken off and reset. Musée du Louvre, Paris, Département des Sculptures (Campana 90)

As noted by Dhanens (1956, p. 162), the wax is a mirror-image of the composition of *Architecture* (Cat. 17) and cannot seriously be considered as a preparatory model. The rectangular tablet held behind the body of the lowered hand in each is similar, but the attribute held in the left hand of the present model is not readily identifiable. Now that a wax model of comparable size for *Architecture* has emerged (Cat. 237), there is still less reason to associate the present piece directly with the statue: it would function well as a pendant and was probably designed as such, possibly by a pupil. Even making allowances for the fact that the surface has deteriorated considerably, the handling, especially in the hair, seems less spontaneous than one expects from Giambologna himself.

ADDITIONAL BIBLIOGRAPHY: Vitry, 1922, p. 45, no. 381.
PROVENANCE: Campana Collection; bt. Museum 1862.

C.A.

239

Ferdinando I

*h.*18.4

Red wax on a wire armature. Both arms (below pauldrons) and lower legs broken off. Surface deterioration.
Victoria & Albert Museum, London (on loan from Brinsley Ford)

The model has been published in detail by Pope-Hennessy (1970) as an autograph sketch by Giambologna for the marble statue of Ferdinando outside the Cathedral in Arezzo, which was actually carved by Francavilla (Dhanens, 1956, p. 273). The statue is dated 1594 and bears the names of both sculptors, with an 'I' for *'Invenit'* after Giambologna's, and an 'F' for *'Fecit'* after Francavilla's. This sketch-model may represent the sum-total of Giambologna's contribution to the project, for the final marble bears the stamp of considerable interpretation by Francavilla, quite apart from its execution. He may have produced a larger model in terracotta, based on Giambologna's sketch, similar to the one which survives in the Louvre (Cat. 240) for another joint, and exactly contemporary, project for an official portrait of Ferdinando I in Pisa.

ADDITIONAL BIBLIOGRAPHY: Avery, 1975/77, p. 472.
PROVENANCE: Sir Thomas Lawrence (sale, Christie, 19 June, 1830, no. 351: *'Two* [i.e. original models by Giambologna] – in wax . . . one of the Medici Family, in armour', bt. Colnaghi, £1. 10s.); Richard Ford; by descent to the present owner.

C.A.

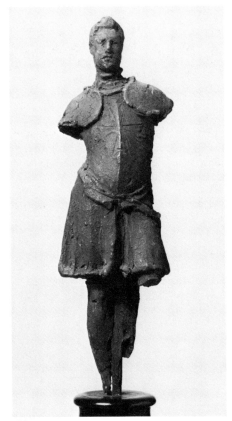

238

239

240

Ferdinando I succouring the city of Pisa
by**Pietro Francavilla** (1548–1615)
h.67
Terracotta.
Musée du Louvre, Paris, Département des Sculptures
(RF 1050)

The marble statue of *Ferdinando I succouring the city of Pisa* (in the Piazza Carrara since 1872: Francqueville, 1968, pp. 104–5) is ignored in Baldinucci's life of Giambologna, but discussed in that of Francavilla (Ranalli, III, pp. 64–5). The only evidence for Giambologna's involvement is the inscription on its base: '*EX ARCHETYPO IOHAN BONON. BELG. PETRVS A FRANCAVILLA CAMERACENSIS FECIT PISIS AD MDXCIIII*'. This implies that he produced a model, which has normally been identified with the present highly-worked terracotta (Dhanens, 1956, p. 273). Pope-Hennessy, however, doubted that Cat. 240 is by Giambologna (1970, p. 304, n. 3): 'It is difficult to believe that Giovanni Bologna was responsible either for the somewhat flaccid handling or for the clumsy composition of the Louvre bozzetto'. Possibly Giambologna's *archetypus* was a tiny wax sketch-model, which Francavilla then enlarged and worked up into the present terracotta. Still further development took place (possibly in a full-scale plaster version) before the marble was finally carved, for there are noticeable differences, particularly in the rotation of the kneeling figure of Pisa into the frontal plane, (which runs counter to Giambologna's compositional ideas), and in the facial types (Dhanens, 1956, pp. 273–4). The details of Ferdinando's armour are also changed. The present marble base has lost any architectural mouldings and is of uncertain antiquity, but its three inscriptions represent variations from the abbreviated one cut into the marble group at Pisa: (front) *FERDINANDI I / ETRVRIAE / MAGN. DVC. / PISANAM / ERIGEN*; (right) *A PETRO / FRANCAVILLA / MARM. RED. / PISISQ. POS. / MDLXXXXIIII*; (left) *IOANNIS / BONONIA / BELGAE / ARCHETYPUS / SIGNI*. The provenance of the model can be traced back only to the middle of the 19th century, but it might have been one of the items from the Medicean collections sold from the Pitti Palace in the 18th century.

FURTHER VERSIONS: Musée Jacquemart-André, Chaalis (cat. 1913, no. 487): according to M. Gaborit, Louvre, of inferior quality.
ADDITIONAL BIBLIOGRAPHY: Vitry, 1922, p. 45, no. 380.
PROVENANCE: (?) Alessandro Castellani (sale Drouot, 4–7 April, 1788, no. 4); (?) C. Timbal (sale Paris, 21–22 February, 1873; sale Paris, 11 May, 1882); bequeathed to the Louvre by Louis Marie Galichon (d. 28 January, 1893).

C.A.

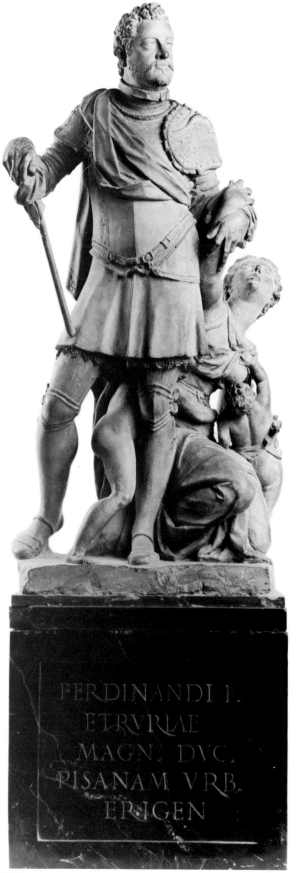

240

241

241

241

Pedestal for equestrian statue
*h.*16.7
Terracotta, painted and partially gilded.
Staatliche Museen, Berlin-Dahlem (876)

This appears to be a highly-worked sketch-model for the base of Giambologna's equestrian statue of Cosimo I in the Piazza della Signoria, Florence, and bears no relation to the aftercast of Riccio's *Shouting horseman* mounted on it (Bode, 1930, no. 58). Gramberg regarded it as a reduced variant of the finished base and Schottmüller (1933, pp. 170–1, nos. 876 a/b) relegated it to the category of 'Florentine, late 16th century' and sought its author among Giambologna's followers, reproducing and discussing only the two small areas of relief on the long sides, as though they were independent of the whole.

The quality of execution and the style of the small reliefs (*h.*5.3; *l.*11.1) points to Giambologna himself, when compared with authentic reliefs on the same, miniature scale, such as the *Acts of Francesco I* (Cat. 128). Their iconography, though different from that of the bronze panels as executed, refers to Cosimo I: *The Signoria offers Cosimo the Ducal crown in 1537* (a subject similar to that of the relief on the end of the actual monument); and *Cosimo's patronage of the arts*, with a river god (possibly the Arno) in the left foreground. The scale of the figures is far larger in comparison with the size of the pedestal than in the full-scale rendering. This may be interpreted in two ways: either the figures were initially intended to be much larger on the reliefs of the monument (in which case they would have been far more legible at a distance than the present, populous scenes with small figures), or the proportion was changed simply for ease of rendering on this small-scale variant.

According to Dhanens (1956, p. 276) the pedestal was built by Zanobi Piccardi between December, 1591 and 15 January, 1593, to the design of Giambologna, but the bronze reliefs were not made until 1596–8, and were worked on by the Della Bella brothers and Pietro Tacca. Dhanens (*loc. cit.*, p. 281) remarks that the final pedestal is small compared with the horse and rider (in length only some 305 cm. against about 400 cm.). Its design is based on that of the *Marcus Aurelius* on the Capitoline Hill in Rome, though its sides are not curved and it is higher, though narrower and shorter. Dhanens (p. 283) remarks the strong narrative and pictorial quality of the three bronze reliefs as executed, and relates it to the effect of Giambologna's visit to Venice in 1593, when he met Tintoretto and possibly Veronese. Could the less ambitious rendering of space and simpler, frieze-like design of the reliefs on the model represent his intentions *before* the visit?

PROVENANCE: purchased 1875 in Venice.

C.A.

242

Giambologna
*h.*13.5
Wax. Considerable surface deterioration.
Visitors of the Ashmolean Museum, Oxford

On the wooden base is a paper label with an old inscription in ink: '*modello originale di Gio Bologna Cos . . . Primo*'. Dhanens (1956, pp. 108–9) identified the cross hanging from a ribbon round the neck as that of the Order of Santo Stefano, founded by Cosimo in 1561 and of which he was Grand Master. Keutner (1958, p. 326) pointed out that the cross is not the Maltese-shaped cross of Santo Stefano, but that of the Knights of Christ, and that the subject is probably Giambologna himself, who was admitted to that order in 1599 (see Cat. 143). Keutner mentioned a possibility that the portrait might have been modelled by Pietro Tacca.

ADDITIONAL BIBLIOGRAPHY: B.F.A.C. cat. 1913, p. 78, pl. XLI.
PROVENANCE: A. G. B. Russell, London.

C.A.

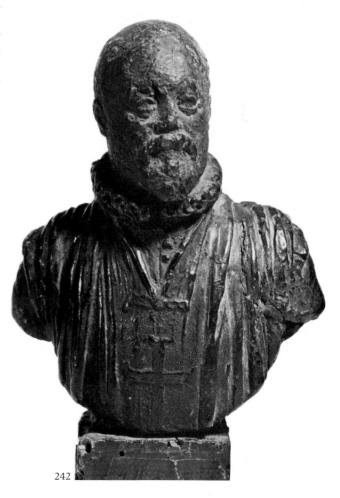

242

243
Woman reclining and writing ('Geometry and astrology')
*h.*20.3 *l.*30.5
Terracotta. Breaks at right elbow, toes of left foot, top of hair, neck.
Victoria & Albert Museum, London (A.110–1937)

Catalogued by Pope-Hennessy (1964, pp. 477–8, no. 502) as 'after Giambologna'. The close relationship of this model in pose and attributes to the small alabaster statuette dated 1569 in Vienna (Cat. 26) suggests that a similar subject is intended, *Geometry and astrology*. A recent cleaning has drawn attention to the good quality of this model. Dhanens (1956, p. 188) regards the composition as too exaggerated to be by Giambologna, and does not discuss further candidates. The motif is distantly derived from Michelangelo's *Times of day* in the New Sacristy of San Lorenzo, and his various designs for paintings of *Venus and Cupid* or *Leda and the Swan* (Tolnay, III, figs. 279–88). The particular pose, with its serpentine arrangement of body and limbs, recalls a chalk drawing by Pontormo in the Bibliotheca Marucelliana (Vol B dei Disegni, no. 175; repro. N. Ferri, 'I Disegni e le Stampe della R. Bibliotheca Marucelliana di Firenze', *Bolletino d'Arte*, V, 1911, p. 293, pl. IV). From the waist down it is also virtually a mirror-image of the figure of Cybele lying at the lower right corner of the reliefs with an *Allegory of Francesco I* (Cat. 118–21) of about 1565.

The question of authorship – as between Giambologna and one of his followers – will perhaps be illuminated in the present exhibition by a comparison with the alabaster statuette and related bronzes (Cat. 27, 28); with other examples of recumbent female figures (*e.g.* Cat. 24, 25); and with other terracotta models (Cat. 224, 228, 244, 246).

PROVENANCE: given by Mr Harold Bompas.

C.A.

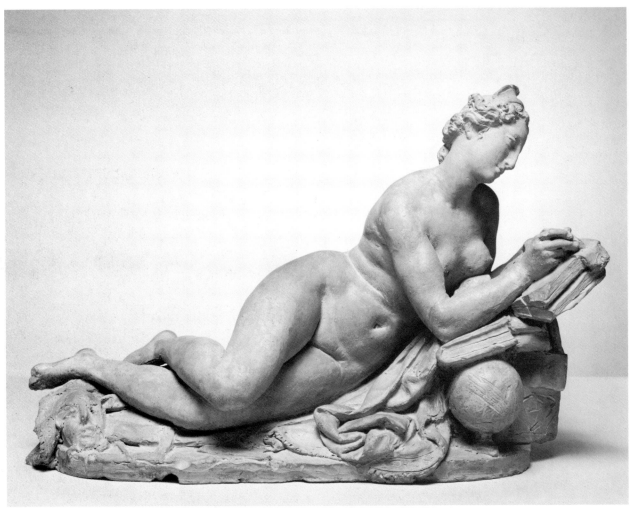

243

244

Seated female figure

attributed to **Pietro Francavilla** (1548–1615)

*h.*58.7

Terracotta gilded, hollow cast in part. Part of the object held in the left hand, the left foot and the toes of the right foot have been broken off.

Victoria & Albert Museum, London (7628–1861)

The statuette was acquired under a traditional attribution to Francavilla, which was retained by Robinson (1862, p. 167) and Maclagan and Longhurst (1932, p. 151), but denied by Pope-Hennessy (1964, p. 479, no. 505). It was ascribed by Dhanens (1956, pp. 144–7) to Giambologna and tentatively identified as a model for the seated statue of *Prudenza Civile* prepared by him for the triumphal arch erected for the entry into Florence of Joanna of Austria in 1565. It does not correspond with a contemporary description (Mellini, 1566, p. 102) cited by Pope-Hennessy, for the attributes held in the hands differ, and he was not convinced that it is by Giambologna. Keutner (1958, p. 328) assigned the model to the circle of Bandini. Comparison with female figures in marble by Francavilla, and in particular with his seated figure of *Charity* of about 1604 at the villa of Bellosguardo, near Florence (Francqueville, 1968, p. 71, fig. 35), lends weight to the traditional attribution.

PROVENANCE: Gigli-Campana collection, Rome, bt. by Museum 1861.

C.A.

245

Rape of the Sabines

*h.*17.2 *w.*17

Terracotta. Modelled in an irregular shape, and not broken.

Victoria & Albert Museum, London (1619–1855)

The relief has been conserved and freed from accretions in stucco which had been added round its edges to make it up to a rectangle: the material was revealed as modelled terracotta and the apparently fragmentary nature of the piece shown to be the result of sketchy, incomplete modelling, and not subsequent damage (*pace* Pope-Hennessy, 1964, p. 481, no. 509). Much additional detail has been clarified by the removal of a surface layer of plaster, and the torso of a fallen warrior, raising himself on his right elbow and holding a shield over his torso, has become legible below the rearing horse, in the bottom right corner. This is a motif often used in schemes for free-standing equestrian statues with the horse rearing, as the fallen figure may be contrived to give support to the fore-part of the animal (*e.g.* Leonardo da Vinci's drawings for the *Sforza Monument*). It is not clear whether the rider is intervening between the soldier on foot and the struggling woman in his arms, or helping him to carry her off.

The relief was described as by Polidoro da Caravaggio when it first appeared in modern times at the sale of Sir Thomas Lawrence, along with several similar items (see Provenance). It was first ascribed by Robinson to Giam-

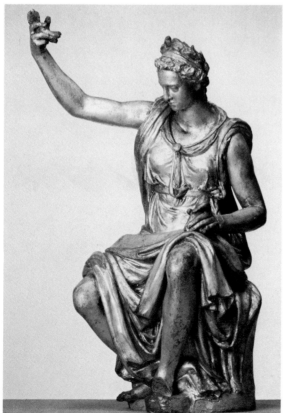

244

245

bologna, and described as 'an original sketch, representing the carrying off of Helen' (p.165, no. 1619). Pope-Hennessy (*loc. cit.*) catalogued it as 'style of Giambologna' stating that 'there are not sufficient grounds for ascribing it directly to this sculptor'. Noted without comment by Dhanens (1956, p. 240).

A sample submitted for dating by thermo-luminescence gave the span 1607–1707, placing the model in the 17th century and including only the last year of Giambologna's life. This seems to exclude the most attractive hypothesis for the origin of the relief: that it was a preparatory sketch for the bronze panel showing the *Rape of the Sabines*, set into the pedestal of Giambologna's marble group in the Loggia dei Lanzi to identify its subject, some time after its unveiling in January, 1583 (Baldinucci, II, p. 565). The exact date of the bronze panel is not documented, but it was presumably made soon after the marble was installed, and not after the turn of the century. The motif of the foot-soldier in a helmet, with a nearly naked woman squirming over his knee, who is gripped with his muscular right arm, appears in the centre, middle-ground of Giambologna's bronze relief; while the fallen figure under the front hooves of a rearing horse fills the bottom right-hand corner, though reversed. The voluptuous modelling of the legs and buttocks of the woman is not inconsistent with Giambologna's style (*e.g.* the *Rape of Europa* relief on the central support of the *Fountain of Oceanus*, Dhanens, 1956, fig. 79). It may however be by one of his close assistants of the younger generation, for it manifests something of the advanced mannerism of Prague, of paintings by Spranger and of sculpture by Adriaen de Vries.

PROVENANCE: Sir Thomas Lawrence (sale, Christie, 19 June, 1830, no. 361: 'The Rape of the Sabines, a group of four figures, by *ditto* [Polidoro da Caravaggio], same manner', bt. Triphook, £4); Henry Farrar, by whom given to the Museum, 1855.

C.A.

246
Judith and Holofernes
*h.*67 *d.*22.5
Terracotta. Good condition, apart from a crack in Judith's lower left leg and Holofernes' right knee. Sword missing from Judith's right hand.
Museum für Kunst und Gewerbe, Hamburg (1950, 63)

The model was first published by Brinckmann (1923, I, pp. 50–1, pl. 14), who ascribed it to Jacopo Sansovino on the basis of supposed analogies with the *Apollo* from the Loggetta and the *Sacristy door* of San Marco, dating it 1550–60. A Venetian origin is to be discounted, for the composition is related in reverse to that of Michelangelo's *Victory* and recalls Giambologna's *Florence triumphant over Pisa* (Cat. 224). Valentiner's attribution (Museum files) of the model to Giambologna himself is untenable, for there are infelicities in the arrangement of limbs and the stance of Judith which are totally uncharacteristic. Kriegbaum introduced the name of Giovanni Bandini (Museum files) and this has been retained with caution ever since. Stylistic analogies exist with a terracotta model of *Moses* which appeared with an attribution to G. A. Montorsoli in the Schweizer sale, Berlin, 5–6 June, 1918, no. 109.

ADDITIONAL BIBLIOGRAPHY: Museum für Kunst und Gewerbe Hamburg, *Bildführer II, Ausgewählte Werke aus den Erwerbungen wahrend der Jahre 1948–1961, Festgabe für Erich Meyer zu seinem 65. Geburtstag am 29. Oktober 1963*, Hamburg 1964, Nr. 69 (Lise Lotte Möller).
PROVENANCE: Goldschmidt, Frankfurt am Main; C. von Weinberg, Frankfurt am Main.

C.A.

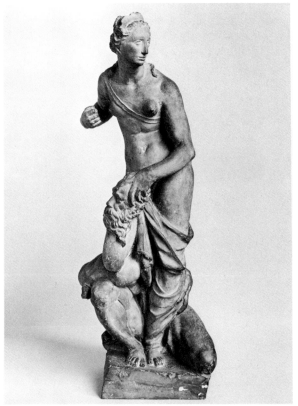

246

247

Woman

*h.*10.6

Wax on iron armature. The head and neck, both arms from the shoulders, the left leg from the calf and the right leg from the knee are all missing.

Brinsley Ford, London

The technique of modelling and the reddish colour of the material point to the Florentine school of the late-16th century. The model, which has not been published, first appeared in England in the early-19th century. Its small scale, the torsion of the body, and the implied directions of the limbs suggest that it may be meant to be complementary to a well-known type of small bronze figurine from Giambologna's workshop, the *Woman bathing* (see Cat. 6). As Professor Keutner suggests, the bronze figurines may reflect the stock-in-trade of models in several media, including wax, which the industrious artist had built up by the time of Vasari's biography (1568). This delicate model may also be one of Giambologna's stock from his early career in Florence when he was most prolific.

PROVENANCE: Sir Thomas Lawrence (sale, Christie, 19 June, 1830, no. 352: '*Two* [*i.e.* original models by Giambologna] – Small wax models of naked female Figures; the heads wanting', bt. Colnaghi, £6.6s.); Richard Ford; by descent to the present owner.

C.A.

248

Woman

*h.*15.3

Red wax. Surface deterioration and craquelure, especially on the woman's back. Head and both arms missing. No armature visible.

John Hewett

The technique of modelling and the red colour point to the Florentine school of the late-16th century. An attribution to Giambologna was introduced by Heseltine in 1916 (*Trifles in Sculpture*, 1916, no. 23). The model has been ignored by scholarship. It appears to be a sketch for a composition very probably by Giambologna, of which there is a marble version in a private collection in Sweden. The marble may be identical with one of the two statues of similar description mentioned by Borghini (1584, pp. 586–7) as having been sent to Germany, whence it might have been taken by the Swedish army under Gustavus Adolphus in the Thirty Years War: the first, called *Galatea*, was two and a half *braccia* high and was despatched by Giambologna's patron Vecchietti to an unspecified destination in Germany. The second was sent, presumably by the Medici, to the Duke of Bavaria and showed a seated girl of about sixteen years old. This has sometimes been thought to be identical with the *Architecture* (see Cat. 17), and sometimes to have been destroyed in a fire at the Residenz in Munich in 1580, but may in fact be the marble statue now in Sweden, on which research is in progress.

PROVENANCE: Angerstein, London; Heseltine, London (Royal Academy, Winter Exhibition, 1888, Burlington House, London, p. 49, no. 10); B.F.A.C., 1913, p. 77, no 56; Paget; P. C. Wilson.

C.A.

247

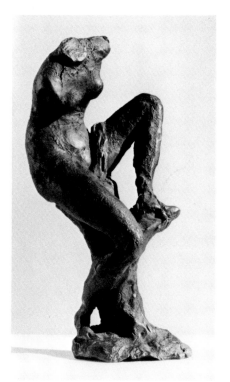

248

249

David and the head of Goliath

by **Giovanni Francesco Susini** (active 1592; d. 1646)

*h.*30

Terracotta

Biblioteca Nazionale Centrale, Florence

Published by Fred Bérence as a juvenile work by Leonardo ('Une terre cuite du jeune Léonard de Vinci?', *Bulletin de l'Association Léonard de Vinci*, Oct. 1962, no. 3, pp. 13–17), the terracotta seems rather to be a sketch-model for a bronze statuette signed 'FRAN. SVSINI F.' which has been in the Liechtenstein Collection since before 1658, when it was recorded in an inventory (Tietze-Conrat, 1917, pp. 21–22, 86, fig. 14: '*Ein David der ein Schwert in der Handt undt dess Goliats Haubt neben ihm hat*'). There is an autograph red chalk drawing for the group also in the Biblioteca Nazionale, which is datable to 1618 (see Bregenz, 1967, no. 151, fig. 72). There is a copy in ivory in the Museo degli Argenti, Florence, attributed to Baldassare Stockamer (*h.* 29.6, Piacenti Aschengreen, 1968, no. 369; K. Aschengreen Piacenti, 'Le opere di Balthasar Stockamer durante i suoi anni romani', *Bollettino d'Arte*, I–II, 1963, pp. 100–101, fig. 3). The composition and facial type are consistent with other independent works by G. F. Susini and this is the first sketch-model by him to have been identified.

ADDITIONAL BIBLIOGRAPHY: Weihrauch, 1967, p. 229.

PROVENANCE: Baron Horace de Landau bequest, 1904.

C.A.

Bibliography

AMEISENOWA, 1963
Z. Ameisenowa, *The problem of the écorché and the three anatomical models in the Jagiellonian Library*, Breslau, Warsaw, Cracow, 1963.

AMSTERDAM, 1955
Triomf van het Manierisme / Le triomphe du Maniérisme, Rijksmuseum, Amsterdam, 1955

AMSTERDAM, 1961/62
Meesters van het brons der Italiaanse Renaissance, Rijksmuseum, Amsterdam, 1961/2.

ANDROSOV, 1977
S. Androsov and L. Fayenson, Gosudarstvennuii Ordena Lenina Ermitazh, *Khudozhestvennaya bronza italyanskogo vozrozhdeniya*, Leningrad, 1977.

AVERY, 1973
C. Avery, 'Hendrick de Keyser as a sculptor of small bronzes.' *Bulletin van het Rijksmuseum*, XXI, 1, 1973, pp. 3–24.

AVERY, 1976
C. Avery, 'Soldani's small bronze statuettes after ''Old Master'' sculptures', *Kunst des Barock in der Toskana*, Munich, 1976, pp. 165–72.

AVERY, 1975/77 I
C. Avery, 'Bernardo Vecchietti and the wax models of Giambologna', *Atti del I Congresso Internazionale sulla Ceroplastica nella Scienza e nell'Arte*, Florence, 1975 (pub. 1977), pp. 461–76.

AVERY, 1975/77 II
C. Avery, 'Gregorio Pagani (1558–1605) as a wax modeller', *Atti del I Congresso Internazionale sulla Ceroplastica nella Scienza e nell'Arte*, Florence, 1975 (pub. 1977), pp. 477–88.

AVERY, 1978
C. Avery, 'Giambologna's sketch-models and his technique', *The Connoisseur*, CLXXXIX, Sept., 1978.

AVERY AND KEEBLE, 1975
C. Avery and C. Keeble, *Florentine Baroque bronzes and other objects of art*, Royal Ontario Museum, Toronto, 1975.

BADIA, 1868
J. del Badia, *Cosimo I de' Medici modellata da Giovanni Bologna e fusa da Giovanni Alberghetti: Documenti inediti*, Florence, 1868.

BALDINUCCI (RANALLI)
F. Baldinucci, *Notizie dei professori del disegno da Cimabue in qua*, Florence, 1681–88, (ed. Ranalli, Florence, 1846, reprinted 1974).

BALOGH, 1975
J. Balogh, *Katalog der ausländischen Bildwerke des Museums der Bildenden Künste in Budapest*, Budapest, 1975.

BARBET DE JOUY, 1855
H. Barbet de Jouy, *Musée Imperial du Louvre: Description des Sculptures Modernes*, Paris, 1855, pp. 32–7.

BARETTI, 1781
J. Baretti, *A guide through the Royal Academy*, London, 1781.

BAUER AND HAUPT, 1976
R. Bauer and H. Haupt, 'Das Kunstkammerinventar Kaiser Rudolfs II, 1607–1611', *Jahrbuch der Kunsthistorischen Sammlungen in Wien*, LXXII, (N.F. XXXVI), 1976.

BERTOLOTTI, 1885
A. Bertolotti, 'Die Ausfuhr einiger Kunstgegenstände aus Rom nach Oesterreich, Deutschland, Polen und Russland vom 16 bis 19 Jahrhundert', *Repertorium für Kunstwissenschaft*, II, 1885, pp. 371–6.

B.F.A.C., 1913
Burlington Fine Arts Club, *Catalogue of a collection of Italian sculpture and other plastic art of the Renaissance*, London, 1913.

BLANC, 1884
C. Blanc, *Collection d'objets d'art de M. Thiers, leguée au Musée du Louvre*, Paris, 1884.

BOCCHI AND CINELLI, 1677
F. Bocchi and G. Cinelli, *Le bellezze della città di Firenze*, Florence, 1677.

BODE, 1911
W. Bode, 'Gian Bologna und seine Tätigkeit als Bildner von Kleinbronzen', *Kunst und Künstler*, IX, 1911, pp. 632–40.

BODE, 1912
W. Bode, assisted by M. Marks, *The Italian bronze statuettes of the Renaissance*, III, London, 1912.

BODE, 1913
W. Bode, *Catalogue of the Collection of Pictures and Bronzes in the possession of Mr. Otto Beit*. London, 1913.

BODE, 1930
Staatliche Museen zu Berlin, *Bildwerke des Kaiser-Friedrich-Museums. Die italienischen Bildwerke der Renaissance und des Barock*, II, W. von Bode, *Bronzestatuetten, Büsten und Gebrauchsgegenstände*, 4 ed., Berlin/Leipzig, 1930.

BOISLISLE, 1881
M. de Boislisle, 'Les Collections de sculptures du Cardinal de Richelieu', *Mémoires de la Société Nationale des Antiquaires de France*, XLII, 1881, pp. 71–128.

BORGHINI, 1584
R. Borghini, *Il Riposo*, Florence, 1584.

BRAUN, 1908
E. Braun, *Österreichische Privatsammlungen, I: Die Bronzen der Sammlung Guido von Rhò in Wien*, Vienna, 1908.

BREGENZ, 1967
Meisterwerke der Plastik aus Privatsammlungen im Bodenseegebiet, Künstlerhaus, Palais Thurn und Taxis, Bregenz, 1967.

BRINCKMANN, 1923–25
A. Brinckmann, *Barock-Bozzetti*, Frankfurt-am-Main, 1923–25.

BUFFALO, 1937
Master bronzes, Albright Art Gallery, Buffalo, N.Y., 1937.

CAMÓN AZNAR, 1967
J. Camón Aznar, *Guia abreviada del Museo Lazaro Galdiano*, Madrid (6 ed.), 1967.

CAMPORI, 1870
G. Campori, *Raccoltà di cataloghi ed inventarii di quadri, statue, disegni, bronzi, ecc. dal secolo XV al secolo XIX*, Modena, 1870.

CASALINI, 1964
E. Casalini, 'Due Opere del Giambologna all'Annunziata di Firenze', *Studi Storici dell'Ordine dei Servi di Maria*, XIV, 1964, pp. 261–76.

CASALINI, 1973
E. Casalini, 'Un Crocifisso da tavolo di Ferdinando Tacca', *Studi Storici dell'Ordine dei Servi di Maria*, XXXIII, 1973, pp. 207–9.

CHAMPIER AND SANDOZ, 1900
V. Champier and G.-R. Sandoz, *Le Palais-Royal*, Paris, 1900.

CHARPENTIER, 1710
R. Charpentier and N. Chevallier, *Girardon: Gravures de ses Oeuvres et de son Cabinet et Gallerie par . . .*, Paris, 1710.

CHURCHILL, 1913–14
S. Churchill, 'Michele Mazzafirri, goldsmith and medallist (1530–97)', *Burlington Magazine*, XXIV, 1913–14, pp. 348, 349.

CHURCHILL, 1926
S. Churchill, *The Goldsmiths of Italy*, London, 1926.

CORTI, 1976
G. Corti, 'Two Early Seventeenth-Century Inventories Involving Giambologna', *Burlington Magazine*, CXVIII, 1976, pp. 629–34.

COURAJOD, 1882
L. Courajod, *Mémoires de la Société des Antiquaires de France*, XLIII, 1882 pp. 220–2 (review of Boislisle, 1881).

DENUCÉ, 1932
J. Denucé, *Inventories of the art-collections in Antwerp in the 16th and 17th centuries*, Antwerp, 1932.

DE NICOLA, 1916
G. De Nicola, 'Notes on the Museo Nazionale of Florence. II: a series of small bronzes by Pietro da Barga', *Burlington Magazine*, XXIX, 1916, pp. 363–73.

DE RINALDIS, 1911
A. De Rinaldis, Pinacoteca del Museo Nazionale di Napoli, *Catalogo*, Naples, 1911.

DESJARDINS, 1883
A. Desjardins, *La vie et l'oeuvre de Jean Boulogne, d'après les manuscrits inédits recueillis par Foucques de Vagnonville*, Paris, 1883.

DHANENS, 1956
E. Dhanens, *Jean Boulogne, Giovanni Bologna Fiammingo*, Brussels, 1956.

DHANENS, 1963
E. Dhanens, 'De Romeinse ervaring van Giovanni Bologna', *Bulletin de l'Institut Historique Belge de Rome*, XXXV, 1963, pp. 161–90.

DÖRING, 1894
O. Döring, ed., 'Des Augsburger Patriciers Philipp Hainhofer Beziehungen zum Herzog Philipp II von Pommern-Stettin: Korrespondenz aus den Jahren 1610–19: *Quellenschriften für Kunstgeschichte und Kunsttechnik*, VI, 1894.

FANTI, 1767
V. Fanti, *Descrizione Completa di tutto ciò che si ritrovasi nella galleria di Pittura e Scultura di Sua Altezza Giuseppe Wenceslao del S.R.I. Principe Regnante della Casa di Lichtenstein . . .*, Vienna, 1767.

FILANGIERI DI CANDIDA, 1897
A. Filangieri di Candida, 'Due bronzi di Giovan Bologna nel Museo Nazionale di Napoli', *Napoli nobilissima*, VI, Fasc. II, 1897, pp. 20–4.

FILANGIERI DI CANDIDA, 1898
A. Filangieri di Candida, 'Il Ratto di una Sabina', *Arte e Storia*, 3ᵃ ser., XVII, 1898, pp. 10–12.

FLORISOONE, 1956
M. Florisoone, 'Jacopo Bassano portraitiste de Jean de Bologne et d'Antonio del Ponte', *Arte Veneta*, 1956, pp. 107 ff.

FORRER, 1934
R. Forrer, *The collection of bronzes and castings in brass and ormolu formed by Mr F. J. Nettlefold*, London, 1934.

FORTNUM, 1876
C. Fortnum, *A descriptive catalogue of the bronzes of European origin in the South Kensington Museum*, London, 1876.

FRANCQUEVILLE, 1968
R. de Francqueville, *Pierre de Francqueville, sculpteur des Médicis et du Roi Henri IV*, Paris, 1968.

FRANSOLET, 1937
M. Fransolet, 'Une oeuvre d'art retrouvée. Le portrait de Pierre de Francheville par Giambattista Paggi', *Bulletin de l'Institut Historique Belge de Rome*, XVIII, 1937, pp. 199–207.

FRANZONI, 1970
L. Franzoni, *La Galleria Bevilacqua*, Milan, 1970.

FRIIS, 1933
H. Friis, *Rytterstatuens historie i Europa*, Copenhagen, 1933.

GAYE, 1840
G. Gaye, *Carteggio inedito d'artisti italiani*, Florence, 1839–40.

GOLDSCHMIDT, 1914
F. Goldschmidt, *Die Italienische Bronzen der Renaissance und des Barock*, Berlin, 1914.

GORI, 1767
A. Gori, *Dactyliotheca Smithiana*, II, Venice, 1767.

GRAMBERG, 1936
W. Gramberg, *Giovanni Bologna: eine Untersuchung über die Werke seiner Wanderjahre*, Berlin, 1936.

GRANBERG, 1929
O. Granberg, 'Inventaire des raritez qui sont dans la cabinet des antiquitez de la Serenissime Reine de Suède. Fait l'an 1652', *Svenska Konstsamlingarnas historia*, I, Stockholm, 1929, appendix III.

GRANBERG, 1930
O. Granberg, 'Project pour un cabinet, qui se pourrait faire à la cour des choses qui se trouvent en Suède', *Svenska Konstsamlingarnas historia*, II, Stockholm, 1930, pp. 98 ff.

GRIMALDI, 1977
F. Grimaldi, *Loreto, Palazzo Apostolico* (Musei d'Italia – Meraviglie d'Italia, 11), Bologna, 1977.

GRIPPI, 1956
R. Grippi, 'A sixteenth century bozzetto', *Art Bulletin*, XXXVIII, 1956, pp. 143–7.

GUIFFREY, 1885
J. Guiffrey, *Inventaire général du Mobilier de la Couronne sous Louis XIV*, I, Paris, 1885.

GUIFFREY, 1886
J. Guiffrey, *Inventaire général du Mobilier de la Couronne sous Louis XIV*, II, Paris, 1886.

GUIFFREY, 1911
J. Guiffrey, 'Testament et inventaire áprès décès de André Le Nostre', *Bulletin de la Société de l'Histoire de l'Art Français*, 1911, pp. 217–82.

GURRIERI AND CHATFIELD, 1972
F. Gurrieri and J. Chatfield, *Boboli Gardens*, Florence, 1972.

HACKENBROCH, 1959
Y. Hackenbroch, 'Bronzes in the collection of Mr Leon Bagrit: II. The female nude', *Connoisseur*, CXLIII, 1959, pp. 214–17.

HEIDEN, 1970
R. an der Heiden, 'Die Porträtmalerei des Hans von Aachen', *Jahrbuch der Kunsthistorischen Sammlungen in Wien*, LXVI, 1970, pp. 135–226.

HEIKAMP, 1963
D. Heikamp, 'Zur Geschichte der Uffizien-Tribuna und der Kunstschränke in Florenz und Deutschland', *Zeitschrift für Kunstgeschichte*, XXVI, 1963, pp. 193–268.

HEIM, 1973
Heim Gallery, *Paintings and Sculptures of the Italian Baroque*, London, 30 May–21 September, 1973.

HERKLOTZ, 1977
I. Herklotz, 'Die Darstellung des fliegenden Merkur bei Giovanni Bologna', *Zeitschrift für Kunstgeschichte*, XL, 1977, pp. 270–4.

HOLDERBAUM, 1956
J. Holderbaum, 'A bronze by Giovanni Bologna and a painting by Bronzino', *Burlington Magazine*, XCVIII, 1956, pp. 439–45.

HOLDERBAUM, 1966
J. Holderbaum, *Giambologna* (I maestri della scultura, 13), Milan, 1966.

HOLZHAUSEN, 1933
W. Holzhausen, 'Die Bronzen der Kurfürstlich Sachsischen Kunstkammer zu Dresden', *Jahrbuch der preuszischen Kunstsammlungen*, LIV, 1933, Beiheft.

JACOB, 1972
S. Jacob, 'Italienische Bronzen', *Bilderhefte des Herzog Anton-Ulrich-Museum*, No. 3, 1972.

JESTAZ, 1978
B. Jestaz, 'La statuette de la Fortune de Jean Bologne', *La Revue du Louvre et des Musées de France*, 1978, pp. 48–52.

JUSTI, 1883
C. Justi, 'Die Reiterstatue Philipps IV in Madrid von Pietro Tacca', *Zeitschrift für bildende Kunst*, XVIII, 1883, Part I, pp. 305–15; Part II, pp. 387–400.

JUSTI, 1886
C. Justi, 'Die Reiterstatuette Karl Emanuels von Savoyen auf der Löwenburg bei Kassel', *Zeitschrift für bildende Kunst*, XXI, pp. 115–19.

JUSTI, 1908
C. Justi, *Miscelaneen aus Drei Jahrhunderten Spanischen Kunstlebens*. II, Berlin, 1908, pp. 243–74.

KANSAS, 1971
From the collection of the University of Kansas Museum of Art, Houston, Texas, 1971.

KEUTNER, 1955
H. Keutner, 'Die Tabernakelstatuetten der Certosa zu Florenz', Mitteilungen des Kunsthistorischen Institutes in Florenz, V, 1955, pp. 139–44.

KEUTNER, 1956
H. Keutner, 'Der Giardino Pensile der Loggia dei Lanzi und seine Fontäne', Kunstgeschichtliche Studien für Hans Kauffmann, Berlin, 1956, pp. 240–50.

KEUTNER, 1957
H. Keutner, 'Two bronze statuettes of the late Renaissance', The Register of the Museum of Art, The University of Kansas, I, 1957, pp. 117 ff.

KEUTNER, 1958
H. Keutner, Kunstchronik, XI, 1958, pp. 325–38 (Review of Dhanens, 1956).

KEUTNER, 1968
H. Keutner, 'Pietro Francavilla in den Jahren 1572 und 1576', Festschrift Ulrich Middeldorf, Berlin, 1968, pp. 301–6.

KRIEGBAUM, 1931
F. Kriegbaum, 'Hans Reichle', Jahrbuch der Kunsthistorischen Sammlungen in Wien, n.f. V, 1931, pp. 189–266.

KRIEGBAUM, 1952
F. Kriegbaum, 'Der Bildhauer Giovanni Bologna', Münchner Jahrbuch der bildende Kunst, N.F., III, 1952, pp. 37–67.

LAARNE, 1967
Bronzen uit de Renaissance, Kasteel Laarne, 1967.

LANDAIS, 1949
H. Landais, 'Sur quelques statuettes léguées par Le Nôtre à Louis XIV', Bulletin des Musées de France, III, 1949, pp. 60–3.

LANDAIS, 1958
H. Landais, Les bronzes italiens de la Renaissance, Paris, 1958.

LANDAIS, 1961
H. Landais, 'Some bronzes from the Girardon collection', Connoisseur, CXLVIII, 1961, pp. 136–144.

LANKHEIT, 1962
K. Lankheit, Florentinische Barockplastik, Munich, 1962.

LAPINI, 1900
A. Lapini, Diario Fiorentino dal 252 al 1596, pubblicato da Giuseppe Odoardo Corazzini, Florence, 1900.

LARSSON, 1967
L. Larsson, Adrian de Vries, Vienna/Munich, 1967.

LEGNER, 1967
A. Legner, Kleinplastik der Gotik und Renaissance aus dem Liebieghaus, Frankfurt, 1967; also published in Staedel Jahrbuch, N.F., I, 1967, pp. 254–6.

LEITHE-JASPER, 1976
M. Leithe-Jasper, 'Bronzestatuetten, Plaketten und Gerät der Italienischen Renaissance', Italienische Kleinplastiken, Zeichnungen und Musik der Renaissance, Waffen des 16. und 17. Jahrhunderts, Schloss Schallaburg, 1976, pp. 51–244.

LENSI, 1934
A. Lensi, La Donazione Loeser in Palazzo Vecchio, Florence, 1934.

LEROY, 1937
S. Leroy, Catalogue des peintures, sculptures du musée de Douai, Douai, 1937.

LEEUWENBERG AND HALSEMA-KUBES, 1973
J. Leeuwenberg assisted by W. Halsema-Kubes, Beeldhouwkunst in het Rijksmuseum: Catalogus Samengesteld. Amsterdam, 1973.

LEWY, 1929
E. Lewy, Pietro Tacca, Cologne, 1929.

LINDBLOM, 1923
A. Lindblom, Fransk Barock och Rokokoskulptur i Sverige, Uppsala, 1923.

LOMBARDI, 1974/75
G. Lombardi, 'Giovan Francesco Susini', Annali della Scuola Normale Superiore di Pisa, ser. III, VIII, 1978, n. 4 (Tesi di Laurea, 1974/75).

LO VULLO BIANCHI, 1931
S. Lo Vullo Bianchi, 'Note e documenti su Pietro e Ferdinando Tacca', Rivista d'arte, XIII, 1931, pp. 137–213.

LUCERNE, 1948
Kunstmuseum, Meisterwerke aus den Sammlungen des Fürsten von Liechtenstein, Lucerne, 1948.

MACLAGAN AND LONGHURST, 1932
E. Maclagan and M. Longhurst, Victoria & Albert Museum, Catalogue of Italian Sculpture, London, 1932.

MANN, 1931
J. Mann, Wallace Collection catalogues, Sculpture, London, 1931.

MANSUELLI, 1958
G. A. Mansuelli, Galleria degli Uffizi: Le Sculture, Rome, 1958.

MATTIOLI, 1976
D. Mattioli, 'Curioso scambio di doni fra Vincenzo I Gonzaga e Cosimo II granduca di Toscana', Civiltà Mantovana, X, 1976, pp. 164–70.

MELLINI, 1566
D. Mellini, Descrizione dell'Entrata della Serenissima Reina Giovanna d'Austria et dell'Apparato fatto in Firenze nella venuta e per le felicissime nozze di S. Altezza et dell'Illustrissimo . . . Don Francesco de Medici, Florence, 1566.

METZ, 1966
P. Metz, Staatliche Museen Berlin-Dahlem, Bildwerke der Christlichen Epochen, Munich, 1966.

MIDDELDORF, 1958
U. Middeldorf, 'Su alcuni bronzetti all'antica del quattrocento', Il mondo antico nel rinascimento (Atti del V Convegno Internazionale di Studi sul Rinascimento, Firenze 2–6 Settembre 1956), Florence, 1958, pp. 167–77.

MIGEON, 1904
G. Migeon, Musée National du Louvre, Catalogue des bronzes et cuivres, Paris, 1904.

MIGEON, 1907
Catalogue raisonné de la collection Martin le Roy, III, G. Migeon, Bronzes et objets divers, Paris, 1907.

MONTAGU, 1963
J. Montagu, Bronzes, London, 1963.

MÜNTZ, 1895
E. Müntz, Histoire de l'art pendant la Renaissance, III, Italie: la fin de la Renaissance, Paris, 1895.

MÜNTZ, 1896
E. Müntz, 'Les collections d'antiques formées par les Médicis au XVIe siècle', Mémoires de l'Académie des Inscriptions et Belles-Lettres, Paris, XXXV, 2, 1896.

NEUMANN, 1966
E. Neumann, 'Das Inventar der rudolfinischen Kunstkammer von 1609–1611', Analecta Reginensia, I, Queen Christina of Sweden, Documents and Studies, Stockholm, 1966, pp. 262 ff.

NICOLA, 1916
G. De Nicola, 'Recenti acquisti del Museo Nazionale di Firenze. Due frammenti del bozzetto di Giambologna pel gruppo ''Il vizio che incatena la virtù'' ', Bolletino d'Arte, X, 1916, p. 5.

NOTRE DAME, 1970
The Age of Vasari, Notre Dame, 1970.

OLSEN, 1961
H. Olsen, Italian paintings and sculpture in Denmark, Copenhagen, 1961.

PARDO CANALIS, 1956
E. Pardo Canalis, 'La estela de Juan de Bolonia en el Museo Lazaro Galdiano', Goya, XIII, July–August, 1956, pp. 2–7.

PARKER, 1956
K. Parker, Catalogue of the Collection of Drawings in the Ashmolean Museum, II: Italian Schools. Oxford, 1956.

PARRONCHI, 1961
A. Parronchi, 'Il Crocifisso di S. Spirito', Studi Urbinati di Storia, Filosofia e Letteratura, Nuova Serie B, I, pp. 5–41.

PATRIZI, 1905
P. Patrizi, Il Giambologna, Milan, 1905.

PHILLIPS, 1958/59
J. Phillips, 'A Shell, Two Saints, and a Bird', Bulletin of the Metropolitan Museum of Art, XVII, 1958/59, pp. 221 ff.

PIACENTI, 1967
C. Piacenti Aschengreen, *Il Museo degli Argenti a Firenze*, Florence, 1967.
PLANISCIG, 1921
L. Planiscig, *Venezianische Bildhauer*, Vienna, 1921.
PLANISCIG, 1923
L. Planiscig, *Collezione Camillo Castiglioni. Catalogo dei Bronzi. Con introduzione e note descrittive.* Vienna, 1923.
PLANISCIG, 1924
L. Planiscig, Kunsthistorisches Museum in Wien, *Die Bronzeplastiken*, Vienna, 1924.
PLANISCIG, 1928
L. Planiscig, 'Eine Unbekannte Bronze Gruppe des Giambologna', *Pantheon*, II, 1928, pp. 382–6.
PLANISCIG, 1930
L. Planiscig, *Piccoli bronzi italiani del rinascimento*, Milan, 1930.
POPE-HENNESSY, 1954
J. Pope-Hennessy, *Samson and a Philistine*, London, 1954.
POPE-HENNESSY, 1964
J. Pope-Hennessy, assisted by R. Lightbown, *Catalogue of Italian Sculpture in the Victoria & Albert Museum*, London, 1964.
POPE-HENNESSY, 1966
J. Pope-Hennessy, 'A new work by Giovanni Bologna', *Victoria & Albert Museum Bulletin*, II, 1966, pp. 75–7.
POPE-HENNESSY, 1968
J. Pope-Hennessy, *Essays on Italian Sculpture*, London, 1968.
POPE-HENNESSY, 1970 I
J. Pope-Hennessy, 'The Gherardini Collection of Italian Sculpture', *Victoria & Albert Museum Yearbook*, II, 1970, pp. 7–26.
POPE-HENNESSY, 1970 II
J. Pope-Hennessy, 'Giovanni Bologna and the Marble Statues of the Grand-Duke Ferdinando I, *Burlington Magazine*, CXII, 1970, pp. 304–7.
POPE-HENNESSY, 1970 III
The Frick Collection, an illustrated catalogue, III, J. Pope-Hennessy assisted by A. Radcliffe, *Sculpture, Italian*, New York, 1970.
POPE-HENNESSY, 1970 IV
J. Pope-Hennessy, *Italian High Renaissance and Baroque Sculpture*, London/New York, 2nd ed. 1970.
POPE-HENNESSY AND HODGKINSON, 1970
The Frick Collection, an illustrated catalogue, IV, J. Pope-Hennessy, assisted by A. Radcliffe, and T. Hodgkinson, *Sculpture: German, Netherlandish, French and British*, New York, 1970.
POPE-HENNESSY, 1971
J. Pope-Hennessy, *Italian Renaissance Sculpture*, 2nd ed. 1971.
POPP, 1919
A. Popp, 'Steigerung, Akzentuierung und aphoristische Formensprache als Kunstmittel der Ägypter', *Zeitschrift für bildende Kunst*, N.F. 30, LIII, 1919, pp. 149–60.
POPP, 1927
A. Popp, 'Giovanni da Bologna: design for a fountain. Collection of Mr. Henry Oppenheimer', *Old Master Drawings*, II, 1927, p. 23, pl. 27.
POTTERTON, 1974
H. Potterton, 'The sculpture collection' (of the National Gallery of Ireland), *Apollo*, XCIX, 1974, pp. 142–5.
RADCLIFFE, 1966
A. Radcliffe, *European bronze statuettes*, London, 1966.
RADCLIFFE, 1972
A. Radcliffe, Ms catalogue of the bronzes in the National Gallery of Ireland, Dublin, 1972.
RADCLIFFE, 1976
A. Radcliffe, 'Ferdinando Tacca, the missing link in Florentine baroque bronzes', *Kunst des Barock in der Toskana*, Munich, 1976, pp. 14–23.
RAUMSCHÜSSEL, 1963
M. Raumschüssel, 'Bildwerke der Renaissance und des Barock', *Der Menschheit Bewahrt*, Staatliche Kunstsammlungen Dresden, Dresden, 1963, pp. 209–15.

REZNICEK, 1961
E. J. Reznicek, *Die Zeichnungen von Hendrick Goltzius*, Utrecht, 1961.
ROBINSON, 1862
J. Robinson, South Kensington Museum, *Italian sculpture of the Middle Age, and the Period of the Revival of Art. A descriptive catalogue of the works forming the above section of the Museum.* London, 1862.
ROBINSON, 1969
F. Robinson, 'Springfield's anatomical horse of bronze', Museum of Fine Arts, Springfield, Mass., *Annual Bulletin*, XXXVI, no. 1, Oct.–Nov., 1969.
RONEN, 1970
A. Ronen, 'Portigiani's bronze "Ornamento" in the Church of the Holy Sepulchre, Jerusalem', *Mitteilungen des Kunsthistorisches Institut, Florenz*, XIV, 1970, pp. 415–442.
RUINI, 1598
C. Ruini, *Anatomia del cavallo, infermità, e suoi rimedii*, Bologna, 1598.
SALMANN, 1969
G. Salmann, 'An attempt at an analysis', *Connoisseur*, CLXX, 1969, pp. 19–23.
SANTANGELO, 1954
A. Santangelo, Museo di Palazzo Venezia, *Catalogo delle sculture*, Rome, 1954.
SANTANGELO, 1964
A. Santangelo, Museo di Palazzo Venezia, *La Collezione Auriti*, Rome, 1964.
SCHLOSSER, 1901
J. von Schlosser, *Album ausgewählter Gegenstände der Kunstindustriellen Sammlung des A. H. Kaiserhauses*, Vienna, 1901.
SCHLOSSER, 1910
J. von Schlosser, *Werke der Kleinplastik in der Skulpturensammlung des Allerh. Kaiserhauses, I, Bildwerke in Bronze, Stein und Ton*, Vienna, 1910.
SCHLOSSER, 1913/14
J. von Schlosser, 'Aus der Bildnerwerkstatt der Renaissance', *Jahrbuch der Kunsthistorischen Sammlungen der Allerhöchsten Kaiserhauses*, XXXI, Part I, 1913, pp. 67–135; Part II, 1914, pp. 347–58.
SCHOTTMÜLLER, 1933
F. Schottmüller, Staatliche Museen zu Berlin, *Die italienischen und spanischen Bildwerke der Renaissance und Barock*, 2nd ed., Berlin, 1933.
SEMPER, 1869
H. Semper, 'Documente über die Reiterstatue Cosimos I', *Zahn Jahrbuch für Kunstwissenschaft*, II, 1869, pp. 83–7.
SETTIMANNI, 1574–87
Cav. F. Settimanni, *Diario Fiorentino*, IV, 1574–87, Florence, (Ms. ASF, *Manoscritti Misc.* voll. 125–47).
SMITH COLLEGE, 1964
Smith College Museum of Art, *Renaissance Bronzes in American Collections*, Northampton, Mass., 1964.
SOUCHAL, 1973
F. Souchal, 'La Collection du sculpteur Girardon d'après son inventaire après décès', *Gazette des Beaux-Arts*, 6e pèr., LXXXII, 1973, pp. 1–98.
SQUILBECK, 1944
J. Squilbeck, 'Bronzes italiens de la Renaissance', *Bulletin des Musées Royaux d'Art et d'Histoire*, Brussels, 3 sér., XVI, 1944, pp. 2–12.
STROHMER, 1950
E. Strohmer, 'Bemerkungen zu den Werken des Adriaen de Vries', *Nationalmusei Årsbok 1947–1948*, Stockholm, 1950, pp. 93–138.
SUPINO, 1898
I. Supino, *Catalogo del R. Museo Nazionale di Firenze (Palazzo del Potestà)*, Rome, 1898.
THIEME AND BECKER
U. Thieme and F. Becker, *Allgemeines Lexikon der Bildenden Künstler*, I–XXXVII, Leipzig, 1907–50.

TIETZE-CONRAT, 1917
E. Tietze-Conrat, 'Die Bronzen der fürstlich Liechtensteinischen Kunstkammer', *Jahrbuch des Kunsthistorischen Institutes des deutschoesterreichischen Staatsdenkmalamtes*, XI, 1917, pp. 16–108.

TIETZE-CONRAT, 1918
E. Tietze-Conrat, 'Beiträge zur Geschichte der italienischen Spätrenaissance- und Barockskulptor', *Jahrbuch des Kunsthistorischen Institutes des deutschoesterreichischen Staatsdenkmalamtes*, XII, 1918, pp. 44–75.

TOKYO, 1973
Nationalmuseum für Westliche Kunst, *Italienische Kleinbronzen und Handzeichnungen der Renaissance und des Manierismus aus Österreichischem Staatsbesitz*, Tokyo, 1973.

TOLNAY, 1970
C. de Tolnay, *Michaelangelo. III. The Medici Chapel*, Princeton, 1970.

TORRITI, 1975
P. Torriti, *Pietro Tacca di Carrara*, Genoa, 1975.

UTZ, 1971
H. Utz, 'Giambologna e Pietro Tacca: ritrovato il "Crocifisso d'argento" con l'imagine del "Cristo vivo"', *Paragone*, 1971, pp. 66–80, illus. 53–63.

VAN MANDER – FLOERKE, 1617/1906
C. Van Mander (ed. H. Floerke), *Het leven der doorluchtighe Nederlandtsche en Hoogduytsche schilders*, Munich, 1906.

VENTURI, 1885
A. Venturi, 'Zur Geschichte der Kunstsammlungen Kaiser Rudolf II', *Repertorium für Kunstwissenschaft*, VIII, 1885, pp. 1–23.

VENTURI, 1937/39
A. Venturi, *Storia dell'Arte Italiana*, X, XI, 1937 and 1939.

VERLET, 1957
P. Verlet, 'Chapeaurouge et les collections royales françaises', *Festschrift für Emil Meyer*, Hamburg, 1957, pp. 286–94.

VERMEULE, 1952
C. Vermeule, 'An imperial medallion of Leone Leoni and Giovanni Bologna's statue of the flying Mercury', *Spinks' Numismatic Circular*, Nov. 1952, pp. 506–10.

VITRY, 1922
P. Vitry, Musée national du Louvre, *Catalogue des Sculptures, I, Moyen Age et Renaissance*, Paris, 1922.

VOLLMER, 1916
H. Vollmer, s.v. Francavilla, Thieme & Becker, 1916.

WARK, 1959
R. Wark, *Sculpture in the Huntington Collection*, Los Angeles, 1959.

WATSON, 1978
K. Watson, 'Sugar-sculpture for granducal weddings from the Giambologna workshop', *The Connoisseur*, CLXXXIX, Sept., 1978.

WATSON, 1979
K. Watson, *Pietro Tacca, successor to Giovanni Bologna: the first twenty-five years in the Borgo Pinti studio* (dissertation to be published 1979).

WATSON AND AVERY, 1973
K. Watson and C. Avery, 'Medici and Stuart: a Grand Ducal Gift of "Giovanni Bologna" Bronzes for Henry Prince of Wales (1612)', *Burlington Magazine*, CXV, 1973, pp. 493–507.

WEIHRAUCH, 1956
H. Weihrauch, Bayerisches Nationalmuseum, Katalog XIII, 5, *Die Bildwerke in Bronze und in anderen Metallen*, Munich, 1956.

WEIHRAUCH, 1967
H. Weihrauch, *Europäische Bronzestatuetten*, Brunswick, 1967.

WEIHRAUCH/VOLK, 1974
Bayerisches Nationalmuseum, *Bildführer*, 1, *Bronzeplastik: Erwerbungen von 1956–1973* (edited by P. Volk from material by H. Weihrauch), Munich, 1974.

WILDE, 1700
J. de Wilde, *Signa antiqua e Museo Jacobi de Wilde per Mariam filiam aeri inscripta*, Amsterdam, 1700.

WILES, 1933
B. Wiles, *The fountains of Florentine sculptors and their followers from Donatello to Bernini*, Cambridge, Mass., 1933.

WIXOM, 1975
W. Wixom, *Renaissance Bronzes from Ohio Collections*, The Cleveland Museum of Art, Cleveland, Ohio, 1975.

WYNNE, 1974
M. Wynne, 'The Milltowns as patrons, particularly concerning the picture-collecting of the first two earls', *Apollo*, XCIX, 1974, pp. 104–11.

WYNNE, 1975
M. Wynne, National Gallery of Ireland, *Catalogue of the sculptures*, Dublin, 1975

Back cover: Coat of arms of Giambologna awarded by the Emperor Rudolph II, 1588.